MW00528126

MASCULINITY AND MONSTROSITY IN CONTEMPORARY HOLLYWOOD FILMS

GLOBAL MASCULINITIES

Edited by Michael Kimmel and Judith Kegan Gardiner

Michael Kimmel is a professor of Sociology at the State University of New York at Stony Brook. He is the author or editor of more than 20 books, including: *Men's Lives, Guyland: The Perilous World Where Boys Become Men, The Gendered Society, The Politics of Manhood*, and *Manhood in America: A Cultural History*. He edits *Men and Masculinities*, an interdisciplinary scholarly journal, and edited the *Encyclopedia of Men and Masculinities* and the *Handbook of Studies on Men and Masculinities*. He consults with corporations, nongovernmental organizations, and public-sector organizations all over the world on gender equity issues, including work–family balance, reducing workplace discrimination, and promoting diversity.

Judith Kegan Gardiner is a professor of English and of Gender and Women's Studies at the University of Illinois at Chicago. Her books are *Craftsmanship in Context: The Development of Ben Jonson's Poetry* and *Rhys, Stead, Lessing, and the Politics of Empathy*. She is the editor of the volumes *Provoking Agents: Gender and Agency in Theory and Practice* and *Masculinity Studies and Feminist Theory*, and a coeditor of *The International Encyclopedia of Men and Masculinities*. She is also a member of the editorial board for the interdisciplinary journal *Feminist Studies*.

Published by Palgrave Macmillan:

Masculine Style: The American West and Literary Modernism
By Daniel Worden

Men and Masculinities Around the World: Transforming Men's Practices
Edited by Elisabetta Ruspini, Jeff Hearn, Bob Pease, and Keith Pringle

Constructions of Masculinity in British Literature from the Middle Ages to the Present
Edited by Stefan Horlacher

Becoming the Gentleman: British Literature and the Invention of Modern Masculinity, 1660–1815
By Jason D. Solinger

The History of Fatherhood in Norway, 1850–2012
By Jørgen Ludvig Lorentzen

Masculinity and Monstrosity in Contemporary Hollywood Films
By Kirk Combe and Brenda Boyle

MASCULINITY AND MONSTROSITY IN CONTEMPORARY HOLLYWOOD FILMS

by

Kirk Combe and Brenda Boyle

First published in 2013 by
PALGRAVE MACMILLAN®
in the United States—a division of St. Martin's Press LLC,
175 Fifth Avenue, New York, NY 10010.

Where this book is distributed in the UK, Europe and the rest of the world,
this is by Palgrave Macmillan, a division of Macmillan Publishers Limited,
registered in England, company number 785998, of Houndmills,
Basingstoke, Hampshire RG21 6XS.

Palgrave Macmillan is the global academic imprint of the above companies
and has companies and representatives throughout the world.

Palgrave® and Macmillan® are registered trademarks in the United States,
the United Kingdom, Europe and other countries.

ISBN 978-1-349-47204-8 ISBN 978-1-137-35982-7 (eBook)
DOI 10.1057/9781137359827

Library of Congress Cataloging-in-Publication Data

Combe, Kirk.
 Masculinity and monstrosity in contemporary Hollywood films /
 by Kirk Combe and Brenda Boyle.
 pages cm.—(Global masculinities)
 Includes bibliographical references and index.
 1. Masculinity in motion pictures. 2. Men in motion pictures.
 3. Motion pictures—United States—History—21st century. I. Boyle,
 Brenda M., 1957– II. Title.
PN1995.9.M34C66 2013
791.43'65211—dc23 2013019947

A catalogue record of the book is available from the British Library.

Design by Newgen Knowledge Works (P) Ltd., Chennai, India.

First edition: November 2013

10 9 8 7 6 5 4 3 2 1

This book is dedicated to our children: Clayton, Olivia, and Hannah—coolest kids ever

Other Publications by the Authors

Brenda Boyle

"At Home with the Unhomely: Vietnamese and Iraqi Narratives of Resettlement." *Representations of War, Migration and Refugeehood: Interdisciplinary Perspectives.* Ed. D. Rellstab and C. Schlote (Routledge, forthcoming).

Fictions of the American War in Vietnam (Bloomsbury, forthcoming).

"Rescuing Masculinity: Captivity, Rescue and Gender in American War Narratives." *The Journal of American Culture* 34.2 (June 2011): 149–160.

Masculinity in Vietnam War Narratives: A Critical Study of Fiction, Films and Nonfiction Writing (McFarland Publishers, 2009).

" 'Phantom Pains': Disability, Masculinity and the Normal in Vietnam War Representations." *Disability and/in Prose* (Routledge, 2008, 83–97).

Kirk Combe

"Bourgeois Rakes in *Wedding Crashers*: Feudal to Neo-Liberal Articulations in Modern Comedic Discourse." *The Journal of Popular Culture* 46.2 (April 2013): 338–358.

"Spielberg's Tale of Two Americas: Postmodern Monsters in *War of the Worlds.*" *The Journal of Popular Culture* 44.5 (October 2011): 934–953.

2084 (Mayhaven Publishing, 2009).

A Martyr for Sin: Rochester's Critique of Polity, Sexuality, and Society (University of Delaware Press, 1998).

Theorizing Satire: Essays in Literary Criticism (St. Martin's Press, 1995).

Contents

FIGURES

NOTE FROM THE SERIES EDITORS

In Sweden, a "real man" is one who does childcare for his own children, and liberals and conservatives argue not about whether there should be government-mandated paternity leave but about the allocation of time between new mothers and fathers. In China, years of enforcing a one-child rule have led to a population with a vast demographic imbalance in the number of males over females, with consequences yet to be determined. In Iran, vasectomy becomes increasingly popular as men seek to take more responsibility for family planning in an atmosphere of restrictive gender roles. In the Philippines, government-supported exports of women as nurses, maids, and nannies to first-world countries alters the lives of boys and girls growing up both at home and in the developed countries, and Mexican-American men adapt to their wives' working by doing increased housework and childcare, while their ideology of men's roles changes more slowly. And throughout the world, warfare continues to be a predominantly male occupation, devastating vast populations, depriving some boys of a childhood, and promoting other men to positions of authority.

Global Masculinities is a series devoted to exploring the most recent, most innovative, and widest-ranging scholarship about men and masculinities from a broad variety of perspectives and methodological approaches. The dramatic success of Gender Studies has rested on three developments: (1) making women's lives visible, which has also come to mean making all genders more visible; (2) insisting on intersectionality and so complicating the category of gender; and (3) analyzing the tensions among global and local iterations of gender. Through textual analyses and humanities-based studies of cultural representations, as well as cultural studies of attitudes and behaviors, we have come to see the centrality of gender in the structure of modern life and life in the past, varying across cultures and within them. Through interviews, surveys, and demographic analysis, among other forms of social scientific inquiry, we are now able to quantify some of the effects of these changing gender structures. Clearly written for

both the expert and more general audience, this series embraces the advances in scholarship and applies them to men's lives: gendering men's lives, exploring the rich diversity of men's lives—globally and locally, textually and practically—as well as the differences among men by social class, "race"/ethnicity and nationality, sexuality, ability status, sexual preference and practices, and age.

MICHAEL KIMMEL
and
JUDITH KEGAN GARDINER

ACKNOWLEDGMENTS

No book comes out of thin air. Many people have knowingly or not contributed to our thinking. Those most directly involved include our children, to whom this volume is dedicated; ours always has been a movie-watching family. Many other supporters are at Denison University: magical technicians Anne Crowley and Trent Edmunds; Denison generally for granting us each paid leave to work on the volume; Brenda's students of war language and war and masculinities whose ideas influenced hers; and Kirk's students of postmodern monsters whose ideas influenced his. Linda Mizejewski at Ohio State also helped Brenda to see it was worth uncovering her face to look hard at the monster on the screen.

This book is also an outcome of our decades-long collaboration in life. For that—the collaboration and the life—we thank one another.

Introduction: Of Masculine, Monstrous, and Me

Imagine that you're sitting in the movie theater waiting to watch *Terminator Salvation*. You've bought your slightly overpriced movie ticket. You're juggling your severely overpriced bucket of soda and barrel of popcorn. At this point, you're tolerating the pre-programming, all the dross that precedes the trailers. Included in this lackluster cavalcade are some of the same commercials that come at you on television. Imagine that one of these advertisements manages to break through the clutter, probably because it's on the big screen, to capture your attention. In commercial terms, this advertisement is epic in scope and, despite its obviously inferior production value, cinematic in ambition. It's an advertisement for the National Guard.

Employing that oldest of claims, the hero story, this advertisement looks to sell you on the concept of the Citizen-Soldier. The Citizen-Soldier is that selfless trooper who one second is shown rescuing the family cat off a rooftop in Any-Flooded-Neighborhood, USA (defending hearth and home), then the next second is shown maneuvering smartly house-to-house with a leveled rifle in Any-Dusty-Slum, Middle East (spreading Democracy around the world). This fusion of hometown sentimental with real-world tactical is a heady mix, even potentially disorienting *if* you were allowed a split-second to reflect on what you're being shown. But advertising is designed to trigger desire, not critical thinking. The pace of the advertisement is Bruckheimerian, the music thunderous (think Qui-Gon and Obi-Wan taking on Darth Maul). You're rushed headlong to an emotional climax of gigantic American flags snapping in the breeze, of little girls wrapped in disaster blankets being reunited with their tattered dollies, of backlit helicopters clacking fearlessly through dangerous night skies. *Hell yeah!* you're supposed to shout inside your head for that twinkling of an eye before the silver screen fills with its next item. *Hell yeah!*

Then it hits you: *Hey, this commercial sure looks a lot like the movie I'm about to see.* Let's pursue that idea for a moment.

To assert Hero, there must be simultaneously an assertion of Enemy, which is to say, an assertion of Monster. That which attempts to thwart all we deem just and good inherently is biased and evil, and therefore misshapen and hideous. Without the opposition of Monster, there is no need for Hero. Broadly speaking, monsters come in two varieties: monsters found and monsters made. Monsters found are beasts emerging out of nature, from beyond the current sphere of human knowledge and endeavor. Sometimes we happen upon such monsters, and other times they happen upon us. However, whether from darkest jungle, deepest sea, or the farthest reaches of outer space, these monsters appear without warning and threaten our status quo. Think, for example, of the moor-wandering Grendel. Monsters made are beasts emerging out of nurture, that is, from *within* the current sphere of human knowledge and endeavor. Whether fabricated as a result of our ignorance, our oversight, or our overreach, these monsters that we manage to cook up for ourselves do far worse than menace our status quo. They *alter* our status quo. They fundamentally change the game. Think of Victor Frankenstein's handiwork.

Interestingly, implied but absent from our direct view in the National Guard commercial are both types of monsters. When dealing with flood, fire, tornado, or any other natural disaster, the Citizen-Soldier battles, in essence, monsters found. Our Hero's efforts are to resist the physical environment in order to restore the interrupted status quo. Think of Hurricane Katrina. However, when hunting door-to-door in foreign lands for insurgents, the Citizen-Soldier encounters monsters made. The suppression tactics being employed here by our Hero represent not a defense against a mysterious peril, but a coordinated effort to enforce an altered status quo that is a result of our *own* doing. Uncomfortable as it is, think of Bin Laden, think of Hussein. Try as we might to distance ourselves from any responsibility for Terrorism or Oil Wars, the former Osama and Saddam are outcomes of our own geopolitical ingenuity—something the Central Intelligence Agency (CIA) terms "blowback" (Johnson). Moreover, just as Victor Frankenstein shrinks from his horrible creation, we deny accountability for our malformed international relations beasts. Victor whinges nonstop about the attacks he suffers at the hands of the monster *he* made and immediately abandoned; we natter on about terrorists "envying our freedom" or about our "liberation of Iraq." In short, like Victor, we hope to slip monsters made over into the category of monsters found, thereby avoiding culpability for our actions. We

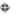

want to explain *all* monsters as inexplicable and immutable, that is, as incomprehensible Evil simply doing what unfathomable Malevolence does: oppose (our equally axiomatic) Good. The trouble with monsters, though, whether found or made, is that they won't stay put. Monsters refuse to play our convenient game of Platonic binaries, of being always Bad to our perpetual Good. Scratch the scaly or ulcerated skin of a monster and out oozes Nietzschean mayhem.

But, so what? You're still in stadium seating, with syrupy soda and greasy popcorn, waiting impatiently for *Terminator Salvation* to begin. What does this monster business have to do with you? The answer is everything. You're about to be fed, just when you're at your most unthinking vulnerable—that is, when you're expecting simply to be entertained—the same fairy tale as that animating the National Guard commercial. Only this time, the production value will be spectacular. By way of a peculiar mix of heroic masculinity and hostile monstrosity, you're about to be subjected to a grandiose and alluring claim for EITHER/OR. The purpose of this book is to investigate that complex intersection of masculinity and monstrosity in contemporary Hollywood films.

If the monstrous body can be read as a metaphor for the cultural body, as Jeffrey Cohen posits, and if gendered behavior is a matter of performativity, as Judith Butler theorizes, then taken together these two identity positions—monster and man—offer a panoramic window into the workings of human society. Moreover, by examining the phenomena of manliness and monsterliness as they are expressed in recent Hollywood movies, this study investigates not only popular culture, but the workings of early-twenty-first-century American social order. We don't regard the movies discussed in this book primarily as aesthetic filmic constructions depicting the inner turmoil of psychologically believable individual characters. Such an approach to creative work tends to obscure the crucial social issues of subject formation and power inevitably present in the text. Instead, we read these movies as complicated markers of and participants within such configuring social discourse. As Judith Halberstam remarks: "the seemingly banal pop cultural text, with its direct connection to mass culturally shared assumptions, is far more likely to reveal the key terms and conditions of the dominant than an earnest and 'knowing' text" (*Queer* 60). With this insight in mind, we focus our analyses particularly on warfare and militarism, capitalism–corporatism–imperialism, the infliction of gender and the gender trouble certain to follow such contrived and rigid obligations, and the singular impulse of any hegemonic group: formulating, naturalizing, enforcing, and perpetuating

a "truth" of Good Us versus Bad Them. We hold that when you partake in the seemingly harmless and undemanding activity of viewing
Terminator Salvation, you're being bombarded, as you munch and
slurp your unhealthy treats, with a wholly specific and highly contrived way to see the world. The remainder of this introduction outlines our theoretical assumptions and approaches to the idea of me
(meaning simultaneously we), to the concept of masculine behavior,
and to that entity deemed a monster.

Theorizing Me

Michel Foucault maintains that within the modern state we are fashioned by a particular technique of power.

> This form of power that applies itself to immediate everyday life cat
> egorizes the individual, marks him by his own individuality, attaches
> him to his own identity, imposes a law of truth on him that he must
> recognize and others have to recognize in him. It is a form of power
> that makes individuals subjects. There are two meanings of the word
> "subject": subject to someone else by control and dependence, and
> tied to his own identity by a conscience or self-knowledge. ("Subject
> and Power" 130)

Thus, within the socializing machinery that Foucault describes as
a panoptic discipline, we are individualized into a useful sameness,
simultaneously being shaped and shaping ourselves into an identity
that conforms to a description of reality both worked out by the most
powerful group within a given society but also so widely diffused in
the culture as to seem natural and thus invisible. This paradox of individuality–commonality is accomplished not primarily by proscription,
but by devising and enforcing a range of allowable behaviors from
which a subject may choose. Says Foucault of this mode of power:

> It incites, it induces, it seduces, it makes easier or more difficult, it
> releases or contrives, makes more probable or less; in the extreme, it
> constrains or forbids absolutely, but it is always a way of acting upon
> one or more acting subjects by virtue of their acting or being capable
> of action. ("Subject and Power" 138)

The modern power relationship grants us actual, not illusory, freedom to decide how to conduct ourselves—but only within a limited and carefully structured possible field of choices. Modern power,
then, is a set of actions upon other possible actions. Moreover, the

more understated, if not invisible, is this type of governance, the more effective it will be. One term for this normalizing phenomenon is ideology, which Terry Eagleton defines pointedly as "the way men live out their roles in class-society, the values, ideas and images which tie them to their social functions and so prevent them from a true knowledge of society as a whole" (16–17). For Eagleton, as well as other Marxist and post-Marxist theorists, the function of ideology "is to legitimate the power of the ruling class in society" in such a way that its dominance "is either seen by most members of the society as 'natural', or not seen at all" (5). Of primary importance to be rendered "natural" or invisible by ideology is the pyramidal hierarchy of the modern state. Like the feudal state that preceded it, the modern state is exploitative and governed by a minority elite, the aristocrat replaced by the One Percent. The productivity of the capitalist marketplace is remarkable as an engine for the generation of wealth; however, the marketplace is equally notorious as a miserable means for distributing that wealth and its benefits. Ideology obscures this crucial system defect. Astonishingly, a fallacy that has become embedded deeply in American popular thinking is the notion that capitalism *equals* democracy. Somehow, in this irrational formula, one cannot exist without the other, and any communitarian impulse is tarred with the label of "socialism" and denounced as the enemy of "freedom." Recently, however, the Occupy Wall Street movement has managed to loosen the stranglehold of such fraudulent concepts on the American mind. Active now in our public debate is a very different description of how capitalism works. Far from operating as a free and open meritocracy, American social order might be better characterized as follows: the working class serves as industrial and military cannon fodder; the middle class pays the lion's share of the bills (in the form of consumer prices and taxes) in order to underwrite US corporate and military adventurism; and the plutocrats rake in the lion's shareholder dividends from the spreading of neoliberalism around the world.[1] Such circumstances hardly constitute democracy.

Obviously, our approach to modern society in this book is that of cultural materialism. Fundamental to our analysis are the theories of Foucault and how those theories have been extended and elaborated upon by various theorists in the areas of politics, economics, gender, sexuality, disability, as well as literary/filmic criticism. Thus, certain concepts will be treated at length in the individual chapters that follow: power as the fabricator of a dominant discourse; hegemony as the dominant discourse ever in contention and under pressure of renegotiation; fictive art as a key player in the game of cultural meaning.

Social quietism in the form of aesthetic analysis, therefore, is *not* the aim of this study. We seek to demonstrate how the dominant never should be mistaken for the universal. In particular, we assert that concepts of monstrosity and masculinity are two essential ingredients in any recipe of power relations formulating a predominating world-view. Identifying behavioral qualities and then sanctioning some while condemning others are among the more important operations of ideology. Within the long-standing patriarchy of Western culture, defining appropriate male actions as well as those activities most in conflict with that patriarchal ascendancy is at the heart, arguably, of our society, and has been for centuries.

Foucault talks of our having to imagine what we could be without the capitalist double bind of simultaneous individualization (e.g., I am a rugged individual) and totalization (who believes in and performs all the same things as the *other* rugged individuals). Says Foucault: "We have to promote new forms of subjectivity through the refusal of this kind of individuality that has been imposed on us for several centuries" ("Subject and Power" 134). A society without power relations, that is, where it's impossible for some to act on the actions of others, is mere abstraction at this point (and likely any other) in human history. Instead, Foucault recommends as a course of action the careful analysis of power relations in a given society—how they form, how strong or weak they are, how to go about altering some and doing away with others.

> For to say that there cannot be a society without power relations is not to say either that those which are established are necessary, or that power in any event, constitutes an inescapable fatality at the heart of societies, such that it cannot be undermined. Instead, I would say that the analysis, elaboration, and bringing into question of power relations and the "agonism" between power relations and the intransitivity of freedom is an increasingly political task—even, the political task that is inherent in all social existence. ("Subject and Power" 140)

The perpetual social task ever at hand, then, is the forging of new power relations that establish a new range of options from which we can choose. Such change, of course, depends on *who* in a given society formulates, as Foucault puts it, "the types of objectives pursued by those who act upon the actions of others." Which group holds the power to create the state determines everything. That group will determine "the system of differentiations that permits one to act upon the actions of others" (i.e., who is better/worse and stronger/weaker

in the society—power differences that are, at the same time, both conditions and results) and the "instrumental modes" for the enforcement of power (by force of arms, economic disparities, systems of surveillance, methods of persuasion, or any other number and combination of things; "Subject and Power" 140). In short, neither the power relations nor the power players in a state ever are fixed and unchangeable. Power and how individuals are shaped into subjects of the modern state is a process in flux and always susceptible to transformation no matter how stable, natural, or everlasting the current state may appear. Panoptic discipline is an instrument—a method, a mode of power—that can be applied for any number of ends. This hegemonic struggle is what we intend as authors to assert, to investigate, and to join. More than just inspect present-day power relations, we aim in this book to enact agonistic pluralism by voicing an argument for radical and plural democracy against the neoliberal hegemony now dominant domestically and globally.

To begin: we've *all* been raised to know precisely what's manly as opposed to monsterly conduct. Correct? For example, in *Terminator Salvation*, manly John Connor fights the monsterly Machines to save humanity from annihilation. The scenario is the stuff of Heroism. Connor and the Resistance, a macho and martial bunch, are tough, technologically savvy, and steely eyed in their opposition to Skynet—the ruthless Enemy that launched Judgment Day. The movie gives us a straightforward battle of selfless Good versus pure Evil. Right? Well, not if you think beyond the action-adventure of the film. When you evaluate past the thrills, a legitimate question becomes: Is there any difference between these two opponents? What's being suggested is not that the Resistance and the Machines simply *comport* themselves the same, but that they *are* the same. Connor's heroics and Skynet's antagonism are two sides of one coin, made of one metal. Let's call it hyper-acquisitive xenophobic militarism. Within the speculative fiction of the *Terminator* saga, Skynet is developed by the US military–corporate complex to be the ultimate weapons system, our means both to defend ourselves with might and to project our might. When the artificial intelligence of Skynet becomes self-aware, the ideology producing such technology becomes, in effect, a conscious entity. It's as though our War Machine literally comes alive. Inevitably, that War Machine enacts the doctrine that created it: protect-against-cum-obliterate all Outsiders. Ironically, at that moment, We become Them, at least as far as Skynet is concerned. We become victims of our own means of oppression. The same twist occurs in the *Matrix* trilogy, where the Machines come into conscious being not as an embodied

War Machine but as, perhaps, a living Panopticon or even Capitalism incarnate. The human bosses are reduced to the laboring commodity: batteries. But in both series of films, the Machines are an extension of the Humans. They are Us. As a result, cheering for John Connor (or for Neo) against the Machines makes no more sense than cheering for the Machines against John Connor. Either way, you're cheering for the same thing: macho men and their war toys (or, in the case of the *Matrix* movies, the monopoly on the means of production).

Let's pursue this line of analysis yet another step. The irony of our being attacked or enslaved by our own machines is not obscured in either storyline. Both Sarah Connor and Morpheus make this blunder plain to audiences. Does such a caustic point being articulated, however, render these films as appeals for disarmament or for fiscal justice? Hardly. That smattering of counterculture might give these movies a calculated Che Guevara-esque, underdog rebel edge, something good for the box office. But these movies do nothing to explore the real issues and conflicts of the arms race or of the modern economic system, that is, to refer again to Eagleton, "a true knowledge of society as a whole." Instead, these movies give us Hero fighting Monster rendered in stirring visual effects—practically the antithesis of cultural exegesis. It is the genius, then, of sophisticated subject formation when an audience can be induced to endorse and not endorse, at the same moment, a single idea. We cheer macho martial display (John Connor) as we revile macho martial display (Skynet). Wouldn't such a situation encourage a fight-fire-with-fire mentality in an audience, that is, one where it's not even possible to conceive of water? Wouldn't such a situation lead an audience to conclude that there *is* no other way to view the world? Hyper-acquisitive xenophobic militarism is made the *way* of the world, an unshakable truth without social alternative. Therefore, in *Terminator Salvation*, even when a case ostensibly is made against the dominant culture (via our hatred for Skynet), the dominant culture (via our love of the Resistance) is reinforced.

Foucault remarks of the modern state: "Never, I think, in the history of human societies…has there been such a tricky combination in the same political structures of individualization techniques and of totalization procedures" ("Subject and Power" 131). While incited to stand out as one of a kind, we are yoked together in tractable uniformity. This topiary practice takes place within a myriad of power mechanisms. We demonstrate in this book how among them, quite prominently, are masculinity and monstrosity as depicted in popular films.

THEORIZING MASCULINITY

Our thinking about gender broadly and masculinities specifically is also founded in Foucault, notably his ideas about how power mechanisms are actualized through discourse. That is, rather than power, history, and subjectivity being preexisting, natural essences only described by and reflected in language, they instead are the consequences of linguistic and physical practices. The effect of discourse is to make seem natural (or unnatural) events, behaviors, and institutions, especially those that, perversely, sustain and propagate the naturalizing effects of discourse. Discourse is not limited, either, to a certain genre or sophistication of text, nor must the components of a discourse display obvious connections. In discussing his work on prisons and punishment, Foucault explains what it means to discern discourse's components:

> In this piece of research on the prisons, as in my earlier work, the target of analysis wasn't "institutions," "theories," or "ideology" but *practices*—with the aim of grasping the conditions that make these acceptable at a given moment; the hypothesis being that these types of practices are not just governed by institutions, prescribed by ideologies, guided by pragmatic circumstances—whatever role these elements may actually play—but, up to a point, possess their own specific regularities, logic, strategy, self-evidence, and "reason." It is a question of analyzing a "regime of practices"—practices being understood here as places where what is said and what is done, rules imposed and reasons given, the planned and the taken-for-granted meet and interconnect. ("Questions of Method" 247–248)

It is such a discursive and iterative regime of practices that we are examining in looking at the interconnections of monstrosity and masculinity. What discourses, we ask, align these two in Hollywood films since the turn of the century? What currently resonant logics and strategies have been deployed simultaneously to naturalize militaristic masculinities and denature opposing monstrosities in these films?

Recognizing the discourses that align monstrosity and gender is not a new move. In the Introduction to *The Dread of Difference: Gender and the Horror Film*, Barry Keith Grant claims "an essential truth about the genre of horror film: the extent to which it is preoccupied with issues of sexual difference and gender" (1). He further comments that, "it may be possible to see the entire genre on one level as about patriarchy and the challenges to it" (2). The collection includes foundational essays by feminist film scholars, most notably

Linda Williams, Carol Clover, and Barbara Creed, all of whom theorize depictions of women in horror and monster films using psychoanalytic theories. In 1983, for instance, Williams published "When the Woman Looks," concluding that in classic horror films of the 1930s and '40s, "the woman's look at the monster offers at least a potentially subversive recognition of the power and potency of a nonphallic sexuality" and the woman is punished accordingly (24). Conversely, in more recent "psychopathic" horror films, the identification between woman and monster is so complete that the woman becomes the monster: "she *is* the monster, her mutilated body is the only horror" (31). In 1986, Carol Clover published "Her Body, Himself: Gender in the Slasher Film," arguing that the "Final Girl" is the young woman who survives the chainsaw or knife or bludgeoning device of the monster because she is smart, mechanically capable, sexually reluctant, and more like a boy than any of the other girls (86). "Figuratively seen," Clover explains,

> the Final Girl is a male surrogate in things oedipal, a homoerotic stand-in, the [male] audience incorporate; to the extent she means "girl" at all, it is only for signifying phallic lack, and even that meaning is nullified in the final scenes…The Final Girl is (apparently) female not despite the maleness of the audience, but precisely because of it. The discourse [of slasher horror films] is wholly masculine, and females figure in it only insofar as they "read" some aspect of male experience. (98)

Creed's essay in the collection originally appeared in 1986, but her 1993 publication of *The Monstrous-Feminine: Film, Feminism, and Psychoanalysis* elucidates her argument: The monstrosity of women in horror films hinges on their sexuality, particularly in their figurative ability to castrate men.

These initial considerations of monstrosity and gender in films focus on femininity. Moreover, these three theorists use "gender" and "feminine" to discuss female bodies, so that when they refer to "gender" and "feminine," they are referring to the behaviors of biological females, as though females essentially are feminine. Keeping in mind Foucault's notion that the material world's meaning is discursively constructed, and influenced further by Judith Butler's idea of gender as performative rather than bodily essence, in this study, we treat the physiological, sexed body and the behaviors it enacts as separable entities. In the 1999 Preface to *Gender Trouble*, Butler clarifies what she means by the "performativity" of gender: "what we take to

be an internal essence of gender is manufactured through a sustained set of acts, posited through the gendered stylization of the body" (xv); gender is "an expectation that ends up producing the very phenomenon that it anticipates" (xiv); "what we take to be 'real,' what we invoke as the naturalized knowledge of gender is, in fact, a changeable and revisable reality" (xxiii). Like Foucault's understanding that meaning is not inherent to but discursively is assigned to acts, Butler sees gender as not an essence inherent to a particularly sexed body— biological males are masculine, biological females are feminine—but a naturalizing and naturalized enactment produced through the repetition of everyday acts construed and understood socially as "masculine" or "feminine."[2] Such naturalizing occurs for Butler as gender and sex "create an *illusion* of stability, certainty, fixity and naturalness concerning the human subject" (Chamber and Carver 40) through "the repetitious activities that make individuals and therefore their bodies what they are through unselfconscious citation of ideas, concepts or norms" (39). Thus Butler's "trouble" is to denaturalize the equation of the body, or sex, and behavior, or gender.

Both Foucault and Butler, then, destabilize what is taken as natural, inevitable, and immutable, creating a portal to examining gender not necessarily as about women, as it so regularly is, but instead to an examination of behaviors related to sexed bodies generally, and to masculinities specifically, that may be imposed on and enacted by bodies human or inhuman, male or female (hetero- and homo-, trans- and intersexual, Butler might add). For instance, in *Female Masculinity*, Judith Halberstam assumes what Butler terms in *Undoing Gender* a requisite "critical relation" to, or distance from, gender norms as she declares that masculinity as performative is most evident in bodies not "naturally" assumed to enact it—that is, in females.[3] "Masculinity," Halberstam contends, "becomes legible as masculinity where and when it leaves the white male middle-class body" (2). Motivated by her frustration with the culture's inability to define masculinity, the culture's "indifference" to masculinities enacted by females, and certain of "heroic" masculinity's dependence on various subordinate or "alternative" masculinities, including female masculinity (1–2), Halberstam's is a political project, aiming toward "gender parity" (272) by making "masculinity safe for women and girls" (268). Halberstam's late 1990s' foray into gender politics might have been motivated equally by the work of men's studies scholars, sociologists like R. W. Connell and Michael Kimmel, who at the time did not discriminate between the body sexed as male and the behavior it purportedly displayed, masculinity. As late as 1995

in *Masculinities*, Connell implicitly equated males with masculinity as he outlined contending versions of gendered behavior among males. By the 2001 publication of *The Men and the Boys*, however, Connell contended that though gender is a social practice related to sexed bodies, it is not constituted by the physiology of those bodies. "Masculinity," Connell asserts, "*refers* to male bodies...but it is not *determined* by male biology. It is, thus, perfectly logical to talk about masculine women or masculinity in women's lives, as well as masculinity in men's lives" (29). In *Gender* (2002), Connell posits this idea more forcefully: "[W]e cannot think of social gender arrangements as just following from the properties of bodies. They also precede bodies, form the conditions in which bodies develop and live" (33). With coauthor James W. Messerschmidt in December 2005's "Hegemonic Masculinity: Rethinking the Concept," Connell reiterates this point: "Masculinity is not a fixed entity embedded in the body or personality traits of individuals. Masculinities are configurations of practice that are accomplished in social action and, therefore, can differ according to the gender relations in a particular social setting" (836). Thus, at the beginning of the twenty-first century, masculinity as a mobile gender identity was recognized as a legitimate area of cultural study.

Connell's most significant contribution to masculinity studies and to our examination of monstrosity and masculinity is the idea that masculinity is practiced in various ways and in variously sexed bodies, but most especially by and among males. Organized hierarchically, and historically and culturally mutable, these sets of practices include hegemonic, subordinate, complicit, and marginalized masculinities. Hegemonic masculinity is the set of practices, whose features are determined locally, which sustains men's dominance over women, sometimes through physical force but usually through cultural and discursive practices (Connell and Messerschmidt 832). Hollywood films are among the most apt of cultural devices to normalize this dominance as they purportedly are benign "entertainment" and not ideological. Connell and Messerschmidt suggest that males are unable to refuse the perquisites of hegemonic masculinity, constrained as they are "by embodiment, by institutional histories, by economic forces, and by personal and family relationships" (842–843). The other three categories—subordination, complicity, and marginalization—indicate the inflexibility among males within the framework of hegemony. "Subordination" is typified by the relationship between avowedly heterosexual and homosexual men (Connell, *Masculinities* 78); homosexual men displaying the masculine physical

ideal are included in this inferior category by those identifying as heterosexual, as are any males perceived as feminine. "Complicity" is the practice of individuals (males or females) enjoying the "patriarchal dividend" of hegemonic masculinity's existence, whether or not they participate in it (79). The fourth of Connell's relationships among males is "marginalization," a category including men not matching the dominant group in terms of class, ethnicity, religion, or race; men with disabilities also would be included in the category. Far from being a homogeneous mode of behavior, masculinity is not only various but also a vital participant in the discourse of modern power.

Most known as a scholar of men's historical social conditions, Michael Kimmel also contributes to our understanding of male performance as he argues that gender is less about biological differences and more about "hierarchy, power, and inequality" discernible across time (*Gendered Society* 1). In *Manhood in America*, Kimmel traces through American history the cultural idea of manhood, of the changing experiences of being a man. In *The Gendered Society*, Kimmel reverses the axiom that gender differences produce gender inequality to say that the inequality produces the difference. He concludes: "As gender inequality is reduced, the differences between men and women will shrink" (264). Kimmel outlines a specific case of power differentials in *Guyland: The Perilous World Where Boys Become Men* (2008). Having interviewed college men across the United States, Kimmel argues that the current model of masculinity available to young men is self-centered, brutal groupthink. He concludes:

> In the end we need to develop a new model of masculinity... Being a real man means doing the right thing, standing up to immorality and injustice when you see it, and expressing compassion, not contempt, for those who are less fortunate. In other words, it's about being courageous. (287)

Although Kimmel regards masculinity as a male behavior and femininity as a female one, his tracing the historical changeability of masculinity in and among men is valuable.

The ideas of these theorists impact how we read American filmic monsters of the last decade. From Foucault we conclude that because meanings about the material world are discursive, discourse crosses genre and discipline boundaries, and films are and have been the United States' most persistent cultural form for the last century, we can look to these texts and their contexts for gendering and monsterizing discourse. Butler's notion of gender as performative extends

Foucauldian discourse to gender and specifies how to read as gendered the practices and physical embodiments of film characters, while Halberstam's contention that masculinity is most legible when performed by female bodies exemplifies Butler's point even more urgently. Connell's ideas both confirm Halberstam's insistence that biology does not determine gender and also helps us discern a synchronic hierarchy of masculinities among males and females depicted in films during the last decade. Kimmel, meanwhile, provides tools to regard gender diachronically, as gender behavior changes across time and, by extension, across cultures. In our book, to track these shifting gender positions, we refer to someone's biological sex by the terms "female" and "male." All other designations—such as woman, girl, man, boy, feminine, masculine, womanly, manly—pertain to the performance of gender.

To test some of these theories, even a cursory application to the *Terminator* films reveals a variety of gender troubles and contradictions. Prominent among these is Sarah Connor (Linda Hamilton) who, between the first and second films in the series, transforms from a feminine to a masculine female. In *The Terminator* (1984), Sarah signifies ordinary feminine female of the 1980s: She has dirty blonde, Farah-Fawcett-like, shoulder-length hair, clothes her unremarkable body with run-of-the-mill outfits, works a humdrum job, holds few political opinions, and overall has few distinctions in her life. What sets her apart, however, is being pursued by the death-dealing Terminator (Arnold Schwarzenneger) as well as the explanation time-traveling Kyle Reese (Michael Biehn) offers for this pursuit: The Terminator has been sent from the future to kill her, and Kyle Reese to protect her, because she is to be the mother to the future world's savior. This new status as the modern Virgin Mary changes everything about Sarah Connor—but most notably her performance of gender. At the outset of *Terminator II: Judgment Day* (1991), she is an entirely different person both physically and psychologically. While being held in a mental institution, she demonstrates a ruthless cunning unimaginable in the former Sarah. She feigns being drugged into compliance while simultaneously preparing for escape. During her escape and once she is out of the mental institution, viewers witness her physical transformation into a masculine warrior. Her long hair, in the first film carefully styled and colored blondish, is straight and longer, not dyed or styled, and usually pragmatically restrained in a ponytail. Her clothing is equally hardnosed, as she wears functional cargo pants and tight-fitting tank tops that display her muscularly developed—and thereby masculine—arms. Without question, Sarah

has built the hard body needed to wield various phallic weapons. Thus, in anticipation of the militaristic aggression of Skynet, Sarah Connor has assumed an equally militaristic and masculinist brawn. Moreover, with her body she's altered her mental outlook. She's no longer the frightened, screaming, helpless, and overemotional woman traditional to monster movies. Now she's adopted the traits of the traditionally dominant male: calculating, cool-headed, assertive, and emotionally withholding. Sarah is grimly determined to raise her son as the best future world's savior she possibly can. To impose the manly discipline of a warrior on John, she must herself be manly and disciplined—which means denying her son motherly love. Evidently, anything traditionally maternal would be detrimental to John's all-important training.

In Sarah Connor, then, we find a glaring example of gender performativity: With a single body, she enacts femininity and masculinity equally well. Her cross-gender performance also calls attention to the attributes and behaviors of dominant masculinity, as Halberstam suggests when female bodies perform masculinity. At the same time, however, Sarah Connor also can be read as a case of gender essentialism: As a biological female, she must necessarily exhibit traditionally feminine characteristics—even if her extraordinary circumstances drive her to the extreme of behaving masculinely. One signifier of traditional femininity that Sarah retains is her long hair. Even with it pulled back into a tight ponytail, and even while she's toting semiautomatic weapons, this splay of hair signals Sarah's innate femininity. Such a detail might be construed to mean that Sarah Connor's transformation to female-masculine is temporary, that her performance of masculinity is simply a necessary but optional response to a particular contingency. As soon as her son is mature enough to lead the resistance to Skynet, Sarah will revert to her more innate female femininity, the films posit. Indeed, before *Terminator II*'s conclusion, Sarah gushes to John about how she loves him as well as rants that *real* creativity is in childbirth—not in the manly stupidity of designing weapons of mass destruction. Regardless of whether the *Terminator* films maintain or break down gender barriers and conventions, gender trouble abounds in them for viewers willing to look.

Likewise, what about John Connor? Despite his being an obvious action-hero, couldn't he also be regarded as a mama's boy? In *Terminator II*, he plays at being a tough and out-of-control street kid, but he turns out to be an unusually responsible, reasonable, and well-mannered teen—even something of an emotional softy. In *Terminator Salvation*, John obsessively listens to tapes of his mother

instructing him. To be sure, he brandishes all manner of offensive weapons. Yet his obsession with saving people, with rescue, seems a "maternal" trait passed on from Sarah. And what about the Machines? Even though most of them take on a masculine shape, they certainly have no essential gender. In fact, they have no essence of any kind. That's part of their monstrosity: They are pure performativity by way of programming. They will act any way they're told; for the more advanced Terminator models, they can also morph into any shape or person needed to complete their deadly mission. To cloud things even more, in *Terminator III: Rise of the Machines* (2003), Skynet sends back in time a gynoid assassin to kill John Connor and his future lieutenants in the human Resistance. This new model of Terminator, the T-X (Kristanna Loken), has the exterior of a stunningly beautiful woman, yet is guided by the same aggressively destructive logic instilled in the "male" Terminators.[4] Part of viewers' objection to this latest killing Machine (even while ogling its cleavage) is its obvious gender bending as well as "her" unfair use of feminine wiles. Such a pretty little gal just shouldn't be slaughtering all those folks. It's funny, though, how we so easily regard this masculine female Machine as the enemy when, in the previous film, we regard masculine female Sarah Connor as the heroine. In short, the inspection of gender quickly becomes a messy business. The popular notion is that there are only two, and that they naturally belong in specific bodies. Therefore, for the majority of viewers, Sarah Connor's bulging triceps cannot obliterate her natural femaleness; John Connor's adolescent need for mother-love will not negate his adult ability to deliver the masculine feats American audiences expect of a hero; and the Machines always will be treacherous and inhuman because their bodies are illegible, not signaling an essential nature within. As we've suggested in this section on masculinity and gender, though, such stability is an illusion of discourse. The same can be said for the concept of monstrosity.

THEORIZING MONSTROSITY

Our method for scrutinizing monsters corresponds with Jeffrey Cohen's Monster Theory, which he describes as "a method of reading cultures from the monsters they engender" (3). Thus, we practice cultural poetics: the investigation of fictive creations not as expressions of "universal" human qualities unbound by time and space, but as local manifestations arising out of the attitudes and concerns of a temporally particular society. This approach does not deny the obvious

circumstance of human cultures around the globe and throughout history imagining evil beings and mythical beasts. However, cultural poetics avoids the Platonic flight of fancy highlighted by Nietzsche: that because many specific leaves exist materially, there must be an ideal pattern for LEAF, from which they all are stamped, floating somewhere on a timeless, spiritual plane (83). For example, consider how in *Das Kapital* Marx likens the activity of capital to a vampire, a dead entity sucking the life-blood out of labor, and how Marxist critics, following this lead, have read Bram Stoker's *Dracula* (1897) as a metaphor for Victorian capitalism. Such treatments of monstrosity neither assume nor assert that their local interpretation of a monster is *the* interpretation of all monsters from all times and for all places. That is, Marx does not declare that the original vampire legends grew from a distrust of late monopoly capitalism. Bafflingly, though, some scholars contend that Marxist and postmodern theorists *are* claiming universality for their readings of monsters. Anthropologist David Gilmore remarks about the vampire–capitalist comparison:

> Such a model, while perhaps useful for Victorian Britain, would be hard put to explain the power of the aboriginal Windigo among Native Americans, or the demons of Oceania, places where capitalism postdates monster lore by thousands of years. But then again, to be fair, these Western-confined theorists do not have the luxury of comparative data. (15)

Gilmore's nod toward evenhandedness, of course, is snide. If he wanted to be fair, he would not so willfully misread this obviously culture-specific view of vampirism. Yet yearning after universals is a difficult habit to shake and a desire deep-seated in Western thinking. Gilmore declares: "monsters are universal, as universal as family or incest taboos, occurring in all kinds of societies and under all economic conditions" (15). One wonders, however, *which* family is *the* worldwide and eternal unit—extended, complex, nuclear, nontraditional, dysfunctional? And if incest is taboo, that means there has to be someone practicing it in order for it to be outlawed in the first place, which means those folks are not partaking of this "universal" taboo. But then again, to be fair, Derrida points out, using the case of Lévi-Strauss, just how fuzzy and confusing the nature/culture binary can be (499).

Gilmore's maintaining a strict distinction between a fixed nature and a variable culture is instructive not only of different approaches to monstrosity, but of the severance between a modern and a

postmodern outlook generally. Gilmore states the obvious when assuring us that a "relativistic social-constructivist approach just does not take us very far" in defining the universal monster (15). Indeed, it does not. Postmodernism and cultural poetics would never attempt or claim to concoct the One True Monster. Of interest to these analytical methods is how individual monsters are constructed within given societies and what cultural functions they serve. This is not to say, however, that Gilmore's findings about convergences in monsters imagined from around the world and throughout history are uninteresting or useless. They're neither. The primary shared attributes he points out are what one might expect: Monsters tend to be very big and to have large, scary biting mouths. From these two basic features issue forth a cavalcade of psychoanalytical and anthropological explications: oral-aggressive fantasies, cannibalistic urges and phobias, sadism, Oedipal guilt, castration anxiety, infantile omnipotence and helplessness, collective species memory of being prey, a return of the primitive reptilian cerebellum, dreamwork and nightmare *bricolage*, repressed emotions, the beast within, god–demon duality, sadomasochistic perversion.[5] Gilmore concludes that, as a symbol, monsters unite "the totality of the psyche in all its grotesqueness, contradictoriness, whimsy, and dynamism" so powerfully that they must be considered a fourth component of the human mind. He declares: "The monster is the super-id" (194). And who are we to argue with Freud as a universal looking glass? Obviously the benighted and time-bound Marx is an inadequate instrument with which to contemplate the Windigo among Native Americans or the demons of Oceania. Freud, however, whose theories originated in the study of nineteenth-century Viennese bourgeoisie, surely applies to every soul who ever trod the planet.

Our book about monstrosity is intent on studying actual leaves on the tree, not the ghostly LEAF. That is, our inquiries involve culturally specific, early-twenty-first-century filmic monsters enjoying wide distribution in American theaters. We offer no transcendental signified for Monster; instead, each instance of monstrosity is pondered as floating signifier within the contemporary American scene. History will certainly figure into our analyses, whether contemplating the Battle of Thermopylae or adaptations of *King Kong*. However, as Eagleton points out: "It is a curiously narrowed view of history which defines it merely as the 'contemporary moment' and relegates all else to the 'universal' " (13). Depictions and interpretations of monstrosity (and masculinity) relating to the combat that took place at Thermopylae in 480 BCE, or to Merian C. Cooper's groundbreaking 1933 film, are

dynamic and interrelating concepts that change markedly over time yet also remain vitally linked. One of Cohen's "Seven Theses" of monster culture states that the monster always escapes. By this he means that the same or similar monsters, for example, vampires, continually resurface within different cultural and temporal contexts, from ancient Egypt to modern Hollywood. While extracting from these various manifestations a supra-cultural and supra-temporal template for all vampiric figures is certainly feasible, that project is also of limited critical value. More interesting and useful is to decipher what each iteration of a monster might signify in the way of local cultural commentary. Says Cohen: "Each time the grave opens and the unquiet slumberer strides forth...the message proclaimed is transformed by the air that gives its speaker new life. Monsters must be examined within the intricate matrix of relations (social, cultural, and literary-historical) that generate them" (5). For Cohen, what makes monsters especially noteworthy as cultural markers is that they induce category crisis. They don't fit into anything we know.

> This refusal to participate in the classificatory "order of things" is true of monsters generally: they are disturbing hybrids whose externally incoherent bodies resist attempts to include them in any systematic structuration. And so the monster is dangerous, a form suspended between forms that threatens to smash distinctions. (6)

More than sending us back to the drawing board with regard to demarcating "reality," monsters confront us with troubling issues of power, exclusion, and oppression. The dominant group and mindset within a society constructs as monstrous those people and ideas not conforming to its worldview. These differences tend to be cultural, political, racial, economic, gendered, sexual, and bodied. Cohen points out how the monster dwells at the gates of difference and patrols the borders of the possible, often enforcing restrictions meant to keep us within accepted social boundaries. At the same moment, by embodying all of those "differences" that are shunned in order to construct a "normal," the monster also demonstrates and challenges the artificiality and fragility of the social order invented by the dominant group. Thus monsters act as a double-edged sword within panoptic discipline, potentially functioning both to enforce and to undermine the subject being formed. Remarks Cohen: "By revealing that difference is arbitrary and potentially free-floating, mutable rather than essential, the monster threatens to destroy not just individual members of a society, but the very cultural apparatus through which individuality is

constituted and allowed" (12). Monster Theory, then, uses the fertile paradox and iconoclasm of monstrosity to uncover the fears, anxieties, hatreds, prejudices, most troublesome problems, even the innermost secret desires of a particular society.

Moreover, we extend Monster Theory to treat monstrosity not as an essential condition attached to a physical body, but as a type of performance akin to the enacting of gender. Just as femininity and masculinity are mobile and changeable (as opposed to fixed and natural) behaviors *not* fused to a female or male body, so is monstrosity an alterable set of actions not necessarily tied to a slobbering beast, a laboratory experiment gone wrong, machinery run amok, or bizarre life forms from outer space. In other words, monstrous is as monstrous does, not what monster looks like. This approach to monstrosity is much like Butler's theory of gender performativity. If gender is "an expectation that ends up producing the very phenomenon that it anticipates" (*Gender Trouble* xiv), monstrosity often entails the same process. That is, it is the waiting for an authoritative disclosure of a monstrous essence that ascribes and installs the authority of that disclosure, not an actual fixed and interior quality. Monstrosity does not have a stable and timeless core, but is a transitory convention achieved by, to use Butler's description of feminine and masculine, "an hallucinatory effect of naturalized gestures" (*Gender Trouble* xv). Similar to the construction of gender, then, monstrosity frequently is produced by a circular process of believing is seeing followed by seeing is believing. Consider one example.

In the novel *Frankenstein*, everyone flees from the Creature out of hand, prior to any understanding of what it is or what it intends. Its hideous, abnormal body divulges to those who flee a monstrous core being. However, no Evil is originally present. Frankenstein's Creature only wants to discover what it is and how it might fit into human society. Any monstrous behavior it adopts comes as a result of being driven to such actions by the harsh and unfair treatment it receives from people in general and, in particular, from its creator. In fact, a reader easily can sympathize far more with the plight of Frankenstein's Creature than with that of Victor Frankenstein. Whereas Victor is a sniveling nabob negligently bringing disaster onto himself, the Creature takes arms against a sea of troubles and evolves into an erudite and pragmatic being. The murders it commits are, of course, terrible acts of violence. But they come in response to the social and semantic act of violence initially done to it, namely, labeling the Creature a monster. Butler worries that "normative gender presumptions work to delimit the very field of descriptions that we have for the human" (*Gender*

Trouble xxii). Those not conforming to the conventional standards for gender and sexuality—that is, those not regarded as legitimately human—find themselves ostracized, often violently. The same principle is at work with regard to the "monster" in *Frankenstein*. The Creature is monster*ized*. It does not start out as *monster*. In effect, the Creature is created twice: once physically when stitched together in Victor's laboratory, then once culturally when abandoned to the expectations of the larger society.

Shelley's novel allows readers to appreciate this cultural phenomenon of monsterization. It's not difficult to think that the Creature is far more reasonable and humane than Victor, and that Victor is far crueler and more selfish than the Creature. And once the human/monster binary is reversed, it's but one more perceptual step to erasing altogether such limiting and violent either/or definitions of "reality." Many monster stories present us with the opportunity for such a semiotic about-face, that is, one leading to a cleansing of our perceptual palates. If neither the "either" nor the "or" of a binary is strictly true, then the entire construction is shaken. This troublesome undecidability in turn calls into question the validity of categories themselves, showing them to be naturalized and sedimented knowledge that operates, in Butler's words, "as a preemptive and violent circumscription of reality" (*Gender Trouble* xxiii). Monstrosity, then, is queer. Like Queer Theories, monsters put "pressure on simplistic notions of identity" and disturb "the value systems that underlie designations of normal and abnormal identity" (Hall 14; see especially Chapters 2 and 3). Monsters can make us admit that there is no such thing as normal, that "reality" is an expansive, changeable, and revisable business.

To exercise these ideas once more, think about the character Marcus Wright (Sam Worthington) in *Terminator Salvation*. He could be construed as in drag, that is, displaying human on the outside but actually being Machine on the inside. Or is his situation so simple? Is his monstrous act of human bending (like gender bending) a straightforward reversal of opposing categories, or is it a muddled obscuring of them to the point where they cease to exist as suitable descriptions of reality? Through sentimentality, the film pushes us in the direction of the former interpretation, of preserving the human/monster binary. However, a modicum of critical analysis leads us to the latter interpretation, that in Marcus we are dealing with something else altogether. Marcus himself is not aware, until about halfway through the movie, that he is part Machine. When he discovers later that his ignorance was programmed by Skynet as part of a scheme to kill John

Connor, Marcus humanly defies that programming by ripping from the base of his skull the hardware linking him to Skynet. He then goes off to save John Connor. In this way, *Terminator Salvation* seemingly cultivates two Heroes. Of course, the suspense of the movie lies in whether or not Marcus will turn out to be an It or a Man. This tension is visible in the first meeting between Marcus and John, which ends in a mirror image, extreme close-up, face-to-face shot of the pair engaged in hostile stare-down (Figure I.1). At this point, viewers can't be sure if Marcus will become John's enemy or John's ally. That tension is resolved, though, at the very end of the film when Marcus volunteers his own heart to replace that of the mortally wounded John. Here Marcus's humanity comes shining through. Women kiss him, small children grasp his exposed Machine skeleton hand, and in another tight close-up, this time in reverse shot, John offers him a manly nod of thanks just before the transplant operation begins. Then, in voiceover underscored by tragi-gallant music, Marcus delivers a Hero speech, the one of schmaltzy uplift:

> What is it that makes us human? It's not something you can program. You can't put it into a chip. It's the strength of the human heart—the difference between us and Machines.

Human affirmed. Monster denounced. The camera fades out showing us Marcus's face as he loses consciousness. A moment later, the camera fades back in showing us John's face as he wakes from surgery.

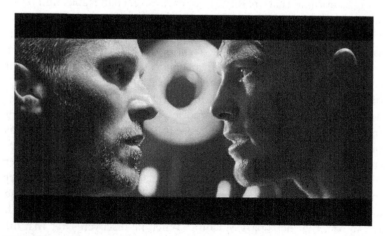

Figure I.1 Mansters meet?

In voiceover underscored by grimly determined music, John then delivers a different kind of Hero speech, the steely one about never quitting. Hyper-acquisitive xenophobic militarism, after all, must never cease in its struggle against the forces of, well, hyper-acquisitive xenophobic militarism. The Resistance lives on, thanks to the indomitable fortitude of the human heart.

Human heart?

Another way to view that adroit fade-out, fade-in is not as one Hero nobly sacrificing himself to save another Hero, but as an inconvenient moment of hybridity. John Connor, brave leader of the human Resistance against the nefarious artificial intelligence of Skynet, is now part Machine. Marcus Wright is not either/or a man or a machine, but a problematic third wheel to the human/monster binary. Marcus is both, and therefore he is neither. Marcus is a cyborg, and thus, as Elaine Graham marks the condition, an example of the "Post/Human."[6] This fact is made clear when Kate Connor (Bryce Dallas Howard) reports to her husband after examining Marcus.

> It's real flesh and blood, though it seems to heal itself quickly. The heart is human...and very powerful. The brain, too, but with a chip interfaced. It has a hybrid nervous system. One human cortex, one Machine.

In short, Marcus is enhanced, an improved human. The upgrades include an unusually powerful heart—one that later in the film withstands a direct hit from a T-800 and winds up beating in the chest of John Connor. Ergo, John Connor is no longer completely human, but a cyborg as well. "*Noooo!*" you shout? You'd rather go with the indomitable fortitude of the human heart? That's your choice. Understand, though, that monsters have the capability to disrupt everything, to call into question all categories, all conventions, all cultural constructs—political, economic, legal, moral, religious, racial, gendered, sexual—all of it. Not every monster triggers such a rowdy social critique. The psychotic ghouls of horror films, for example, the Jasons and the Freddys, are primarily intended for audience titillation and therefore tend to reinforce the human/monster binary (along with betraying a deep misogyny). Similarly, when every effort is made to keep the depiction of monstrosity at arm's length, as with the cockroach-like invading aliens of *Independence Day* (1996), monsters become the patsy foils to human heroism—normally represented by guys in military flight suits. The monsters considered in this book, however, emphatically cross and blur lines. They queer all we know,

all we think we know, all we try to know, even all we don't know. The hybridity they wreak shoves us into new territory, one where we're pushed beyond familiar society and identity.

What We're Up To

Our study looks closely at seven recent films where masculinity and monstrosity figure prominently. These films are *King Kong* (2005), *300* (2006), *V for Vendetta* (2005), *Tropic Thunder* (2008), *District 9* (2009), *Avatar* (2009), and, finally, *The Hurt Locker* (2009). Among these productions are films not featuring large or horrible creatures—the traditional fare of so-called monster movies. This circumstance is no oversight, but a point. As discussed earlier, neither monstrosity nor masculinity belong only to certain bodies. Thus monsters are not always slobbery beasties. Both masculinity and monstrosity, as conditions and as concepts, travel and change. These films demonstrate, individually and collectively, precisely this phenomenon at work. Each involves the formulation of a dominant masculinity and a suppressed monstrosity, and each problematizes those formations. Some of these films seem consciously aggressive in blurring the boundaries between he-man and fiend; others are intent on marking and maintaining those boundaries, and only reading against their grain, such as has been done in our cursory analysis of *Terminator Salvation*, can produce radical interpretations of them. Moreover, our project keeps with Western cultural tradition. The word "monster" comes from the Latin *monstrum*, "a portent"; its root word is *monere*, which means "to warn." Prior to that, the Greek word used by Aristotle for abnormal creatures is *teras*, also meaning a warning or portent. The medieval practice of teratology combined, in fact, the categorization of freakish creatures with the reading of them for the purposes of prognostication or divining (see Cawson 1; Friedman 108). Longstanding Western custom, then, is to be apprehensive about not just the *kinds* of monsters that we imagine to lurk nearby, but our appropriate *response* to them as well. This book is a continuation of those anxieties.

Throughout the book, certain key theorists and theories will be touched on more than once both by way of reminder and because, as our points of departure, they bear repeating and elaboration. As should be evident from the preceding pages, those receiving special notice are Cohen on monstrosity, Connell on hierarchical masculinities, Butler on gender performativity, and Foucault on the modern state. Like many recent scholars, we look to apply, expand, and, where

needed, innovate on the ideas of these intriguing and challenging thinkers. It should be pointed out as well that this book is a collaborative effort of two authors. While every aspect of our exploration of recent monster films has been considered jointly, the primary research and writing for specific movies have been divided. Brenda has worked particularly on *300*, *Tropic Thunder*, and *The Hurt Locker*, while Kirk has taken on *King Kong*, *V for Vendetta*, *District 9*, and *Avatar*. Moreover, great lengths have *not* been taken to homogenize our two writing styles or critical points of view into one voice and outlook. Following the adage that two heads are better than one—and thus, as a tandem, we are something of a hybrid monstrosity ourselves— we decided early in the project that allowing our individual scholarly proclivities and theoretical orientations to find full expression would produce an overall richer examination of the materials. Thus, Brenda concerns herself most with issues of masculinity, disability, and warfare, while Kirk focuses chiefly on cultural hegemony and corporatism. This is not to say, however, that what follows is merely a collection of unrelated essays. Each chapter builds on those previous to it; moreover, the social topics we deliberate intersect, blend, and compliment one another when contemplated within the broad framework of monstrosity. Lastly, we stress again our conviction that films, maybe today more than ever, have a wide-reaching impact not just as cultural events and the reflectors of culture, but as the *makers* of culture. They should not be consumed mindlessly or analyzed superficially. With that in mind, our first four chapters each are close readings and extended analyses of a single film. Even though a movie is designed for viewing in one sitting and, typically, amid an atmosphere of casual entertainment, such a painstakingly crafted work of fiction deserves—more, requires—careful consideration. Often, what we need to inspect most is that which we are encouraged to think about least. As with advertising, the moment we imagine we're immune to the influence of films—that we make them but that they don't make us—is the moment we fall under their spell. What we offer the reader of this book, then, is an incisive consideration of masculine and monstrous behaviors as depicted in contemporary popular films. What we hope our inquiry sparks in the reader is a mind open to various and vexing readings of those movies, of American society, and of our individual places within it.

In 2012, the film *Act of Valor* brought full-blown Hollywood production values to, in essence, that commercial for the National Guard contemplated at the outset of this introduction. Persistent in both pieces is a gritty, hand-held quality to the visuals that masquerade

as reality. Common to both, but particularly in the film, is amateur acting delicately calibrated between insufferable and effective for the task at hand. Insistent in both is the portrayal of monsters made as monsters found. Both hero stories make it their business to gloss over the international complexities of terrorism as blowback to perform, instead, the sentimental pipedream of pure Evil, inexplicable in its motiveless malignity, assaulting our innocent and valiant Good. However, as a recruiting vehicle for the US Military, *Act of Valor* is so, *so* much more effective than the pathetic advertisement for the National Guard. In the film, we're given actual Navy SEALs. We get a glimpse at their actual tactics and gadgetry. There are nods to melting-pot band of heterosexual brotherhood (even though all the protagonists are white). On the home front are nothing but sturdy gals, towheaded kids, and beer-fest barbeques. Out in harm's way, the action is decisive, noble, and guilt-free (all coming in the form of the wholesale slaughter of nonwhites around the globe, from Asia to Africa to Latin America). The mission is simple: don't let the monster cross our border again. At all costs, export our mayhem. In short, what's *not* to get the young men in the audience pumped up and signing on the dotted line? *Act of* Valor is as pat and engaging as a first-person shooter videogame. The movie practically *is* a first-person shooter videogame. And let's not kid ourselves. Soon in theaters we will be *playing* first-person shooter videogames.[7]

For about a century now, Hollywood depictions of manliness have been influencing American popular notions of what such conduct is. We wonder if, in the first decades of the twenty-first century, hegemonic masculinity isn't undergoing redefinition where hyper-acquisitive xenophobic militarism vies to become the new normal. What does it portend, for instance, that the stalwartly militaristic John Connor remains grimly determined, newly equipped with his cybernetic heart, to battle to the death against the Machines that mirror precisely his stalwart, grim, and, dare we say, macho militarism? By the same token, what Hollywood depicts as monstrous speaks volumes about the fundamental fairness, inclusiveness, and collective intelligence of American society. What does it say about us currently when glorified in a film such as *Act of Valor* is the exemplar of shoot first and ask no questions later?

See you at the movies.

Tossing Blondes in Peter Jackson's
King Kong

When the mighty Kong breaks loose from those chrome-steel chains, when that giant ape bursts through the façade of the swanky Broadway theater to leap into a crowded Times Square—the beating heart of New York City, go-go capital of the modern world—it's an undeniable moment of thrilling terror. Now comes the rampage, the wanton destruction. We've come to that moment of truth in all monster stories when the mysterious savage runs riot on our dear, familiar civilization. We clutch the armrests of our theater seats in anticipation of the full horrors of the Beast. The original Kong, from Merian Cooper's 1933 film, does not disappoint. That ape derails an elevated train, bites off a man's head, and casually drops a woman some 20 stories to her death. Granted, Cooper's Kong is seeking after his prize, that is, Beauty in the form of Ann Darrow. But his search seems distinctly secondary to his mayhem. In the 1933 *King Kong*, there's no doubt that the Beast has come to town. Such is not the case in Peter Jackson's 2005 *King Kong*.

Jackson's Kong is on a single and singular mission, one of locating Ann, his comrade and soul mate. From the moment this monster frees himself, Kong picks up and inspects blondes, specifically, platinum blondes—women who, at first glance, match the Hollywood ideal for Beauty. Kong obsessively pursues no fewer than five such women in the first minutes after his escape. Finding none of them to be Ann, the giant ape tosses these blondes aside—comically, dismissively, shockingly if you imagine the landings these poor women are going to have. Yet none plunges to death; none is decapitated for snack food; Kong rifles the trolley car only because there is a blonde inside it. His destruction is not wanton. It's incidental. The fact is that Jackson's Kong behaves distinctly *un*hell-bent on wreaking havoc on New York City. Most of the collateral damage occurs when Kong gets sidetracked

chasing Jack Driscoll, his rival for Ann's love, or when the military chases Kong once he has Ann. Otherwise, the Beast simply wants to find his cherished companion and be left in peace. Even more peculiar, Ann is the one who locates, eventually, the huge gorilla. She appears, backlit and angel-like, walking toward him down a deserted city street. Once he sees her, Kong instantly drops what he's doing (trying to kill Jack in a taxicab) and locks simian with human eyes. Magic fills the cold night air along with the minor chords of the Ann–Kong love theme. Soon Ann is back, willingly this time, in the giant hairy grasp. Obviously, none of this is the scenario for thrilling terror. A different moment of truth is taking place. Jackson's movie is not a remake of *King Kong*, but a thoroughgoing retelling of that Hollywood classic.[1]

In this chapter, we argue that Kong tosses blondes aside because Jackson pits two powerful concepts against one another: Beauty versus Beautiful. By Beauty we mean that persistent Hollywood illusion of the platinum blonde bombshell as a signifier of all that is desirable, not only in a woman but in life itself. By Beautiful we mean a genuine connection between two sentient beings grounded in the realities of this world. Jackson creates a dichotomy between these conceptions in his film, and, in doing so, effectively inverts the meaning of Cooper's original. Where the 1933 *King Kong* gives us Carl Denham as the focal and driving character of the narrative, the 2005 version gives us Ann Darrow. Where the original movie promotes colonialism, capitalism, and American dynamism as the essence of modern civilization, Jackson's new vision proposes postcolonial, post-Marxist, and environmental readings of the tale. Where Cooper's Kong is a brute likely to incite in contemporary 1930s' audiences both fear of the African-American man as a rapist of Caucasian women and apprehension of the Depression working poor rising up against their economic oppressors, Jackson's Kong is figured as a champion of the colonized Other, of the exploited worker-slave, and even of Nature itself. That is to say, Kong becomes, in Jackson's hands, a complex and multilayered signifier in opposition to the hegemonic forces of imperialism, neoliberal economics, euro-centrism, and dominant masculinity. This Beast initially may have been ensnared by the charms of Beauty, but by the time he's survived kidnapping, the Middle Passage to America, and being put on the auction block of popular entertainment, his one concern when breaking free in New York City is reestablishing what he's come to know as the communitarianism of Beautiful.

Peter Jackson's re-visioning of *King Kong*, then, brings to audiences a tragic and, particularly in its final images, dizzying story where

monsters are heroes, heroes are monsters, and damsels-in-distress are protagonists—in short, the overthrow of modern normal. For the viewer willing to puzzle through the array of emotion-packed objective correlatives on offer, Jackson's film delivers a cautionary tale about how our world violently has been colonized, materially and ideologically, by exploitative forces. All that's needed to appreciate the radical implications of *King Kong* is an attentive inspection of how the filmmaker twists the conventions of the traditional monster movie. To accomplish such a reading, we look first at Jackson's depiction of Beauty, next at its antithesis of Beautiful, and finally at how modern exploitation in Jackson's film, to include the monsterization of Kong, is the product and the pursuit of hegemonic masculinity.

UNDERMINING THE ALLURE OF BEAUTY

In both Cooper's and Jackson's films, there's no doubt that Ann Darrow is the prize. Virtually everyone and everything clamor after her. Her primary allure, of course, is her looks. She's that size-4, platinum blonde movie idol devised to be craved. How Cooper and Jackson use this iconic figure in their films, however, couldn't be more different. One critic of Cooper's film notes, "Ann's role as its obsessive object is designated in the film as not merely representing a generalized mass desire for prosperity but rather serves as an emblem of the specific articulation of that desire effected by the Hollywood spectacle" (Torry 67). As the blonde bombshell, Ann is no less than the signifier of the American Dream itself. To possess her equates to success within American capitalism. The overreaching Kong, then, in his brutish obsession to have Ann, becomes the interloper. He is the monstrous gatecrasher of the white bourgeois patriarchal party. Most scholars of the 1933 *King Kong*, in fact, read that film in such classist and racist terms. Situated in its early-twentieth-century cultural context, Cooper's movie is seen as a conservative and disciplinary work warning both the Depression-era working poor and the Jim Crow–era blacks to stay in their place at the bottom of the economic and social ladder.[2] Carroll in particular sees the original *King Kong* as a remarkably arrogant and self-congratulatory film; it functions as "a popular illustration of Social Darwinist metaphors which, in turn, were and to some extent still are generally held articles of faith of the American *weltanschauung*, shared by every class" (213). If the American economy is a jungle, as Cooper's movie strongly signals, then it is telling that the survival of the fittest goes to Carl Denham, first in his gun-and-camera, jungle film adventurism on Skull Island

and then in his entrepreneurial gambit on Manhattan Island. As the dominant male of the American domain, Cooper's Denham necessarily suppresses Kong's one-ape uprising.

Everything in Jackson's *King Kong* makes the opposite impression. Jackson's platinum blonde isn't just a pair of screaming lungs, but has brains, courage, compassion, and agency. His Carl Denham isn't a megalomaniac blowhard, but an endearing dodger who comes to see the error of his greed. Jackson's Kong is not an infantile ogre wanting back his toy, but a creature of maturing understanding and developing language. Moreover, in his retelling of the Kong story, Jackson shifts the fundamental point of view of the film. Where in Cooper's movie we see things through the eyes of the dominant class, in Jackson's movie, our perspective is basically that of the underclass. Where Cooper glosses over the Depression, Jackson rubs our noses in it. Where Cooper makes a goddess of Beauty, Jackson exposes it as an instrument of oppression.

Jackson's first step is not to affirm the law of the jungle, as does Cooper's film, but to present us with the pathos of the zoo. His opening montage begins with a scrawny monkey scratching, followed by a series of listless animals trapped in a dilapidated Central Park Zoo. The shot widens to Central Park itself, looking like a garbage dump and filled with listless people trapped in Shanty Towns. The equation is simple: The captured poor are the same as the captured animals. Al Jolson's brassy version of "I'm Sitting on Top of the World" ironically plays over intercuts of Depression-era New York. Beneath the bustle of the city streets, we focus on moments of despair: an old man or a mother and children rifling through garbage cans for food, people being evicted from their homes, long soup lines, the indigent asleep on benches or huddled in doorways. We see as well civil unrest in prohibition raids on stills or large street protests with angry mobs carrying signs reading "We *Demand* Evictions Are Stopped" and "*Land* To The People." Meanwhile, in the face of this joblessness and expropriation, American flags flutter from skyscrapers still rising over Manhattan. Obviously, the rich and the powerful ignore the ugly underbelly of 1930s' America; they continue their joyride despite the current economic bust.[3] For the working class, however, capitalism just as obviously equals captivity and exploitation. Hoovervilles *are* zoos. Short of returning to nature, the poor have no other social-economic system available to them. Setting this Marxist table, then, Jackson ponders in some detail, over the first part of the movie, the plight of two groups of working-class people. The first is an ensemble of Vaudeville performers whose dwindling audiences lead to their not getting paid and

finally losing their jobs. Out of this hapless bunch emerges our plucky heroine, Ann Darrow (Naomi Watts). The second, more extended, and more telling group examined by Jackson is the crew of the trap steamer *Venture*, the ship carrying the main characters to Skull Island. Here Jackson makes major changes and additions to the original version of *King Kong*, all of which seem designed to undercut the classism of Cooper's 1933 film. Examining a few of these characters reveals Jackson's very different ideological orientation.

Cooper's film invests little human interest in the crew of the *Venture*. They are more or less props, faceless sailors at sea and spectacular dinosaur bait on Skull Island. Jackson, on the other hand, goes out of his way to focus on them as individuals, even if they are not all named. The camera lingers on close-ups of their faces to register their reaction to events. Special emphasis is given to watching the crew below deck. During the voyage, we see shots of burly, sweaty, grimy-faced men tending to the steaming machinery or shoveling coal into the blazing engine furnaces. Clearly, we are meant to realize that Denham's film and financial venture is kept afloat by the little guy, the worker at the bottom of the capitalistic ladder. More than just thoughtfully presenting the little guy, though, Jackson inserts into the story two working-class friendships that foreground a number of social issues.

In the original film, Charlie is a stereotypical Chinese cook played by bit-actor Victor Wong. Despite having a fair number of lines, this part goes uncredited in Cooper's production, making Charlie little more than seafaring window dressing. Charlie's big moment comes when he discovers that the natives of Skull Island have been aboard the *Venture* to steal Ann. In his pidgin English he calls all hands on deck while running to the Captain the evidence of the incursion, a native bracelet left behind. There he declares: "Crazy black man been here!" Racial stereotype upon racial stereotype. In the 2005 DVD restored edition of the original *King Kong*, the second disc is a documentary produced by Jackson about the making of the 1933 film. Here Victor Wong is named in the cast list. However, Wong's character is identified as "Lumpy," not "Charlie." There is no character named Lumpy in Cooper's film. In Jackson's version, though, Lumpy is the ship's cook, and he's a telling character played by Andy Serkis. In a nod to the original Charlie character, Lumpy's sidekick, and apparently number-two cook, is Choy (Lobo Chan). Lumpy and Choy share a deep bond, one of working class and mixed ethnic solidarity. Lumpy is always watching out for Choy, so much so that he tosses aside his machine gun when Kong is trying to shake the rescue party off the giant log and desperately tries to prevent Choy from

falling to his death. In contrast, Carl Denham (Jack Black) desperately tries to rescue his camera from falling off that log. Preserving the footage he's shot that eventually can be turned into a smash hit movie is all that's on Denham's mind—even as members of his film crew are killed on the island. Thus, Jackson goes out of his way to underscore a working-class ethos of we're-all-in-this-together versus a bourgeois fetish for material wealth. In the Deluxe Extended Edition of the movie, Lumpy delivers the best line in this vein. When emerging from the swamp after the attack by a gigantic, primitive fish, Denham anxiously tests the camera to see if it's still operational. Accidently, he films the monster snatching and dragging under one last crewman as the man struggles ashore. When the crewman's screams subside, Lumpy, standing nearby, asks Denham bitterly, "Did ya get that did ya?" It should not be lost on us, either, that Andy Serkis plays two parts in Jackson's film, Lumpy and Kong. In a film thick with meta-references (to the original movie, to the entertainment industry), Serkis's double casting seems a deliberate move to link Kong with the modern worker. Only, symbolized by Kong, the little guy suddenly ain't so little anymore. Instead, similar to Shelley's Frankenstein monster, Jackson's monster can be seen to represent a proletarian revolt against the bourgeoisie.[4]

An even bigger addition to Jackson's Kong story is the friendship between Mr. Hayes (Evan Parke) and Jimmy (Jamie Bell). Some critics of Jackson's film thoroughly dislike this Huck-and-Jim duo that passes time discussing Conrad's *Heart of Darkness*.[5] However, their relationship could be viewed as an important corrective to the racism of Cooper's film and as a device by which Jackson tells us how to view his remake. Not only are Hayes and Jimmy another pair of mixed-race, working-class friends enacting solidarity, but they also are characters that overturn racial stereotypes. Read in its historical context of early-twentieth-century American culture, the original *King Kong* can't avoid being seen as a profoundly racist film. As Bellin argues:

> Rather than being connected to issues of race only incidentally, *Kong* is deeply, inextricably, indeed indistinguishably involved in a pervasive and urgent early-twentieth-century cultural project to define and defend whiteness, a project that ritualistically found its fulfillment in the conjuring to life, and condemning to death, of a fantasized scapegoat: the black ravisher of white womanhood. (24)

In an era of lynching and black migration from the rural south to the urban north, it would have been impossible for 1933 audiences not

to view Kong as a symbol of all dangerous black males rolled into a one-ape race riot quelled only by modern (white) technology (Rice 195–196). Cooper's film conforms to this cultural project underway at the time, particularly in the popular media, to affirm white superiority via the negative portrayal of blacks.[6] Through Hayes and Jimmy, Jackson disrupts any such racist holdovers from the original movie. Mr. Hayes, the first mate of the ship, is nothing less than the anti-Stepin Fetchit. He is an intelligent, well-spoken, industrious, worldly, and honorable male who happens to have dark skin. What is more, Hayes has assumed the role of father figure to Jimmy, a white orphan lad he discovered on board, stowed away and feral, several years ago. Now working as a deckhand, Jimmy is the mischievous and undisciplined adolescent. Hayes's project is to see to the young man's education and social rise. Among all the crew members of the *Venture*, Hayes emerges in Jackson's film as a working-class hero. When Jimmy puts on Mr. Hayes's cap after the first mate has been killed, it's clear that Jimmy will try to live up to his mentor's high ideals. Jackson gives Hayes too many admirable qualities for audiences to see in him merely the stereotype of a black caretaker for a white child.

Equally significant in Jackson's *King Kong* is Hayes's erudition with regard to Joseph Conrad's famous and provoking novel about colonization. Obviously, the passage from *Heart of Darkness* that Hayes recites, and that we hear as a voiceover while Denham and his film crew enter the native ruins on Skull Island, is far more than a book club discussion he's having with young, naive Jimmy. This moment in the movie represents, arguably, Jackson as a filmmaker speaking directly to his primary audience—that is, a bourgeois American audience not unlike immature, white Jimmy. That audience has come into the multiplex to enjoy a good holiday-release blockbuster, a rousing tale—featuring big-name stars and spectacular special effects—of Beauty saved from the Beast. What they get instead, not unlike the Broadway audience come to see Denham's "Eighth Wonder of the World" on stage, is Kong unshackled from such naive conceptions of what a monster is and foolish expectations that monsters can be kept conveniently under control for the sake of mindless entertainment. When Jimmy asks why Marlow keeps going up the river, and while Hayes replies that despite Marlow's inner dread he has a more compelling need to know, we see intercuts of both Ann and Denham entering the same kind of feral world as Conrad's steamboat captain. The implication is that both characters are on a voyage of awful discovery similar to Marlow's. When Hayes quotes from Conrad's novel, "We could not understand, because we were too far...and could not

remember, because we were travelling in the night of First Ages...of those Ages that are gone, leaving hardly a sign and no memories...We are accustomed to look upon the shackled form of a conquered monster, but there, there you could look at a thing monstrous and free," we watch Denham arrogantly leading his expedition into the same heart of darkness, not in the Congo, but on Skull Island. Jackson's signal to his viewer is that what is about to unfold is the polar opposite of the 1933 *King Kong*: not an action-film celebration of white civilization over black savagery, but an exposé of the sentimental veneer of European "civilization" thinly masking the brute forces of imperialism and capitalism. Jimmy's realization that, "It's not an adventure story—is it, Mr. Hayes," must be our realization as well. We're getting more than we bargained for in watching Jackson's monster movie. Mr. Hayes's frank reply, "No, Jimmy, it's not," confirms the warning: We need to pay attention to this story with our active and analytical minds, not just passively consume it with our thrill-seeking guts. Nor does it seem a coincidence that Jackson chooses to deliver this caveat through a pair of characters that simply could not have existed in Cooper's film.

Another vital change in characters made by Jackson is to Jack Driscoll. In the original movie, Driscoll, played by Bruce Cabot, is the first mate of the *Venture*. He's a regular-Joe leading man of the era, that tough guy with a heart of gold and a big hero streak. Even though he thinks dames are quite a nuisance, especially aboard ships, he falls for Ann, famously played by Fay Wray, and commits himself subsequently to a lot of rescue work for the rest of the film. His character, though, remains secondary behind the bigger personalities of Denham, played by Robert Armstrong, and Kong. Playfully, Jackson splits Driscoll into two characters. One is Bruce Baxter (Kyle Chandler), who is a spoof of Hollywood leading men of the 1930s. He's starred in such adventure films as *Dame Tamer* and *Tribal Brides of the Amazon*. In another metafilmic reference, Jackson has his Denham film Baxter and Ann performing a famous piece of dialogue from the earlier movie, one where Cooper's Driscoll displays his tough-guy mettle. Clearly, Jackson wants us to know that his Jack Driscoll will be nothing of the sort. Played by Adrien Brody, he's not. First of all, Jackson's Driscoll is no longer a sailor. He's a playwright and an intellectual, and as such is an in-between character, that is, not working class yet not quite part of the Hollywood illusion-making machine. Jackson bases him on the young Arthur Miller (Morton 325). Second, both Driscoll and Baxter, as characters in Jackson's *King Kong*, contribute decidedly to the debunking of Beauty. Each

factors into exposing the lie of Hollywood, dominant-culture propaganda. When Jack accuses Baxter of being "nothing like the tough guy you play on screen" and a coward for wanting to abandon Ann's rescue, Baxter says: "Hey, pal, wake up. Heroes don't look like me— not in the real world. In the real world they've got bad teeth, a bald spot and a beer gut...be seeing ya." For his part, Jack both captures "the voice of the common people" adeptly in his plays and bonds well with the crew of the *Venture*, creating the kind of worker-intelligentsia solidarity necessary for modern revolution. Baxter at one point asks Jack accusingly, "What are you, a Bolshevik or something?" To which Jack muses, "Actors. They travel the world but all they ever see is a mirror." In a nutshell, here is socialism versus venture capitalism (pun intended). Just as actors narcissistically globetrot, so does imperialism—helped in no small way by the dissemination of Hollywood entertainment—callously spread and impose its Western culture and market economy around the world. Moreover, as an intermediary character between the working class and the elite, Jack assumes something of the role of father figure to Jimmy once Mr. Hayes is dead as well as displays remarkable tolerance for Denham's shenanigans. Jack knows that the filmmaker is a shyster, yet also understands that Denham is not all bad. Jack's comment, "That's the thing you come to learn about Carl...his unfailing ability to destroy the things he loves," is a crucial one, and an idea that will be inspected in depth later in this chapter. At this point, however, we must consider one other alteration Jackson makes to Cooper's original classist depiction of the *Venture* crew, namely, the reinsertion of the famous Spider Pit sequence that was edited out of the 1933 movie.

On Skull Island, the normally "shackled form of a conquered monster" that the film crew and the ship crew now encounter as "a thing monstrous and free" (to use Conrad's words spoken by Mr. Hayes) is more than Kong. It's Nature itself. As with Conrad's novel, Jackson's film does not insult us with romantic depictions of an idealized natural state. Skull Island is a kill-or-be-killed Hobbesian environment without noble savages or one ounce of return-to-nature charm about it. The inhabitants there no doubt live in a tough neighborhood. The perils and cruelty we witness on Skull Island are only different from those we've just seen on Manhattan Island by their degree of sudden rawness, not by their disciplinary qualities. Both the matriarchal tribal society on Skull Island and the patriarchal capitalistic society on Manhattan Island engineer dog-eat-dog social orders in the face of monstrous Nature. That is to say, the most vulnerable of each society are sacrificed—in one case, to a giant gorilla; in the other, to

nonliving wages—so that the most powerful can thrive. Modern civilization does little more than ancient ones to protect all of its citizens. This parallel savagery of Skull and Manhattan islands is represented strikingly by Jackson's reconstruction of the Spider Pit scene that was cut from the original movie.[7] Some critics have reacted badly to Jackson's sequence, thinking it to be an action-stopper as, apparently, did Cooper himself. Cashill, for example, finds that the scene plays "funereally"; he complains as well "too much reality is a myth slayer" (43; see also David Griffin 18). Given how Jackson has just told us that his movie is not a mere adventure story, such impressions likely are the point.

The crew members of the *Venture* falling into the Spider Pit is symbolic of all the Depression-era images and issues marking the first half of Jackson's film. The gruesome fate of these working-class men is reminiscent of, for example, Jack London's "Social Pit." That is, the reward for hard work performed within the capitalistic labor market is to be abandoned miserably, in the end, to the pitiless realities of life. Just as London "saw the picture of the Social Pit as vividly as though it were a concrete thing, and at the bottom of the Pit I saw them [working people], myself above them, not far, and hanging on to the slippery wall by main strength and sweat," we watch the crew struggle not to be knocked off the log by Kong, but only in the end crash down into the deep chasm. Just as London "found there all sorts of men, many of whom had once been as good as myself and just as *blond-beastly*; sailor-men, soldier-men, labor-men, all wrenched and distorted and twisted out of shape by toil and hardship and accident, and cast adrift by their masters like so many old horses" (460), we watch the crew exposed to the callous workings of the brutal natural world. Our working-class hero, Mr. Hayes, already lies dead from the long fall into the chasm. Jimmy sobs over the death of his father figure and material guide, and Lumpy mourns over the dead body of his good friend, Choy. Once more, though, Denham's concern is not for camaraderie, but for fame and fortune. When he regains consciousness at the bottom of the ravine, he mourns only the destruction of his camera and the loss of the incredible footage he's shot on Skull Island. As the crass capitalist, however, Denham is about to undergo his first transformative experience in the movie: a taste of life at the bottom.

Various monstrous bugs appear and begin to tear the crewmen apart. While defending Choy's body, Lumpy is devoured by grotesque, slug-like creatures that look a combination of penis and vagina dentata. Jack is soon covered by wetas the size of dogs. Two meta-filmic features bear noting here. First, just as Andy Serkis's Lumpy dies a

horrible death at the hands of Nature, so will Andy Serkis's Kong die a horrible death at the hands of Civilization. The message seems to be that the working guy always gets screwed. Second, Jackson includes in this sequence a dizzying shot from above the Spider Pit of Jack being overwhelmed by bugs. The shot is in motion, the camera swirling counterclockwise. The same disorienting point of view will be used to show Kong falling from the Empire State Building at the end of the film. More than coincidence, these identical violent camera movements come at key ideological moments in the movie to help Jackson signal his intent to alter the complacent worldview of his bourgeoisie audience. Jack, our middle-class role model of the film, is undergoing in the Spider Pit of Skull Island what he only writes about in his plays—the harsh reality of the common man. We should pay close attention and learn this grim lesson with him. By the same token, Kong, signifying the working man and the black man, is being thrown back in his place at the bottom of the Social Pit of Manhattan Island. That big ape should not be cavorting atop modern white civilization's *real* Eighth Wonder of the World, the world's tallest skyscraper just completed in 1931, and especially not with a run-away platinum blonde, an icon of all modern white desire. Such uppity behavior needs to be punished.[8] Moreover, in case viewers don't see these connections, Jackson has given us Jack Black's mercurial Carl Denham as an object lesson in what *not* to do—namely, be obtuse about recognizing these issues of social justice.

With the grisly bug attack, Denham is forced to spring into action, picking up a stick and desperately battling off the swarming insects. For the first time, he's not fighting to save his film, as he did earlier during the brontosaurus stampede and the attack in the swamp. Now he's fighting simply to save his life in this Skull Island version of a Hooverville. Luckily for him and Jack, Jimmy, already enacting Mr. Hayes, loads a machine gun and deals with the first wave of creatures. Once the rescue party arrives to save them in the nick of time, Denham has a strange moment. He goes a bit loopy, seeming both to see but not see the gravity of his near-death experience. Wearing a smile that, on the face of Jack Black, is more than a touch deranged, Denham reports to Baxter about that moment before you die: "Your whole life passes before your eyes. And if you've lived as a true American…you get to watch it all in color." While Jack Driscoll has realized fully the need for social solidarity while interacting with the crew of the *Venture*, his fellow bourgeois, Carl Denham, has undergone only a near-enlightenment moment on Skull Island. He's *almost* seen the bigger picture—that is, there's something more to

the world than money—but not quite. As soon as Denham is back out of the Pit, he's up to his old tricks, hatching the capture-Kong-alive scheme. At this point, the Hollywood illusion of Beauty, of getting "to watch it all in color," still has too strong a hold on him. Even "the shambles at the bottom of the Social Pit" (London 460) lacked sufficient punch to amend Denham's hell-bent ambition. Over the course of the rest of the movie, the audience will watch Denham too slowly come to realize his mistake. However, before considering any further this purblind filmmaker, we need to examine Jackson's alternative to Beauty: Beautiful.

ADVANCING THE SOLIDARITY OF BEAUTIFUL

Critic David Griffin, writing in *The New York Review of Science Fiction*, dislikes nearly everything about Peter Jackson's remaking of *King Kong*, from Jack Black's portrayal of Denham to the story being "ladled over with solemn references to *Heart of Darkness*" (18). If there's an aspect of the film Griffin likes least, however, it seems to be Kong brought back to civilization.

> The final New York scenes are a (literally) colossal anticlimax... Jackson's Kong chucks blondes lightly aside (you can practically hear the comic book "oof!" as they land). Where's the catastrophe? So when Darrow offers herself willingly up to Kong, she's in no danger. She's like a nurse dispensing a soporific to an unruly child, and when she and Kong slide around the Wollman Rink it's like a Muppet Show finale.

Obviously, Griffin believes that a credible monster must pose the threat of destruction to civilization and, moreover, such a menace is best signaled by a terrified, screaming woman.[9] Griffin seems to want to watch Jackson's *King Kong* as Merian Cooper insisted his original *King Kong* be viewed: with Kong as simply a very large and terrifying gorilla bearing no symbolic reference to anything, and with the film itself being regarded as nothing more than a simple adventure story (Morton 84). Of course, such a naive viewing of Jackson's film, or of Cooper's, for that matter, is impossible. The modern concept of monsters may be one of Evil Beast momentarily upsetting the applecart of Good Civilization, but the postmodern, cultural poetics view of monstrosity, typified by Cohen's concept of Monster Theory, is nothing so binary and straightforward. Griffin objects to Jackson's Kong in New York City because there seems to be no catastrophe afoot. What this critic has failed to appreciate is how Jackson has inverted the catastrophe.

Jackson's finale is not about the Beast let loose upon Civilization, but about Civilization let loose upon the Beast. Moreover, Jackson's Beast is far from a clear-cut brute or fiend. Once put in league with Ann (the erstwhile Beauty), Kong transforms from monster into leading man. This union of Kong and Ann, in fact, realizes fully the potential always available in the figure of the giant ape, namely, the monster as the true protagonist of the story. Despite Cooper's efforts to portray Kong as nothing more than a savage animal (Morton 58–59), in Jackson's hands, Kong becomes, particularly during the finale on Manhattan Island, the tragic hero meeting his doom.

Scholar Cynthia Erb, examining Kong as an icon of world culture, finds that Cooper's monster stands in for much more than a giant terror gorilla. Kong is:

> one of the most familiar popular dramatizations of the ethnographic encounter in American visual culture. Although reductive and "kitschy," the King Kong story nevertheless stands as an important popularized account of transcultural contact—of a transaction accomplished between an arrogant white explorer and an exoticized other...The contours of King Kong's original story are thus potentially global and multicultural, and the film's use value issues from its dramatization of contact between representatives of First and Third Worlds. (15)

Erb also finds that despite the original movie being filled with racist assumptions of the early twentieth century, Cooper's film "is nevertheless significant for its invitation to identify with the suffering black exotic" (17). Jackson certainly is aware of both of these elements of the original *King Kong*—transcultural contact and the possibility of identifying with the outsider. He puts them to extensive use in his reconfiguration of Kong. Jackson's great innovation in creating empathy for Kong, however, is to reimagine thoroughly the relationship between Kong and Ann. The 1933 Kong, particularly in the restored version of that film, is "mad, bad, and dangerous to know" (Cashill 42). Ann wants nothing to do with him, ever, as Fay Wray's incessant screaming makes abundantly clear. De Laurentiis's 1976 *King Kong* does much to develop the "love story" between Kong and the Ann character, renamed "Dwan" (Jessica Lange). The ape becomes something of a giant, untoward pet to the woman, and the film amplifies usefully the idea of Kong representing an exploited Natural and Third world.[10] Yet more than mustering a bit of pity for a magnificent animal/subjugated exotic brought down by modern greed and weaponry, the bond established between Ann and Kong

by Jackson is one of militant solidarity and requited love. Ann and Kong unite as a pair to a degree that not only renders poor Jack Driscoll a sad third wheel in the love triangle, but that blends the duo into a conglomerate entity set in opposition to modern power itself. Together, Ann and Kong embody the subaltern voices of women, of workers, and of non-Western peoples, as well as represent the natural world under siege. Their struggle against Denham and the Hollywood Beauty–fabricating machine epitomizes the resistance by the oppressed to what bell hooks famously terms "white supremacist capitalist patriarchy."[11] The rebellious cry that Ann and Kong, alone, share in Jackson's movie is a single word: Beautiful.

Initially, both Ann and Kong are ensnared by the charms of Beauty. Ann accepts Denham's offer of "money, adventure, fame…the thrill of a lifetime and a long sea voyage" out of her desperate poverty and her aspiration to land a part in a Jack Driscoll script. Kong is swept away both by the novelty of Ann's blondeness and by her Vaudeville act. Denham's comment to Ann about Vaudeville being "a tough audience. If you don't kill them fast, they kill you," is later played out, literally, on Skull Island when Ann tries to distract an enraged Kong with her juggling and dancing. Reminiscent of the overweight, hysterically laughing and wheezing man in the audience during the opening montage of the film, when Ann is actually performing on a New York City stage, Kong becomes delighted with his captive's efforts to amuse him. When Kong turns too participatory, though, prodding Ann with a massive finger to make her perform more tricks, threatening bodily harm to her, Ann angrily draws the line on this popular entertainment. "No! I said no!" she shouts, slapping Kong's finger away. "That's all there is…there isn't any more." Ann's gutsy defiance, renouncing objectification under such extreme circumstances, begins her special bond to Kong. Rather than pulverize her, Kong pouts violently and then goes away, leaving Ann free to go. Kong will reappear, dramatically, to save Ann from the three T-Rexes. Near the end of that astonishing fight, Ann repays Kong's goodwill by showing her understanding that he's not a mindless brute. By backing away from the last T-Rex and under the imposing form of the giant gorilla, Ann acknowledges to Kong that she knows he's there to protect her, that his motives are selfless. At that moment their love affair begins—not romantic love, of course, but comradeship love. Jackson cements this social link when Kong brings Ann to his lair atop the highest peak on Skull Island. This time Kong ignores Ann's Vaudevillian shtick when she attempts, in gratitude for her rescue from the T-Rexes, to amuse him. As the tender music of the Ann–Kong love theme starts to play

for the first time in the film, Kong is intent instead on watching the sunset, something that seems a regular event for him. Slowly, Ann comes to see what Kong is doing. She turns to look at the panorama herself, eventually commenting: "It's beautiful." There's a slow, rising camera pan from behind them, silhouetting the new companions in the glow of that beautiful sunset—uniting them in glorious Nature (Figure 1.1). Ann turns to the contemplative Kong and repeats the word. He looks down at her with inquisitive, nearly sad eyes. In the manner of a language teacher, Ann says the word "beautiful" again, this time accompanying it with a gesture, an open palm patting her chest. Kong watches her closely then looks back toward the sunset. We're not sure anything has registered with him until Kong opens his hand to Ann, inviting her into his palm. She accepts this invitation, so different from his previous violent abduction of her during the sacrificial ritual of the islanders. At that moment, the allure of Beauty— that is, of glitz and empty ideology—is overthrown for the solidarity of Beautiful—for an authentic amity connecting living beings. This counterculture partnership will be Ann and Kong's private affair, similar to the friendships between Lumpy and Choy, Mr. Hayes and Jimmy. Like those working-class attachments, theirs is also ill fated. All of them live on the wrong side of modern power.

Ann and Kong's compassionate relationship is predicated on Jackson giving us a very different big ape than Cooper. In the first part of the segment "Bringing Kong to Life," Jackson says his aim was to "get empathy into the title character" (*King Kong*, Deluxe Extended

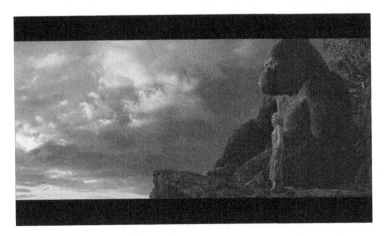

Figure 1.1 Ann and Kong's first Beautiful moment together.

Edition, disc 3). The filmmaker looked to Charles Laughton's performance as Quasimodo in *The Hunchback of Notre Dame* (1939) as a model for a lonely and misunderstood outcast who connects to a young woman. The result was Jackson's creation of a forlorn and isolated Kong, cut off from the highly social life normal to gorillas. Kong's violent outbursts on Skull Island reflect this tragic isolation. Thus, Jackson didn't want to fashion just a flat movie monster, but a Kong that "has a heart...has a soul." Andy Serkis, who traveled to Rwanda to observe wild gorillas and was impressed by their gentleness, agrees that Kong is "a creature with an enormous heart." Serkis adds: "He is an honest character, and therefore heroic." However, along with this deepening of Kong's temperament, Jackson was careful as well not to lessen the savage nature of his title character as a beast coming from a hostile environment (Morton 329). Jackson says his primary interest was not in developing the romantic aspect of the Ann and Kong relationship; instead, he wanted to explore "the notion that Kong's connection with Ann awakens the great ape's compassion." For the first time in his long and brutal life, Kong experiences "empathy for another living creature" (Morton 325). Jackson's Kong, then, is not so much softened as he is socialized. At first the ape wants to kill Ann; then he wants to save her; then he simply wants to be with her, to have her as company. The same pattern could be said to hold for Cooper's original Kong, but the only sympathetic touches to that beast are the ones his animator, Willis O'Brien, could force into the picture (Morton 58–59). Otherwise, the 1933 Kong has no tangible psychological depth, and he certainly forms no social–linguistic kinship with Ann. Jackson's innovations and additions to Kong are extensive not just in a creative sense but, conceivably, in a profound political sense as well. The alliance Jackson portrays between Ann and Kong represents a post-Marxist unity formed by the oppressed against their oppressors; moreover, their radical pairing detaches "the power of truth from the forms of hegemony, social, economic, and cultural, within which it operates at the present time" (Foucault, "Truth and Power" 318). That is, due to the bond of Beautiful, Ann becomes unmarked as Beauty and Kong becomes unmarked as Beast. We as an audience are forced to see them anew, to reconsider Ann and Kong as more complex and historically grounded beings than the "truth" (meaning, really, myth) that modern capitalism (in this case, enacted by Denham) has fabricated and imposed on them. Thus, Ann and Kong show us a social construction alternative to that of imperialistic capitalism, one not grounded in competition and greed but in cooperation and community.

This socialist revolution within the Kong story is indicated as well by Jackson's negating the sexist fairy tale of the Knight in Shining Armor. For Ann and Kong to embody Beautiful to the fullest extent, Jack Driscoll as the typical Hollywood leading man must be annulled. We've seen already how the prototypical Hollywood leading man has been spoofed in Jackson's movie through Bruce Baxter. Likewise, his Jack Driscoll character is nothing like Cooper's. Jackson's Driscoll has been changed utterly from swaggering first-mate to cerebral playwright. Without a doubt, Jack is both a remarkable and good guy. Not only is he an egghead who mingles well with the common man, but Jack turns out to be, also, extraordinarily good at dodging dinosaurs, stealthily making his way through hostile jungle, and not being crushed by the fist of Kong. Not too bad for a scrawny bourgeois white male. Yet, in the end, he is no robust hero and lover, and critics have noted this apparent deficiency. David Griffin quips: "Adrien Brody as the ostensible love interest is neither loving nor interested and appears to have been cast primarily for completely lacking the qualities of an 800-pound gorilla" (18). Cashill ponders the conclusion of the film: "with her animal companion dispatched, I can't have been the only one wondering how long a strengthened Darrow would be content with the effete, withholding Driscoll, who's a bit of a bore" (41). It's doubtful, however, that Jackson's Driscoll is a result of flawed casting or inept screenwriting. As Adrien Brody himself says of the film: "What Peter and Fran and Philippa have been able to do is create all of these nuances that never existed. It's not just a giant gorilla and a damsel in distress" (Horn 3). Shifting the part of leading man from Driscoll to Kong seems intentional. Jack plays the role of Knight riding to the rescue perfectly up to the point where he comes for Ann in Kong's lair. Wakened like Sleeping Beauty, Ann is stunned and touched to see Jack there. After all, as the old Vaudevillian, Manny, informs us about Ann at the beginning of the movie: "Ever since you were small people have been letting you down." Now Ann has two suitors looking out for her: Kong and Jack. In a well-constructed shot, as Ann and Jack reach to touch hands with the sleeping face of Kong behind them, this love triangle is depicted patently. The instant human fingers join, Kong's eyes pop open, and the ape tries to kill his rival. Jack manages to take Ann away from Kong, but his triumph as a rescuer-hero is both compromised and short-lived. Just prior to Jack's feat of derring-do, Ann and Kong have had their Beautiful moment. They are already partial solidarity mates. Once back at the native village and on the other side of the wall dividing Civilization from Nature, Ann commits fully to Kong by rejecting Jack, thinking him merely a part of Denham's plan

to capture the gorilla alive. As Jack tries to pull her away from the fray to subdue the huge animal, Ann says to him angrily, "Let go of me! Stop it! Leave me alone!" Down by the boats, once Denham finally has subdued Kong with the chloroform, Ann makes her choice even more clear. As she sobs over the fallen Kong, Jack watches her in disbelief. Ann's returning look is unapologetic: Kong is her man. In Cooper's film, Kong is the rejected rival to the Jack and Ann couple, a formula that fits the standard fable of Dragon, Knight, and Damsel. In Jackson's film, that formula is reversed—Jack is the rejected rival to the Kong and Ann couple—and the fable is trashed—Dragon and Damsel rebel together while the Knight becomes irrelevant. Fittingly, Jackson tells this new tale of underdog unity displacing Hollywood romance on Manhattan Island.

In New York City, Ann and Kong's fight against the forces of Beauty is told in three sequences: Denham's Broadway stage spectacular, the interlude in Central Park, and the final stand atop the Empire State Building. All three sequences have their stirring moments. Most riveting, perhaps, is the image of Fake Ann rising from below stage in mirror image of the manacled Kong. For the price of an admission ticket, here is Blonde Beauty and Black Beast packaged together and on display for the exclusive gaze of the rich and the powerful—represented best by all the white men in tuxedo-and-tails at the premier, each one reminiscent of the Monopoly Man. Both victims are shackled between pillars, in the posture of crucifixion (Figure 1.2). Around them swirls the dance show of Africanized "natives" reenacting Ann's

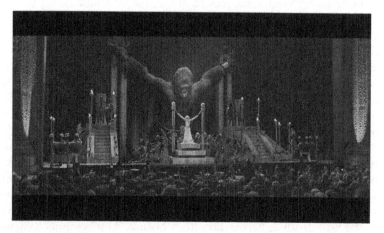

Figure 1.2 For sale: blonde beauty and black beast.

sacrifice to Kong on Skull Island. In this sequence, Jackson bombards us with all the latent racist, sexist, and imperialist ideas of the original *King Kong*.[12] We see how Denham is a slaver, and Kong is his captured, transported, and auctioned-off slave. We see how Denham is little more than a pornographer, and Ann (whether the real Ann Darrow or a blonde look-alike—the actual girl matters little in this business) is his delicate female prop to situate in dangerous and titillating juxtaposition with the biggest black rapist the white world has ever seen. We see as well how Denham inaccurately puts non-Western culture on exhibit as exotic and buffoonish savagery, and this Broadway extravaganza is nothing but a minstrel show. In fact, more than a wry tribute to Cooper's movie, transforming the music, choreography, and costuming of the original "Kong dance" into a tacky production number is one of Jackson's best moves at deconstructing the racial politics of Cooper's movie. Critics lack imagination who charge Jackson with perpetuating the racism of the 1933 *King Kong*. Stephen Hunter of *The Washington Post* writes that Jackson's film "remains a parable of exploitation, cultural self-importance, the arrogance of the West, all issues that were obvious in the original but unexamined; they remain unexamined here, if more vivid" ("King Kong" 2). Similarly, David Edelstein of *Slate* maintains that "Jackson doesn't deal with the implicit racism of *King Kong*—the implication that Kong stands for the black man brought in chains from a dark island (full of murderous primitive pagans) and with a penchant for skinny white blondes" (3). To the contrary, it's reasonable to argue that one of Jackson's primary aims, aside from the necessity of making a box-office-friendly adventure movie, is to expose and discredit Cooper's racism.

Societal psychiatrist and race commentator Kwame McKenzie appreciates Jackson's antiracist efforts to a degree. Although it was impossible for the film not to feed "into all the colonial hysteria about black hyper-sexuality" and "the black male stereotype," McKenzie judges that Jackson's "attempt to shelve the lust angle and portray the relationship between Kong and Darrow...as owner and favourite pet—in that order—worked. The cinematography was excellent and my worst fears were not realised." McKenzie thinks, however, "that if Jackson had put as much thought into the rest of the racial imagery as he did into the relationship between Kong and Darrow this could have gone down as a much less offensive film" (1). Conceivably, though, Jackson *did* put as much thought into the rest of the racial imagery of his film. Where misunderstanding might occur is in overlooking another major aim of Jackson's in remaking *King Kong*,

namely, to expose and discredit the *economic* politics of the original film. Much of the racial controversy over Jackson's movie stems from the portrayal of the inhabitants of Skull Island. If they are taken merely as "murderous primitive pagans," as Edelstein does, racial discomfort surely results. But, as we argued earlier, if this Skull Island culture imagined by Jackson is recognized for its essential *similarities* to Manhattan Island culture (as opposed to contrasted for "primitive" versus "civilized" differences), then a very different reading of these inhabitants can be formed. For Jackson to have given us genial "noble savages" as Skull Islanders would be nearly as insulting, and almost as unrealistic, as Cooper's ludicrous, pseudo-African village filled with folks wearing grass-skirts and coconut-shell bras. Instead, as Vance Aandahl points out, "Jackson recruited a team of genuine Melanesians and gave them all horror-movie makeovers" (3). It seems unlikely that, after going to the trouble of adding Mr. Hayes to his script, Jackson is looking to assert European racial and cultural superiority with this creative decision about the islanders. Obviously, he's going for realism, albeit an over-the-top realism, as these people look barely to be eking out a seaside living hemmed in, as they are, by their great wall to keep out Kong. Such grim circumstances likely would make anyone slightly deranged.

More impressive, though, than these current bleak circumstances are the crumbling remnants of their once flourishing civilization. Unlike Cooper, Jackson does not put these people in grass huts; rather, his Skull Islanders inhabit what looks like a formerly mighty city made of stone. In fact, throughout the island, in the form of statuary, columns, and grand staircases, we see evidence of an ancient and sophisticated society having existed. All of these trappings are not primitively antithetical to the modern world but actually are reminiscent of the gray canyons of New York City. Moreover, both societies enjoy a good sacrificial spectacle of a young woman given to a giant ape. Thus, in both cultures, the weak and vulnerable die in the service of the strong and powerful. Where on Skull Island that sacrifice is literal, on Manhattan Island, it is emblematical. Denham's Broadway show represents the actual exploitation of slaves, of workers, and of women. Because of these similarities, it's reasonable to venture that Jackson's point about "primitive" (Skull Island) and "modern" (Manhattan Island) society is fundamentally that of Marx: that both are exploitative. Both promote plutocracy and thereby social injustice. Both matriarchal tribalism and patriarchal capitalism chew up certain people and spit them out. There is no idyllic return to Nature available to human society, no going back to a simpler, purer form of

Edenic harmony. Instead, it's time for us to unionize and to move on. Thus Jackson counters with socialism the well-known and energetic anti-Bolshevism of Cooper.[13]

The Beautiful union of Ann and Kong in New York City begins with Kong's trying to speak to whom he thinks is Ann shackled before him. Kong leans down and grunts several times insistently at the blonde woman in the white evening gown and elbow-high gloves. When the woman turns her face up to Kong and he sees that she's not Ann, the ape flinches backward. When the woman begins her Fay-Wrayesque screaming and delivers her wooden line ("Eeek! Save me from the beast!"), Kong winces. Then he roars back in anger. Kong isn't interested in just any blonde, just any generic Beauty. He wants to be with Ann. But everything about Denham's stage presentation is phony—from its damsel-in-distress heroine to its great-white-hunter hero, from its greasepaint natives to what shortly will turn out to be Denham's biggest lie of all: "Don't be alarmed! It is perfectly safe. These chains are made of chrome steel!" For her part, Ann is not at The Alhambra on Times Square that evening. She's at The De Luxe Theater, on a far more humble stretch of street, appearing as just one more member of a chorus line of indistinguishable slender platinum blondes. They're all dressed just like the Fake Ann tied up for Kong—in white evening gowns and elbow-high gloves. They're onstage as window dressing for the star of the show—a man doing a soft-shoe in top hat, cane, and tails—just like Fake Ann appears as a prop to help Denham dance and spin his illusions on Broadway. Jackson doesn't miss a symbolic trick. Denham had offered Ann all kinds of money to appear in his Kong show, but she rejected such tainted fortune and fame. As a result, she's been forced once again into hustling show business jobs. Judging by the abstracted look on her face, Ann is little more satisfied with this gig as blonde eye candy than she was with the burlesque job she rejected just before Denham found her. In short, after her transformative experience on Skull Island, Ann is unwilling to serve any longer as a bauble for Beauty. In the middle of "Bye, Bye Blackbird," during the line "Where somebody waits for me, / Sugar's sweet, so is he," Ann stops her performance of the hackneyed routine. While the others continue, she stands, staring blankly into space. At that moment we cut back to Kong, also staring, blankly, also trapped in an extravaganza not of his choosing. Clearly, each one is thinking of the other. Soon, both Kong and Ann will break out of their respective playhouses of Beauty. Kong will begin his rampaging search for the right blonde. Ann will follow the sirens, hoping to locate Kong. They need some Beautiful time together.

Arguably, the most outrageous aspect of Ann and Kong's interlude in Central Park is how believable it is. Against all odds, the scene works at this moment in the film. These fugitives are on the lam from the entire City, yet here's time to play on a frozen pond. Certainly, many reviewers object to this preposterous scenario. Yet even a critic generally negative of Jackson's remake, Robert Cashill, feels the emotional connection made by Watts and Serkis as actors working through a complex technological process of green screen and motion capture. Cashill describes their Central Park sequence as "a go-for-broke... *pas de deux* on ice that goes on long enough to be thoroughly winning, and not just an embarrassing throw-away moment" (39). Cashill, in fact, thinks Jackson's innovative storyline of mutual affection between Ann and Kong "mature, smart, credible—qualities that have been lacking from the template set in 1933" (40). Along with emotional viability, though, this small moment of calm before the climax of the movie potentially signals a variety of impressions to viewers as well. Foremost is the reestablishment of Ann and Kong's enlightened bond of Beautiful. Only now it occurs in a quintessentially Western setting: a wintry, Christmas-time, frozen landscape that is as foreign and incongruous to the jungle-adventure film genre as Jackson can take us. If Ann could be made to feel safe and comfortable for a moment on Skull Island in the presence of her caring companion, Kong, here the favor is reversed on Manhattan Island. If audiences like, they can see symbolized in this Central Park frolic a fleeting glimpse of world harmony between the G-20 and the Global South. Or, if viewers prefer to think of Kong not as representing the Oppressed Other but as the irrepressible force of Nature, it's environmentally ironic that he finds his only New York minute of ease in the commons of this cruel megalopolis, that one place where the natural world, hemmed-in, is still allowed to exist. Skull Island is all Nature with a bit of city clinging to it; Manhattan Island is just the opposite. A third way to watch Ann and Kong's skating date is with tragic dread. From a dramatic point of view, even if one had never heard of Cooper's original movie, moviegoers sense that looming ahead for this momentarily happy couple is a disastrous end. Unmerited misfortune always finds the tragic hero, and without question Kong's tragic flaw is his desire to be with Ann. Kong's childlike delight in discovering ice, his sudden idea to try a headfirst slide, and his innocence in assuming everything is fine now that he's reunited with Ann brims with pathos. Audiences also can feel for Ann in her doomed mission. Just as she was powerless to prevent Kong's capture on Skull Island, she's unlikely to be able to prevent his slaughter on Manhattan Island.

The forces marshaling to destroy the renegade, Beautiful bond of Ann and Kong are those of modern, militaristic, technological, and masculine hegemony. These Jackson goes out of his way to portray as brutal, hard-boiled, indiscriminately violent, and bigoted. The first representative of it we see is a steely eyed, grizzled Army Commander ordering mortar rounds to be lobbed into the Park, causing the frozen pond to erupt beneath Kong. In a matter of moments, though, this officer's grim and arrogant determination is turned, ironically, into panicked cowering. As Kong bounds by, the man is incidentally crushed inside the cab of his vehicle. The audience can't help thinking that it serves him right. In the Deluxe Extended Edition of Jackson's film, the next agent of modern power we see is a fanatical Sergeant giving his men a pep talk as they go into battle. While the squad hurtles through the streets of New York in the back of a troop truck, this stern and strident veteran barks at them:

> Listen up! This is New York City. And this is sacred ground. You hear me? It was built for humans, by humans, not for stinking, lice-infested apes! The thought of some mutant gorilla crapping all over the streets of this fair city fills me with disgust! So this is how it's gonna be. We find it! We kill it! We cut its ugly head off! And we ram it up its aaahhhhhhhh.

The Sergeant's inspirational words are cut short by Kong suddenly running through an intersection, more or less accidently knocking the troop truck into the side of a building. That Jackson dispatches these two Army tough-guys so comically and dismissively shows where our sympathies should be—with Kong. He's the victim here. He's the escaped slave making a run for freedom. That the Sergeant's speech was deleted from the theatrical release of Jackson's *King Kong* is not surprising. The mention of New York as "sacred ground," along with the mindless prejudice displayed by the Sergeant, seems an overt send-up of the jingoistic fervor generated in America post-9/11. Inclusion of the scene would have been far too sensitive politically, and thereby risky remuneratively, for Universal Pictures to allow. But even without that speech, Jackson's depiction of the military response to Kong is completely unflattering. Soldiers in jeeps careen about the streets of Manhattan like cowboys on a Saturday night. They blaze away wildly at the elusive ape with 50-caliber machine guns and small artillery pieces, while New Yorkers at street level scramble for cover. Their own guardians are more of a threat to them than the menace of Kong—who'd still be sliding peacefully over in the Park with Ann

if only they'd left him alone. Jackson seems to be saying: how typical of imperialistic power to create, via subjugation, the very "terrorist" it must then scramble to eradicate. In other words, Kong is recognizable as "blowback."

The term "blowback" was first used in a 1954 CIA report on the operation, undertaken in 1953, to overthrow the government of Mohammed Mossadegh in Iran. The authors of that report used the word as a metaphor "for the unintended consequences of covert operations against foreign nations and governments" (Johnson 113). CIA misgivings about its interference in Iranian internal affairs, of course, proved prophetic. Installing the Shah as head of state led to the revolution of Ayatollah Khomeini, which led to conflict with Saddam Hussein and, more than half a century later, here we are today having waged an unjustified war in Iraq and in tense conflict with Iran. Similarly, Osama bin Laden himself was once listed as an "asset" of the CIA in its covert operation to arm and train the *mujahideen* as "freedom fighters" against the pro-Soviet government of Afghanistan. The larger aim, in fact, was to draw the Russians into the quagmire of invading that country. In the words of Zbigniew Brzezinski, President Carter's National Security Adviser who endorsed this clandestine strategy in Afghanistan, such a move would hand the United States "the opportunity of giving to the USSR its Vietnam War" (114). Destabilizing the Soviet Union would come at the cost of 1.8 million Afghan casualties and 2.6 million refugees (not to mention 10 million land mines left in the ground)— an acceptable price to pay, in US eyes, in the geopolitical chess match against international Communism. However, in this instance, the unintended consequences of American policies kept secret from the American people would lead to the most spectacular and devastating example of blowback to date: Osama bin Laden putting his CIA training to use to bring down the World Trade Center and hit the Pentagon, killing as many as 4,000 people. On top of that, currently the United States remains mired in an occupation of Afghanistan. As far-fetched as a connection between these events of American foreign policy and the movie *King Kong* might seem at first glance, a viewer in 2005 would be hard-pressed to see Kong's "rampage" in New York City as an attack on America, but instead regard it as a necessarily violent reaction to the imperial project and the patriarchal militarism that has been directed against *him*. Any viewer willing to allow the uncomfortable political analogy to fall into place—that is, of Kong as blowback, of Kong incredibly as a kind of bin Laden—would not have trouble allowing that terrible thought to stray into her mind.

As analysts of popular culture, we don't believe we're reading more into Jackson's film than is available to be seen, or that perhaps he intended to be seen. We are aware, however, that we've likely strayed well past the mark where the typical moviegoer wants or anticipates critical thought—and particularly uncomfortable ideas of a political-economic nature—to be provoked when watching a blockbuster movie. Yet such is the nature of the monster film genre: its capacity to signify, culturally, much more than audiences normally care to perceive. In the case of Jackson's *King Kong*, we think a great deal of social commentary is present intentionally. The director and the screenwriters bring that commentary, along with their plot, to a dynamic close with Ann and Kong's last stand atop the Empire State Building.

Out of reach from the military frenzy below, the pair enjoys a second brief respite as they sit on top of, in 1933, the pinnacle of modern civilization. For Kong to take possession of, at that point in history, the tallest building ever erected smacks of slave revolt and the empire striking back. Before Kong's inevitable showdown with the master, however, Jackson replays, in reverse, the Beautiful moment experienced by Ann and Kong as they sat on top of that highest peak on Skull Island. Kong begins this conversation, attempting first to talk with Ann vocally. When she doesn't react to his voice, Kong looks to the eastern horizon, where the sun is just coming up, and performs the sign for Beautiful—a gentle fist beat over his heart. Perched in the ape's giant hand, Ann comes to realize, but not quite believe, what's happening: Kong is speaking *back* to her. He's using language she'd taught him in order to establish real communication between them. Therefore, Kong is not a dumb animal. He's advanced up the evolutionary scale to wog, that is, the colonized subject undergoing the disorienting phenomenon of "double consciousness." He's smitten with an admiration for the oppressor's culture. He's learned to express himself in the oppressor's language. At the heart of Kong's tragedy, then, is Homi Bhabha's concept of "unhomeliness." The term refers to the way a colonized subject perceives the divide between two antagonistic cultures, those of the colonizer and of the indigenous community. Because the colonial subject is conscious of both cultures, she feels fully comfortable, that is, at home, in neither one. This distress of not belonging, of having no "home" culture is, for Bhabha, "inherent in that rite of extra-territorial and cross-cultural initiation." It's plain that, by the end of the film, Kong feels intensely the effects of such a disruption to his accustomed worldview. For that matter, so does Ann. Their Beautiful relationship is new to them both—an instance of cultural hybridity indigenous to neither Skull

nor Manhattan islands. Bhabha goes on to point out that the crisis of unhomeliness often is most evident within the private sphere, that the "recesses of the domestic space become sites for history's most intricate invasions" (9). Such is the case in Jackson's movie. In the relationship between Kong and Ann, we witness both the violent clash of cultures and the hopeful comingling of them. Notes Bhabha: "The unhomely moment relates the traumatic ambivalences of a personal, psychic history to the wider disjunctions of political existence" (11). Ann and Kong's moment of dialogue atop the Empire State Building, then, crystallizes the personal–political turmoil of imperialism depicted by Jackson's odd couple. In their exchange, Kong uses his new gesture-image "beautiful" to remark on the sunrise, while Ann responds with her more standard sound-images: "Beautiful...yes...yes it is." At this point, their eye contact becomes more than ever meaningful. Left to themselves, Ann and Kong likely could establish their own, private cultural home. Their cross-cultural, interspecies (meaning really interracial) contact not only is remarkable and endearing, but it harms no one. Jackson lets us hope against hope just for a moment. Then the biplanes show up. The appearance of the military might of the colonizer is inevitable not because Jackson follows Cooper's storyline, but because hegemonic groups are, by culture, controlling and bigoted. Ann and Kong's innovative domestic space is intolerable to the dominant culture. As Bhabha points out, echoing Foucault, the private sphere is "the space of the normalizing, pastoralizing, and individuating techniques of modern power and police: the personal-*is*-the-political; the world-*in*-the-home" (11). For the imperialist, to allow such hybridity is to relinquish supremacy.

Kong's last stand against the most advanced modern technology is heroic but doomed. Whether read as the defiance of the Other or as the reprimand of Nature, Kong's roaring and chest-pounding over the almighty city of New York is not tolerated for long by Civilization. The grim-faced pilots and gunners swarm the Beast. Always careful of Ann's safety, Kong battles the planes intelligently and athletically. The first one he manages to down by luring the pilot in too close. Two others he dispatches with a sudden and spectacular snatch-and-spin move. We viewers don't concern ourselves with the awful deaths of these six aviators. They are goggled and helmeted aggressors, dehumanized compared to the team of Kong and Ann. Throughout the clash, these two vie to protect one another. At one point they share the peril, side-by-side, of dangling off the skyscraper together. Just as during the T-Rex fight on Skull Island, Kong makes another fantastic saving grab of Ann when she falls. However, unlike

that earlier encounter with vicious predators, during this one, Ann is just as actively looking to save Kong. Amid pinging bullets and shards of flying glass, she relentlessly climbs ladders to reach her colleague-in-battle. Her plan is simple and what it has been ever since walking out of The De Luxe Theatre: wave off the military; stand in the way of them and Kong; be her partner's human shield. By the time she's able to do this, there are only three planes left—mirroring the three T-Rexes—but Kong is badly hurt and the planes are circling for their kill. The harsh face of the squadron commander fills the screen, followed by Kong returning an insubordinate glare. When the great ape rises up to bellow and chest-drum at the threat, Ann scrambles at last to the top of the building, dashes between his legs, and plants herself between Kong and the approaching planes. At this moment, Jackson diminishes slightly the sound of Kong's shriek, the menacing drone of the warplanes, Ann's desperate cries of "NO! NO!" This sound effect serves to remove viewers just enough to appreciate better the magnitude of what's taking place.

If, back on Skull Island, Ann backed away from the last T-Rex to hide beneath the protective bulk of Kong, here she steps boldly back out into the open to face down a monster and to hide Kong behind *her*. If, back in The Alhambra, Kong and (Fake) Ann had been staked together on stage as helpless slaves, here in the real world appear Kong and the real Ann in full-throated autonomy, mutiny, and solidarity. If, throughout the movie, Ann had been depending on the kindness of strangers—Denham, Jack, Kong—here Ann emerges, finally and fully, out from underneath the stigma of needing male protection. In a smart analysis of the sexual politics taking place in Jackson's *King Kong*, Meghan O'Rourke finds that, in spite of significant efforts to the contrary, Jackson "seems to reinforce the very stereotypes on which the original film was built." Even though Ann actively defends Kong "as few 1930s heroines would've dreamed doing," O'Rourke judges that, in the end, the film "implicitly suggests that traditional manliness (strength and courage) is the essential fabric of romance and that women value protection above all" (3). Up until this climactic scene atop the Empire State Building, O'Rourke's assessment is quite accurate. However, the moment Ann steps in front of Kong, either she's performing masculinity in her blonde bombshell body or she's appropriating strength and courage as an attribute of innovative womanliness. Either way, Jackson takes the last step in turning Cooper's original *King Kong* entirely on its head. Ann becomes the Hollywood leading man. While the title character of Jackson's remake is certainly crucial as the persecuted tragic hero, Kong is being gunned down and unable

to protect himself against modern military technology. While Jack certainly has displayed a great deal of agreeable spunk during the movie, at this filmic climax, he's stuck in a slow-moving elevator 50 floors below and nowhere to be seen. While Denham is the star of Cooper's film, Jackson recasts the pushy filmmaker as a likeable and primarily comedic jerk. However, when Ann stands up on top of the Empire State Building by herself, after Kong has slid away and plummeted dreadfully to the streets below, there is nothing Damsel or distressed left about her. All of her former vulnerability is gone. Ann claims the role, in practice, of epic hero. Ann is the character in Jackson's film whose virtuous conduct we should admire and, more to the point, emulate. When Jack shows up, it's as an afterthought. Ann doesn't need him, but decides to accept him—as her equal. Or perhaps, really, as his superior. The look in her eyes is *not* the same astonished gratitude that shone when Jack came for her in Kong's lair on Skull Island. Rather, Ann's expression now is one of: *Oh, it's you...that's sweet.*

Therefore, along with classism and racism, one more target of Jackson's looks to be the sexism of Cooper's *King Kong*. Patriarchy is shaken to its core and the conventional performance of gender is troubled severely when blonde bimbo transforms into righteous action hero. In fact, the swirling, dizzying shot from above the Empire State Building as Kong falls rocks our whole bourgeois worldview. We are made to feel pity for Kong—the Negroid/Worker/Environment we otherwise exploit and abuse. We are made to feel admiration for Ann— the mouthwatering dish we otherwise dream of gobbling up. We are made to feel antipathy for our Military—what we otherwise lionize as "heroes" and protectors of our "freedom." We never imagine our armed forces as cowards behind superior weaponry, keeping the conquered in line and shooting opponents in the back. We are made to feel ashamed of ourselves embodied by the mob on the street clamoring to catch a glimpse of Kong's mangled corpse. The slimy photographers climbing on top of Kong to snap sensationalistic pictures for their daily rags disgust us. The soldiers posing and mugging for that Press using the dead Kong as a prop disappoint us. The yahoo photographer with the thick New York accent blithely remarking that Kong was, "Just a dumb animal. Didn't know nothin'," makes us see Red. After all, we've just watched, along with Ann, undeserved death dilate Kong's big brown eyes. In sum, every major aspect of foundational modern "Truth" has been exposed by Jackson as a Big Lie and thereby severed from the source of modern Power that, we now realize, fabricated it. With Kong, the World falls figuratively to its death as well, murdered by Hollywood glitz, technical supremacy, militaristic bloodlust, and

hyper-capitalism. It's quite fitting that the man responsible for this catastrophe comes pushing through the mob to have the final word in *King Kong.* Cooper's Denham and Jackson's Denham speak the same lines. Their meanings, however, couldn't be more different.

CARL DENHAM'S CRISIS OF MASCULINITY

As we have just seen, patriarchy comes under intense scrutiny in Jackson's *King Kong* through the character of Ann. In addition to this feminist social critique, gender theorist R. W. Connell's four main patterns of masculinity in the current Western gender order—hegemony, subordination, complicity, and marginalization—are in intense play as well in the film.[14] Just as Ann serves both as an example of Halberstam's female masculinity and as an exemplar of heroic conduct for the audience, Denham provides the audience, through his vexed masculinity, with an object lesson in knowledge too late. Specifically, where Cooper's Carl Denham embodies wholly and unmistakably the hegemonic male of 1930s' America, Jackson's Carl Denham experiences instead a crisis of masculinity in Connell's sense of that phenomenon. That is, the crisis is *not* Ann's feminist threat to a stable patriarchy; rather, masculinity is constantly in crisis in that hegemonic masculinity—the justification *for* patriarchy—is perpetually under the pressure of renegotiation and redefinition. Connell stresses that: "hegemonic masculinity embodies a 'currently accepted' strategy. When conditions for the defence of patriarchy change, the bases for the dominance of a particular masculinity are eroded" ("Social Organization" 39). Jackson's Denham undergoes such an erosion of masculinity over the course of the film in that he slowly comes to realize that the dominant masculinity he enacts—or attempts to enact—is not only bankrupt but, in the end, supremely destructive. Denham becomes educated to the point where he sees through the oppressive practices of the reigning hegemonic masculinity, and, as an audience, we are tutored along with him. The tragic circumstance turns out to be, of course, that Denham doesn't learn his lesson in time. The more important question is left hanging by Jackson: Will we?

Played by actor Robert Armstrong, the original Carl Denham epitomizes fast-talking, hard-charging, acquisitive modernity. He won't be denied his goal of, as he declares in his first scene, "going out and mak[ing] the greatest picture in the world! Something that nobody's ever seen or heard of!" Denham will go to any lengths in this project, from stocking the *Venture* with, as her Captain points out, "enough ammunition to blow up the harbor" to capitulating to public demand

for a romance element in his new movie. "Holy Mackerel," he complains to the theatrical agent who has failed to procure an actress for the part, "do you think I *want* to haul a woman around?" It follows, then, that Denham also exemplifies the hegemonic masculinity of the day. He's white, he's a venture capitalist, he's sexist, he's an adventurer, and he's up on the latest technology (whether the new media of film or, as the Captain points out, "those new gas bombs of yours"). Denham is a creature of the patriarchy. When we first see him aboard the *Venture*, he's surrounded by all things presumably masculine: guns, cigars, a grizzled sea captain, a strapping first-mate, a mysterious voyage at hand, raw ambition in the air. The last thing he needs is a woman ruining this boys' club. But he has no choice. The Free Market has spoken. Both critics and distributors say that Denham's films "would gross twice as much" if they had "love interest" in them. Denham barks: "the public, bless 'em, must have a pretty face to look at!" Therefore, "I'm going out and get a girl for my picture—even if I have to marry one!"

Moreover, the type of pictures Denham makes—the very genre out of which Cooper's *King Kong* emerges—epitomizes the white supremacist capitalistic patriarchy of the 1920s and 1930s. Enjoying widespread popularity at the time were travel documentaries and jungle adventure films. Prior to making *King Kong*, both Cooper and his codirector, Ernest B. Schoedsack, had established their reputations as filmmakers working in these forms.[15] As Erb points out, such films featured two prominent tropes: the "camera/gun story" and the "drama of the touch" (66). The first emphasizes the aggressive Western masculine gaze. Camera and gun combine as one instrument to invade and dominate the exotic landscapes and peoples of the "uncivilized" world. The media expert and the adventurer likewise combine into one heroic figure, in this case Denham, who is equally handy at shooting things either to capture or to kill.[16] The second convention, the drama of touch, features actual physical interaction between "civilized" whites and "primitive" blacks (Erb 69). Sensationalistic by design, such "dangerous contact" routinely involved the implied, if not the actual, sexual threat of black men to white women. Overall, these films partake of a larger cultural phenomenon of the early twentieth century known as modernist primitivism—fundamentally, a Euro-American artistic fascination with non-Western culture. Erb characterizes this problematic movement as:

> an uninformed decontextualization and mixing of African, Arabic, Oceanic, and other cultural traditions. Primitivism can thus appear

almost inevitably narcissistic, a discursive project saying little about the actual lives and experiences of aboriginal people, instead revealing more about the views of the Western artist or ethnographer, the one doing the "primitivizing." (66)

Cooper's *King Kong* is imbued with all of these ingredients: modernist primitivism, the drama of the touch, and the camera/gun story.[17] What is more, all of them emanate from the actions of Denham, the prime mover of Cooper's primitivist and Orientalist fantasy.

Jackson's Carl Denham, played by Jack Black, does not wholeheartedly engage in this brand of cultural hegemony. In fact, in his opening scene, Jackson's Denham is set in opposition to it. The studio executive, Zelman (Pip Mushin), and the two lowbrow investors (Jim Knobeloch and Ric Herbert) represent the profit-at-any-cost mentality of Cooper's Denham. Jackson's Denham, by contrast, is concerned with the artistic quality and integrity of his film. When the sleazier of the two investors asks hopefully of Denham's new movie, "Will there be boobies?" Denham is momentarily speechless. The investor elaborates: "Jigglies, jablongers, bazoomers! In my experience people only go to these films to observe the ... undraped form of the native girls." Denham replies to this ignorance adamantly and, given the investor's apparent mobster demeanor, riskily:

> What are you—an idiot? You think they asked De Mille to waste his time on nudie shots? No—they respected the filmmaker. They showed some class! Not that you'd know what that means—you cheap low-life!

Where Cooper's Denham is nothing but swaggering entrepreneur, Jackson's Denham is equal parts hustler and artiste. This aesthetic side to Denham provides the chink in his armor of hegemonic masculinity for ideas *other* than domination to occur to him. Much to the dislike of hostile reviewers such as David Griffin (18), Jack Black plays the role of Denham paradoxically, as a kind of comedic oppressor. He's a charismatic weasel and scammer who will go to any lengths to get the shot he wants, but he's not overtly domineering and imperialistic. Those evil qualities come more as a result of his looking-out-for-number-one ignorance than, as with Cooper's Denham, a will-to-power violence. In this regard, Jackson's Denham is quite similar to Mary Shelley's Victor Frankenstein: Both characters are self-absorbed bourgeois men who, in pursuing their passions, create a monster-slave and then stupidly wonder at that creature's destructive rebellion. Where Victor stays blind to his own culpability, however,

Denham realizes, at last, that the blood is on his hands. His increased awareness of social reality, as opposed to remaining obtuse within his bubble of dominant ideology, comes primarily through his interactions with other masculinities.

Considered earlier in this chapter was how Denham's view of the world shifted as a result of his contact with the crewmen of the *Venture*. After narrowly escaping the dangers of the swamp, Lumpy shames Denham into turning off his camera. Following the ordeal of the Spider Pit, where his camera is destroyed, his precious film footage is ruined, and his fight is for his life, Denham nearly has a breakthrough in seeing past the Hollywood allure of Beauty. These incidents are two in a series of near-epiphanies Denham experiences that bring him to his enlightenment. All of these teachable moments involve Denham's performing hegemonic masculinity while being confronted by non-hegemonic men. The first of these men is Denham's long-suffering assistant, Preston (Colin Hanks), enacting Connell's position of subordination. Although no solid reason exists in the movie to suppose that Preston is gay, much of his behavior conforms to the stereotypes of gay behavior as defined by American patriarchy. Preston is generally a milquetoast; he's mild-mannered, sensitive to others, neat in his appearance, intellectual, and completely subservient. Preston is also out of his element aboard the *Venture* and on Skull Island. Action and adventure amid manly men is obviously not Preston's cup of tea. However, Preston and Denham have a relationship where the assistant serves as his boss's moral compass. Even though Denham always dismisses his assistant's nagging honesty, telling him things such as, "you have a lot to learn about the motion picture business" (meaning it's based on lies and deception) or to stop worrying because, "I'm real good at crapping the crappers," nonetheless Preston's ethical admonishments always go noted by the scamming filmmaker. Preston is like Denham's conscience, forever close at hand and constantly reminding him to do the right thing. The best example of this connection is whenever a member of the film crew dies on Skull Island and Denham makes a wild, remorseful promise to finish the movie and "donate the proceeds to his wife and kids—because that man is a hero and he deserves nothing less!" These are palpable lies of self-justification on Denham's part, and Denham knows that Preston knows they are. When the kindly old cameraman Herb is devoured by Carnotaurs, Denham increases the magnitude of the lie, declaring to Preston:

> Herbert didn't die for nothing. He died for what he believed in, and I'm gonna honor that. He died believing there is still some mystery

left in this world—and we can all have a piece of it—for the price of an admission ticket!

Of course, Denham's statement is hegemonic nonsense, and the knowing and disappointed look on Preston's face signals as much.

Preston's reminding Denham of right and wrong comes to a head at the Broadway premier of "King Kong: Carl Denham's Giant Monster." Denham basks in his hard-won but ill-gotten Hollywood fame and fortune. The "crapper" now hobnobs with the "crappers"—Zelman and the two philistine movie investors—who are decked out in all the trappings of dominant masculinity: tuxedos and platinum blonde starlets clinging to their arms. In the midst of the media frenzy, Denham notices Preston watching him. Their eyes meet and, as Preston's knowing half-smile fades, Denham's glee disappears for a moment. Preston's silent presence reminds him of those cock-and-bull stories he told on Skull Island: We doubt that much, if any, of the profits being made from Kong's showing will be donated to the wife and kids of the dead film crew members. Preston's subordinate influence on Denham is not enough to make the filmmaker alter his behavior, but that is not the point. The point is that Denham knows he *should* alter his behavior. At some level, Denham realizes how his bravado and his recklessness—his acting out dominant masculinity—is a mask for self-interest and for greed. This mask also led to the deaths of 17 men on Skull Island. More to the point, Preston's principled challenge to patriarchy is intended ultimately for the edification of the predominantly bourgeois audience of *King Kong*. *We* know that Denham knows his conduct is reprehensible when he only watches out for number one—and that knowledge should give *us* pause.

A second non-hegemonic man influencing Denham is Jack Driscoll performing Connell's practice of complicity. As an intellectual and a playwright, Jack does not present the typical dominant masculinity. As white and bourgeois, however, Jack easily enjoys what Connell calls "the patriarchal dividend" (40). That is, he can pass for a dominant man, and thereby gain from the subordination of women and the disempowerment of the other categories of subordinated and marginalized men. Jack can imagine himself as not being the obvious manipulator and plunderer that Denham is, especially since he rubs elbows so well with the crew members of the *Venture*. However, ultimately, Jack is a mere tourist in the Spider Pit/Social Pit. Once Jack returns to Manhattan Island, he's right back to his literati pursuits, writing a stage comedy as a way to pine for Ann. His intensive experience of solidarity with Mr. Hayes and the boys has

had no lifestyle-changing impact on him. Is Jack now putting Jimmy through school? Is Jack helping to organize a tramp steamer sailors' union? Doubtful. It is precisely this obliviousness as a complicit man that constitutes Jack's effect on Denham, and by extension on viewers of *King Kong*. To mix gendered with economic identity positions, Jack's complicit masculinity marks the same behavior as Jack's being a liberal bourgeois. That is, a complicit male and a liberal bourgeois both will express sympathy for the oppressed while, simultaneously, either refusing to see or refusing to redress the fundamentals of the oppression. This willful ignorance or inaction stems, bluntly, from the fact that recognizing or, more to the point, doing something to correct the social injustice would negate the masculine-liberal patriarchal-economic dividend they enjoy. Jack's being an artist signals his position as the complicit man and liberal. Ann's original fear that Jack Driscoll the playwright will be "one of those self-obsessed literary types, you know, the tweedy twerp with his nose in a book and his head up his" ass will turn out, in the end, to be true. Ann emerges as the admirable character in Jackson's film precisely because she refuses to be complicit with bourgeois patriarchy. Meanwhile, Jack never quite shakes off his liberal egoism and Denham secretly aspires to be a tweedy twerp like Jack. That is, although enacting hegemonic masculinity, Denham keeps his *desired* masculine performance closeted.

Cooper's Denham is without a liberal bone in his body. As a hard-boiled capitalist and imperialist, he has no qualms about dominating anyone or anything. The world exists for his personal use. On the outside, this would seem to be the case for Jackson's Denham as well. He plays everyone for his own advantage, not caring who gets hurt along the way. In Denham's relationship with Jack, however, we glimpse a different side to this brigand. Not only does Denham want the star-power of Jack writing the script for his movie, he longs to be, as well, an artiste of Jack's renown. Denham makes that aspiration clear to the knuckle-dragging investors. He wants to be respected as a filmmaker in the way that Jack is celebrated as a playwright, namely, for being artsy. This fundamentally liberal urge makes Denham a closet complicit man—even, arguably, a closet subordinate man like Preston—and puts him in conflict with his own enactment of conservative, aggressive, and avaricious hegemonic masculinity. Thus, where Cooper's Denham is a pipe-chomping man's man who shoots a scene with all the passion of a plumber unclogging a drain, Jackson's Denham can betray signs of being an artistic dandy when it comes to matters of filmic zeal. For example, when filming Ann at sunset emoting on the aft of the *Venture*, Denham is practically in tears as

he coaxes along her performance. Jack's bringing him more pages of the script at that moment symbolizes their collaboration as aesthetes. Denham's sending Jack away because his presence is interfering with Ann's acting signals as well a director earnestly at work. The character of Denham is by no means wholly derided here. In many ways, this sensitive perfectionist seems to be the real Carl Denham. The crass, huckster, hegemonic side of him is an act, the necessary means by which Denham situates himself to make his art. However, if we stop our analysis at this point, we miss the real implications of Denham's secret complicit masculinity.

As Connell points out, one of the problems with normative definitions of masculinity is "that not many men actually meet the normative standards" (40). Likewise, one of the problems with living under capitalism is that not many people actually have enough capital to practice it. Just as Connell notes that the great majority of males within the patriarchy are "not rigorously practising the hegemonic pattern in its entirety" (40), so too do a great many bourgeois exist within capitalism as, in practice, glorified laborers. How many of the middle class purchase raw materials and human time in order to produce a product to sell? Instead, most sell their labor for wages within that exploitative formula. As a result of being, again to blend gender with economic terms, complicit capitalists, we live under a regime— bourgeois patriarchy—that benefits few and actively harms the rest, in particular whenever the Stock Market crashes. As a pair of complicit liberal men, Denham and Jack embody exactly this situation. They live within a capitalist, masculinist system that uses them but that they both gainsay and embrace. Calling our attention to this complex paradox is their friendship, which is rather odd and, in due course, produces the film's most enigmatic line.

Throughout the movie, Jack is extraordinarily tolerant to Denham's hustler shortcomings. He sees through them, and thereby seems not to be overly bothered by them. To Jack, Carl is ever the scamp, even when Jack himself is tricked by Carl into not disembarking the *Venture* in time and thus becoming committed to the long sea voyage. In return, Jack is the only person with whom Denham has authentic emotional engagement. We see how he admires Jack as a writer. Albeit in soliloquy, Denham pauses to say "I'm sorry" to his compeer after Jack disappears into the jungle to continue the desperate rescue attempt of Ann. At that moment after crawling out of the Spider Pit, Denham is split between what's been called Beauty and Beautiful, that is, between hegemonic and radical behavior. Capital must be served, however, so Denham shamelessly opts to profit off of Jack's

bravery by talking Captain Englehorn (Thomas Kretschmann) into the attempt to capture Kong alive. In effect, they'll use Jack and Ann as the bait. Denham indicates that he's aware his decision is shameful, however, by voicing that apology to Jack. Without blinking an eye, Cooper's Denham exploits far worse in the original *King Kong* and never apologizes to anyone for anything. Jackson's Denham, on the other hand, at least will wring his hands a little over his abuse of Jack. A way to read Jackson's Denham, then, is as the quintessence of a bourgeois masculine double consciousness. That is, as a practitioner of both complicit masculinity and of liberalism, Denham with a bad conscience will avail himself nonetheless of the hegemonic patriarchal–capitalistic dividend. At some level, he knows what he's doing is wrong, but he can rationalize following the dictum of profit simply as the way of the world over which he has no control. Denham easily could argue that he'd be a fool *not* to take advantage of his friend Jack in this way. Here we are led back to Jack's influence as a complicit man on Denham: their shared trait of obliviousness.

While the capture of Kong is underway, Ann tries to stop it and Preston takes an uncharacteristically bold action to undermine Denham's plan. Denham hopes to lure Kong through the giant gate by preventing Jack and Ann from crossing the drawbridge too soon. After listening for a moment to the terrified pleas of Jack and Ann trapped outside the wall, Preston tells his boss, "Drop the bridge! Do it now, for chrissakes!" When Denham refuses, Preston takes matters into his own hands, snatching up a machete to cut the rope and drop the bridge himself. For his trouble, Preston receives a gash on his cheek from the flying rope—a mark of defiance on this otherwise subordinated male. In contrast, Jack may not like what Denham is up to, shouting at him, "Are you out of your mind?" but he'll do nothing to stop it. Jack quickly resigns himself to the situation, pulling Ann away from the struggle and telling her, "There's nothing we can do! It's too late!" Because of Jack's complicit behavior, that is, his immediate and passive acceptance of this frenzy of destructive hegemonic masculinity, Ann rejects Jack. She orders him bitterly "Let go of me!" and breaks free from his protective grasp. At that moment, still in the jungle of Skull Island, Ann bravely separates herself from the patriarchy. This strange allegiance between Jack and Denham as liberal men, however, persists and culminates at the Broadway premier. Even while witnessing Denham spin outrageous lies about what transpired on Skull Island, Jack is still willing, if not to defend, at least to gloss over Denham's astonishing capacity for sleaze. With his badge of courage, his scar from Skull Island, featured prominently on his cheek,

Preston remarks with trenchant irony to Jack: "He was right…about there still being some mystery left in this world. And we can all have a piece of it…for the price of an admission ticket." Jack can offer only a wan smile and reply quietly, "That's the thing you come to learn about Carl…his unfailing ability to destroy the things he loves." Not only is this response surprisingly mild, given what happened on Skull Island compared to what's taking place before their eyes on stage, but Jack's philosophizing compels the filmgoer to puzzle over a couple of indistinct ideas as well. First, what are these "things," exactly, that Carl simultaneously loves and destroys? Second, what is this "unfailing ability" Carl possesses not only to carry out such a contradictory feat, but that we seem obliged to come to learn about him? In short, what the hell is Jack talking about? Possible answers to these questions emerge best when Denham, as the dominant man, is examined alongside the examples of marginalized masculinity seen in Jackson's *King Kong*.

As might be expected, Denham conflicts most with the marginalized men in the film. Their confrontation represents, in Connell's terms, the crisis of the currently accepted strategy for hegemonic masculinity undergoing the pressures of renegotiation. Not surprisingly, the primary point of their contention is exploitation. Denham is out to use these other men, often rashly, to achieve a handsome payoff on his investment project. Nothing else is of consequence to him, to include, as we've seen, the lives of those around him. Among the *Venture* crew, Denham butts heads most with Lumpy, Mr. Hayes, and especially Captain Englehorn. All of these men become well aware of the greed driving Denham, and they are understandably reluctant to be misused. Certainly, none of them are averse to hard work, making money, or manly behavior. Quite the opposite. Taken on outward appearance, they perform most of the traits of dominant masculinity far better than Denham. Where they differ crucially from Denham, however, is in their sense of solidarity.[18] As discussed earlier, Jackson imbues the crew members of the ship with the collective values of socialism as opposed to the selfish aims of capitalism. That clash of ideologies animates as well the crisis of masculinity depicted in Jackson's movie. One significant moment where this conflict is clearly in evidence is when Denham, after climbing out of the Spider Pit, convinces Englehorn that the potential profit in capturing Kong is worth the enormous risk. Despite the fact that Englehorn has just said of Denham, "That's the thing about cockroaches; no matter how many times you flush them down the toilet they always crawl back up the bowl," the canny director is able to win over the Captain through the allure of money mixed with a subtle challenge to his masculinity.

Denham: [quietly to Englehorn] We can still come out of this thing
okay—[pause]—more than okay. Think about it. You've got a boat
full of chloroform we can put to good use.
Englehorn: [laughs] You want to trap the Ape? I don't think so.
Denham: Isn't that what you do? Live animal capture? I heard you
were the best.

At this turning point in the film, the dominant paradigm of bour-
geois patriarchy prevails, with Denham clearly at its helm. The violent
capture and transport of Kong, as opposed to just the filming of the
giant gorilla, leads to the ultimate collision of hegemonic versus mar-
ginalized males in the film, namely, the struggle between Denham
and Kong. Connell points out that, "Violence is part of a system of
domination, but is at the same time a measure of its imperfection. A
thoroughly legitimate hierarchy would have less need to intimidate.
The scale of contemporary violence points to crisis tendencies...in
the modern gender order" (44). The showdown of Beauty versus
Beautiful in Jackson's *King Kong*, then, is perhaps exemplified most
instructively by this clash between the white bourgeois patriarch
against his thoroughgoing Other. At stake in our witnessing of this
battle is nothing less than determining exactly who is the monster
being depicted in this movie.

As we've seen, Jackson meticulously constructs two conflicting
worlds in *King Kong*. The hegemonic one is located on Manhattan
Island, where the culture is avaricious, exploitative, technological,
militaristic, Euro-American, and patriarchal. Denham epitomizes
this aggressive "civilized" world and acts as its agent of conquest,
extending modern might overseas. Opposing this dominant world is
the subaltern one on Skull Island. That locality is collectivist, nonin-
dustrialized, organic, Asiatic, and matriarchal. Not only does a raw
and brutal Mother Nature govern this environment, but the islanders
are ruled by a shamanistic hag and her creepy, little girl apprentice.
Even Kong, who epitomizes this so-called primitive world, displays
nurturing traits often taken to be feminine. His protection of Ann
against the T-Rexes, for example, could be likened to a mother watch-
ing over her young. More overt, after their Beautiful moment in his
lair, Kong is shown cradling and caring for the sleeping Ann, exactly
like a baby safe in a mother's loving arms. Compare this visual to the
scene eventually edited out of the 1933 original movie where Kong,
figuring the big black rapist, peels off and sniffs bits of Ann's clothing.
The point here is that a common mindset for colonization is to femi-
nize the besieged culture as a strategy for naturalizing and justifying

the invasion. Within Western patriarchal ideology, such thinking links the resource-rich land to be possessed with its dark and alluring females to be possessed, the result being rape masked as economic and cultural "development" and "protection." In effect, this colonial mindset feminizes the indigenous males as well, portraying them as weak, indolent, and ultimately (because they lack the firepower to match the invaders) nonthreatening.[19] Arguably, this trope of feminization within Orientalism is visible in both Cooper's and Jackson's *King Kong*. However, it's important to note that the dramatic conflict of each film arises from the colonized male, represented by Kong, fighting back not as a feminized male but, instead, as a marginalized male. Particularly in Jackson's film, Kong may show a nurturing and "soft" side, but equally he displays conventional "manly" behavior far exceeding anything enacted by Denham. After all, Kong kills three T-Rexes where Denham only bamboozles three movie investors.[20]

That the bone of contention between Denham and Kong becomes Ann, the white woman, signals the audacious extent of Kong's resistance. The colonizing men have come to take the dark women, *not* the reverse. What makes the struggle between Denham and Kong so different in Jackson's film as compared to Cooper's film is Ann's response to Kong as a resister to colonization. In Cooper's movie, Ann remains steadfastly in the world created by the hegemonic male. Her adherence to patriarchy is signaled most by her persistent performance of traditionally weak and helpless femininity. In Jackson's movie, Ann breaks free from the modern patriarchy, crosses over to the subaltern realm, and allies with the marginalized male. Her rebellion is most visible in her appropriation of behavior traditionally viewed as masculine-heroic. Clearly in each film, as Ann goes so goes the sympathies of the audience. We read against the grain of Cooper's *King Kong* to feel compassion for that Beast. Making that counterreading easier is Willis O'Brien's humanizing animation of Kong and the fact that, subsequent to the original release of the film, most viewers see the censored version of *King Kong*, that is, the one where Kong is not peeling off Ann's clothes, squishing Skull Islanders into the mud, biting off heads, and dropping women to their death. Even so, Cooper's Denham remains that film's entrepreneurial hero and Driscoll its romantic hero rescuing the ever-screaming Ann from the clutches of the monster. In the case of Jackson's *King Kong*, we would have to read strenuously against the grain *not* to pity Kong; obviously, viewers are meant to share Ann's ideological journey. To ensure audience empathy and insight are channeled in that direction, Jackson constructs his Driscoll as a second-option romantic hero and

Denham as a kind of dominant-male clown, both roles cast perfectly with Brody and Black.

Like Cooper's pair of hegemonic males, Jackson's duo of complicit males contends with Kong for possession of Ann. Their head-to-head duel is signaled by moments of stare-down between them. When Kong first gets hold of Ann outside the great wall, Denham, peering through the gates, is the first of the *Venture* party to see the giant ape. Before disappearing into the jungle, Kong turns to lock eyes with Denham defiantly, as though issuing a warning to a rival dominant male to stay away. The two lock eyes again during the capture of Kong. As Kong watches Jack forcibly pulling Ann away from the scene, the ape's line of sight is cut short by Denham's grim and determined stare. The presence of this adversary sends Kong into a frenzy that will only be subdued by Denham with a well-aimed bottle of chloroform. Jack, too, experiences such moments of ocular enmity with Kong. When creeping to Ann's rescue in Kong's lair, Jack suddenly finds himself frozen by the angry gaze of his rival. Similarly, in the Broadway theater after Kong has broken free of his chains, the great ape senses Jack's presence and turns to deliver a killing stare before commencing his attempt actually to kill Jack. In both the original movie and the remake, Kong and Jack contend over Ann for love while Denham wants Ann, like everything else, for profit. Likewise, in both movies, the white men win out in the end. Kong is killed and Ann is restored to the patriarchy. What feels like a wondrous victory for modernity in Cooper's film, however, feels like a distressing setback for humanity in Jackson's. Punctuating how we might feel about Kong's downfall at the end of each of these movies is Denham's final line about Beauty killing the Beast.

Jackson's interpretation of the Arabian proverb could not be more different from Cooper's use of that old saying. Cooper starts his movie with it as an onscreen epigraph.

And the prophet said:
And lo, the beast looked upon the face of beauty. And it stayed its hand from killing. And from that day, it was as one dead. (Old Arabian Proverb)

The idea of a pretty female face disempowering an otherwise fearsome and robust male runs as a sexist axiom throughout Cooper's *King Kong.* Denham is particularly fond of its wisdom. During the outbound voyage, he makes several unprompted remarks to or about Ann linking her with "Beauty and the Beast." When he warns Jack

not to fall for Ann, Denham makes the proverb his advice: "Better cut it out, Jack…I never knew it to fail. Some big, hard-boiled egg gets a look at a pretty face and bang, he cracks up and goes sappy." Finally, Denham reveals to Jack that the saying is at the heart of his film project.

> It's the idea of my picture. A beast was a tough guy, too. He could lick the world. But when he saw beauty, she got him. He went soft. He forgot his wisdom and the little fellas licked him. Think it over, Jack.

Cooper's Denham uses the proverb as a pitch to his Broadway audience, mixing that angle with the titillation of a romantic triangle. After introducing Ann and bringing her out on stage to stand at the feet of the chained Kong, Denham declares to the audience:

> There the beast and here the beauty! She has lived through an experience no other woman ever dreamed of! And she was saved from the very grasp of Kong by her future husband!

Jackson's Denham uses sex and sexism as a marketing strategy, too. After describing Kong to the Broadway spectators as "a savage Beast, a monstrous aberration," he adds with a twinkle in his eye:

> But even the meanest brute can be tamed. Yes, Ladies and Gentlemen, as you will see, the Beast was no match for the charms of a girl—a girl from New York—who melted his heart. Bringing to mind that old Arabian proverb: "And lo the Beast looked upon the face of Beauty and Beauty stayed his hand. And from that day forward he was as one dead."

However, unlike Cooper's film, in Jackson's film, this moment late in the story is the first time the analogy of Beauty and the Beast is applied to Ann and Kong. Moreover, its use is the invention of the character of Denham, not an idea put forward seriously by Jackson as the theme of his movie. Jackson does not support the sexist gist of the proverb, nor does it serve as a motto for his *King Kong*. Thus, where little to no ideological distance lies between Cooper the actual filmmaker and Denham the fictitious filmmaker, Jackson significantly distances himself from his Denham. We see small indications of that political distancing throughout the film in Denham's being at odds with men of different masculinities. In Denham's war to dominate Kong, Jackson makes it plain that he does not share the hegemonic worldview of his filmic surrogate.

Cooper's Denham experiences no comeuppance and no compunction for causing Kong's rampage in New York City. When Kong breaks free of his chains, Denham and Jack revert instantly to (concrete) jungle-adventure mode. They chase Kong on rooftops, come up with the idea to send planes after the Beast, and finally retrieve Ann atop the Empire State Building. Even though Jack is more assertive than Denham during this final flurry of action, the pair remains our dominant male heroes to the end. They succeed in wresting the helpless blonde from the monstrous big black paw. In sharp contrast, all heroism in New York City belongs to Ann in Jackson's film. Jack puts in a worthy initial effort when he focuses Kong's destructive attention onto himself, but after that Jack is inconsequential. Jackson's Denham, however, is rendered a complete bystander to the debacle he's created. All he can do when Kong breaks loose from those chrome-steel chains is watch in guilty horror and come to the inescapable conclusion that this mayhem is *his* fault—the direct result of his greed, ambition, and lack of concern for others. This awful truth hits Denham the moment the first blonde goes sailing by. Rather than giving us one climactic, defiant stare-down between Denham and Kong, Jackson makes the filmmaker a pathetic onlooker. Denham stands transfixed onstage watching Kong kill audience members, obliterate the ornate auditorium, and finally scramble into the mezzanine after Jack. The last time we see Denham—that is, before he shows up at Kong's corpseside to deliver the eulogy—this erstwhile charming rascal wears an expression of pained epiphany on his face, as though he's thinking: "Oh, shit! What have I done?" Of course, that question *always* comes too late.

The manner in which Cooper's Denham and Jackson's Denham deliver the last lines of the movie is instructive as well. The original Denham pushes his way through the throng of rubberneckers to name-drop his own name to get by the police. When the lieutenant in charge of the scene repeats loudly, "Carl Denham?" a woman in the crowd chirps with exhilaration and approval, "Denham? Oh, that's the man that captured the monster!" The crowd then buzzes with the thrill of being in proximity to a celebrity. After being allowed to pass, Denham swaggers up to the dead Kong where the lieutenant remarks that the airplanes got him. "Oh, no," Denham corrects him loudly. "It wasn't the airplanes. It was beauty killed the beast." Overhearing this extraordinary comment, the spectators nod excitedly and hum once more. We catch snippets of their astonishment: "Beauty? Oh my, yes!" Denham is the absolute star of his own incredible show—a spectacle that has been staged, now, across midtown Manhattan. At the very

end, the filmmaker–adventurer–entrepreneur slips his hands casually into his pockets and shakes his head over the massive carcass, as if to say, "Golly, what a waste of an amazing money-maker!" In other words, not one hint of anger or culpability directed at Denham seems to cross anyone's mind, least of all Cooper's.

Jackson reverses the circumstances under which Denham brings the tale to a close. Where Cooper's Denham basks in the glow of clever public declaration, Jackson's Denham shrinks in the gloom of shamefaced private realization. Hat pulled low over his eyes, he jostles his way anonymously through the unruly crowd. No one recognizes him. No one speaks to him, nor does he try to make contact with anyone else. Denham overhears the end of the conversation between the two newspaper photographers debating why Kong climbed up the Empire State Building in the first place. The thickheaded one concludes, "What does it matter? Airplanes got him." That photographer turns, then leaves. Denham delivers the famous lines to himself, with only us listening in. "It wasn't the airplanes," he mutters to correct his missing interlocutor. There's a long pause before we're given the final word. During that interval, we see on Denham's face his piecing together the idea he's about to articulate. He's adding everything up and arriving at an appalling summation. He states quietly, "It was Beauty killed the Beast." He says these words as though grasping the big picture for the first time. Abstracted and ashamed, Denham then disappears into the mob as we pan back, upward, and away. Tragic music builds. Credits roll.

What is it that Denham has just come to understand? That exploiting Kong was wrong. That "Beauty" cannot kill a Beast; only a bigger Beast can kill a Beast. That the real Beast is Denham himself: his capitalism, his imperialism, his hegemonic masculinity—in short, the entire bourgeois circus he personifies and for which, throughout the movie, he has performed as a ringmaster. Denham knows that it was not small, blonde Ann emasculating big, strong Kong that led to the poor ape's demise. That's showbiz baloney. Instead, what killed this innocent Beast was Beauty in the sense of Hollywood's profit-making fantasy factory—an ideological apparatus accompanied by superior funding and firepower. What should we, the audience, come to understand, then, by watching Carl Denham's crisis of masculinity come to a head? Here we return to Jack's enigmatic characterization of the filmmaker to Preston: "That's the thing you come to learn about Carl...his unfailing ability to destroy the things he loves."

As noted before, two questions are embedded in Jack's remark. First, what are the things that Denham both loves and destroys? It

seems reasonable that the general answer to this question is people and the natural world, that is to say, life itself. Kong represents stirring mystery to Denham, but in capturing that mystery to put on show, Denham extinguishes it. The very thing he claims he wants to commit artfully to film, Denham annihilates in the process. Isn't this a metaphor for how the modern world seems to be going? The more we organize people and things to yield profit, the fewer people thrive under this organization and the less things survive to be organized in this way. The second and slightly more confounding question implied in Jack's statement is what "unfailing ability" does Denham possess, and that we should learn about him, that brings about such a disastrous cross purpose? At this point, one answer should be plain. Denham's destructive capacity is his outlook and behavior as a complicit male and as a complicit capitalist, otherwise known as a liberal bourgeois. This pattern of masculinity and this ideological subject position combine to fuel and enable Denham's ruinous, oppressive ways. In Jackson's film, we witness not just a crisis of masculinity undergone by Denham, but a crisis of his very social being. Up until his moment of final terrible recognition, Denham feels entitled to misuse Kong. Symbolically, then, when watching Denham, we watch the liberal hegemonically masculine male dominating, in Kong, a range of subordinate identities: the marginalized male, the exotic Other, the worker-slave. Kong easily figures the natural world being plundered as well. In Cooper's *King Kong*, Denham and Driscoll are celebrated as hegemonic modern men for their rightful domination of all these things, plus for their control over Ann. In Jackson's remake, Carl and (perhaps to a lesser degree) Jack are the monsters of the film because they collude with modern power, that is, with bourgeois patriarchy. As complicit males and as liberals, they avail themselves of the patriarchal–capitalistic dividend whether they benefit ignorantly, reluctantly, or guiltily.

More distressing than Jackson's turning heroes into monsters is the possibility that we, as viewers of his film, are implicated in this same brand of monstrosity. Chances are good, in fact, that if we're sitting in a comfortable Cineplex watching Jackson's *King Kong*, we're indulging, regardless of our sex, in what's been termed above as a bourgeois masculine double consciousness. That is, we're similarly complicit with modern power. The idea should come as no surprise. As Americans, we've been disciplined to see our social-economic structure as natural and productive. However, Denham's "unfailing ability to destroy the things he loves" could describe us as well if we continue to allow go-go capitalism to dispossess people and destroy

the environment. If you're thinking that such an assertion is merely the bleeding-heart, tree-hugging, "politically correct" claptrap typical of college professors, consider that Americans comprise roughly 4 percent of the world's population, but we consume 40 percent of the world's resources. Consider that at the turn of the twenty-first century, we spend at a ratio of 16:1 preparing for war as opposed to trying to prevent war, and that this militarism—meaning the phenomenon where a nation's armed services put their institutional preservation ahead of actual national security or the integrity of the governmental structure of which they are a part—has produced an overwhelming American military presence around the globe. Consider as well that the American-inspired process of "globalization," much of it carried out by secretive organizations such as the World Bank, the International Monetary Fund, and the World Trade Organization (which are dominated by the US government but *beyond* Congressional oversight), works inexorably to widen the gap between global rich and poor (i.e., wealth for the West, misery for the rest). Finally, consider that by the late 1990s, the US Department of Defense named, as one of the primary reasons for our striving to dominate the militarization of outer space, the need to protect US interests and investments around the world in light of this widening global divide between "haves" and "have-nots."[21] In other words, there are those at the top of modern power who are well aware of the human and ecological ruination they are overseeing—and they are indifferent, incapable, or uninterested in altering their behavior. The great majority of reliable information about wealth distribution (both nationally and globally) and environmental degradation these days paints an unhappy picture of future prospects. Frankly, many Americans, like Carl Denham, are at risk of understanding the looming disaster in a naive and an untimely fashion.

Is this *way* too much to read into a simple, big-ape adventure movie? Maybe. If nothing else, it's certainly fair to say that Jackson's *King Kong* recommends Beautiful over Beauty. But Jackson seems determined to deal with issues and to issue challenges more meaningful than simply appreciating someone's (or something's) inner beauty. With his update of an iconic Hollywood monster movie, Jackson asks us to contemplate why Kong would toss aside blonde after perfectly good platinum blonde in search of the one-and-only Ann. Jackson moves us to feel pity and indignation over the capture, exhibition, and slaughter of an unruly and terrifying creature. He makes us recognize that glitzy opulence is by no means the work of Providence, but rather founded on mendacity and the exploitation of those who

do the actual hard work. Jackson makes us squirm, uncomfortably, at Denham's all-too-recognizable obtuseness. Jackson even might push us to cringe a little bit when Ann walks into Jack's embrace at the end—just when she's managed, through her grit and amazing compassion, to stand powerfully and on her own atop, then, the world's largest phallic symbol. If she taught Kong language, Kong encouraged in Ann this bold gesture of defiance and self-determination. Even if such social, economic, and environmental messages come our way, strangely, as allegories wrapped inside a holiday blockbuster, the ideas in Jackson's film nonetheless are urgent ones—and ones, unlike Carl Denham, we need to grasp before it's too late.

Hooah! We...Are...Sparta!

The movie *300*, directed by Zack Snyder and based on the 1998 graphic novel of the same title by Frank Miller and Lynn Varley, opened in the United States in March 2007 to great fanfare. In the first weekend, it set a March record for number of tickets sold (Reuters), outsold previous ancient battle films like *Troy* (2004) and *Gladiator* (2000), became the third-highest grossing R-rated film after *The Matrix Reloaded* (2003) and *The Passion of Christ* (2004), and was the "biggest IMAX debut ever" (Gray 2010). In the ensuing months, the US$65 million film continued to draw audiences, accruing by July nearly US$211 million domestically and US$246 million in theaters abroad (*Box Office Mojo*), especially in Greece (Bresnan). That this film has been resoundingly successful across the world but especially with American audiences reveals American attitudes to the ancient world, to warfare, to masculinity, and how those attitudes impact conceptions of monstrosity.

Miller's graphic novel and Snyder's film tell the story, based primarily on Herodotus's late-fifth-century BCE *The Histories*, of the 480 BCE stand taken at Thermopylae by several thousand Greeks to stall hundreds of thousands of invading Persians. The contingent of 300 Spartans is featured in both graphic novel and film, as the Spartans of history had assumed leadership of this Greek action and the Spartan king, Leonidas, was their leader. The film more than the graphic novel focuses on Leonidas (Gerard Butler) before the Spartans leave for Thermopylae and then while there. These are the broad strokes of the story told in both texts, and accord with the few historical records available: Persians are invading and Greeks meet them at "The Hot Gates," Thermopylae.

Aside from their depictions of violence, what problematizes both texts is their simultaneous reliance on and infidelity to the historical record. This issue of historical adaptation is debatable not because

these texts don't follow precisely Herodotus's record—itself already a representation—but because through the point of view of the narrator, anachronistic use of quotations, and omission of details about the battle and Spartan culture, the texts manipulate the ostensible unassailability of history as "fact" to tell a story very different from and perhaps antithetical to that of the historical record. Belief in American exceptionalism can lead Americans to a diffident relationship with history, especially as it is complicated by nuance and interpretation. Such exceptionalism maintains that the United States is exempt from and also the pinnacle of history; all histories revolve around and culminate in the American story (Loewen). Both the novel and the film exploit this exceptionalist belief as they draw, however figuratively, a straight line from events at Thermopylae to the turn-of-the-twenty-first-century United States. A battle that occurred 2,500 years ago, the two texts contend, has a discernible connection to the United States of America now. Although through domestic popular culture Americans at the turn of the twenty-first century are primed to understand history as interpretation, simultaneously, Americans can believe "there is no point to comprehending the overwhelming complexity of motives and acts and material causes that make up history since, in the long run, history will comprehend and confer meaning on even the most simple-minded of us" (Sobchack 2). Thus, when an event recorded by history becomes the subject of representation, especially one as foreign to Americans as the battle at Thermopylae, American viewers are prone to suspending disbelief. If the film alludes to a historical event American audiences may be at most only dimly aware of, even though the audience members cynically accept history as interpretation, they also want to believe that the camera never lies, that what is being shown on the screen is faithful to the historical record, not an inaccurate, unrealistic, or even prevaricating representation or interpretation of the event. Ironically, then, for their historical impact on the here and now, the two *300*s rely on their readers' willing ignorance of or amnesia about what is understood of the ancient past.

In a book about monstrosity and masculinity, taking on the representations of the Persians in a chapter discussing the *300*s could be expected (Figure 2.1). Those would be easy pickings, as the Persian bodies signify their absolute and total horrendousness. In the novel, Miller casts the Persian emperor, Xerxes, as a decadent, petulant, self-absorbed giant of illegible gender and sexuality with a harem of freakishly formed females; the Immortals as identically faceless automatons unquestioningly doing Xerxes's bidding; the multitudes of Persian

Figure 2.1 Monstrous and masculine.

forces as a pan-Asian, verminous infestation; and the Persians' elephants as immensely evil as the ollyphants in Peter Jackson's *Lord of the Rings* trilogy. In his desire to replicate and magnify Miller's monstrosities, to create spectacular scenes of "hysterical weirdness" (qtd. in Nisbet 140), Snyder reproduces and digitally multiplies Miller's monsters, adding to the Persian forces: a humanoid, male-looking creature with ax-like arms who chops off the heads of Xerxes's generals when they displease him; a giant with sharpened teeth so indiscriminately ready to kill that he is delivered in chains to the battle; oversized rhinoceroses that charge the Greeks; and Persian forces so frenzied by mayhem that they incinerate an entire village and impale its inhabitants on a tree. This is not to mention the monstrous colluders, hideously deformed Ephialtes and the lecherously leprous Ephors of both texts. In fact, the collisions of gender with monstrosities pervading the Persian forces—and those who collude with the Persians—are so patent as to be farcical.

Which is why they operate as a feint, a distraction to the audience from what is happening in the two texts. Yes, the monsters legibly function in this representation of war as the Enemy to the Friendly, the Bad to the Good, the Barbaric to the Civilized, the Them to the Us. The monsters (Enemy, Bad, Barbaric, Them) persuade the audience (Friendly, Good, Civilized, Us) that we/the Spartans are the normal, the unmarked, the original basis for comparison, and the monsters are the necessary deviation. Without monsters, after all, there would be no heroes. And here is the feint, like the historical

Spartan phalanx tactic of pretending to retreat and then, having lured in a pursuing enemy, reversing instantaneously (Herodotus 5.212; Matthews 79–81). The spectacle of the monsters so entirely absorbs audience attention that members are diverted from thinking about or looking at Us, the Spartans. What, after all, in the novel and the film is there to inspect among the unremarkable when their perfect bodies obviously reveal perfect minds and hearts?

A lot if not most of what is known of the historical Spartans is concealed by the monster spectacle of the *300*s, attitudes and practices that would be considered by a modern audience immoral if not barbarous. Deliberate suppression of these unseemly Spartan elements, first by Miller, imitated by Snyder, and buoyed by classical historians such as Victor Davis Hanson, amplifies the monstrosities of the Persian hordes, leading less to concluding that the *300*s are degrading Middle Easterners of today and more to thinking that militarism, the Spartan raison d'etre in these two texts, is the only viable response of right-thinking humans to any enemy, enemies always being monstrous. What is censored of ancient Spartan history and culture in the *300*s in order to normalize militarism is the subject of this chapter.

Critics from various professional affiliations have remarked on the film's historical anomalies. While most film critics observe that Zack Snyder's rendition is faithful to Frank Miller's graphic novel (whose story already includes historical refractions), few of the negative reviewers forgive the film's historical sins just because it is an adaptation. Scott Holleran comments that the film "drops the pretense of history," "hijacking" history into a horror movie. Dana Stevens disbelieves Frank Miller and Zack Snyder's claims that their graphic novel and film are unrelated to the current war with "actual Persians," citing the film as "a mythic ode to righteous bellicosity." Mitchell Atkinson notes that the film's refusal of historical accuracy extends not only to the Greeks' body armor but also to their hairlessness, a physical quality A. O. Scott sarcastically attributes to electrolyis. Although Scott acknowledges the story's basis in ancient history, his beef with *300* has less to do with its anachronisms than with its "bombastic spectacle of honor and betrayal," the subsequent depiction of "300 prime Spartan porterhouses," and "the videogame that '300' aspires to be."

Classicists and historians, many of whose professional lives are dedicated to detecting, investigating, and interpreting the historical records and archaeological remains of the ancient world, also object to the film's incomplete and erroneous depiction of fifth-century BCE Greece. Paul Cartledge points out that not only are films like

300 "entertaining and provocative," they also can "pander to, even inflame, the worst kind of cultural contempt, and indeed hatreds" ("Forever Young" 12). Stuart Price asserts that the film succumbs to "attribution," the pattern of retrospectively assigning "particular sensibilities and beliefs to ancient cultures," concluding that such assignation leads to many cultural practices remaining unexamined on the universalist assumption that "certain outstanding deeds speak for themselves" (118). These assumptions prevail in *300*, Price claims, resulting in the oversimplification of a variety of Spartan practices and events at the battle at Thermopylae. Gideon Nisbet chides the film's costuming faux pas, citing its unwitting use of the lambda, the icon now used by gay rights groups, as the "L" on the shields of the Spartan Lacedaemonians, and its long red Roman capes instead of the short ones appropriate to the Spartans (72–78; Pomeroy 87).

Other academics challenge the classicists' objections to the film. For instance, in "300 Lies? Give Poetics a Chance," David C. Ryan chides classicists for their willful misunderstanding of the literariness of the film, of the context in which narrator Dilios is making his case, and the inherent fictionality of all stories, whether labeled history or fable (Note 2). Ryan objects to the narrow approaches of the classicists as he argues for a rhetorical understanding of *300*, asserting that the film uses traditional genres of allegory and heroic epic to champion the Spartan way of life. Like Ryan, other academic critics see a silver lining in this dark cloud of fantastic Spartan violence. Writing in *The Journal of Military History*, Frank J. Wetta contends that though there is no denying the film's basis in "academic history," it is also "history informed by popular culture" (632), offering thereby a gateway to teaching students about the uses of history. In the *European Journal of Archaeology*, Jenny Wallensten makes a similar case, suggesting that the film's allusions to historical events are calibrated not to invoke those events, manifesting themselves as fantasy more than history. Like Wetta, she is hopeful that this interest in "fantastic things *that really happened*" will draw more students into the study of classics (80; emphasis in original). In comparing the graphic novel and the film, G. N. Murray claims that, though both texts are based on historical events, they also are stories narrated solely from Dilios's point of view, and subsequently their story is "a Spartan story, told by a Spartan, for Spartans" (25).

Other reviewers are more enthusiastic about the film. Reuters, for instance, emphasizes the film's "female appeal" with the depiction of Leonidas's wife as a "true partner" to Leonidas, while the Associated Press quotes one of the film's producers calling the film

"old-fashioned storytelling with all the brilliant use of the technology available." In the *National Review*, David Kahane—pseudonym for a Hollywood writer—applauds the film's violation of a post-9/11 taboo against depicting enemies as culturally offensive, comparing *300* to Gary Cooper and John Wayne films of yore, which was "real all-American stuff, in which our heroes stood up for God and country and defending Princess Leia and getting back home to see their wives and children, with their shields or on them." Although immediately following the film's 2007 release, Peter Travers of *Rolling Stone* ridicules the "turbocharged visuals," "roaring" action, and "artful excess," his final, sarcastic assessment is that the film will be irresistible to males "of all ages and sexes."

Travers posted his review on March 7, 2007; two years later, in an online forum fans still were discussing the film in response to his review. While it is difficult to discern how many of these 2009 posters are the males Travers describes above, exit polls at the release suggest that the majority of spectators are male and under the age of 25 (Gray).[1] These forum postings support Travers's supposition that what he ridicules will be the very thing attracting fans, and supports other critics in their caution about the ahistoricity of the film: few of the forum posters demonstrate any understanding of the historical event beyond what they learn from the film (or the graphic novel). Comments include characterizing the film as "Aryan Superiority Porn" (merc100), as "war propaganda" (saaaadddy), and as sexually titillating (for people of various sexualities). Although articulateness and erudition in the 29 responses are rare, they tend to focus on several stances: The film's source material is the graphic novel, so historical accuracy is not required nor should be expected; a clear distinction is made between feature and documentary films, so that features are unmediated genres made to entertain, not edify or ideologize; any racism detected by the viewer is in the eye of the viewer, not in the film; and the aesthetic appeal is not only the computer-generated imagery effect and color palette, but also the "boobs, blood and battles" of action films (megaton76).

What is bewildering about these responders is not their ignorance about ancient history but their refusal of the potential historical and ideological forces at work in both texts, especially in the source material, the graphic novel. To them, "entertainment" precludes such a possibility as it trumps historicism. While Frank Miller claims that his impetus for writing the novel was having seen as a child the tragic conclusion to good-guy Leonidas's efforts against bad-guy Xerxes in the equally historically inaccurate film, *The 300 Spartans* (1962), this

innocent motivation does not explain his listing historical sources as "Recommended Reading" at the conclusion of the novel (*300* 83).[2] Those include: "The Hot Gates," an essay by William Golding about his return to Thermopylae after having fought in World War II (1966); Herodotus's *The Histories*; Ernle Bradford's *Thermopylae: The Battle for the West* (1980); and Victor Davis Hanson's history of ancient Greek hoplite battle, *The Western Way of War: Infantry Battle in Classical Greece* (1989). Including these nonfiction sources—instead of *The 300 Spartans* or Steven Pressfield's 1998 novel, *Gates of Fire*—at the novel's conclusion has them working as a conventional bibliography, implying that the story is based on historical verifiability or at least has some unambiguous connection to the historical record.

Moreover, in an interview with *The Comics Journal* in 1998, Miller discusses his historical preparation for writing the novel, a story he had thought about since very young but knew "it was the project that I was going to tackle when I thought it [sic] was ready for it," something he could not face until after visiting the battlefield in Greece and conducting "an intense period of research."

> I've never attempted anything like this before. It was very difficult. At first I felt very trapped by the truth of the historical material, then very frustrated as I spent years hunting things out about this little-known battle. But ultimately, all the research turned into a treasure-trove. The best moments in the story—and the best lines of dialogue—are the ones that are really drawn from the old texts. (Brayshaw 65)

Here Miller reveals his dependence on historical records to tell his story of Thermopylae, a reliance he had not had in telling any other of his stories; those originated in his imagination and his cultural context while this one came from the historical record. "It was liberating," he claims, "to be dealing with material that was so simple, so pure. Reality is so often much more strong than anything you can imagine" (65). Simultaneous to Miller's relishing the purity of the battle story, however, he also acknowledges that there were elements of Spartan life, like slavery and brutality toward children, which must not be included in the novel because "a modern audience would simply turn off." Miller's appeals to a traditional comic-book audience, one expecting the fantastic (of righteous superheroes) and not the actual (of physical abusers), had to be considered:

> [S]elling historical material to a market dominated by superheroes is, on the face of it, rather difficult. In no other medium would a war

story about ancient Greece being [sic] considered off the mainstream, but these days if the guys don't wear tights, you're obviously going against the flow of things... It would have been very easy for our field to ignore a historical piece. (68)

Miller's omission of elements of Spartan culture to appeal to his "modern audience" contradicts the battle Miller notoriously fought against censorship in the comic-book industry.[3] Clearly, the story Miller wanted to tell, the one born in the mind of a little boy wounded by a story of injustice, could tolerate only so much of what the adult Miller learned about the Spartans.

Like the novel's "Recommended Reading" list, desire for historical authority extends to the film as well. For instance, though in *300: The Art of the Film*, director Zack Snyder claims that the film is "more fantasy than fact" (39), still, classical military historian Victor Davis Hanson is called upon to write the Foreword, lending credibility to the film by referring to the historical record:

If critics think that *300* reduces and simplifies the meaning of Thermopylae into freedom versus tyranny, they should carefully reread ancient accounts and then blame Herodotus, Plutarch, and Diodorus—who long ago boasted that Greek freedom was on trial against Persian autocracy; free men in superior fashion dying for their liberty, their enslaved enemies being whipped to enslave others. (6)

Furthermore, British classical historian Bettany Hughes is called upon in the DVD version of the film's special features to lend historical authenticity to the film's rendition. Apparently, Miller's qualms about the story's grounding in history were transferred to the filmmaker's anxieties about the same issue.[4] Well before the film's release, classical historian Hanson—not a film or graphic novel specialist—was called upon to vindicate the film script's adaptation of the graphic novel, emphasizing the novel's use of history to accord with popular taste. "The script is not an attempt in typical Hollywood fashion to recreate the past as a costume drama," claims Hanson. "Instead it is based on Frank Miller's... comic book graphics and captions. Miller's illustrated novelette of the battle adapts themes loosely from the well-known story of the Greek defense, but with deference made to the tastes of contemporary popular culture." Hanson concludes that while "artistic license is made with the original story" by both Miller and Snyder, still the movie "*300* preserves the spirit of the Thermopylae story" ("History and the Movie '300' ").

That the graphic novelist, filmmakers, and the film's supporters like Hanson and Hughes admit freely that it is fair to omit elements of Spartan culture objectionable to modern audiences as long as the "spirit" of an event in history is captured furthers the confusion Americans, already diffident about their relationship to and place in history, might have in regard to *300*. Consider, then, the small sampling of the "modern audience" to whom the texts appeal, the 2009 respondents to Peter Travers's 2007 *Rolling Stone* review referred to above. It is likely that most of these posters have been educated in the United States, and it is equally likely that their education has not included ancient history. In "Teaching Classical Myth and Confronting Contemporary Myths," college teacher Peter W. Rose comments that for the majority of his students at a selective, midwestern American university, the only exposure to ancient Greece is through Greek mythology (294). Another college teacher, Paul D. Streufurt, echoes the comments of Wetta and Wallensten earlier, emphasizing in "Visualizing the Classics: Frank Miller's *300* in a World Literature Class" that students resist reading the classics, finding them "boring, irrelevant, and elitist" (214). However, Streufurt adds, because it is a nontraditional genre, Miller's graphic novel "helps negotiate the temporal and cultural differences between ancient literature and these particular modern readers" (210). If college teachers find that students have little to no exposure of reading historical sources about the ancient world and actively resist that exposure once in college because it reflects a world foreign to their own, it is unlikely that most of these forum posters have had any education in ancient history. To them, it might as well be fantasy. Moreover, exposure to Sparta or Spartans probably has been in any of three ways: the many towns named Sparta in the United States; the ubiquitous Spartan mascot of American high schools, colleges, and universities; and perhaps most influential for the fans of Snyder's *300*, the cyborg Spartan Master Chief of the best-selling videogame, *Halo*.

It's likely that this latter rendition of "Spartan," the messianic avatar players typically embody when they play this first-person shooter game, is what informs many young Americans' eager response to the film and their attribution of its historical infidelities to Miller's graphic novel. "First-person shooter" means each player plays and fires a wide variety of weapons almost always from the first-person point of view. *Halo*'s plot is futuristic: An alien race, the Covenant, is trying to eradicate the humans, who have colonized other planets. SPARTAN-II cyborg soldiers are designed to protect the humans and attack the Covenant on a planet/spaceship named Halo. Players

may elect to embody a bad-guy Covenanter, though unsurprisingly they almost always choose to play the good-guy role of Master Chief, the SPARTAN cyborg protector of humans. *Halo*, then, does not offer the range of assumable identities or activities available in many other videogames. Although weapons may change and the player will have to make choices about the course of the journey through the Halo landscape, the objective remains pretty much the same for the good-guy first-person shooter: Kill the Other, usually a Covenanter. For such a player, it would not be hard to extend one's sensibilities from the *Halo* Spartan to the *300* Spartan, nor would it be difficult to extend one's spite for the Covenanter to the Persian. To young Americans weaned on such a storyline, "Spartan" is synonymous with hard-bodied warrior and unwavering militarism.

Both the written and filmic texts, then, manipulate the historical record to create Spartan heroes and Persian monsters. The effect of such manipulation is both texts making several assertions: What is "right" is a universally recognized and accepted concept; Spartan warriors, all males, naturally are superior specimens of masculinity; an essential self is in every character and is clearly signified by the condition of the exterior body. On the face of it, these claims might seem harmless, or at least ordinary in today's Hollywood blockbuster world. Why not fictionalize the historical record? Why should graphic novelists and filmmakers faithfully adapt the primary sources? Isn't entertainment the value of Hollywood films, after all, and how can the facts, figures, names, and events of the historical past entertain modern audiences? This chapter implicitly takes up the issues raised by these questions. In doing so, we reveal the Spartans as monstrous, demonstrating how Miller, Snyder, and their cohorts deliberately have both used and abused the historical record to position the Spartans as heroes. Equally important to their freely painting the Persians as unmitigated monsters has been Miller and Snyder's censoring of what we now would consider Spartan monstrosities. To create heroes recognizable to a modern audience, Miller and Snyder have exploited the historical record and then disingenuously denied their indebtedness to it, surreptitiously creating a Spartan monster that resonates dangerously now as American militarism. While the graphic novel has won awards for its artistry and the film has been commended for its allegiance to the novel, there are notable differences between the two texts that accentuate their relationship to the history of the past and of the modern day. To begin the discussion of how specifically the texts use history, we examine what both do as they replicate and

diverge from the historical record, and then move to how the film departs from the novel.

Re-presenting History

Primarily, both texts are paeans to Leonidas as they construct him as the "world's one hope," or savior of reason and justice (Miller and Varley 11, 39). As a grown man he is represented as the "maverick" hero (Boggs and Pollard 170), apparently the only person in Greece to recognize the need to counter the Persians, and the only one to know where and how to do this. The novel and the film achieve this representation by suggesting that Leonidas always was destined for such a fate: As an infant he is found worthy by the male elders assessing his tiny body for imperfections, he survives the brutal Agoge martial training that began when he was seven, and, most importantly, he slaughters the wolf stalking him when he is an adolescent. In fact, the two texts claim, it is the wolf-killing that leads to Leonidas becoming king: "And so, the Boy, given up for dead, returned a king. Our king! Leonidas!" (Miller and Varley 10). The parallel is clear: The boy's valor demonstrated in the chasm with the wolf presages the man's valor in the narrow Hot Gates with Xerxes's troops. Heroes are born, not developed. As Leonidas thinks early in the novel, "All his fifty years have been a straight road to this one gleaming moment of destiny." Lest we readers and viewers think Leonidas's fateful thinking is megalomania, another Spartan warrior pitches in. "Training," says Dilios, the storyteller in the novel, "can make a man a good warrior—but a great warrior is crafted by the Gods" (8).

Two notable changes to or omissions of history are made by the two texts, the first having to do with the construction of Leonidas as savior, and more particularly to how he became king. According to Paul Cartledge in *The Spartans* (per Herodotus), Leonidas ascended to the throne in 490 BCE at about the age of 40, and was one of the two Spartan kings, the other being Leotychidas II. As the third son of Anaxandrides, Leonidas would not have expected to become a monarch, except that his older half-brother Dorieus was killed in Sicily and Cleomenes, another older half-brother, already king, allegedly committed suicide by slicing himself into pieces (Herodotus 7.205; Cartledge, *Spartans* 97). Although Herodotus posits three other suspicious causes for Cleomenes's death, Cartledge postulates that Cleomenes may have been murdered on the orders of ambitious Leonidas (*Spartans* 100; *Thermopylae* 85).[5] The novel and the film's

making Leonidas a boy-king therefore avoids the issue of his ascending to the throne under suspicious conditions, but also minimizes for a youthful audience the physical and mental heroics of a middle-aged man.[6] Having young Leonidas preyed upon by a demonic wolf and his killing it in self-defense makes the story palatable to a modern American audience familiar with tales of innocents victimized by predatory wolves. Less savory but more historically accurate would be Leonidas hunting boars or even humans, the Spartans' Helot slaves, as a member of the secret-society Krypteia (Cartledge, *Spartans* 71; 32). Perhaps, to avoid further distressing current readers and moviegoers who live with the incest taboo, Miller and Snyder also omit the historical record's claim that Leonidas's much younger wife, Gorgo, was Cleomenes's daughter and therefore Leonidas's niece.[7] In the story told by the novel and the film, young-looking and virile Leonidas is appropriately heroic and appropriately mated to an appropriately young, beautiful, and unrelated wife.

Though to the pagan ancients a warrior hero was a troublesome figure, verging on the divine and sometimes acting as a destroyer of civilization, Leonidas is the modern-day fully human hero of Miller's novel and Snyder's film (Van Nortwick 92). American heroes are not expected to display the petulance and self-centeredness of an Achilles or an Odysseus (77). Like the ancient Greeks, Americans expect heroes to be male, but unlike them American heroes are expected to display a selfless commitment to others and an aura of the messianic. If some novel readers but moviegoers in particular, especially those familiar with Christian iconography, have not gathered Leonidas's parallel to Jesus Christ by the time of his death, his physical positioning in both texts as a crucified figure in a Renaissance-looking painting asserts the point vividly (Miller 79). The story told by Miller and then Snyder demands this sort of hero-savior to hoist the banners of "reason," "freedom," and "justice" invoked as the Greek motivation for repelling the Persians.

But Leonidas's depiction as a modern-day religious icon is complicated in the two texts by his hostile relationship with Spartan religious figures, the second notable alteration to history the two texts make. As the single enlightened Greek who understands the urgency with which the Persians must be countered, Leonidas resents his "victory" having been "thwarted" (Miller 16) by the physically (and thereby, morally) repugnant Ephors: "Priests to the old gods. Inbred swine whom even the king must bribe—and beg" (18). Both texts' Ephors, from Leonidas's point of view, are equally motivated by lust for gold, for young, erotically charged, female oracles, and by rigid adherence

to "ancient, senseless, stupid tradition" (20). After Leonidas explains to them his Thermopylae strategy for forcing Xerxes to "abandon his campaign" to invade Greece and the Ephors elect to consult their oracle, Leonidas implores them instead to trust their reason, not the mystical poetry delivered by a young, drugged woman. The oracle, however, utters the final word: The religious festival Carneia must be honored, and so the Spartans are not to battle during that period of religious observance. Snyder's Leonidas would much rather be able to respond to Persian aggression unilaterally without conferring with the Ephors, with the woman oracle, with the other (historical) king, or with any other Spartan government figures, just as in the graphic novel he unilaterally pushes the Persian messenger into a well (14).

In depicting the Ephors as morally and physically monstrous, as Emperor-of-the-Dark-Side religious figures whose despicable power over the heroic monarch maddens Leonidas, the graphic novel and film conflate two historical entities, religion and government. Although Sparta was perhaps the most pious of all Greek city-states at a time when Greek "religion and politics were inseparable" (Cartledge, *The Spartans* 60) and a seer accompanied the Spartans to battle, the Ephors were not religious figures per se and Sparta did not host an oracle. Moreover, the Ephors shared the government of Sparta with two other bodies: the Gerousia, comprised by the two kings plus 28 (male) citizens over the age of 60; and the Spartan Assembly, which included all adult (male, warrior) citizens (Cartledge, *Spartans* 64–66; Kennell 92–114). While the Gerousia and Assembly were standing governing bodies, the Ephors were five officials elected annually from among the Spartan citizens, who were by definition male. Their role was to check the power of "excessively charismatic and powerful kings" in a city-state that valued above all abiding by its laws, allegedly set down by Lycurgus centuries earlier (Cartledge, *Spartans* 70). Presumably, once their year in office was concluded, the Ephors would return to their ordinary lives as Spartan soldiers.

Religious practices to mollify the fickle gods were pervasive throughout Spartan culture and the Ephors were likely to have taken part in those rituals (Matthews 74). Moreover, there is evidence that mollification often took precedence over attending to earthly matters.[8] But for Miller and Snyder to pit religion against activities of the state is a false opposition, as they were one and the same. Sparta was unique among Greek city-states as a martial state, but all Greek life at the time centered on relationships with the gods. Moreover, the Spartans and other Greeks would confer with an oracle for portents, but she was at Delphi, not in the vicinity of Sparta. Representing the oracle in

the way the novel and film do—as the conveniently local minion of the utterly corrupt and corruptible Ephors—minimizes the integratedness of religion in Spartan culture. The impact of the texts' conflation of physically and morally diseased Ephors and erotically charged oracle pits religion squarely against the reason embodied by Leonidas, emphasizing again the tremendous odds stacked against his valor.

Thus, not only are his pure and selfless aims to ensure liberty and reason countered by the horrendous Persian multitudes, the aims also are hindered by the impure mysticism inherent to Leonidas's own culture. Surely, the graphic novel and the film say, to fight for what is right means Leonidas must transcend the cultural particulars of his time in history. The two texts conclude, then, that what is right is a universal quality characteristic of human nature, transcending time and space and culture; violations of this common knowledge are made by those whose bodies already are marked as inhuman or monstrous. Records of history are not necessary, the texts suggest, because human nature does not alter over time and is not influenced by ideology, culture, technology, or other social institutions. Just as there were Spartans who were the "world's one hope for reason and justice" and Persian "beasts" (Miller and Varley 11) capriciously ready to snuff out that hope only because they could, twentieth- and twenty-first-century Americans can derive comfort from knowing that currently there are valorous Leonidases who are fated shields against the inevitable, inhuman, and monstrous marauders of the world.

This need to transcend history and culture might explain the omission from the novel and the film of other historical details pertinent to the depiction of the Spartans and Leonidas. For instance, like most if not all Greek societies, Sparta was a slave-based culture; Paul Cartledge says, "These Helots [slaves] are the single most important human fact about ancient Sparta" (*Spartans* 29). But not a single mention is made of such a slave system in either the novel or the film, even when each of the 301 Spartan hoplites (soldiers) was probably attended by two or three "personal servants" who carried his armor, armed him when the time for battle arrived, dressed his wounds, and likely buried his dead body (Hanson 62–63).[9] The Spartans differed from other Greeks, however, in that they conquered and enslaved not "barbarian" non-Greeks but their immediate Greek neighbors, and that without this large body of Helots to work the Spartans' farms, cook their food, weave their cloth and sew their clothing, make their art, fashion their weapons and armor and accompany them to battle, care for their children—in short, do everything—the male Spartans would not have been able to live as professional soldiers nor the

Spartan females able to focus on breeding strong children (Cartledge, *Spartans* 73; Pomeroy 51–54). Other Greek hoplites were constrained by the seasonal agrarian demands of planting and harvesting, whereas Spartan hoplites were uninhibited—barring religious observances— from warring whenever they chose (Hanson 38). Thus, with the slave system unobserved in the novel and the film, when Leonidas boasts that all of his troops are soldiers whereas the other Greek warriors at Thermopylae are farmers or craftsmen or artisans, the implication is that the Spartans naturally are superior, not only because they are (born) superior physical specimens but also because they have chosen the correct path for a masculine male: to spend his life preparing for and conducting war.[10]

This "choice" to become a Spartan warrior is debatable, however, and ironic given the Greek belief in the "incontrovertible" nature of fate (Van Nortwick 100) and Leonidas's carrying the standard for liberty. In *The Western Way of War*, one of the graphic novel's four "Recommended Reading" texts, Victor Davis Hanson describes the Helot system: "Supported by an entire class of rural, disenfranchised servants known as helots who worked their farms, Spartan hoplites were free to drill and campaign without any obligation to work their farms or to return from battle to harvest their crops" (38). Although Hanson subsequently refers to the Spartan "nightmarish system of apartheid," that he consistently refers to Helots as "servants" implies that the Helots have a choice in this matter, that they have chosen their occupations. That the Spartans are described as "free to drill and campaign" also suggests that their way of living is optional. Given such freedoms, especially with twentieth and twenty-first-century understandings of "choice," Hanson's reader might conclude that male Helots could choose to become professional Spartan soldiers and Spartan citizens could opt for farming, or that both might opt for neither occupation and become artisans or craftsmen. These options apparently were not the case in history, however much insinuated by omission from the novel and film. Lycurgan law forbade Spartan citizens any business but that of war (Cartledge, *Spartans* 29). The state forbade male Spartiates having a trade, practicing agriculture or arts, owning gold or silver, and regulated their martial aptitude by killing those male infants deemed by the elders malformed for combat, and by separation from the household and training beginning at the age of seven (Bradford 61). Spartan males deliberately were born and bred and educated to fight for the city-state, and Spartan females were born and bred and educated to bear male Spartan warriors and females to bear more warriors (Pomeroy 3–4). It was for these laws that it is said in the

graphic novel and the film the Spartans died at Thermopylae: "Go tell the Spartans, passerby: That here by Spartan law we lie" (78).[11]

That Sparta's was a state system of forced slavery or serfdom and not voluntary servitude is evidenced, too, by what historians and archaeologists know of the Krypteia, a kind of Spartiate secret service employed to terrorize and police the Helots.[12] Paul Cartledge describes this group as comprised of "distinguished youths" between the ages of 18 and 20 who were sent to " 'blood' themselves by killing any Helots they happened on—or perhaps rather Helots who were known troublemakers" (*Spartans* 236).[13] Even when Sparta was at war, Ernle Bradford postulates, some Spartan soldiers always were left behind to oversee the Helots as they numbered at least 15 to every 1 Spartan and always threatened to revolt against their masters (60). Sarah Pomeroy contends, too, that of the male Helots, those most resistant to their forced servitude were targeted by the Krypteia so that, in a society governed by belief in eugenics, the more servile would be reproducing. As the prey of Spartiates, Helots were anxious to produce as many children as possible to ensure strength in numbers (101–102).

The eugenical belief that physical abnormalities could and should be eliminated in the general population through male infanticide is considered in the novel and the film. But because this issue appears in the novel's narrative only from the perspective of the hideously formed Ephialtes (and at the very beginning of Dilios's narrative of the film), that brief and visually small appearance in the novel implies that exposure is righteous because it only affects those it ought to affect, not those 301 fit and enduring warriors who apparently passed the test conducted by the Spartan male elders. Exposure—literally casting into a chasm infants who are deemed by the state to be physically deficient—is represented in the two texts as inconsequential to what really matters: the morally correct development of martial Spartan manhood. In the novel, before Ephialtes has presented himself as a viable warrior to and been rejected by Leonidas, and as he sees Persians approaching the Spartans, he counts himself worthy of having been "protected" by his father from infanticide, and consequently as one of the Spartans. "Persian bastards. We'll kill you all" he says to himself. In a series of six tiny panels concluding with one filling nearly a full page of Ephialtes overlooking the older Spartans tormenting the younger ones, triumphantly he summarizes exposure and the 11-year Agoge training for all Spartan males:

> We Spartans will destroy you...We are born. We are inspected...If we are small or puny or sickly or misshapen, we are discarded...We are

starved. Driven to steal and fight and kill...We are tested. Tossed into
the wild. Left to pit our wits and will against nature's fury...By rod
and lash, we are punished. Trained to show no pain...Our training
never ends. We are Spartans. (30–31)

Although monstrously shaped Ephialtes has internalized his oppres-
sor by identifying with the Spartans, the effect of his narrating the
Spartan practice of infanticide almost as an afterthought makes it
seem reasonable, given his apparent escape from and acceptance of it,
and the fact that the Spartans following Leonidas are prime physical
specimens for warring.

Of course, the historical record does not even hint that Ephialtes
is physically or mentally disabled, or ideologically sympathetic with
either the Greeks or Persians; he was only financially opportunistic.[14]
Little more is said of him by Herodotus than that he was a local
"man from Malis," "son of Eurydemus," motivated "in hope of a rich
reward," and that given his fleeing to Thessaly, he was "the guilty one"
who had revealed the mountain track to the Persians (7.213–215).[15]
That pro-Spartan Ephialtes is rendered both by Miller and Snyder
as a hunchback has the effect of his potentially bridging the world
between the morally depraved Persian slave masters whose monstrous
immorality is physically revealed, and the morally righteous Spartans
whose bodies reflect inner human perfection. In the Miller and Snyder
world, Ephialtes's body is Persian but his spirit is Spartan. Although
the Leonidas of both texts compassionately recognizes Ephialtes's
undaunted desire to become a part of the phalanx, Leonidas's mas-
culine reason, his understanding of how the phalanx must function,
prevents him from accepting Ephialtes as a phalanx hoplite. The two
texts resolve this issue differently, however. In the novel, following
Leonidas's rejection, Ephialtes attempts suicide by throwing himself
off a cliff (38). In the film version, though Leonidas rejects Ephialtes
as a hoplite member of the phalanx, he encourages Ephialtes to par-
ticipate in the Greek effort otherwise by recovering the dead and pro-
viding water to the wounded. The novel reader might conclude that
it was Leonidas's unyielding reason in refusing Ephialtes that moti-
vated Ephialtes's revealing the mountain track to the Persians. A film
viewer, however, might conclude that in accepting Ephialtes's hideous
body by offering him a role in the Greek struggle, Leonidas frees
himself of any responsibility for Ephialtes's betrayal of the Greeks to
the Persians. If the leader of the Greeks can be so accepting, a viewer
might deduce, then it only can be Ephialtes's prideful refusal to tend
to the demeaning battlefield tasks (normally conducted by Helots)

of delivering water and recovering bodies that prevents him from joining the Greeks. A viewer might further conclude that Ephialtes's pride extends from his insecurity about his body; though able-bodied men can overlook the state of his body, he cannot. In effect, claims the film, deformed bodies are essentially monstrous, but even more disturbing (to those who are not such monsters) is that these exteriors unfailingly reveal the corruptibility of the moral faculties. According to the film, bodies always are clear signifiers of the internal condition. Leonidas's perfect body always was fated to be on the side of good and Ephialtes, the side of bad.

Once again, the case of Ephialtes reveals how the novel and film, perhaps especially the film, are less about the collective 301 Spartans and more about the individual maverick hero, Leonidas. This focus on the individual applies especially to the depiction of Leonidas's death. In the novel, on the third and final day of the battle, Leonidas and Xerxes face off, keenly aware of the other as his nemesis (Miller 69–78). Their enmity is emphasized by their differences in appearance: Xerxes is a bald, fey, pierced, decadent giant and Leonidas a short, brawny, hirsute man of simple tastes. The Persian Immortals, having marched on the mountain path all night, reach the heights above the Greeks in the pass. In the few pages rendering his demise, Leonidas recalls his adolescent experience with the wolf in the gorge, thinking it was not fear of death that motivated him then or now, but "a restlessness, a heightened sense of things" (71). Removing his helmet and dropping his shield, Leonidas first poignantly addresses Ephialtes, who accompanies the Persians and then, feigning obeisance to Xerxes by kneeling, hurls his spear at the Persian emperor as the Immortals' arrows rain down on the Greeks. As Leonidas's body is violated by multiple arrows, lest the reader forget Leonidas's heroic fate, we are reminded by the narrator that Spartans are said to be descended from Herakles, and fearless Leonidas is described as "staring death square in the eye" (74). Despite his display of fearlessness, as the Immortals aim their arrows at Leonidas, the last thoughts ascribed to him are for his wife: "My queen. My wife. My love. Be strong. Good-bye" (76). After two pages of arrows pelting the Greeks, a reader is not surprised to find Leonidas sprawled dead on the ground, impaled by at least a dozen arrows and surrounded in the phalanx's circular pattern by other dead, red-robed Spartan warriors. The visual rhetoric here is not only that Leonidas the savior sacrificed himself for the Greek cause but also that the surrounding men sacrificed themselves for him (Figure 2.2).

We know little about Leonidas from the ancient historical record. We learn this from Herodotus, writing for a hostile Athenian audience

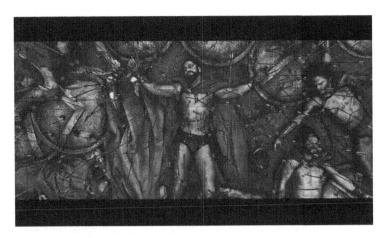

Figure 2.2 Leonidas, crucified.

about 60 years after the Persian Wars: He was "the most respected" of all Greek officers and would command the entire Greek army opposing the Persians; that he traced his descent to Herakles; he unexpectedly had become king when his two older [half-]brothers died; he was married to his [half-]brother's daughter; he deliberately chose to accompany him to Thermopylae 300 male Spartans based on whether they had living sons; and knowingly leading this suicidal Spartan force to Thermopylae as ordered by the Spartans, Leonidas was joined by at least 3,000 other Greeks in anticipation of the main body's arrival and to "encourage the other confederates to fight and prevent them from going over to the enemy" (7.204–209).[16] The main departure by the novel and film from this record is that they make Leonidas's a unilateral decision to "go for a walk" to Thermopylae, not a decision reached multilaterally by the Spartan leadership and Greek allies. Moreover, the novel and film make victory a realistic possibility to Leonidas, contrary to Herodotus's evidence that choosing only men with sons indicates that Leonidas knew the mission was suicidal.[17]

However, the two texts most dramatically depart from Herodotus's description of Leonidas's death. Here is Herodotus's version: Although Leonidas knew that the Immortals had bypassed the Phocians stationed on the mountain track and so were on their way, Leonidas was killed before the Immortals arrived above the pass. The battle continued; the Persians and Greeks fought to retain Leonidas's dead body, with the Greeks finally rescuing it (7.225). It was not until the battle's conclusion that Xerxes learned Leonidas was the Spartan leader and

ordered Leonidas's body to be decapitated and his head mounted on a spike. Herodotus opines that such treatment was unorthodox and can only be explained by Xerxes's "fiercer anger against him [Leonidas] than against any other man," because "the Persians, more than any other nation I know of, honour men who distinguish themselves in war" (7.238). To heighten or even create the singular heroism of such a man as Leonidas, especially in an American culture inculcated with belief in individualism, he not only must make the unilateral decision to resist tyranny, he must sacrifice himself, Christ-like, for what all humans know to be good and right. It is not enough that he knowingly and willingly goes to his death. No, he must die resisting that death and the one person dealing that death: Xerxes. This means that he must follow the Spartan dictum of never surrendering, and of focusing on his single mortal enemy, not the totality of Persian forces.

Other elements of Spartan culture that may have impacted the battle story were censored because of Miller's certainty about his audience's preferences but also to sustain this focus on an image of the maverick hero. For instance, in the novel, Spartan sexual practices are almost never referred to directly. When sexual practices are referred to directly, it is clear they are construed monstrously: Leonidas's reference to Athenian "boy-lovers" (13); the salacious Ephors's "men's needs" (20); the promise of multiple women by Xerxes to Ephialtes (61). Sexual practices are featured in the film, however, and, except for those that also appear in the novel, as exclusively opposite sex. Assuming the outline of another feint, the freakish sexualities of the film's monsters emphasize the normalcy of Leonidas's sex with his wife and even Theron's sex with Leonidas's wife, and divert any audience inquiries about Spartan sexual practices. Neither the novel nor the film refers to the same-sex male pederasty institutionalized among Spartan warriors who were required to live in all-male barracks until the age of 30 (Blundell 151), nor to the policy of separating male lovers in the phalanx (Cartledge, *The Spartans* 225). As Paul Cartledge explains it, the pederasty integral to the Agoge training system was a component of worshipping Apollo and his sexual relationship with Hyacinthus. "Their joint cult therefore symbolized and represented the real-life pederastic relationships between young adult Spartan warriors and the adolescent youths who were undergoing the state-controlled educational cycle" (58).[18] Cartledge elaborates:

> Such literally pederastic ("boy-desiring") pairing relationships between an unmarried young adult citizen warrior (aged, say, twenty to twenty-five) and a teenaged boy (aged between fourteen and eighteen) were

not abnormal or unusual; actually, they were more or less obligatory for all in Sparta, as part of the *agoge*. The Spartans even devised a special local vocabulary for them: the older partner was called the "inspirer" and the younger one the "hearer." Of course these metaphors might well have been a cover for the relationship's carnal and earthy aspects. (*Thermopylae* 70)

Such erotic relationships were not limited to males, either. Sarah Pomeroy argues in *Spartan Women* that same-sex relationships between Spartan females were well known, especially between older and younger women (16, 29). Both Cartledge and Pomeroy speculate that these same-sex erotic attachments were consequential to the separation of men and women, with male Spartiates living in barracks until the age of 30 and as warriors until 60, and women living in their households with other females, male and female Helots, and Spartan boys younger than seven years of age. Pomeroy adds that same-sex and nonreproductive opposite-sex sexual practices were contraceptive (54), fertility practices according to written accounts known only of Spartan women (64).

Cartledge comments in his discussion of pederasty that "[t]he Spartans had a reputation among other Greeks, no doubt exaggerated, for being addicted to buggery" (*Thermopylae* 70). It is interesting, then, that both the graphic novel and the film so aggressively cite the Athenians as "boy-lovers." But marriage practices among Spartan men and women suggest that the reputation for buggery has some basis in the historical and archaeological record, not just in gossipy exaggeration. As Pomeroy explains it, "marriage by capture," or rape, was the marital ritual, not a chaste formal and public ceremony. The marriage was simulated rape in that the bride would know when the groom was going to enter her bedchamber and participated in this performance by preparing for his arrival. That preparation included shaving her head and dressing in a man's clothing. The shaven head was expected of all Spartan wives, who after their marriages wore veils over their hairless pates (Cartledge, *The Spartans* 171–172). The man's clothing worn by the bride, however, ostensibly was donned just for that night. "Brides' costumes," comments Pomeroy, "may have also helped to ease the husband's transition to procreative sex from the homosexual intercourse to which he was accustomed" in the barracks (41–43; 114).

A MONSTROSITY OF HISTORIC PROPORTIONS

Thus, we can see in sexual practices an example of how distorted is the representation of Spartan culture and of Leonidas in the graphic

novel and the film as they tell a story that may inculcate the "spirit" of the battle but only reflect back to modern-day audience members ideologies and cultural practices we prefer to see: a pure, unmediated story of pure and unmediated heroism. This monstrous distortion is no more pernicious than in the always-unnamed "queen" of Leonidas.[19] That the queen of Leonidas is featured so prominently in the film, but appears on only one page in the graphic novel (22), and never is named in either text except in terms of her relationship to Leonidas, is one of the film's most notable departures from the graphic novel and the most telling of the film's styling a hero for twenty-first-century moviegoing Americans. On the novel's page picturing the queen, she is in 6 of the 14 panels, and in those panels, she demonstrates some of the powers Spartan women are recorded in history as having. First, she is physically dominating, only second in size among all the characters in the largest panel to Leonidas's Greek-vase-like silhouette. Her body is well-nourished and strong-looking with ample breasts and a defined waistline; her face is squarely sculpted with prominent eyes, nose, mouth, and cheekbones; and her hair is long and full. Second, she contradicts the other Spartan males in this panel, not only agreeing with Leonidas's unilateral decision to "go for a walk" but also urging him to take his entire royal bodyguard of 300 with him. "Call me protective," she adds drolly, with hooded eyelids. Third, in subsequent panels when Leonidas explains he will head north, she understands the geopolitics of the direction, but, fourth, she has an additional puzzle piece to clarify Leonidas's intent: his sexual "enthusiasm last night" and her positive reception. Fifth, as Leonidas departs for his "walk," the queen calls "Spartan" to him, commanding him to "come back with your shield...or on it." In the first panel of the next page, Leonidas's head is pictured again in black silhouette while the narrator comments about the queen, "A strong woman. A fine wife. To him, only a memory now. He will never see her again. He will never see Sparta again" (23). As much as she means to him, between his departure and death at the end of the novel, Leonidas's wife never occurs to him again.

According to the historical record, Spartan females were trained physically to be strong, though not through as formal a process as Agoge. Unlike other Greeks, this investment in females suggests that the male Spartans—who retained political power—did not regard females as naturally inferior, as the soft, wet emotional inferior to male dry reasonable hardness (Van Nortwick 51). Because legitimacy as a male Spartan citizen came only from Spartan parents, and because the state was a martial one reliant on male and female adherents to

its masculinist ethos, females were raised to become physically and mentally strong mothers. Exempted by Helots from domestic duties, Spartan females' strength emerged from public physical and intellectual education, and central to this education was normalizing the masculine values of the militarist state. As Cartledge puts Sparta's eugenical aims, "ensuring that the female half of the population internalized the state's dominantly masculine values" was crucial to the endurance of the state (*Thermopylae* 72). Pomeroy recalls Foucault's notion of discipline when she writes pointedly that:

> Every well-governed state that comes into existence and evolves as the result of deliberate creative acts and legislation endorses the child-rearing practices and values it needs. The educational system is part of political organization, and each role in it, including parent, teacher, and pupil, is socially constructed. Only at Sparta did the state prescribe an educational program for both boys and girls beginning in childhood. (3)

While through state-prescribed education and social mores females thus had more power in Sparta than in other polises, gender roles still were fixed. Males performed their masculinity in combat; females performed their femininity in producing male warriors. "The goal of the educational system devised for Spartan girls was to create mothers who would produce the best hoplites and mothers of hoplites," claims Pomeroy, "because all the girls were expected to become the same kind of mothers, the educational system was uniform" (4). Females possibly were trained in reading but certainly in music, dancing, and poetry, and were encouraged, unlike their silently and invisibly respectable sisters in Athens and even their Spartan brothers, to speak and appear publicly (135). Spartan females were noted among Greeks for their athleticism, and though they were not trained for combat, engaged in running, wrestling, and discus- and javelin-throwing (8–16). Their clothing, scandalously to other Greeks, afforded athletic movements with short skirts and easy removal for frequent exercising in the nude (25). There were fewer inhibitions on females' sexuality than in other Greek polises, too, so that except for offspring's legitimacy in terms of inheritance (41), Spartan women were free to practice sex with other women and girls, men other than their husbands, and with multiple husbands if they chose (37; Blundell 156).

Except for her long, unveiled hair, a signifier of female attractiveness among twenty-first-century Westerners, the queen of the graphic novel generally accords with what historians tell us about Spartan

women and resonates with Judith Halberstam's female masculinity.[20] The queen's large and well-defined body indicates rigorous physical exercise and adequate nutrition; her vocal assertiveness displays the social condoning of women's speech in public and among men; her understanding what "north" means signals her engagement in politics; her recall of Leonidas's night-time "enthusiasm" implies her unabashed welcome and perhaps even initiation of such attentions; and her commanding Leonidas to "come back with your shield...or on it" reflects her internalization of what Cartledge calls the "state's dominantly masculine values."

It is peculiar to Miller's novel and Snyder's film, however, to have a wife deliver the line, "come back with your shield or on it," as history records this otherwise. Plutarch ascribes this to a mother as her son departs for battle, and is a command symptomatic of a relationship between Spartan men and the women who gave birth to them that modern Westerners might find peculiar (Blundell 157). In modern Western culture, a mother's love should be intrinsic and unqualifiedly encouraging, nurturing, and protective, not the unqualified threat imbued in this Spartan command from mother to son. However, a Spartan mother would not have been physically close to her son once he entered Agoge at the age of seven. Furthermore, the "dominantly masculine values" inculcated in Spartan females, expressed as their being the "most vocal mouthpieces of this [eugenics-based] ideology" (157), and general reservedness of Spartan emotional culture also likely curbed any emotional attachments extending from accidents of birth. After all, Spartan women were known not to weep or wail at the death of those close to them, males or females (Cartledge, *The Spartans* 178), and also to harangue publicly those men who had behaved as cowards or had not married (and produced legitimate sons) by the time of their eligibility (Pomeroy 9).

What might be most important in the historical record about who delivers the line—with your shield or on it—is that mothers and their daughters, the female blood relatives of a warrior, particularly would feel the repercussions of a son and brother who returned from battle without his shield. The shield of Greek hoplites is what distinguished them from warriors of other countries, not only in appearance but also in signification (Matthews 52). The shield made the phalanx possible as its size and shape protected its bearer and the neighbor to the bearer's left, so the shield represented the collective effort of hoplite warfare. If one shield failed, the entire phalanx could collapse. Moreover, though shields were heavy and unwieldy, they were expensive to craft, so a hoplite warrior would not readily part with

such a costly and fundamental part of his panoply. Furthermore, if he died in battle and his body was returned to Sparta by his Helots, it's likely that his shield would be returned with him to be passed on to male progeny.[21] Thus, a warrior's returning home alive but without his invaluable shield would be interpreted as cowardice, as though he had "tossed" it while running away from battle (Hanson, *Western Way* 63). Because this cowardly behavior was likely to be enacted by young men facing combat for the first time, while it would have had an immediate impact on the outcome of the battle, a son's cowardice also severely impacted mothers and their unmarried daughters. Not only would his "trembling" ostracize the young man so that no eugenics-thinking Spartan woman would accept him as a father to her children, that ostracizing would extend also to his unmarried sisters (Pomeroy 37). Neither trembling warrior sons nor unmarried daughters would be seen as eligible to produce legitimate, fearless Spartan sons and daughters. The Spartan mother, therefore, whose life's purpose was to produce Spartan warriors and daughters who in turn would produce Spartan warriors, would have failed at these duties if her son returned alive to Sparta without his shield.

That Leonidas's wife delivers this line in the graphic novel and the film skews the signification of the shield in Spartan culture. Not only was it unlikely that her middle-aged and experienced warrior husband would discard his shield out of cowardice, even if he did return to Sparta without his shield, she probably would not be affected in the same way as his female blood relatives; she's already married. However, because in the graphic novel there is no mention or appearance of a son, perhaps novel-queen would be similarly affected by refusing to reproduce in the future with coward-Leonidas. That possibility may account partially for the son Leonidas and his wife are given in the film, as evidence that they already have a son and heir free of any cowardly taint.

More importantly, this command's being voiced by Leonidas's wife in both texts typifies the manipulative use of history in the graphic novel but especially the film. Leonidas's wife plays a significant role in the film, ostensibly to attract twenty-first-century female moviegoers by presenting a strong and feminine woman in what is otherwise a masculine man's world (Mendelsohn 37). It seems apparent, however, that this appeal to a female audience instead is a Snyder ruse, not unlike his Persian monsterizing, pandering to a heterosexual male audience when the representation of Leonidas's wife is less the shaven-headed and muscular woman we might expect from a historically proximate tale and more the twenty-first-century heterosexual

man's dream of a highly sexualized wife who not only endorses her husband's masculinist exploits, but also actively encourages them. This wife of Leonidas—known in Herodotus and other historical sources as Gorgo—is used both by Miller and Snyder not to eluci- date ancient Sparta's women or even to appeal to twenty-first-century women, but instead to magnify the maverick heroism of Leonidas, especially the rightness of the masculinist militarism he enacts. Her facilitative role is signaled by the fact that though Gorgo is one of the few Spartan women whose name is recorded by ancient sources, she never is named in either the graphic novel or the film, and only is referred to in terms of her relationship to the king.[22]

Leonidas's wife appears throughout the film because once the 301 leave Sparta, the film juxtaposes Leonidas's doings at Thermopylae with his wife's at Sparta. Although like the novel the film focuses on Leonidas as the maverick hero, that in the film he partners with his wife in raising their son and in securing an undefined "free- dom" is a crucial element of constructing him as such a hero for twenty-first-century viewers unfamiliar with the conventions of graphic novels. While this modern viewing audience, like film critic Peter Travers's respondents cited earlier, might desire to see beauti- ful Leonidas's wife as an independently strong woman who brings to the relationship her own strength and power, her beauty cannot fully distract us from her total dependence on him for her power. To accomplish their partnership, he must grant her some of the power he complicitly enjoys as a male in a masculinist environment. In exchange, she normalizes his Spartan ethos in repeatedly supporting and often enacting his masculine values of controlling himself and other people (Van Nortwick 27). Thus, the partnership is contingent because only Leonidas is pictured as inherently and consistently pow- erful and the only power his wife has is the masculine power he elects to confer on her.

For an instance of Leonidas's wife normalizing Spartan masculine values, consider the scene early in the film when Leonidas wrestles with their young son in their domestic courtyard. She stands by with arms crossed, observing, evaluating, smiling, nearly overseeing. She does not wince, she does not call out when it seems their son might be harmed, she does not object to the activity; she studies the scene with masculine reason, calmly and unemotionally. Later, when she and the loyalist counselor observe her son playing and the counselor comments that soon she will experience the anguish of having her son enter Agoge, she again is masculinely reasonable, not femininely emotional: Yes, it will be "hard but necessary." Leonidas's wife is

represented as a willing and rational partner in this Spartan system of preparing males for a life of combat.

Her embrace and propagation of the masculinist values imbued by the Spartan martial system become especially apparent when the Persian messengers arrive to demand submission from Sparta and Leonidas. When the Persian emissary objects to her speaking among men, she counters his objection by saying that the voices of Spartan women are welcome because "only Spartan women create real men." Not only does her assertion validate her having an opinion publicly, it also emasculates the male emissary, his not having been born of a Spartan woman. When it is clear that Leonidas will not submit and has backed up the emissary and his men to the maw of an oddly cavernous well, he looks to his wife for her agreement with what he is about to do: Shove the Persians into the well. She nods slightly and he shoves vigorously.

Although the well-shoving is anachronistic because it was an event that Herodotus records as having occurred in Sparta but about ten years earlier when Cleomenes was king, and Gorgo is reported to have made this claim about Spartan women but to an Athenian woman in an entirely different context, the scene is used in the film (and not the novel) only to demonstrate the extent of the partnership between Leonidas and his wife.[23] Not only is she unafraid to speak, he is unafraid to have her speak; not only is she unafraid of his decision to push the Persians into the well, he is unafraid to seek her agreement. She has everything to gain by performing masculinity in a masculinist world; as a dominant masculine man of Snyder's world, he has nothing to lose in granting her masculine power.

Another illustration of Leonidas's partnership with his wife follows the Persian emissary's unfortunate visit to Sparta and Leonidas's almost equally unfortunate visit to the Ephors. While her previous appearances might suggest that Leonidas's wife's power could challenge or diminish his, this scene in their bedchamber allays any audience concerns—especially those of young heterosexual men aspiring to current-day hegemonic masculinity—that the power she wields would make her equally controlling of their sex life. Worried by the martial paralysis imposed on him by the Ephors and their oracle "slave," Leonidas sleeplessly wakes his wife, to her disappointment wanting to talk, not have sex. His quandary, as he explains it to her, is that as a king he cannot decipher what to do.

Leonidas's wife: "There's only one woman's words that should affect the mood of my husband; those are mine."

Leonidas: "Then what must a king do... to save his world when the very laws he has sworn to protect force him to do nothing?"
Leonidas's wife: "It is not a question of what a Spartan citizen should do, nor a husband nor a king. Instead ask yourself, my dearest love, what should a free man do?"

This exchange verges on the woman manipulating the man into discarding the obligations of Spartan citizenship and kingship and into using her ill-defined concept of "free," though the discussion culminating in their having sex dispels any audience fears of her being overly in control. The sex scene intimates that their sharing the dominant topmost position means they are equal partners in bed, but the camera focuses the spectator's gaze on her body, not his, her gasps and not his, her orgasmic responses and not his. Clearly, in the bedroom, it is her response to his activity, his control of and power over her body that signifies most. Just as the brawny bodies of the Spartan warriors and omission of male pederasty normalize for male spectators how heterosexuality should look, so does Leonidas's wife assure male and female spectators that a strong-minded woman can also be heterosexually beautiful and sexualized.

Having made his decision as a "free man" to go walking, the next day Leonidas meets his assembled 300 in a golden wheat field on the outskirts of Sparta. Notably, as the men prepare for their march to Thermopylae, the film suddenly becomes colorful with their red battle capes, as though the promise of combat brightens the dull sepia tones of their domestic world.[24] Although the elders, dressed more like toga-ed Athenians than peplum-ed Spartans (Nisbet 29), appear on the scene to challenge Leonidas's "walk," the emergence of Leonidas's wife and (also unnamed) son into the background behind him, out of focus but obviously she holding her husband's shield and he holding his father's helmet, clarifies whose opinion matters most and for whose "freedom" Leonidas is fighting. As the 300 depart, Leonidas approaches his little family, gathering his shield and helmet, the wolf's tooth necklace from his wife, and her command that he come back with his shield or on it. Except for those words and grim looks between Leonidas and his wife, nothing else is said, nor do Leonidas, his wife, or his son weep at his departure. Weeping would not be what a "hard" or "strong" Spartan of either sex or any age would do, the narrator reminds viewers.

Understanding that a price must be paid for freedom, Leonidas's wife is willing to fight for it on the home front by whatever means available. "Freedom isn't free at all," she declares to the loyalist

counselor, meeting secretly in her bedchamber to discuss motivating the Council to send the entire Spartan army to Thermopylae. Unlike many American depictions of twentieth and twenty-first-century wives of officers in combat dutifully consoling the wives of men serving with their husbands (Ryan, M.), Leonidas's wife has no time for other women and takes the direct route to supporting her husband with masculine political intervention. While it's evident in the film that her husband's presence culturally validates her crossing a gender boundary by speaking publicly with the Persian envoy, it is equally clear that Spartan culture does not grant her the same power in his absence. Even though audiences may wish Snyder's Sparta to appear progressive, it is not so progressive as to threaten its very existence as a militarist state in which male masculinity dominates. In effect, then, Leonidas's wife is a filmic prop, a proponent and internalizer of the very masculinist system that refuses her power independent of a masculine man.[25] Understanding her powerless position as a woman in a man's culture and as a queen in relation only, Leonidas's wife can only appeal to another man with power, Counselor Theron, for a chance to speak publicly before the all-male Council. Because he is the Council member whose power is most threatened by Leonidas's unilateral decision to take a walk—the camera focuses on the antagonistic looks exchanged by Theron and Leonidas during the departure of the 300—Leonidas's wife recognizes his hostility to her cause. In case we American viewers overlooked those signs, Theron is played villainously, leering at Leonidas's wife and suspiciously speaking with a British accent.[26] Viewers understand that any power she has extends only from her partnership with her husband, so his absence forces her to lobby another man, even Theron, a monstrously despicable one. Just as any hoplite should be able to replace another in the phalanx, in a Spartan militarist environment, one masculine man can be exchanged for another, even though one is painted as "good" and the other, "bad." Given a Spartan ethos that valorizes masculinity and reason above all, however, qualities as a woman she is not naturally supposed to have, all Leonidas's wife has to offer Theron in exchange for a Council appearance is her body; that, apparently, is all he wants. Although this intimate scene between Leonidas's wife and Theron can be regarded either as Leonidas's wife betraying Leonidas, following as it does Ephialtes's traitorous visit to Xerxes in his harem filled with freakish female bodies, or as a rape, like the women in the harem Leonidas's wife's female body is the scene's central feature. While Theron makes clear to Leonidas's wife that his penetration of her will be a painful and unpleasant violation, like the earlier scene with

Leonidas and his wife, it is the man's control of her body that matters most in the film's meaning-making. And like the feinting Spartan phalanx, the "partnership" between Leonidas and Leonidas's wife is a ruse: In this militarist culture, (always) masculine males govern (always) feminine females.

Even if twenty-first-century American audience members did know more about Spartan history, about Gorgo and the martial Spartan culture, they might still hope for the Spartans to meet modern gender ideals, ideals even moderns are unable to meet. In Snyder's monstrously deceptive and manipulative filmmaking, Leonidas's wife is made to look as modern males and females of all sexual proclivities are tutored to imagine feminine and sexualized females should look. At times, she even sounds like the strong-minded woman conventionally hoped for in the United States. Some viewers, like Travers's responders who admire the film's depiction of "the equality of women" (jbailey), the "hot" queen (jegler), and Queen Gargo [sic] being a "strong" woman (Teleri), take the filmmakers' bait and agree that Leonidas's wife represents the ideally assertive, beautiful, heterosexual woman of the twenty-first century. Charmed by her appearance, viewers are positioned by Snyder to overlook how contingent her strength and power is on masculine men and how her valuing of Spartan masculinism is the very thing that imperils her access to power and devalues her as a female. Just as the unusual look of Snyder's film can beguile spectators into cheering for and believing in the beautiful Spartan warriors and booing and hating the monstrous Persians, so may the appearance of Leonidas's wife have those same viewers believing that she is an independent woman.

The final element of Snyder's film that differs so dramatically and significantly from Miller's graphic novel is its narration. As a critic cited earlier avers, Dilios is the storyteller of the graphic novel and the film, and given the rhetorical aims of this storyteller at the scene of Plataea, none of what he says should be claimed as historically accurate (Murray). Granted, storytellers embellish, often to extract a more affective truth than the details of actuality, so novel-Dilios's casting Ephialtes, Xerxes, and the Persians' elephants as creatures of nightmarish proportions is understandable, as is film-Dilios's multiplying the cast of Persian monsters and freaks. Dilios's Greek storyteller's license means, too, that viewers can accept his version of the battle's conclusion, even though, having been sent by Leonidas back to Sparta to tell the "grand tale" of the "victory" at Thermopylae, it was an ending he did not witness (Miller 64). What distinguishes the two versions of Thermopylae, however, is the narrative form. Yes,

from beginning to end Dilios obviously is the film's narrator, and the venue for his storytelling is the battle of Plataea, about a year after the battle at Thermopylae. The effect of the story being told solely from his point of view is to heighten Greek (and the American audience's) antipathy for the monstrous Persian enemy, but even more to hearten the Greeks (and the American audience) by casting "brave Leonidas" as a lone, individual, David-hero against a gigantic Goliath-antihero.

Although the film's narrative strategy is to make Dilios its sole and thereby quirky narrator, that is not the graphic novel's. Instead of an individual narrator like Dilios, the novel has a plural narrator, emphasizing the collective, proto-socialist nature of Spartan culture and society. Dilios is described by the novel's narrator as a storyteller within the novel, is depicted telling the story of Leonidas and the wolf (8–10), and is introduced at the novel's conclusion as telling a story of Thermopylae before the battle of Plataea. But Dilios is not the novel's narrator. The novel begins "We march. From dear Lakonia— from sacred Sparta—we march. For honor's sake—for glory's sake— we march" (2–4). The plural narrator is implied here, but becomes clearer within a few pages during the wolf story: "Night. The summer blows cool, off the Aegean. Dilios spins his stories. Our favorite story. The one about the boy" (8). That the collective narrator tells us Dilios "spins his stories" but is not the individual narrator of the graphic novel is reiterated twice more in the novel: the night just after Xerxes's ambassador comes seeking the Spartans' surrender and just before Ephialtes appeals to Leonidas ("Dilios spins his stories. His story about the Olympics. Not his best" 34); and the second night of the battle, after Dilios has lost the sight in one eye and Leonidas urges him to tell the men a story ("Dilios spins his stories. The story of Marathon. A perfect choice" 62).

That the film's narration departs from the novel's does not make it wrong. The choice to make the film narrator a single person with the poetic license to tell his story in whatever way he chooses, complete with embellishments and elaborations, may have been a practical one on the part of Snyder and his crew: Depicting a collective narrator would be difficult using a visual medium. The effect of the film's narrative alteration, however, compounded by all of the other differences between the novel and film, and novel, film, and historical record is to emphasize the individual over the collective, primarily Leonidas over the other Spartans but also the Spartans over the other Greeks and the Greeks over all of the Persians. This emphasis occurs deliberately in the film using other methods, too, when, for instance, during battle certain men, especially young ones, leave the phalanx for individual

combat, even though leaving the phalanx was against the protocol in hoplite action and was considered "berserker" behavior (Hanson 29; Cartledge, "What Has Sparta" 176, n. 51). Hugh Bowden comments: "It is quite important to bear in mind that victory was dependent on the sheer strength and cohesion of the phalanx; there was, quite literally, no room for individual acts of valor, and anyone who, before the moment of collision, stepped out of line, weakened his own side considerably" (53). The film's deliberate emphasis on the individual as opposed to the collective is also accomplished in the "Hero Kills" devised by the filmmaker, shots designed especially to focus audience attention on the individual Spartan combatant's death, already designated heroic because he is a Spartan and not Persian.[27] So here's another atrocious ruse: The film's discounting what the historical record asserts is the "hideous monster" of a collective Spartan tactical effort, instead featuring lone male efforts to pacify American audiences raised on the national myths of individual males enacting heroic masculinity.[28]

Because Americans have so little grounding in what are claimed to be the ancient Greek antecedents of our Western culture, and that minimal grounding, according to college educators Rose and Streufert cited earlier, is in the fantastical mythology of Greek gods and goddesses, they may be especially receptive to the "hysterical weirdness" with which Miller and Snyder tell the Thermopylae story. The hazard of American receptivity to the allure of "weirdness" is that it also can make viewers dismissive of the film's connection to their own lives except in its allegedly unmediated "entertainment" value. As Gideon Nisbet writes, Snyder's stylized characterization of the battle "handily pulled the plug on reading [the film] for ideology" (140). The respondents to Peter Travers's film review cited earlier repeatedly dismiss intimations that the film could be anything more than spectacularly entertaining. "[P]eople really should learn to separate fiction from reality" clucks megaton76; "suspend your disbelief for a few hours and enjoy the movie for what it's supposed to be. Entertainment" commands samanthadian; "It's just a movie and it is based on a GRAPHIC NOVEL and lightly from Greek mythology...stop over analyzing [sic] movies, they are just movies" elucidates ahalebgsu. They and other respondents exhort viewers to shelve their eye-of-the-beholder racist, misogynistic, ideological, historicist lenses and just enjoy the purity of the entertainment. Of course, what these exhortations ignore is that "entertainment," too, is in the eye of the beholder, a definition that can be debated ad nauseam. But the utter reliance on historical sources of both novel and

film—Miller's prolonged research and "Recommended Reading," and Snyder's gathering affidavits of historical authenticity from the likes of Victor Davis Hanson and Bettany Hughes—make Snyder's disclaimer of "weirdness" disingenuous and the respondents naive. Making patently clear his own ideological intents and, by extension, Zack Snyder's, Frank Miller comments about his novel *300* that "cartooning has shown itself to have editorial power" (Brayshaw 72), and the story of Leonidas at Thermopylae is a medium for his editorial. Showing his own ideological hand, Snyder refers to his film as combat violence rendered aesthetically, an "anti-anti-war film, where battle, death, and sacrifice are things to be celebrated" (*300: The Art of the Film* 39).

LEGACIES OF LEONIDAS

Americans Miller and Snyder are not the first to exploit the story of Leonidas and Thermopylae for editorial and ideological purposes, however. It seems that Thermopylae, the Spartans, and Leonidas since the clash at the Hot Gates always have been used ideologically, first by the Hellenes and then by Western Europeans. Paul Cartledge claims that Leonidas was not legendary while alive (*The Spartans* 257), but that to valorize their own effort at Thermopylae, the normally undemonstrative Spartans deliberately and uncharacteristically initiated an awards ceremony immediately after Thermopylae, inscribed a casualty list, and took the lead in commissioning Simonides to write the renowned couplet eulogizing all of the Greek dead (*Thermopylae* 155–159). Moreover, while Spartan kings killed in war typically were buried wherever they died, just as Sparta–Athens conflict was brewing and would culminate in the decades-long Peloponnesian Wars, Leonidas's remains serendipitously were recovered 40 years after his death and a Spartan cult was developed around his underdog legacy (160–163). Classical historian John Marincola claims not only that such "mythologizing" of the 479–480 BCE Persian Wars began with another Simonides creation as soon as the battle at Plataea was over, but that all history is a "deformation" as it reflects "present-day concerns" and local, unavoidable biases (106). Consequently, during the "culture wars" (Cartledge, *Thermopylae* 168) of the remainder of the fifth century BCE and into the fourth, after the area had endured the Peloponnesian Wars and when almost all Hellenic historians were patronized by Athens, the Spartan contribution to the Persian Wars was largely ignored (Marincola 107, n. 7) and the monstrously feminized Persians were "invented" by Athenian playwrights and vase

makers (Hall, "Asia Unmanned" 108). Although in the first century BCE Cicero translated into Latin the "Go tell the Spartans" epitaph written by Simonides (169), ideological use of the Spartans appears to have waned for a few centuries. At the turn of the millennium, however, the "Legacy of Leonidas" was renewed through Plutarch's AD first-century inclusion of Leonidas in *Sayings of Kings and Commanders*, the AD second-century establishment by the Romans of Sparta as a shrine-cum-tourist-attraction, and an AD third-century Christian's comparison of Leonidas to Christ (Cartledge, *The Spartans* 261–262). Evidence of the ancients' use and heroicizing of the Spartans at Thermopylae continued through AD second century as rhetoricians' and sophists' nostalgia for a golden past (Cartledge, *Thermopylae* 172), but seem to have halted in AD fourth century when, amid pagan and Christian conflict, Synesius of Cyrene claimed his Spartan (i.e., pagan) lineage (173).

Although by the fourteenth century in the Western world Rome had become the preferred ancient exemplar, admiration for Spartan Leonidas and the battle at Thermopylae appeared during the Italian Renaissance in a travelogue and a painting (Cartledge, *Thermopylae* 175–176). The greatest resurgence, however, continuing what twen-tieth-century-scholar Francois Ollier terms "le mirage spartiate," appeared across Western Europe during the sixteenth through nine-teenth centuries in artistic expressions such as operas and paintings, but especially in the eighteenth century Enlightenment and the nine-teenth-century "Age of Leonidas."[29] An example of the mirage, Ian MacGregor Morris tells us, was eighteenth-century Spartanophiles working with an eighteenth-century (mis)conception of Sparta, who reversed the up-to-that-time negative view of "democracy" as anar-chy and generated instead a positive connotation, forming what has become our current conception with a sprinkling of Athenian values ("The Paradigm of Democracy" 333). Prompted by the seventeenth century's challenge to the Church as the sole source of morality, in this "Quarrel of the Ancients or Moderns" (342) many European intellectuals looked to the ancient world as a source of morality and ethics (349). Men like Charles Rollin (339–343) and Gabriel Bonnot de Mably (343–347) came down against the Athenian model that exemplified for them restraints on freedom, and on the side of Sparta's concern for freedom in the collective through direct political partici-pation (345). At the same time, Cornelius De Pauw and others saw freedom in the Athenian commercial world with individual citizen participation in civics, not politics (347–349). Morris concludes that though the Sparta model used by Rollin and Mably was "the Sparta

of the eighteenth-century imagination" (347), that imaginary Sparta has significantly influenced our Western democratic civilization. "*Politically*," Morris asserts, " 'democracy' came to mean a system of representative government [via the imaginary Sparta]; but *culturally* it maintained its Athenian connotation" (356; emphasis in original).

In this essay, Morris refers to Richard Glover's 1737 epic poem, *Leonidas,* as a text that elucidates a main point in the "Quarrel": the conflict between individual and collective interests. The poem, claims Morris, resolves that conflict in combining the two: "The public sphere does not subsume the private; it is not a question of choosing between personal and public interests; rather, it is recognizing that they are one and the same." Glover's Leonidas, Morris claims, verifies this "one and the same" sentiment as he believes that "[t]o fail to die for his country would be failing his family" (350). In another essay, " 'To Make a New Thermopylae': Hellenism, Greek Liberation, and the Battle of Thermopylae," Morris takes up the poem again, pointing out its signaling the beginning of the "eighteenth-century obsession with Thermopylae" (211), an obsession typified by the British and French philhellenistic belief that, to counter Turkish domination, the Greeks needed to be awakened to their glorious past, and the philhellenes were the ones to do that (220). The Spartan Mirage tale of *Leonidas,* then, was used ideologically to rouse the eighteenth-century Greeks against the eighteenth-century Turks. Furthermore, reasons Morris, though Glover might have opted for another Greek hero from the Persian Wars to make his case, Leonidas was the most suitable figure not because he was exceptionally heroic but because, as the only one of the heroes to have died in battle during these wars, "[h]e alone was untainted" by subsequent ignominy (221). Perhaps most resonant in this investigation of the twentieth- and twenty-first-century *300*s, Morris reports that *Leonidas* follows the historical sources (Herodotus, Diodorus, and Plutarch) about Thermopylae except in one notable instance: Glover makes Leonidas the last of the Greeks to die, "a necessary device for the central hero of an epic poem" (228, n. 8). It is apparent that on this crucial plot point, Miller and Snyder followed Glover's eighteenth-century Spartanophile lead and not those of the ancient sources as alleged, for instance, by historian Victor Davis Hanson.

Moreover, because according to Herodotus and these later Spartanophiles Leonidas knew that the battle was suicidal, his heroism was regarded by eighteenth- and nineteenth-century philhellenes like Glover as more moral than martial: "While [Leonidas' heroism] necessitates physical bravery, it is much more than that because the

source of that bravery is moral. It is premeditated and inspired by a love of 'liberty,' which to the eighteenth- and nineteenth-century mind was inextricably connected to 'virtue' " (Morris, "To Make a New Thermopylae" 222). Thus, ancient Thermopylae was used ideologically as a moral exemplar by Glover and other philhellenes such as Romantic poets Lord Byron and Samuel Taylor Coleridge for the eighteenth- and nineteenth-century moral and political regeneration of Greece. Paul Cartledge adds that *Leonidas* "can be seen as having kick-started the construction of a modern myth: one that evolved from Glover's literary paradigm into a rallying cry of moral rearmament" (*Thermopylae* 184–185). Scholar Emma Clough joins the discussion of *Leonidas* as she argues for the "contemporary relevance" of Thermopylae in the eighteenth-century Western world (365). Her disquisition in "Loyalty and Liberty: Thermopylae in the Western Imagination" concludes that, for British monarchs still reeling from the aftereffects of the 1688–1689 Glorious Revolution, Glover's 1737 *Leonidas* provides a model of the "patriot king." If the British monarch were to follow Leonidas's example of uncompromising loyalty to his homeland, Clough argues the poem asserts, like Glover's Leonidas he "would be guaranteed this kind of unswerving loyalty from his people" (368). Both Cartledge and Clough also raise the patriotic theme ascribed to Thermopylae in their separate discussions of Jacques-Louis David's painting, "Leonidas at Thermopylae," completed in 1814 for his patron, Emperor Napoleon Bonaparte. Clough continues her case that Thermopylae has been made to resonate in the modern world, while Cartledge cites David's intents for the painting: "he had wanted 'to characterize that profound, great and religious sentiment that is inspired by the love of one's country' " (*Thermopylae* 182).

Despite these centuries of the Western world's use of Thermopylae to elucidate contemporary ideological situations,[30] according to scholars perhaps the most significant contribution to the modern Western conception of Thermopylae and the Greek connection to the Western world is George Grote's monumental 1846–1856 *History of Greece*. In a contemporary review of the first of Grote's volumes, nineteenth-century economist and philosopher John Stuart Mill "forcefully expressed" an idea gleaned from Grote's history, the "connection between the ancient Greeks and Us" (Cartledge, *Thermopylae* 199). Current scholar Alexandra Lianeri affirms that connection being made, but claims it was Grote's contemporary history and not the partial and uncritical ancient Greek historiography that created the cultural opposition between East and West. How else, she asks, "could a parochial antagonism [between Greeks and Persians] come to be

seen as the inaugural conflict between East and West, civilization and barbarism, liberty and despotism, rule of law and subjection to oppression?" (333). Predicated on the unexamined assumption that the Persian Wars represented the foundational divide between civilizations, Grote's history not only "authorized the modern conceptual polarity between East and West" (333), it also privileged European historiography with universality, with being the voice of all humankind "by excluding the Orient from the realm of historical consciousness" (334).

Late nineteenth- and twentieth-century uses of Thermopylae, Leonidas, and the Spartans include the British public school system; Greek, English, Scottish, and Irish plays, poems, and novels; Nazi eugenical ideas and resistance to those ideas; and representations of another ostensibly East–West conflict, the Cold War (Cartledge, *Thermopylae* 185–194; Bridges, "The Guts and the Glory" 406–410). D. S. Levene also cites uses of Thermopylae in the mid-twentieth-century United States: the 1951 signing of the Marshall Plan in Thermopylae ("Xerxes Goes to Hollywood" 383, n. 3); then-presidential candidate Thomas Dewey's 1948 linking of the Greek fight against communism to the battles at Thermopylae and Salamis (384, n. 5); former-presidential candidate Adlai Stevenson's 1959 casting of the Athenians as democrats and the Spartans as tyrants (385, n. 7); and Joseph Alsop, in a 1963 eulogy to the assassinated JFK, quoting Simonides's epitaph, "Go Tell the Spartans" (384, n. 6). Interestingly, Hollywood film, the twentieth and twenty-first centuries' dominant cultural medium in the United States, has used Sparta, Thermopylae, or Leonidas very little; only *The 300 Spartans*, the film Frank Miller cites as inspiring his graphic novel *300*, has featured Thermopylae (Solomon 328). Even that lone film, made during (and about) the Cold War, was overshadowed by the tens of "sword and sandal" films featuring ancient Rome (Cartledge, *Thermopylae* 193; Solomon 21).[31]

Gideon Nisbet explains that ancient Greece has been problematic in Hollywood for two reasons: first, Greece is known for its ideas, and not only are ideas challenging to represent visually, American audiences equate ideas with boring intellectualism; second, Greece is also known for male same-sex desire, another subject Hollywood has been challenged to represent (7). "Male same-sex attraction," contends Nisbet, "was—and remains—Hollywood's greatest taboo" (98). Therefore, because in the United States martial character is assumed to be and enforced as heterosexually masculine, Sparta is the "last, best hope for a heterosexually presentable Greece" (76). This heterosexual representation prevails in 1962's *The 300 Spartans*, a film

D. S. Levene says was "sanitized" for its Cold War American audience to make the Spartans–Western alliance appear democratic, and, by extension, the Persians–Soviet bloc tyrannical (399). Not only were the filmmakers advised by their historical consultant to censor from the film Spartan institutionalized pederasty, he also urged eliminating other elements of Spartan culture regulated by the state: helotry, the syssitia (the male communal barracks and messes), Agoge, the Krypteia, and formal exile, or xenelasiai (386–387).[32] While these prevaricating omissions have appeared in Miller's and Snyder's texts, added to the 1962 representation of Leonidas and replicated in the graphic novel and the recent film is the notion of Leonidas's abandonment by Spartan leaders and his unilateral decision to face the Persians with his few 300. Levene explains that political abandonment of the military was a "prevalent" theme in twentieth-century America, echoing then-popular film representations of the Alamo, resentments about the unresolved US war in Korea, and portending a similar resentment about Vietnam (388, 394–395).

LESSONS IN AND ABOUT HISTORY

Given the long and consistent ideological use of Thermopylae, Sparta, and Leonidas, how are these subjects being used in the two versions of *300* appearing at the turn of the twenty-first century? Aside from his desire to depict a good man doing good and achieving good, how is Miller editorializing? What editorializing is Snyder doing with his "hysterical weirdness," burdened as "hysterical" is with misogynist and homophobic overtones? What editorializing are both effecting when they frame the Spartans as morally and militarily faultless and the Persians as utter monsters? Because blue-screen filmmaking is among the most mediated of film products, what is the outcome of this film's mediations?

Most of the film's critics admit that the film verges on silly: the "nuttiest film ever to become an enormous box-office hit" and a "porno-military curiosity" says David Denby in *The New Yorker*; the film is "so stylized that it might as well be animation" claims BBC's Paul Arendt; "the sheer hyperbole of the film's style…militates against taking it too seriously" advises *The New York Review of Books*' Daniel Mendelsohn (38). While Mendelsohn acknowledges the film's ahistoricity, he ridicules those who *do* take the film seriously, especially the "indignant" Iranians with "fervent eyes," or in the United States "even more moderate spokesmen for Iranian interests" who connect the representations of the Persians to 9/11/01 (37).

"[I]t's hard to believe," says Mendelsohn, "as many of the film's critics do, that these cultural stereotypes [of rational Greeks and decadent Persians], coming at a tense moment in US relations with the Middle East, are the reason for its enormous popularity." Despite an apparently even-handed dealing with stereotypes of Greeks and Persians, what Mendelsohn continues to search for in audiences, however, is "anti-Asian sentiment," discovering instead "that people understood quite well that they were in the presence of an over-the-top, highly stylized representation that had little pretension to any kind of historical or even cultural verisimilitude" and that "few of the audience members found themselves inspired by the experience of watching *300* to change their feelings about Iranians or anyone else" (38).

Mendelsohn's focus on the Persians instead of the Greeks is telling. Granted, the look of the film, the muscleman bodies and martial single-mindedness of the Spartans is stylized, "over-the-top," perhaps even camp. But in the context of the film and its source material, the graphic novel, with their omissions and additions to and anachronistic uses of what little we know about the Spartans, and the two texts' varying narrative points of view, the Spartan masculinist and militarist ideology is so entirely normalized and unchallenged in both that American audience members become the Spartans and see the Persians only through their eyes. Regardless of our sex, *we* have survived being culled as infants, *we* have been trained to be masculine warriors from a young age, *we* are ready to die for "freedom," and *we* admire the decisive and principled action-taking of our king. We always are the normal Spartans, and they—whomever they have been or might be—always already are the abnormal Other.[33] The experience of watching the film, Mendelsohn grumbles, is "not even that of reading a comic book but that of playing one of the newer, graphically sophisticated video games" (39). To write off the novel and the film as juvenile claptrap having little to no American cultural or ideological resonance is as disingenuous for Mendelsohn and critics like him as it is for Miller or Snyder.

Admittedly, graphic novels and feature films, especially those concerning war, are more popular culture than high. It is easy to suggest, as have many of the responders to Peter Travers's online *Rolling Stone* film review, that the film *300* only is entertainment, intimating that the film only is meant to move viewers emotionally, not intellectually, to provide distraction from the everyday, not a heightened or critical awareness of the everyday's meaning. Paradoxically, even though all media is by its very definition mediated, "entertainment" typically

is used to mean a text that is unmediated, apolitical, uncontrived, "real." It is equally easy for those less familiar with the genre and more comfortably at home with imageless written storytelling to dismiss graphic novels as visual mindlessness, as kids' stuff, as "comic books." But because the visual is a central element of American education—through films, 24-hour television, videogames, the Internet, YouTube, not to mention Facebook—we ignore at our peril these kinds of texts as not only edifying but also ideological.

The US military understands how popular culture can impact its real-world mission. In *The Hollywood War Machine*, Carl Boggs and Tom Pollard assert that since the inception of American filmmaking, the Department of Defense and Hollywood have been mutually supportive, with American filmmakers' continuing investment in filmic depictions of war and the Department of Defense supporting (with locales, weapons, uniforms) those depictions as long as they favored the military and, hence, enlistment rates. Ed Halter, author of *From Sun Tzu to Xbox: War and Video Games*, agrees with Bogg and Pollard's assessment:

> For nearly a century [by 2002], the Army and other U.S. service branches had worked with the major film, television, and radio corporations on projects to help boost the military image... *Top Gun*, the 1986 Tom Cruise aerial vehicle—produced with the assistance of the Navy—reportedly increased [enlistments] by a ridiculous 400 percent; the Navy even set up recruiter tables at movie theaters once they realized what was happening. (xix)

This long-term military commitment to public relations in films culminated in the July 4, 2002 release on the Army's recruiting website of "America's Army," a first-person shooter videogame aimed at providing "vicarious insights into the challenges and rewards of Soldiering and national service" otherwise denied to young adults (vii–xxvii).[34] The game was a component of what Secretary of Defense Donald Rumsfeld termed "perception management" through the "blurring of news, propaganda, and entertainment" (Brewer 8, 234). According to Halter the game was spectacularly successful, having been downloaded 2.5 million times in its first two months (ix), and by 2005 was a commercial product (xix). Furthermore, in 2005, the game was joined on the Army's website by a serialized "America's Army" graphic novel, further appealing to the Army's typical demographic group of young males. In both cases, according to Halter and the Army's website, because the game and novel are digital, completely

mediated texts, the military was able to deliver directly to individual users a cohesive message without having to negotiate with filmmakers or radio producers.

What these two developments in perception management suggest is that these genres, and genres that resemble them aesthetically, can be used efficiently to great ideological effects. Boggs and Pollard detail one example of how this occurs:

> The military is now the main designer of war [video] games, developed through a working partnership with the entertainment industry, computer firms, and academia. At the University of Southern California, for example, the Institute for Creative Technologies (ICT) links these partners through a series of lucrative grants (including $100 million from the army in 2004) to manufacture sophisticated cycles of war games. (230)

To disclaim as nonideological the two versions of *300* because of their genres or appearance ignores the significant educational role these texts play in the lives of young people. What lessons, then, do Frank Miller's graphic novel and Zack Snyder's film teach?

First, they teach lessons about history. Primarily, they urge, history is learned through books in a classroom, that being a dull, colorless, and dispiriting exercise occasionally punctuated by images but fundamentally about memorizing dates and names. In that absolutist context, history simply is, and is not open to debate or interpretation. Once freed of classroom strictures, however, one no longer is expected to replicate names and dates or even have a basic understanding of the human past. In fact, the lesson continues, it is acceptable to alter the historical record to suit one's current needs; at this point, history is the opposite of rote memorization, and is largely opinion unencumbered by evidence. Capturing the "spirit" of a historical event, to use historian Victor Davis Hanson's language, is adequate for "entertainment" ("History and the Movie '300' "). Apparently, if one desires historical accuracy, even approximate accuracy, one should not look to be entertained, one should look to a documentary film. According to this binaristic lesson, feature films are for entertainment and documentary films are for edification. History either is in one thing or another; it cannot be in both.

Second, given the first lesson about history, Miller's graphic novel and Snyder's film teach that certain concepts have universal meaning, are natural, and so require no definition or cultural or historical contextualization; though abstract, the meanings of these concepts

cross boundaries of time and space and implicitly are understood by all humans. American audience members tacitly are expected by the texts to identify with the Spartans, an identifying that precludes challenging these supposedly universal notions. In this case, the concepts used as universal include three of the graphic novel's chapter titles—Honor, Duty, and Glory—and other words used frequently in both texts—freedom, courage, reason, and justice, all seven words that in their abstraction require an emotional as opposed to intellectual understanding. As they are used in the graphic novel and the film, they are neither defined nor debatable, especially because the cultural values and practices of the historical Spartans—helotry, pederasty, paganism, eugenics, that male Spartans have no choice about their martial careers nor females about their maternal ones—that could be seen as at least challenging and perhaps refuting these concepts as Western moderns understand them now have been censored from the two texts. Just as the film represents with "the spirit" of the historical event only the barest outlines of the Battle at Thermopylae, so too do these words represent abstractions on which audience members may not agree. This second lesson is that if spectators query the meaning of these concepts, the problem is not in the ideas being challenged but in spectators' inability to know inherently what these universal terms mean. The novel and film are not about human culture; they are about human nature.

Third, like the universalist terms taught through the second lesson, the graphic novel and film teach that traditional gender roles are natural; crossing gender role boundaries only can produce Persian (and colluders') unnatural decadence and physical monstrosity. The lesson emphasizes that masculine males naturally want to become warriors, naturally are suited to the Agoge training, and are at their natural best when they are in combat. They are decisive, audacious, able-bodied, and willing to die for proper though ill-defined causes. Despite the intense and long-term training invested in their preparation for combat, (Spartan) males are viewed as naturally masculine, masculinity being a state of reason and control. The texts also teach that masculine control as a male means engaging in sexual behavior exclusively with females. The masculine behavior of Leonidas's wife in the film complicates the equation of male = masculine, but the film especially clarifies that her performance of masculinity is anomalous and that any power she garners from that performance is only via her relationship with a man, the original and natural source of masculinity. Yes, she and by extension other Spartan females, suggest these texts, behave in masculine ways, but naturally they are physically

unsuited to combat, where real masculinity is enacted. Instead, their natural condition is to reproduce future male warriors and mothers of warriors, thereby supporting the masculinist, martial state. Males in this Miller/Snyder world who unnaturally breach this gender divide become nine feet tall, have stentorian voices, fey affectations, multiple body-piercings, dark skin, and layers of eye make-up. Females who unnaturally breach this divide find themselves in harems where they prefer women as sexual partners, have multiple and freakish disabilities, and support the male breachers in their monstrous and unreasonable efforts. Whether behaving naturally or unnaturally, the texts teach us, as though unable to resist what is instinctual, females regardless of their gender always follow the leads of and support males.

Finally, and perhaps most importantly, these texts teach that militarism is the truest and most enduring organizational tool for a civilized society. While some scholars confine militarism's meaning to the overtly negative results of a nation's armed forces prioritizing over other national needs its interests in recruitment, individual financial compensation, development of weaponry, and political power (Johnson), others broaden the term's scope to include the subtler integration of martial ways of thinking into the broader culture, what John Hopton calls the "glamorization of military culture and military actions" (115). The graphic novel and the film teach an amalgam of both versions with the Spartans as exemplars. First, the military is an apolitical institution, thereby committed to reasonable and pure, even self-sacrificing aims. Second, military members, with their masculinity naturalized and primarily driven by patriotism, voluntarily belong to this purely freedom-loving, defense-driven institution. Third, the military is led by a virile, masculine, sensitive man motivated only by the institution's pure intentions. Fourth, because of his selflessness, this leader can be trusted on his own to make geopolitical decisions for the state. Fifth, and finally, members of the nation, whether citizens or noncitizens, must not question the military's methods to achieve its pure aims but instead should be grateful, so that all of the members' activities unquestioningly are in support of the military's efforts. To challenge military activities in this militaristic context is to be at least, unpatriotic and at most, treasonous.

These lessons reveal not only Miller and Snyder's reliance on the records of ancient history, but the lessons also reveal their teachers' reliance on current events and sensibilities to lend resonance to their texts. Just as the seemingly benign online videogame and graphic novel recruiting tactics of the US Army are aimed at persuading young people, males especially, that the military is a viable and heroic option

to which they should commit their lives, so too do Miller's graphic novel and Zack Snyder's film try persuading their audiences that militarism is *the* viable option when good civilization is threatened by bad barbarism. Although their depictions of the Persians can be viewed as contrived and offensive, their depictions of Spartans speak to a post-9/11 American audience intent on seeing itself as the victim of a "clash of civilizations."[35] As Andrew Bacevich points out in *The New American Militarism*, this militarist ideology, "a tendency to see military power as the truest measure of a nation's greatness" (2), originated soon after the conclusion of the Vietnam War and was heightened by 9/11/01 and its ensuing events during the two-term administration of US President George W. Bush. Bacevich enumerates the manifestations of this militarism: a military budget that is disproportionate to the needs of the United States' defense (16); a conviction among Americans that war is normal and can be used to enforce diplomacy (19); with increased use of combat technologies, an American view that war is spectacle and aesthetically respectable (20); and the increasingly iconic status of American military institutions and their members. All of these qualities apply to the Spartan culture depicted in the *300*s, with its entire reason for existence committed to (self-)righteous warfare. Bacevich sarcastically draws a connection between the current American military and the ancient Spartans when he quotes Victor Davis Hanson, the classical military historian also called upon to validate Snyder's *300*, enthusing about the American soldiers as they advanced on Baghdad in March 2003: "Victor Davis Hanson saw something more than soldiers in battle. He ascertained 'transcendence at work.' According to Hanson, the armed services had 'somehow distilled from the rest of us an elite cohort in which virtues cherished by earlier generations of Americans continued to flourish' " (24).

Bacevich holds several actors responsible for this post-Vietnam resurgence of militarism: military officers trying to redeem their status after the Vietnam War; neoconservatives contending that evil existed globally and American military force could and should counter it; Ronald Reagan's constructing a Golden Age myth of a pure-hearted and noble American military; evangelical Christians demanding a return from the chaos of the 1960s to the traditional family values of proper gender roles, order, discipline, and self-sacrifice; "War Club" intellectuals trying to redesign the practice of war through "deterrence" and "precision attacks"; and the persistent American desire since the 1980 Carter Doctrine to secure access to oil. Products of popular culture, like films, videogames, music, and graphic novels,

reinforced these causes, so that together these efforts over the last 40 years predisposed the United States "toward militarism to produce the full-blown militarization of U.S. policy so much in evidence since 9/11" (177).

The agendas of these proponents of militarism also help to account for the appearance of Miller's graphic novel in 1998, a pre-9/11/2001 publication date sometimes used to explain away the novel's ideological effect, and the same year that Congress, under pressure from a group of neoconservatives, passed the Iraq Liberation Act of 1998.[36] Miller's link directly to the neoconservative cause is again through Victor Davis Hanson, who not only describes soldiers invading Iraq in 2003 as transcendent, but also is described by Bacevich as a neoconservative spokesperson who in 2002 anticipated the fall of Baghdad as an opportunity "to create a landscape for real revolution in the Middle East—a reordering that might prevent a future clash of civilizations" (94, n. 98). Hanson echoes the language of the neoconservative Project for the New American Century's "Statement of Principles" issued on June 3, 1997:

> As the 20th century draws to a close, the United States stands as the world's preeminent power. Having led the West to victory in the Cold War, America faces an opportunity and a challenge: Does the United States have the vision to build upon the achievements of past decades? Does the United States have the resolve to shape a new century favorable to American principles and interests? [37]

Snyder is also connected to this new militarism when he claims that "*300* is like twenty dozen Frank Frazetta illustrations made real, edited into an anti-anti-war film, where battle, death, and sacrifice are things to be celebrated. Every slash, impalement and decapitation should be rendered as a thing of beauty. It's war transformed into art" (*300: The Art of the Film* 39). While such aestheticizing of violence may not cause its viewers to want to kill or even resort to violence, Snyder's assertion romanticizes and thereby normalizes the actual violence of real war. As "disguised militarism," set as they are 2,500 years ago, Miller's graphic novel and Snyder's film may actually be more potent than outright propaganda as they exalt themes like patriotism, militaristic masculinity, and abstractions such as "freedom" (Boggs and Pollard 170).

Miller and Snyder's texts include other themes evident in the new militarism, especially a return to "traditional values" and the gender roles they demand. Women especially are adversely affected by

this redirection, as the resumption of pre-1960s' authorities signal a return to patriarchy and traditional versions of masculinity and femininity. According to Bacevich, this theme appears in the neoconservative and evangelical Christian discourses of militarism; the former proposes that crisis is a constant illness and that only decisive male leadership can provide the antidote (77–78); the latter bitterly resents the "feminizing" influence of women in the military. As Bacevich puts it, "Evangelicals wanted to put women on a pedestal, not in a cockpit or a turret" (144). Both of these attitudes had been simmering within the militarist resurgence for years before 9/11, but surfaced furiously after the 2001 attack. In *The Terror Dream*, Susan Faludi claims "Long before the towers fell, conservative efforts to roll back women's rights had been making inroads, and the media had been issuing periodic pronouncements on the 'death of feminism.' In part, what the attack on the World Trade Center did was foreground and speed up a process already under way." What Faludi notes, however, is that feminism and women independent of men astonishingly are blamed nationally for the Twin Towers attack. "In the fall and winter of 2001, the women's movement wasn't just a domestic annoyance; it was a declared domestic enemy, a fifth column in the war on terror. To the old rap sheet of feminist crimes—man hating, dogmatism, humorlessness—was added a new 'wartime' indictment: feminism was treason" (22). Faludi cites numerous public instances of such accusations, most of which conclude that "women's liberation had 'feminized' our men and, in doing so, left the nation vulnerable to attack" (23). This militarist and antifeminist context of the film's making explains how problematic expanding the role of Leonidas's wife from Miller's version might have been for Snyder. Had the film been true to the historical record of the ancient past, she would have been veiled, an image that in 2007 would negatively have evoked reportedly unfree burqa-ed Muslim women. Had she been depicted more as a modern-day, independently powerful American woman, she would negatively have evoked a treasonous feminist. To satisfy neoconservatives, she had to appear completely in support of her husband, the man with "flinty determination, moral clarity, and inspiration" addressing crisis (77–78), and for evangelical Christians, she would have to support her husband's war effort but know that her natural place is to be the protected at home, not the protector in combat.

The battle at Thermopylae has now been fought for millennia, as its end product, finally, is meaning. Ever since the battle, its meaning has been contested: does the conflict reveal anything about the human condition writ large? Can it illuminate the current situation?

How likely is it now that what we know of the battle and its context even comes close to what happened then? What Frank Miller's graphic novel and Zack Snyder's film show us is that as much as their makers claim otherwise, they cannot be outside of history, and that history itself is not immutable, it is not just names and dates; it always is interpretation within discourse. Although in using history we have an obligation not to prevaricate, not to misrepresent, our interpretation of it is bound to reflect who and when we are and how we see the world. Yes, the *300*s of Miller and Snyder unrelentingly depict the Persians as irredeemable horrors, but they commit an even greater and more desperate energy to concealing the monstrosity of (Spartan/American) militarism.

So Far ...

At this point in examining masculinity and monstrosity in contemporary Hollywood films, we've looked closely at two recent major movies, *King Kong* and *300*. Both drew considerable audiences worldwide and both are packed with signification beyond a casual viewing. In chapter 1, *King Kong* was opened up to suggest a range of left-leaning political standpoints available in it. Jackson weaves a laborite tale, and if there is an overall villain in his parable, that culprit is corporatism. In this chapter, *300* is unpacked to reveal the conservative political agenda at its heart, one well hidden and attractively packaged for ready consumption by its target audience: adolescent boys approaching and young men of military age. In a word, that film's agenda is militarism. So far, then, film monsters are turning out not to be what they, at first glance, so evidently seem to be. The fiercer Beast in *King Kong* is blind greed, not a giant terror ape. The greater Evildoer in *300* is Spartan masculinist bellicosity, not Persian freaks. Not incidentally, this tandem of corporatism and militarism forms the bedrock of global capitalism today. If monsters can be read as signifiers of crucial issues within the culture producing them, it should be unsurprising that these two principles of neoliberal globalization figure prominently in current Hollywood monster movies. Fittingly, the remainder of this book focuses on corporatism and militarism as these doctrines are intermingled in films with the concepts of masculinity and monstrosity. The next chapter, examining *V for Vendetta*, concentrates on corporatism. The chapter following, looking at *Tropic Thunder*, focuses on militarism. Of course, neither creed exists (nor can be discussed) without the other. Militarism is funded by corporatism, which, when push inevitably comes to shove,

is spread by militarism. In our fifth chapter, then, militarism, corporatism, masculinity, and monstrosity are explored as a culturally rich and telling mixture in *District 9* and *Avatar*. In our conclusion, we exercise our newfound vision on a film not typically associated with monsters: *The Hurt Locker.*

Love and Violence in *V for Vendetta*

In the Norsefire regime of James McTeigue's 2006 film, *V for Vendetta*, we come face-to-face with the corporate–military monster we've only sensed lurking in the background of *King Kong* and *300*. It should come as no surprise that figured in this near future, British totalitarian regime is the Bush administration of 2000–2008. Where Alan Moore, in his original graphic novel series, envisaged Norsefire as an expansion of the conservative Thatcher government in England during the 1980s, McTeigue and the screenwriters/producers of the film, the Wachowski siblings, do not disguise their updating of the story to a post-9/11 political landscape or their depiction of fascism as the neoconservative Republican party of the late-twentieth and early-twenty-first century. Like the Republicans, Norsefire embodies neoliberal, "free" market, commodity capitalism; it enacts hyper-acquisitive xenophobic militarism; it decrees Christian fundamentalist religiosity; it exudes hegemonic masculinity. High Chancellor Adam Sutler is a distinctly more articulate version of George W. Bush; Security Minister Peter Creedy is the ruthless and sinister power-behind-the-throne á la Dick Cheney; hate-T.V. host Lewis Prothero on BTN (British Television Network) is a spitting image for any number of fear-and-hate-mongers on FOX News—from Bill O'Reilly when the movie was first released to Glenn Beck subsequently, with the godfather of broadcast bigotry, Rush Limbaugh, distinctly in view. The film leaves no doubt that Norsefire is the NeoCon dream team and that its ideology is our worst nightmare. Norsefire power both produces and is founded on warped and heavily manipulated "truth" that the state shoves down the throat of its citizenry. While such jiggery-pokery is, of course, the standard formula for the hegemonic masquerading as the universal, Norsefire disciplines its subjects with ham-fisted resolve. As a result, its monstrous attributes are many and obvious.

The lone challenger to this apotheosis of the modern state gone wrong is the enigmatic title character named only as V. In pursuing his private revenge against Sutler and other officials who horribly disfigured him, V sparks a popular rebellion that topples the Norsefire regime. Similar to Frankenstein's Creature, V is a latter-day creation of the Enlightenment project that not only turns on its maker, but exposes the lie of, to evoke DuPont's old advertising slogan, better living through chemistry. The bourgeoisie of the early nineteenth century were concerned primarily with better living for themselves. That their devotion to scientific method coupled with capitalism also generated the byproduct of a large, unruly, and desperate proletariat, plausibly represented in Shelley's novel by the Creature, was an unfortunate circumstance that had to be both suppressed and concealed.[1] The Norsefire NeoCons of the early-twenty-first century engage in this same civic and scientific program, only now with a Nazi-like ruthlessness and efficiency. Their unfortunate byproduct, though, is V. He's a political detainee/subject of human experimentation who, as a result of being used as a lab rat, mutates into having, as his scientist-tormentors describe him, "the abnormal development of basic kinesthesia and reflexes." It is both with and because of these enhanced physical capabilities that V carries out his vendetta-cum-revolution. What is vital to note about V, and what differentiates him from the modern monster that is Frankenstein's Creature, is that the mode of V's rebellion is distinctly postmodern and its motivating concepts are aggressively post-Marxist. McTeigue and the Wachowskis do not deliver a run-of-the-mill, rugged individualist, underdog-sticking-it-to-The-Man revenge tale that is one of Hollywood's specialty genres. Nor do they make any effort to replicate Alan Moore's appeal, in his *V for Vendetta* series, to adolescent male libertarianism via bombastic and incoherent proclamations about Anarchy. Either of those story forms, ultimately, obscures the historical particularities and vexing complexities of the modern state and, thus, diverts audiences from scrutinizing our existence under modern power. Instead, the film *V for Vendetta* risks being a vehicle for openly socialist instruction and illumination—a true rarity for a Hollywood blockbuster film.

Not only is McTeigue's movie overtly anti-neoconservative (meaning set in opposition to corporatism, militarism, jingoism, racism, sexism, homophobia, culture wars, and all other power plays that NeoCons routinely pursue), *V for Vendetta* is an anti*liberal* film as well. That is, focus is not on the exceptional individual in a way that minimizes the social circumstances that put the hero into his predicament in the first place, such as what happens with John Connor in *Terminator*

Salvation. In McTeigue's film, nearly the reverse takes place. V's individuality is all but negated; he spends the entire movie behind a mask while other key characters—indeed, at the end, an entire nation—rise to his level of populist heroism. Thus, in *V for Vendetta*, bad guys die and buildings blow up not just for the gratifying, revenge-saga entertainment value of such spectacle. The hero(-monster) of this film is designed to make us *think* about why these events take place—and think about them in historical, social, political, and economic terms. In fact, more than just ruminate on the nature of modern power, V incites us to *change* the modern state as well. These elements of gnosis and praxis make *V for Vendetta* a Hollywood novelty, if not impossibility. Can the entertainment branch of liberalism actually release an action-thriller socialist treatise? We'll go out on a limb to assert that, with this film, it has.

Perhaps nowhere is this oddity more evident in *V for Vendetta* than in its treatment of love and violence. With regard to love, far from giving us the standard Hollywood subplot of the hero's love interest, in this case, a romantic relationship between V and Evey, McTeigue gives us instead love in the sense of social solidarity. As we saw with the relationship between Jackson's Ann and Kong, love in *V for Vendetta* denotes not sexual passion between two individuals, but a collective care and regard for our fellow beings—in other words, that old-timey, labor union notion of we're-all-in-this-together that is anathema to capitalism. Socialist love is placed at the center of this film in resistance to NeoCon hate. With regard to violence, far from presenting us the pat give-peace-a-chance lecture that sells well on the coasts, McTeigue offers instead a candid, Malcolm X take on violence. That is, meeting the brutality of bigotry and social injustice with aggression undertaken in the cause of inclusion and equality. While John Connor's violence against the Machines is a futile mirror of his own hegemonic status quo, V's violence against Norsefire is socially transformative. As uncomfortable as this lesson in realpolitik might be, this film, for all its dystopian fantasy, plunges viewers into the mess and the chaos of agonistic modern power. Moreover, unlike John Connor, the characters most in conflict with and monsterized by the Norsefire regime—V and a companion political prisoner at Larkhill, Valerie Page—represent the antithesis of hegemonic masculinity. Thus, modern hegemony is hyperbolized into the monster of Norsefire while the monstrous Others of Valerie, signifying socialist love, and V, signifying justified violence, are normalized into a postmodern society founded on pluralism, discursivity, and the promise of social justice. To investigate the radical democratic

politics animating *V for Vendetta*, first Valerie and V's clash with Noresefire will be explored. Next, we'll look at how other characters in the movie, liberals and neoconservatives alike, come to their senses to join in with Valerie and V's uprising.

VALERIE'S LOVE VERSUS PROTHERO'S HATE

V for Vendetta opened in March 2006 and by the end of its theatrical release had grossed over US$70 million (*Box Office Mojo*). With this impressive financial showing, however, came an intensely split critical response. Reviewers either hated or loved the film, and largely for the same reason: its unabashed allegory for the Bush administration—a correlation McTeigue openly acknowledged (Ott 40). As one critic sums things up bluntly:

> *V for Vendetta*'s England with its gay-bashing, spin doctoring news manipulation, Guantanamo Bay type concentration camps, and brutal authoritarian control really represents a dystopian version of contemporary America which is now continuing the legacy of Nazi Germany with suspension of civil liberties for suspected "terrorists", [*sic*] illegal confinement, government surveillance in defiance of its Constitution, torture, humiliation, and murder of prisoners aided by the complicity of an apathetic population who are the twenty-first century's equivalent of Hitler's "willing executioners." (T. Williams 18)

Many critics have enumerated these parallels between the Norsefire regime and, more than just Bush's America, the entire neoconservative backlash of the Republican Party that began with Reagan and continues its goal of reversing Franklin D. Roosevelt's New Deal.[2] Some reviewers find the comparisons apt and successful (Corliss; Kenny; Otto; Puig) and comment, for example, "The best political films are the ones that fuel debate afterwards and *Vendetta* should do that in spades" (Otto 11). Other commentators find the likenesses ridiculous (Burr; Denby, "Blowup"; Hunter, "'V'"; Podhoretz; Shepard) and call the movie "a dunderheaded pop fantasia that celebrates terrorism and destruction" (Denby 1) or "an *Atlas Shrugged* for leftist lunatics" (Podhoretz). If McTeigue and the Wachowskis wanted to stir the political pot as America headed for the 2008 presidential elections, mission accomplished.

More than agitate the political moment, however, *V for Vendetta* accomplishes what speculative fiction often does, namely, a revelation of the workings of power. Apocalyptic science fiction and dystopian visions frequently involve political realism, more often than

not displaying "the violence committed in the name of founding new modes and orders as well as for the sake of destroying unjust regimes"; despite the fantastical nature of these tales, in "portraying the upheavals wrought by political theology, they lay bare its mechanisms" (Paik 19–20). McTeigue's film avidly implements such a project. In his creation of Norsefire, McTeigue confronts head-on the conventional wisdom that capitalist liberal democracy constitutes the best of all possible worlds, in effect ending history in a bourgeois utopia founded on the "natural" human qualities of acquisitiveness, individual ambition, and meritocratic domination.[3] According to this cant, radical change to the current economic and political order both is unnecessary and would be calamitous. After all, runs the myth, neoliberal capitalism has already given us abundance and equality, and any move toward state socialism will only plunge us into "sclerotic bureaucracies, corrupt one-party rule, pervasive economic stagnation, and a disillusioned and cynical population" (Paik 125; see also Jhally). If one considers the paradox of this line of reasoning, the new conservatism "has succeeded in presenting its programme of dismantling the Welfare State as a defence of individual liberty against the oppressor state" (Laclau and Mouffe 175; see in general 171–175). That is, the very system *causing* poverty and inequality (thus necessitating welfare programs) must be protected from any rival system that seeks to *eradicate* poverty and inequality—raising the question of where the oppression lies. One has only to listen to the incessant railing against Barack Obama's being a "socialist" coming from FOX News to appreciate how any form of Marxist thought (however poorly understood by rightwing pundits) is one of the primary boogiemen paraded out by neoconservative propaganda. The other prominent fiend set before us by FOX and the Tea Party, of course, is the Other in various manifestations. Whether the offending differences are based on racial, religious, ethnic, sexual, class, bodied, or ideological grounds, any departure from the "normal" identity positions of neoliberal hegemony is construed as a threat. In *V for Vendetta*, Norsefire is rife with all of these beliefs and attitudes, and nowhere do we see them in a more concentrated form than in the character of Lewis Prothero (Roger Allam).

As the front man for the regime, Prothero disseminates its policies and viewpoints nightly on his television program "The Voice of London," broadcast over the state-run medium of BTN. The first time we see our protagonists, V (Hugo Weaving) and Evey (Natalie Portman), each in front of a mirror separately preparing for a night out, Prothero's show is on in the background, as though inescapable.

In this initial exposure to Norsefire, we're subjected to Prothero's shocking vitriol. His topic is the USA, or, as he calls it, the "Ulcered Sphincter of Asserica."

> I mean, what else can you say? Here was a country that had everything, absolutely everything, and now twenty years later, is what? The world's biggest leper colony. Why? *Godlessness.* Let me say that again. *Godlessness.* It wasn't the war they started. It wasn't the plague they created. It was Judgment.

In the near-distant future of the film, the United States has fallen from its superpower pedestal and is in the throes of a civil war. According to Prothero, however, England avoided such a catastrophic collapse—associated by him with gay sex and sexually transmitted diseases (STDs)—thanks to the Godliness and stern resolve of Norsefire. He concludes his rant:

> You think He is not up there? You think He is not watching over this country? How else can you explain it? He tested us but we came through. We did what we had to do. Islington. Enfield. I was there. I saw it all. Immigrants. Muslims. Homosexuals. Terrorists. Disease ridden degenerates. They had to go! Strength Through Unity, Unity Through Faith! I am a God-fearing Englishman and I am God-damned proud of it! (Applause.)

We'll come to discover, however, that this "test" from God was a string of disasters orchestrated by Norsefire in the form of "terrorist attacks." These assaults were brutally perpetrated on the English citizenry to create panic and, during the crisis, seize absolute political control. Far from being a God-fearing Englishman, then, Prothero turns out to be a preening charlatan and arch-hegemonic man—capitalistic, militaristic, racist, and homophobic. Far from defending capitalist liberal democracy, Norsefire is an especially vicious manifestation of the hegemonic project Laclau and Mouffe term "liberal-conservative discourse," the purpose of which is "to articulate the neo-liberal defence of the free market economy with the profoundly anti-egalitarian cultural and social traditionalism of conservatism" (175). Such discourse hypocritically preaches democratic principles within a free market environment while simultaneously rigging laws and institutions in favor of the already economically advantaged as well as preserving the inequalities existing in many social relations. Key to that strategy is establishing equality for *some*—that is, fixing as "natural" and "universal" not only the neoliberal economic order

but long-established social hierarchies and prejudices. Such a task quintessentially is Prothero's. His individual articulations of hatred, bigotry, and lies add up to an overall Norsefirean discourse that seeks to demarcate reality into a frozen and eternal moment. Any ideology or element of society not conforming to Prothero's vision, of course, automatically becomes the enemy of Norsefire "truth."

More than just a chilling, over-the-top depiction of the NeoCon Bush administration, however, McTeigue's Norsefire can be understood as a portrait of the neoliberal hegemony in its death throes. In the future world of *V for Vendetta*, the capitalist system appears to be near, or already to have reached, its inherent limit and point of self-cancellation. In our own non-fictional world, the capitalist imperative for endless growth is colliding today with the competition for dwindling resources as well as with environmental deterioration. Decades from now, when this story is set, the proverbial shit seems to have hit the fan.[4] In response to the predicament, Norsefire has all but ceased being a modern state in Foucault's conception of that entity. The techniques of pastoral power and discipline have been abandoned by Chancellor Sutler. No longer is a pyramidal hierarchy induced by "agonism," that is, by power relations where citizens "are faced with a field of possibilities in which several kinds of conduct, several ways of reacting and modes of behavior are available" (Foucault, "Subject and Power" 139). Instead, the Norsefirean Panopticon functions strictly as a confrontation strategy, not managing a set of actions on possible actions but governing its subjects in a master–slave relationship (142–143). The apocalyptic endgame of capitalism certainly is on Alan Moore's mind when depicting the Norsefire of his graphic novels. Paik comments perceptively about how a society accustomed to abundance can lose sight of a reasonable preservation of its status quo to engage instead in a damaging and hopeless defense of unjustifiable expectations. Of Moore's fascist regime, Paik says: "*V for Vendetta* unfolds on the other side of that threshold, in which a liberal democratic society, having been dealt too many devastating blows, has succumbed to the forces of inhuman will and unforgiving necessity" (181). McTeigue's Norsefire shows us the same prospect of a liberal democratic society pushed past the brink. However, the politics and circumstances of Moore's and McTeigue's visions are quite different. Moore's vendetta is aimed at the heavy-handed policies of the Thatcher government as it discriminated against homosexuals and those suffering from AIDS, and his political countersolution is Anarchism.[5] McTeigue's target is Bush-era neoconservatism as it exploited post-9/11 fear and bigotry via the specter of Islamic terrorism, and his political alternative is Socialism.

Thus, while Moore is eager to assert the calamity of capitalism's downfall and hence the pernicious nature of Thatcherism, McTeigue is engaged in proposing a way to avert calamity before it's too late, and thus work against the Republican politics of hate. Probably this difference is why the film "defangs fascism" in Moore's view. Instead of a traumatized population, as we see in the graphic novel, "the people in the film are shown as thoroughly pacified and almost super-naturally untroubled, as though their state of deception and bovine immersion in the insipid and heavy-handed programming produced by the government were enough to substantiate their innocence in the atrocities committed on their behalf" (Paik 158). Is this not a fitting description and portrait, however, of a fat, dumb, and happy American public in the early twenty-first century? Are we not, as a nation, more engrossed in *American Idol* than alarmed by American wars in the Middle East? Moore wants to shock and shame 1980s' British readers with biting political satire.[6] McTeigue seeks instead to rouse and motivate 2006 American moviegoers, and particularly the newest generation of voters, with thriller-packaged political allegory. Therefore, similar to American actress Natalie Portman's playing the crucial role of Evey Hammond in the film, the citizenry portrayed in *V for Vendetta* is in essence the American public, but fitted out with English accents and cultural trappings. Often displacement, taking a fictive step back, is the best strategy for political comment and satire. With our first taste of Prothero's "The Voice of London," American audiences know that we're not really in England. This is unmistakably American-style hate T.V. we're seeing, and so we realize from the start that this movie will tell us something about ourselves, about our here and now. In this educative project, McTeigue's focal instructional device is Valerie Page (Natasha Wightman), an ostensibly minor char-acter introduced halfway through the film.

Many critics note the importance of Valerie in the film, point-ing out how her plight at Larkhill Detention Centre parallels that of "enemy combatants" illegally held at Guantanamo Bay (Porton 54) or how the homophobia she suffers figures for a range of other prejudices (racial, religious, political) suffered by prisoners of the Nazi death camps (Davidson 159). When searching for the ideologi-cal heart of McTeigue's movie, though, it's clear we need look no further than Valerie, and specifically to her autobiography written on toilet paper and delivered surreptitiously to the prisoner in the next cell. Quite simply, Valerie is the anti-Prothero. Everything he (and Norsefire) is, she is not. Prothero is hegemonic man, propagan-dist, capitalist, militarist, heterosexual, and oppressor. Contrariwise,

Valerie is lesbian, resister, artist, and oppressed. The cardinal principle of Norsefire is hatred fueled by fear via demonizing the Other, and its cardinal actions are scapegoating and forging universality. As we will see, Valerie's cardinal principle is love resulting in solidarity, and her cardinal actions are pluralism and freeplay. *V for Vendetta*, then, stages an overtly political clash between the currently dominant neoliberal hegemony (fictively pushed to its extreme) versus, generally, a more equitable and inclusive democracy. It also imagines the overthrow of the former by the latter through agency that is anything but hegemonically masculine.

Ellen Crowell explores insightfully the iconic presence of Oscar Wilde as a gay activist and aesthetic superhero in the *V for Vendetta* graphic novel and film. Her essay traces how in the underground British comic-book culture of the 1980s, a new "Wilde type" emerges that reimagines Oscar Wilde not as a "martyred artist and gay saint" but as "a physically imposing and ideologically incendiary agent of social transformation, who enacts, rather than inspires, outraged vengeance" (21). Obviously, this heroic character is V. V's whole motivation for vendetta, however, originates with Valerie. Crowell not only points out how Valerie's prison letter functions as "a queer epistolary autobiography turned countercultural weapon" in the story, but also demonstrates how Valerie's letter can be understood "as a provocative echo of Wilde's *De Profundis* and its potent afterlife in the history of queer activism." That is, Valerie's prison letter, like Wilde's, represents martyrdom that "inspires future acts of civil disobedience" (30–31). The similarities between the two writings are not slight or unintended. Notes Crowell:

> Wilde's letter, like the film's depiction of Valerie's story, veers wildly between memories of past artistic and romantic triumphs and present ignominious suffering, and finally coalesces into a spiritual autobiography of sorts, in which one finds shame, anger, and hatred replaced with a poetics of suffering, humility, and ultimately, love. (40; see also 40–42)

As will be explored later in this chapter, the film *V for Vendetta* foregrounds connections to and reverberations of Wilde much more than the graphic novel. No link is more important, though, than Valerie and her letter. Emotionally and visually, Valerie's voiceover and flashback mark the turning point of the film from cramped repression and abject fear to the hope and excitement of resistance (Ott 45–46). Both main characters of the movie, V and Evey, see their revolutionary

rebirths in opposition to Norsefire as a result of reading Valerie's letter. Far from Evey's being manipulated in a sexist manner by V in her imprisonment and torture experience, then, as critics have objected,[7] the radical spirit of the film stems from the social and political convictions of Valerie. As Tony Williams observes, "Valerie thus becomes the true center of the film. Evey achieves personal liberation through the agency of a gay woman rather than a male as in *The Phantom of the Opera*. After V leaves the stage, she will not end the narrative by loving Big Brother. Instead, Evey envisages a new form of community" (23). This new community originated by Valerie, birthed by V, and lived by Evey, is both non-patriarchal and post-Marxist.

The foremost political mechanism laid bare by McTeigue's dystopian vision is hegemonic subjectivity. The movie demonstrates for viewers how a faction of society, in this case Norsefire, both seizes and maintains power not only through the force of arms but, even more proficiently, through the force of discourse. Prothero's whole purpose, as we've seen, is artificially to freeze social relations into a bogus order and "universality," into what Laclau and Mouffe term "nodal points." These are privileged discursive moments of partially fixed meaning, as any political discourse "is constituted as an attempt to dominate the field of discursivity, to arrest the flow of differences, to construct a centre" (112). As with any transcendental signified, however, there are more signifiers than a bogus center can accommodate and thereby bring under control. As Laclau and Mouffe point out, "the premise of *'society'* as a sutured and self-defined totality" is a chimera; "neither absolute fixity nor absolute non-fixity is possible" (111). The articulation of nodal points arises out of "the infinitude of the field of discursivity," and thus every discourse is constantly at risk of being overflowed by that infinitude of meanings (113). Valerie, along with all the other detainees of Larkhill, represents a floating signifier threatening to swamp the Norsefirean boat of frozen meaning. Hers is a subjectivity that does not fit—or, to put it more precisely, suit—their particular (posing as universal) concept of society. Valerie's renegade identity makes her a discursive gap in the hegemonic social order, that is, what Laclau and Mouffe term an "antagonism":

> If...the social only exists as a partial effort for constructing society—that is, an objective and closed system of differences—antagonism, as a witness of the impossibility of a final suture, is the "experience" of the limit of the social. Strictly speaking, antagonisms are not *internal* but *external* to society; or rather, they constitute the limits of society, the latter's impossibility of fully constituting itself. (125)

More than an inconvenience to the dominant discourse, such antagonisms endanger the status quo. The existence of an Other not only exposes the artificial nature of a nodal point; it can provide a basis for rebellion as well. Valerie's resistance to the Norsefire regime is clear in her prison letter:

> It seems strange that my life should end in such a terrible place, but for three years I had roses and apologized to no one. I shall die here. Every inch of me shall perish. Every inch, but one. An inch. It is small and fragile and it is the only thing in the world worth having. We must never lose it or give it away. We must never let them take it from us.

More to the point, Valerie's active social antagonism of the Norsefire hegemony renders her atrocious and insufferable in its eyes. She is to be segregated, imprisoned, and ultimately destroyed—though not before experimenting on her for profit. Valerie (and her ilk), then, is the monster in the film *V for Vendetta*. To Norsefire, she is the creature from *beyond*. And her exact menace to this society is love. Valerie concludes her letter:

> I hope that whoever you are, you escape this place. I hope that the world turns and that things get better. But what I hope most of all is that you understand what I mean when I tell you that even though I do not know you, and even though I may never meet you, laugh with you, cry with you, or kiss you, I love you. With all my heart. I love you.

Here Valerie speaks, obviously, not of romantic or sexual love but of a broadened societal concord based on the pluralistic acceptance of all people, not just those of the dominant order. If we wanted to arrest our analysis at this point, a facile critical satisfaction, or dissatisfaction, could be achieved by reading the movie as yet another liberal entreaty from Hollywood for the dawning of the Age of Aquarius. That is, everybody is simply to love one another right now. Happily, McTeigue and the Wachowskis give us no such one-dimensional gratification. Their political vision in *V for Vendetta* is more complex and troubling.

The beast of McTeigue's film—that is to say, in turn, Valerie then V then Evey—embodies and pursues what Laclau and Mouffe identify as "radical and plural democracy." In their call for a new socialist strategy, Laclau and Mouffe dismiss the notion from traditional Marxism of the worker being a transcendental signified, that is, a homogeneous group that someday will set right all of the wrongs of capitalism. In place of this idea, Laclau and Mouffe advocate for a post-Marxist

agenda that tackles issues of both "redistribution" (meaning wealth inequity) and "recognition" (meaning social identity). In their view, what needs to be challenged along with the subordination of the working class under capitalism is the subordination of various subject positions as well; in this way, "struggles against sexism, racism, sexual discrimination, and in the defence of the environment" can be "articulated with those of the workers in a new left-wing hegemonic project" (xviii). *V for Vendetta*, like Jackson's *King Kong*, effectively unites these two concerns. Norsefire is vilified both as an economic manipulator and as a cultural bully, with more emphasis put on culture war issues in the film. Valerie's love in opposition to Prothero's hate concretizes the struggle for a plural democracy. Equally crucial to Laclau and Mouffe's political praxis is the radical dynamic of post-structuralist freeplay in combination with the socialist agenda. As described above, for these political theorists, any hegemony is made to be broken and, in turn, replaced with another ever-under-negotiation hegemonic discourse. Incessant hegemonic struggle is not only "the nature of power relations, and the dynamics of politics" (xix), but also the guarantor of democracy itself. Any regulative idea of a rational consensus, no matter how benign, in fact puts at risk the democratic project. For Laclau and Mouffe, "without conflict and division, a pluralist democratic politics would be impossible" (xvii). What this means is that democracy never reaches an endpoint; it's never wholly complete; circumstances always will demand adjustment; politics is a perpetual conversation—if not shouting match. The enactment of this political freeplay in McTeigue's monster movie is brought to screen in the death-match between modernist Chancellor Adam Sutler, who has tried to stop all discussion, and postmodernist rebel V, who is bent on introducing a different point of view.

V's Violence versus Sutler's Violence

Where Valerie incarnates the principles of radical and plural democracy, V is the instrument to carry them out. His objective is dual: to avenge the atrocities done to those at Larkhill, and to start the agonistic conversation that will negotiate a new hegemony. While the stage is set for the customary Hollywood action-revenge movie that centers on the deeds of an everyman hero (very often named Jack), V gives us anything but such a normative character. Instead, V presents us with such a range of characteristics and identity positions that he ends up having no recognizable identity whatever. In his creation at the hands of scientific experimentation, V is similar, as mentioned before, to the

Frankenstein Creature. Like that famous patchwork of reanimated body parts, V emerges from the explosion at the Larkhill Detention Centre with his memory erased, having extraordinary strength and agility, and so deformed as to be something hideous and undecipherable. What to make of V as a social entity, then, is a problem. With regard to bodiedness, V is both hindered by the awful scorching he underwent but also super-enabled by his physical enhancement. With regard to sexuality, many critics type him as gay (see T. Williams 21), while others see V as a "strangely chaste, apparently heterosexual" character (Porton 54). With regard to culture, one commentator regards V as a floating signifier of intertextuality who "leaps into and out of a variety of narratives, deriving and lending a meaning only briefly before he moves on to the next meta-cultural reference" (Keller 10). Part of this shape shifting involves four political identities of those Norsefire inters at Larkhill: Muslims, foreigners, homosexuals, and dissenters. Keller notes how the film is vague about linking V specifically to any of these groups, but judges that gay and nonconformist are the likeliest descriptors for him, singly or in combination (80). The result of this ambiguity is that "audiences are not invited to identify with V" (Ott 45). Instead, like the other characters in the film, we are confused and disconcerted by him. V upsets our concept of "normal." He is queer in the peculiarly outrageous way theorized by Cohen, where monsters are "the living embodiment of the phenomenon Derrida has famously labeled the 'supplement.' " As disturbing third-term hybrids, such beings shatter our binary thinking habits and force "a radical rethinking of boundary and normality" (6–7). Nowhere is V's patent Otherness more troubling than with regard to gender.

At different points during the film, V fits all four of R. W. Connell's categories for modern masculinity. The most confounding swing might be his enacting both hegemonic warrior and subordinate aesthete, symbolized by his leaving a rare breed of rose on the bodies of his victims. Such effete violence is difficult to process. At times, V is decidedly feminized as well. He mothers Evey back to health early in the film, and later acts as a midwife to her political rebirth (just after brutalizing her as her jailor). In one scene, V even plays the role of Mum in the kitchen, frilly apron and all, cooking up a breakfast of "eggie-in-the-basket" for Evey and thereby creating a moment of domestic refuge that Norsefire had ripped away from her as a girl. The key to this disparate behavior by V, of course, is Judith Butler's concept of performativity. V is a gender monster precisely because he is pure performance, able to play all identities without, at core, being

any one of them. V's air of theatricality highlights this playacting. He disrupts the regulatory fiction of gender as a primary and stable identity, and such a disturbance inherently is resistant to hegemonic subjectivity. As Butler reminds us, "That gender reality is created through sustained social performances means that the very notions are also constituted as part of the strategy that conceals gender's performative character and the performative possibilities for proliferating gender configurations outside the restricting frames of masculinist domination and compulsory heterosexuality" (*Gender Trouble* 141). V's gender jamboree in defiance of the artificial stability of hegemonic masculinity, then, is a crucial ingredient of his insurrection against Norsefire (which is, by no coincidence, a masculinist and a neoliberal regime). Being a gender rebel and being a political rebel are indistinguishable in the case of V's monstrosity. Accentuating V's unstable identity are his Guy Fawkes mask and costume along with his aforementioned vaudevillian panache. V performs constantly and single-mindedly. We should take to heart his remark to Evey at their first meeting: "the paradox of asking a masked man who he is." As we are reminded throughout the film, V is no one. When Evey inquires about his personal background then offers to remove his mask, V stops her, saying: "There is a face beneath this mask, but it is not me. I am no more that face than I am the muscles beneath it or the bones beneath them." Instead, we are told, V is an idea. Creedy desperately asks V, after shooting him repeatedly, "Why won't you die?" V tells him, before killing him, "Beneath this mask there is more than flesh. Beneath this mask there is an idea, Mr. Creedy. And ideas are bulletproof." V's floating and performative identity thus operates as the primary delivery vehicle for the political messages of *V for Vendetta*. So the question becomes: What idea *is* V? What concepts animate his elaborate performance?

McTeigue asserts the open nature of this question, saying his movie is "politically ambiguous, and the more credit and intelligence you give the audience, the better. I think it's time for films to be put out there and for audiences to make up their minds rather than have movies bleat to them, 'This is what to believe' " (qtd. in Lyall). Film reviewers and academic critics certainly have offered a range of reactions. Among the most dismissive are reviews by Shepard and Podhoretz. Shepard complains of the lightweight political theory of the Wachowskis as the screenwriters of *V for Vendetta*: "Having, in *The Matrix* sequels, demonstrated a nodding acquaintance with contemporary French philosophy, they herein offer homilies culled from the writings of various political thinkers that come off sounding like

pithy wisdoms devised by the owner of an anarchist fortune cookie factory." Even more virulent is Podhoretz's comparison of the movie with Ayn Rand's infamous novel: "And just like *Atlas Shrugged, V for Vendetta* is an exercise in didactic propaganda in the guise of an adventure story meant to appeal to teenage boys and their narcissistic fantasies about being at the very center of the universe. Both works prominently feature a cool, beautiful, and skinny chick who throws in her lot with the nerds." Among more scholarly responses, Davidson finds that a "pseudo-philosophical vagueness" mars the script; he also sees V's appreciation for high art standing "for classical liberal values" while at the same time V's politics seem a throwback to "the 1960s among the New Left, such as Yippies...or various Maoist groups" (160–161). Reynolds, meanwhile, dislikes McTeigue's film for its inadequate adaptation of Moore's graphic novel. He complains that the original political messages have been watered down and sanitized: "The ideologem of the comic is anarchy: reducing the ideologem to a general statement of resistance ensures both the absence of politics, and circumvents the adaptation's ability to grasp the complexity and aesthetic potential of the source material" (130). Because precious Anarchy is removed as V's revolutionary political action, Reynolds concludes that "the film rehearses the kinds of oppression it purports to attack," namely "Western hegemony" (132). In a thinly disguised New Critical stroll through the graphic novel and the film, Keller similarly proposes a fundamental conservatism at work in McTeigue's movie, calling its apparent politics of liberation in fact "a type of scaremongering...that could just as easily promote rightwing policies...or initiate a leftwing totalitarian backlash" (103). Liberal quietism is perhaps to be expected from a book-length study of two such politicized texts where Keller only mentions Marxism once, trivially and in passing (182). Paik, on the other hand, scrutinizes the radical authenticity of graphic novel and film, affirming that of the former while calling the latter "leftist-liberal posturing" (178). He judges the filmic V to be "a verbose and somewhat pitiful figure, given to bombastic speechifying and lugubrious self-revelations" (179).

Most adverse readings of the movie hinge on the confrontation between V and Sutler, and in particular how there is little difference between these two violent and domineering characters. When discussing the sequence where Sutler and V are equated during Gordon Deitrich's television program, Porton comments on "the odd symmetry between state terror and passionate resistance" (53). Even Zizek opines on parallels in the use of terror practiced by both the Chancellor and his extraordinary adversary (*In Defense* 192–193).

What has largely been missed or underestimated by critics of the film, however, is V's post-Marxism—a political orientation that offsets V's actions from those of Sutler. Using a term from Zizek, in fact, best identifies the notions underlying V's intricate performance: legitimate democratic power. Fundamentally, the Creature in *Frankenstein* plagues Victor to do right by it, that is, to care for his creation properly as would a good father or overlord. At the end of the novel, the Creature is filled even with a baffling remorse and self-loathing for having driven Victor to an untimely death, and the monster vows to kill itself for that crime. V suffers from no such devotion to his abusive creator. The tagline of the movie is an unabashed threat: "People should not be afraid of their governments. Governments should be afraid of their people." By it, V serves up no platitude of comic book or fortune cookie Anarchy; instead, he outlines an explicit political course of action—one that he undertakes in the film. V is an agent of change pitted against a Norsefire government, under Sutler, dedicated to no change whatever. V does not advocate an end—that is, an alternative and specific manifestation of government to replace Sutler's—so much as he represents a means—that is, a process by which a more equitable government is derived. V does not seek to replace X with Y; more exactly, he points out how the current X will never do. His society must come up with something better. V pushes future England (meaning, really, present-day United States) to move on—that is, "to deepen and expand" liberal-democratic ideology "in the direction of a radical and plural democracy" (Laclau and Mouffe 176). The cardinal markers of this political agenda are V's violence, his discursive relativism, and the open-ended nature of his overthrow of Sutler.

With the phrase "legitimate democratic power" Zizek applies the postmodern condition of undecidability to the implementation of political authority, stating: "the condition of impossibility of the exercise of power becomes its condition of possibility." By this, he means that an end stage of perfect democratic statecraft will never be achieved; therefore, "the ultimate uncertainty and precariousness of the exercise of power is the only guarantee that we are dealing with a legitimate democratic power" ("Class Struggle" 94). All attempts to arrest and limit democracy make such regimes illegitimate. While Zizek differs in his views from Laclau and Mouffe regarding whether the struggle for legitimate democracy can be carried out within the framework of liberal-democratic ideology, for the purposes of analyzing the radicality of the movie *V for Vendetta* their postmodernist approaches both pertain. Laclau and Mouffe also point to the

primacy of a "Discursive *discontinuity*," declaring: "there is no radical and plural democracy without renouncing the discourse of the universal and its implicit assumption of a privileged point of access to 'the truth', which can be reached only by a limited number of subjects" (191–192). The history of contended and shifting hegemonic discourse, of course, is one marked by violence. Both those sincerely convinced of their "truth" and those cynically manipulating their power—and in particular those, such as Sutler, who are a mix of the two—are unwilling to relinquish their supremacy. Change typically must be forced. V willingly engages the fight at all levels. Even though vengeance strongly motivates V, his vendetta is not politically blind. On the contrary, his targets are precisely the architects of Norsefire's ascendance. When Evey, horrified, asks V if he had anything to do with the death of Prothero, V responds matter-of-factly, "Yes. I killed him." He explains to the flustered Evey:

> *V*: Violence can be used for good.
> *Evey*: What are you talking about?
> *V*: Justice.
> *Evey*: …oh. I see…
> *V*: No court in this country for men like Prothero.
> *Evey*: And are you going to kill more people?
> *V*: Yes.

V's demolition targets are likewise pointed. Because men like Prothero are above Norsefire law, V destroys the Old Bailey at the beginning of the movie, saying, "It is to Madam Justice that I dedicate this concerto, in honor of the holiday she seems to have taken from these parts and in recognition of the imposter that stands in her stead." He blows up Parliament at the end of the movie for similar reasons: It no longer houses democracy, but oppression. Like Malcolm X, whose voice we hear during the end credits delivering parts of his speech "On Black Power," V meets the violence of injustice with violence to restore justice.

Similarly, V engages Sutler in a contest over strategic signifiers. When Evey asks V if he really thinks razing Parliament will improve the country, V replies:

> There's no certainty. Only opportunity…The building is a symbol, as is the act of destroying it. Symbols are given power by people. Alone a symbol is meaningless, but with enough people, blowing up a building can change the world.

Here we see that V is not a fanatical, inhuman, pure evildoer bent on the irrational destruction of civilization. Such wild-eyed and random-acting terrorists are an expedient myth of power needed to manufacture the hegemonic binary of Good Us/Bad Them. As a monster, V is far worse. He is modernity's worst nightmare. V is a Nietzschean relativist locked in a semiotic contest for Foucaultian Truth and Power with the pyramidal hierarchy of the day. V understands the disciplinary tactics of the modern state, and he works to counteract the articulated nodal points of the Norsefirean discourse. That's why he commandeers Sutler's main propaganda mechanism, BTN, to broadcast not a "message of hate," as is later claimed by BTN, but to issue, cheekily over VTV, a challenge to debate. Unlike when Chancellor Sutler addresses the nation, V spouts no dogma nor browbeats with intimidation. On the contrary, he invites fellow citizens to join him in a critical inspection of the present time, a historical and political assessment of their here and now. During this chat, V offers that, out of fear, the people handed over their freedoms in exchange for the alleged law and order of Norsefire. He proposes that, in place of national security, what they have at the hands of Sutler is only "cruelty and injustice…intolerance and oppression" along with "censors and systems of surveillance, coercing your conformity and soliciting your submission." What is worse, culpability for these events rests not only with their immediate perpetrators, but, more vitally, with the people themselves. Says V: "Truth be told, if you're looking for the guilty, you need only look into a mirror." With his broadcast, V proposes an alternate politicality to Sutler's. But, distinct from Sutler, V is not propagating a discourse of the universal. The truths he points out are circumstantial, not eternal. As a semiotician, V knows that the real power of words lie not in their fixed meanings, but in their mutability. More to the point, V grasps that in the contest for political power, winning control of the signified for key words is paramount. As V points out to Londoners, keeping in check crucial concepts is why Sutler brooks no other voices.

> Why? Because while the truncheon may be used in lieu of conversation, words will always retain their power. Words offer the means to meaning and for those who will listen, the enunciation of a truth. And the truth is, there is something terribly wrong with this country, isn't there?

With the destruction of the Old Bailey and this rogue television transmission, V has reopened the political discussion—as much for real movie audiences as for the fictive BTN viewers.

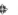

The key words V seeks to resignify are "fairness, justice and freedom." V stresses that these "are more than words. They are perspectives." While many critics see this line (and others by V) as pretentious pseudo-philosophizing (e.g., Davidson 160), some recognize the post-structuralism at work in the film. In a study of the use of Guy Fawkes in the graphic novel and the movie as an icon for militancy, Lewis Call draws attention to the value of V's mask as a free-floating signifier.

> In the hands of McTeigue and the Wachowskis, the face of Fawkes realised its full potential. It became a truly nomadic, perpetually mutating postmodern symbol, impossible for the state to nail down. Shifting meanings in every frame, the face demonstrated its ability to destabilise the entire representational order which underwrites state power in the postmodern world. (156)

Destabilizing the Norsefirean *perspective* that fairness, justice, and freedom belong only to a privileged and limited number of subjects is V's aim. To subvert Sutler's representational order, V seizes the state TV/simulacrum. As Call points out, if the authority of the modern state is based on its ability to manipulate reality, revolutionaries have a ready line of attack: "They need only seize the engines of simulation, puncture the veil of illusion, and replace the official discourse with a radical alternative narrative" (163). In post-Marxist terms, what V accomplishes with his prohibited speech is the restoration of the agonism inherent in the power relations of the modern state—what Sutler had hoped to nullify. V's political project is not liberating the individual from the state, but of promoting, as theorized by Foucault, "new forms of subjectivity through the refusal of this kind of individuality that has been imposed on us for several centuries" ("Subject and Power" 134). By "this kind of individuality," Foucault means capitalistic individualization and totalization procedures, a kind of discipline that, in his view, should not be regarded as "an inescapable fatality at the heart of societies, such that it cannot be undermined" (140). V's separation of Sutler's truth from the brutal Norsefirean power that sustains it is what Foucault identifies as a "new politics of truth," that is, the production of a different version of reality ("Truth and Power" 317–318). V's new truth is no more essentially true than Sutler's truth; however, it is one that eschews bigotry and exploitation in social-economic formation. McTeigue's V is not, then, a nihilist or any kind of simplistic anarchist. He's a postmodern socialist. As Call describes V: "his post-structuralist rejection of all absolute meaning

does not imply a meaningless relativism, but rather a perspectivism which may still evaluate various viewpoints, and endorse those which promote progressive values" (167). Laclau and Mouffe emphasize that the demands of subjugated groups are not defiance of a certain order, but are part of a "strategy of construction of a new order." This new hegemony "must base itself upon the search for a point of equilibrium between a maximum advance for the democratic revolution in a broad range of spheres, and the capacity for the hegemonic direction and positive reconstruction of these spheres on the part of subordinated groups" (189). Building a society more fair, just, and free than Norsefire is V's definitive purpose.

Laclau and Mouffe, however, point out as well that the goal of an equitable hegemony is never attainable: "this articulation should be constantly re-created and renegotiated, and there is no final point at which a balance will be definitively achieved" (188). This feature of hegemony and socialist strategy is reflected in the open-ended finale of McTeigue's film. V accomplishes his revenge killings of all those responsible for the torture and death of Valerie, especially Sutler and Creedy. V does *not* leave in place, though, the perfectly just new state to replace Norsefire—in other words, the very thing for which he has fought and died. A number of critics find this ending to be a major flaw in the film. While admitting that *V for Vendetta* is likely a political watershed for comic-book movies, Porton sees in V only "a hyperindividualist superhero" and "a charismatic flawed savior" (54). Davidson complains that the climax of the film isn't violent enough and that the Wachowskis' script comes up short in the realpolitik department. Verisimilitude, for Davidson, demands blood running in the streets, and so following "Hollywood's usual inability to imagine social change, this ending doesn't ring true" (162). Reynolds seems incensed that a film adaptation of Moore's comic book dared alter one iota of the original, charging that the "characters of the graphic novel are redrawn in order to create a political thriller—but without any actual politics" (132). Reynolds proceeds to quote some passages from the graphic novel—for example, "Anarchy wears two faces, both creator and destroyer" (Moore and Lloyd 248)—as though they *do* contain actual politics. The attitude and status of Moore's Evey at the end of the graphic novel are particularly fuzzy. Says the comic-book Evey:

> The people stand within the ruins of society, a jail intended to outlive them all. The door is open. They can leave, or fall instead to squabbling and thence new slaveries. The choice is theirs, as ever it must be. (Moore and Lloyd 260)

By "society," does Moore's Evey mean the defeated Norsefire regime? Or, anarchically, is Moore indicating that all Society is a jail, forever fraught with squabbles and slavery? If the latter, where exactly would people go if they left the jail of Society? Can *every*one live off the grid? If the former, how are squabbling and new slaveries going to be ended after the downfall of Norsefire and during the reformation of what Moore's Evey calls "our better world"? That is to say, when it comes to power relations, who gets to have the last word? Such "political" statements in the graphic novel are as clear as mud. Moreover, Moore's Evey is oddly detached from whichever project is at hand. She declares: "I will not lead them, but I'll help them build, help them create where I'll not help them kill" (260). But she's just sent off V's bomb train to blow up Downing Street, and she's now assumed V's role—mask, costume, Shadow Gallery, and all—with "things to do . . . people to see" (263). So what gives here, Moore's Evey? Are you superheroing or not? Alan Moore was justified in complaining that the film project abandoned his political vision to present, instead, a "Bush-era parable" (qtd. in Xenakis 135). It was also reasonable for Moore to characterize the upshot of such a parable as "current American neo-conservatism versus current American liberalism" (qtd. in Davidson 162). That binary seems to be the limited extent of political debate in the United States. However, along with V's tactic of direct force and his flair for deconstruction (of both the brick-and-mortar and linguistic variety), the filmmakers' decision not to have V miraculously whip up an "ideal" form of government for the people, but rather leave to them the thorny task of state-building, signals a post-Marxist move that pushes beyond the shortcomings of liberalism.

The surest sign that a fictive text has crossed the line into socialism is not that it upsets conservative critics but that it unnerves liberal critics. Call points out how the chorus of conservative commentators denouncing McTeigue's film as a celebration of terrorism was joined by many liberal commentators as well, with the climactic demolition of Parliament acting, for them, as a kind of last straw (169). Denby, for example, can't stand watching that "icon of liberal democracy" reduced to rubble. Similarly, Keller thinks that only the wild-eyed tenured radicals of "the 1980s and early 90s" could appreciate the "heavy-handed" way the movie "intercedes in contemporary cultural, social, and political practices by manipulating public discourse on the subject" (58–59). Apparently, that V and Sutler (or the Wachowskis and Karl Rove) use similar tactics, but in the pursuit of vastly different ideologies and ends, disturbs these critics.[8] In the land of well-heeled tolerance, we are to play nice and concentrate on high culture—not low politics. Some

critics, however, see the leftward jolt of the film. Tony Williams points to movies such as *Good Night and Good Luck*, *Syriana*, and *Munich* (all released in 2005) initiating "a hesitant form of protest against the Bush Regime."[9] *V for Vendetta*, though, uses popular culture unhesitatingly to attack the Bush White House in a way "explicitly involving protest *and* revolution" (17). Unlike the "gratuitous individual destruction" coming at the end of *Fight Club* (1999), the ending of *V for Vendetta* "challenges…the audience to consider what creative possibilities may follow for any future revolutionary society that must not repeat the mistakes of the past." For Williams, the movie urges contemporary Americans, and in particular the younger generation, to "build anew in a much more humanitarian and positive manner" (23). In the same vein, Ott asserts that, contrary to theories of the Frankfurt School on the "culture industry," a careful analysis of McTeigue's film shows "that mainstream mass art can be politically progressive and counter-hegemonic" (48). He notes how *V for Vendetta* severely critiques the Bush administration before it became widespread, if not fashionable, to do so. With that critique, moreover, comes a calling for "viewers not to passively sit by as their rights and liberties were being curtailed" as well as empowering "viewers to question and speak out against their government" (48–49). Call points to the important difference between Moore's graphic novel ending and McTeigue's film ending. While Moore's is "an inspirational story about one woman's journey to political engagement," McTeigue's represents more than Evey's replacing V as the lone libertarian. In the movie, not just Evey becomes V, *everyone* becomes V, as symbolized by the sea of Guy Fawkes masks at the end. For Call, then, the film is "a postmodern narrative about a subversive political symbolism which can spread through a culture like a virus or meme, rewriting that culture as it goes" (170). The face of Fawkes continues to be a shifting sign of subversion, one capable of generating political change.

Crucial to the idea of political action leading to social transformation is the film's *not* filling in the governmental blank for us. In his earlier writings, Marx attempts to characterize the ideal of communism as a condition unto itself, that is, not defined negatively in terms of the exploitative society it replaces (see *Early Writings* 346–352). His descriptions are vague, however, with the only notions of the humanism Marx hopes to delineate emerging as a result of its contrast to present conditions. In his later works, Marx concentrates on describing what needs to be abolished and theorizes, most notably in *The Communist Manifesto* (60–64), that the collapse of capitalism is inevitable. He does not, however, prescribe what should replace

capitalism, or that socialism or communism is sure to follow. Marx leaves the next steps up to the people of that specific time and place to negotiate within their own historical and hegemonic conditions.[10] This stance is precisely that of McTeigue and the Wachowskis. No Hollywood happy ending ("As only celluloid can deliver," notes V) follows the collapse of Norsefire neoliberalism. Mixed with the euphoria is the immediate and practical problem of what comes next. As much as we might long for an ideal social order to descend on us from heaven, the political is unendingly hard and precarious work. In the end, moviegoers must leave the theater more vexed than contented. In this respect, *V for Vendetta* departs from formula and does not fulfill our expectations of a blockbuster. V is no martyr or guru or loner good guy riding into town to kiss the gal and save the day. V is, and remains to the end of the film, a monster designed to shake us out of being sheep and to spark our political engagement—if only, initially, at the contemplative level. What is more, while kicking NeoCons in the teeth, the film renders problematic as well the comfortable Liberal myth of tolerance. To tolerate others means doing so, fundamentally in an act of charity, from a privileged and empowered baseline of "normal" subject identity. In this way, as the film suggests, tolerance can easily revert to intolerance when, for whatever reason, the standard group is inclined to feel less charitable. Sutler's Norsefire regime demonstrates the extremes of such a lapse. The prevailing "normal" identity in the United States consists generally of patriarchal heteronormativity and bourgeois possessive individualism. V's monstrosity aggressively embodies and enacts an identity wholly and unremittingly at odds with this modern normal.[11]

Now that V as a queer and performative incarnation of legitimate democratic power has been considered, it's appropriate to speak of V's symbolic identity, that is to say, his monstrous persona that conveys his radical polity. After her staged imprisonment and torture, Evey discovers that Valerie and her letter are real and motivate V's vendetta against Sutler. When Evey questions the validity of this incentive, V snaps at her, "What was done to me was monstrous!" Evey replies coolly, "And they created a monster." Exactly so, and no matter that V subsequently smashes a mirror with his mask and weeps over this circumstance, or that Evey attempts to rehumanize V with her love, nothing can be done to bring him back to "normal." V's monstrosity precludes reintegration; he is a violently changed being whose being now elicits disturbing change. At the crux of Cohen's Monster Theory is that monsters exist at the "gates of difference." Monsters prowl the border of inclusion and exclusion, existing

somewhere between convention and abomination. Most important is that while rhetorically situated in a distant beyond, monsters originate from within. That is, monsters are constructions of what the hegemonic normal wants to exclude, to suppress, to pretend does not exist. Affirms Cohen: "Any kind of alterity can be inscribed across (constructed through) the monstrous body, but for the most part monstrous difference tends to be cultural, political, racial, economic, sexual" (7; see also Graham ch. 2). As discussed earlier, Valerie and V represent all of these differences, with V's complicating as well issues of bodiedness and, in particular, gender. Cohen further points to the importance of René Girard's work on the phenomenon of the scapegoat with regard to monstrosity. That scapegoating mechanism is a technique of the modern state used to demarcate normal from abnormal. However, Girard posits that, paradoxically, "persecutors are never obsessed with difference but rather by its unutterable contrary, the lack of difference"; that is, the practice of scapegoating in the end discloses "the truth of the system, its relativity, its fragility, and its mortality" (21–22). As Cohen sums up the situation, "the monster threatens to destroy not just individual members of a society, but the very cultural apparatus through which individuality is constituted and allowed" (12). Such is emphatically the case with V. What begins with Sutler's scapegoating certain groups to propagate Norsefire authority backfires into V's erasing, instead, the very differences Sutler engineers. Thus, as a monster, V not only kills individuals within Norsefirean society; V shatters Norsefirean individuation by exposing its bigotry and hatred. In combination, these monstrous exploits allow V to raze the oppressive state. As mentioned in the previous section of this chapter, the persona in which V carries out his revolution is the unusual one of the Wildean superhero.

With the radical political trope of Guy Fawkes, Call locates the force of McTeigue's movie in its highlighting, much more than the graphic novel, the grim realities of homophobia and the heroic resistance to hegemonic subjectivity and sexuality. He comments: "The film makes an important and courageous decision, to portray alternative sexualities as a powerful antidote to the enforced cultural conformity which fascism requires." Call notes an obvious influence in this decision: the fact "that the writer formerly known as Larry Wachowski is now Laurenca, a pre-operative transsexual." The bold and unapologetic marginality and Otherness of V is, for Call, his most striking and dangerous feature. Not only is V's body "radically unorthodox," but there is "certainly a radical sexual ambiguity about V, and this is clearly part of his power" (168). Linking Call's readings with those of

Crowell, as she describes the many Wildean elements in McTeigue's film, rounds out perfectly V's post-Marxist character. As we've discussed, for V, defying masculinist domination and compulsory heterosexuality is one and the same with defying neoliberal hegemony. An ingenious way to portray such a mixture of disobedience is in the figure of Oscar Wilde. Crowell points out how Valerie's letter provides the emotional and political fulcrum for both the graphic novel and the movie *V for Vendetta*. However, "other key alterations made at the character and plot levels mark the film's depiction of this moment of transformation as distinctly, instead of vaguely, Wildean" (36–37). Included in these alterations is V's being strongly coded, from the start of the movie, as "an aesthete-terrorist...committed to preserving—in his sartorial choices, paradoxical conversations, even his explosive stagecraft—the art, music, literature, and cultural traditions deemed decadent and destructive by a theocratic regime reminiscent of the worst excesses of Victorian morality" (38). Crowell explains other links of V to Wilde in the film, such as his half-Fawkes and half-Wilde costume of cape and conical hat (26–27), V's destruction of the Old Bailey as the site of Wilde's famous trial (37–38), and the renaming of the roses V leaves on his victims from "Violet Carsons" in the graphic novel to "Scarlet Carsons" (42). Thus, V's monster-political identity is the hybrid of scientifically deformed–enhanced body housing the personage of Oscar Wilde wearing a Guy Fawkes mask. No wonder Chancellor Sutler is speechless and terrified when he and V finally meet in the abandoned Victoria Station. Little could be less "normal" to Sutler than the bizarre figure of V giving him a rose. Yet, for viewers, V has become the completely normalized and understandable one, while Sutler whimpers before us as the hideous beast at long last brought to its knees. This moment in the film when V meets and avenges himself upon his maker confirms the inversion of both monster and terrorist in a way that the novel *Frankenstein* does not achieve. Unlike the Creature in his lonely war with Victor, V steps outside the modern normal with the death of Sutler—and we are brought along with him. Our crossing into the unknown territory of a monstrous beyond—that is, into the radical democratic politics of socialism—is prompted decisively by V's identity precluding romantic love with Evey.

V and Evey Not Sitting in a Tree

The stage certainly is set for romance between V and Evey. Starting with their dystopian "cute-meet" where he rescues her from rape by

the Fingermen, all the Hollywood signs are present. As moviegoers, we've been trained to assume that leading men and leading ladies fall for one another. Not surprisingly, most critics want to see heteronormativity at work in McTeigue's film. For example, throughout his study, Keller asserts romantic love between V and Evey. Theirs is a "potential romance" tragically "doomed from the start." The primary obstacle, predictably in this scenario, is V's "obligation to revenge." For Keller, "Evey constitutes a distraction, a temptation to opt for happiness rather than social justice" (100). Likewise, Giles is adamant about reading V as a straightforward romantic hero. He complains: "Sure, Evey tells him he's a monster—and then tries to make out with his mask. In a movie, when the pretty girl falls in love with you and stays in love with you, you're a hero" (69). Both of these critics are anxious to read the film in familiar Hollywood ways, with Giles evidently flummoxed by the complications of V's monstrous identity. However, nothing like heterosexual romantic love occurs in *V for Vendetta* except for its conspicuous absence. Even if Evey is mistaken thinking that she and V can run away together as a couple, that's a delusion we're meant easily to see *and* one in which V never participates. Something more is at stake than the comic-book movie clichés of pow-bam action, dark vengeance, and ill-fated love. The real story here is not one of Evey's romantic love tragically unable to save V; rather, it's one of V's socialist love joyously—though at great cost—able to save Evey. In other words, something grander is at work in McTeigue's film. One can go so far as to see, in fact, prominent elements of the Miltonic.

In *Paradise Lost*, Eve is maddeningly caught up as a pawn in the war between a stern and aloof God (whose viceroy in Eden is Adam) and a charming and cogent Satan. Eve's stark choice: obedience or rebellion. In *V for Vendetta*, Evey in the same way finds herself forced to choose between loyalty to High Chancellor Adam Sutler or insurrection with, as BTN reports it, "a psychotic terrorist identified only as the letter V"—a satanic challenger to authority if ever one hit the big screen. In both stories, Eve-Evey stands in for the reader or the viewer; that is, she represents Humanity. Milton's epic condemns Eve-Humanity for the sin of disobedience and thereby preaches, to its early modern readers, conformity as the only pathway to salvation: God's Providence and Grace. McTeigue's movie, on the other hand, commends Evey-Viewer for coming around to the resistance of tyranny and thereby endorses, to early-twenty-first-century film audiences, postmodern political innovation as the way to progress. Moreover, in each text, the relationship between the proxy character

(Eve or Evey) and the monster (Satan or V) conveys these central messages. How this pivotal connection works in *Paradise Lost* is for the reader to be subtly seduced by Satan, like Eve, until we find ourselves, in Stanley Fish's words, surprised by sin. That is, Milton sets a reader response trap for us, and we Fall for it. How this pivotal connection works in *V for Vendetta* is through the similar ploy of teasing along our well-trained movie expectations for romantic love to blossom between Evey and V—and then *not* meeting them. Like Evey, we believe things are moving in that inexorable Hollywood direction. When we find the idea of love, however, being bounced onto an entirely different track, that jolt awakens us, along with Evey, to a deeper political awareness. In other words, we are surprised by socialism.

For audiences, Evey is the character with whom we most readily identify. As noted by Ott: "her transformation over the course of the film from frightened victim to engaged and emboldened citizen functions symbolically as our own" (44). Evey's reaction to V as the monster is indicative of this transformation. Initially, Evey experiences V as what Cohen terms the "monster of prohibition"; that is, acting as a kind of policing mechanism, V exists "to demarcate the bonds that hold together that system of relations we call culture, to call horrid attention to the borders that cannot—*must* not—be crossed" (13). Like Satan to Milton's God, V embodies all that is taboo to Norsefire, and so Evey is conditioned to flinch from him. To step outside official boundaries "is to risk attack by some monstrous border patrol or (worse) to become monstrous oneself" (12). Evey feigns allying with V in his plan to kill Bishop Lilliman (John Standing) to escape the monster and return to her normal life. However, as discussed earlier, Cohen also emphasizes how the "monster's destructiveness is really a deconstructiveness: it threatens to reveal that difference originates in process, rather than in fact (and that 'fact' is subject to constant reconstruction and change)" (14–15). Therefore, even though the monster is constructed by power to personify attributes that must be exiled or destroyed, for Cohen the fear of the monster is potentially a form of desire as well. He says: "We distrust and loathe the monster at the same time we envy its freedom, and perhaps its sublime despair" (17). The monster can show us that our social fabric is a fraud, and that we covet liberation from its constrictions, too. As the movie progresses, and as Evey and V's relationship develops, just such a monstrous attraction unfolds. Evey's attitude toward V evolves from fear to escapist fantasy to affinity to unity. While it's clear, in retrospect, that V carries out only a program of political education

with Evey—culminating in the harsh lessons of prison and torture and then personal sacrifice—she (and we) mistakes the instruction for romantic love instead. A review of V's curriculum for radicals and Evey's ultimate learning of his lessons confirms this reading.

V doesn't begin his schooling of Evey until she shows interest in the subject matter. During the "eggie-in-the-basket" scene, Evey asks about the rationale behind V's plan to blow up Parliament, and she receives key lesson #1: that government should fear (meaning serve) its people and not the other way around. Predictably at this point, Evey expresses only pessimism about the possibility for positive change. Key lesson #2—that violence can be used for good—comes when Evey discovers that V has killed Prothero. Again, predictably, Evey is not at all receptive to such confrontational ideas. In fact, she's so frightened by V's politics that she begins to plan her escape from his Shadow Gallery. At this point, too, the romantic ruse of the film *The Count of Monte Cristo* (with Robert Donat as Edmund Dantes) is introduced. That revenge-love tale piques our anticipation of the same relationship coming to pass with V and Evey. It's only Evey (and us), though, who reaches this conclusion. Emotionally touched by the film and its closing image of Edmund and Mercedes nestled together in a tree, Evey remarks that she feels sorry for Mercedes. When V asks why, Evey says, "Because he cared more about revenge than he did about her." The "he" here obviously bears a double meaning: both Edmund and V. To her statement, V says nothing, only nodding once and letting out a "hmm" to indicate his interest in Evey's reaction to the movie. The thought is planted in our heads, however, of whether or not V will come around to love Evey more than he loves revenge. Habitual as Hollywood romance is, most of us assume that's how this summer blockbuster will play out: with V's coming to love Evey romantically. McTeigue is happy to let us assume that V and Evey will be looking for their own tree even as the education of Evey continues. After all, most viewers, and in particular Americans, are conditioned to find a love story more interesting to watch than a lecture on philosophy, politics, and economics.

Evey's telling V about her family's tragedy at the hands of Norsefire as well as her confessing to political weakness by saying, "I wish I wasn't afraid all the time, but... I am," are sincere revelations of her character in spite of their being part of a scheme to get away from him. They also lead to V's harshest pedagogical move—Evey's imprisonment and torture—and thus to key lesson #3, the most central lesson of all: Valerie's prison letter and its message of solidarity. Once Evey learns to defeat her fear of Norsefire by embracing Valerie's

conception of love, she is freed from being defined and cowed by a regime of bigotry and oppression. Evey now has the ability to create herself, exchanging political ignorance and cowardice for political awareness and, if not yet engagement, at least defiance. Her political rebirth is symbolized by her stepping into the rain to discover a better identity, which is juxtaposed against V's emerging from the fire of Larkhill burned to a crisp and without an identity (Figure 3.1). A number of critics have offered good readings of this scene, most of them premised on Evey-water denoting creation and V-fire destruction.[12] What has not been noted enough is that while both their reincarnations are consequences of reading Valerie's letter, V and Evey start from different standpoints. Evey's transformation is from Fear of Norsefire to Love for humanity, while V emerges from Hate. He says to Evey:

> See, at first I thought it was hate, too. Hate was all I knew. It built my world, imprisoned me, taught me how to eat, how to drink, how to breathe. I thought I'd die with all the hate in my veins. But then something happened. It happened to me just as it happened to you.

This difference is vital to V's being a monster-hero while Evey becomes a savior. Like John Connor in *Terminator Salvation*, V is fire fighting fire. That is, to eradicate hyper-acquisitive xenophobic militarism, V uses the tactics of hyper-acquisitive xenophobic militarism. V is as much a direct creation of Norsefire, physically and

Figure 3.1 Radicalization in the rain.

ideologically, as John Connor is of Skynet. If *V for Vendetta* were only a revenge thriller, then our cheering the martial display of V as we revile the martial display of Norsefire would be politically as barren as watching John Connor battle Skynet. Both movies would encourage only a fight-fire-with-fire outlook in audiences, with no possibility for any other view of the world. However, McTeigue's film gives us the option of water in Evey. That is to say, *V for Vendetta* shows us a social alternative to liberalism, and that's socialism. This tutorial comes to fruition at the climax of the film when we find that, all along, romance has never been an option for V and Evey.

When Evey takes her leave of V, who tells her "You won't find any more locked doors here," we have an impression that her education is complete. She's been put through something like the radicalization experience of V, been shown that Valerie was real, and is prepared to strike out on her own unafraid of Norsefire. Even though Evey calls V a monster at this parting, she also thanks him for taking away her fear and moves in close to his mask, obviously thinking about kissing him goodbye. Just before Evey leaves, V requests to see her one last time before the fifth of November. After she's gone, V hurls his mask against his mirror and we see a head-and-shoulders shot of him with his visage a black void. He sobs into his hands. The ready explanation to this behavior is tragic romantic love. What plays out in their relationship is something else. Evey has one political lesson yet to learn.

When she returns to the Shadow Gallery for the last time, V and Evey play out an amorous encounter. They dance to a slow tune; she remarks how strange it is to be seeing his "face" (meaning his Guy Fawkes mask) everywhere in London; she declares how important he is to her and attempts to remove his mask. All of these actions have, instead, political implications to which V brings Evey back around. After he stops her from lifting his mask and explains that the face beneath it isn't really him, Evey says, "I understand," to which V replies, "Thank you." At this moment, Evey seems to comprehend that V is a political being, one dedicated to, as argued above, separating Norsefire truth from power in pursuit of the construction of a new social order. In place of romance, V has a gift he must give to Evey: the choice to destroy Parliament and start a revolution. Explains V:

> And the truth is you made me understand that I was wrong. That the choice to pull this lever is not mine to make...Because this world, the world that I'm a part of, that I helped shape, will end tonight. And tomorrow a different world will begin that different people will shape, and this choice belongs to them.

V's post-Marxist gift to Evey—and by extension to viewers—is the radical and frightening undecidability of legitimate democratic power. V admits that he does not have, nor does he have the right to pretend to possess, the "correct" or "true" political viewpoint. Such arrogance would make him as bad as Sutler and his war against Norsefire as futile as John Connor's against the Machines. If V is to be the instrument to carry out the principles of radical and plural democracy, he must allow the hegemonic struggle and constant redefinition of society to pass into different hands. Evey, however, tries to dissuade V from confronting Sutler.

> *Evey:* V, wait! Please, you don't have to do this! You could let it go. We could leave here together.
> *V:* No. You were right about what I am. I've no tree waiting for me. All I want, all I deserve is at the end of that tunnel.
> *Evey:* That's not true. [She kisses him.]
> *V:* ...I can't.

Evey's plea looks to be one last appeal for romantic love, and certainly might be. However, the possibility at least exists that, alternatively, Evey acts on her newfound understanding of V's single-minded political agonism; that is, as a friend and comrade, she's naturally concerned for his safety and proposes instead a less strident commitment to political action. There are practical reasons for why V can't respond romantically to Evey, such as the possibility that he's gay or that, at his fiery emergence from Larkhill, his genitals were erased along with his identity. Whatever the case, V walks away from Evey's offer to pursue individual happiness. His interest in her has developed as a mentor, not a lover. In order to complete both his vendetta and his tutelage, he'll keep his culminating appointment with Creedy and Sutler.

Critics disagree about the significance of Evey's kiss. Keller sees sexuality as the basis for their relationship and reads V as being "surprised by love," eventually succumbing to Evey's appeal enough so that, at this dramatic juncture, "his revolutionary zeal momentarily wavers" (89). Call, on the other hand, regards the moment when Evey's lips caress V's Guy Fawkes mask as being only politically charged: "Evey loves the meme. She loves the symbol, its power, and the way V has wielded this power to give Britain a fighting chance for freedom" (170). While at this point in the film Evey is moving in the direction of a sophisticated political understanding, she's not quite there. V has a final lesson to demonstrate to her, one crucial to Evey's ability to accept his political gift of a tube train stacked with

gelignite and aimed at Parliament. Key lesson #4 for Evey is the most difficult of all: commitment to real political action. If Evey is to be rid of her fear, she cannot merely be defiant of Norsefire; she must work to overthrow it. As discussed earlier in this chapter, V's postmodern monstrosity demands our stepping into political terra incognita. For Evey as well as for early-twenty-first-century American audiences generally, there is no more unknown civil territory than socialist politics, let alone active uprising. Nonetheless, V's going "to meet my maker and to repay him in kind for all that he's done" while leaving the future of the revolution in Evey's hands is his ultimate enactment of radical democratic politics. The lesson is painful, but one Evey takes seriously, completing her education.

When V returns mortally wounded from his vendetta, he tells Evey while dying in her arms:

> For twenty years I sought only this day. Nothing else existed . . . until I saw you. Then everything changed. I fell in love with you, Evey . . . like I no longer believed I could.

Once more, the easy assumption here would be that V speaks of conventional romantic love. Granted, that's an available reading, and a way to explain V's earlier sobbing over Evey's departure from the Shadow Gallery. However, a better reading of V's death scene might be as a kind of final exchange of gifts between V and Evey. The love V speaks of could signify not that for Evey as a pretty young woman, but for Evey as a representative of all people. In the same way that V encountered and was saved from his all-consuming hate by Valerie's solidarity love 20 years ago, now he has been rejuvenated by falling in solidarity love with Evey-Humanity. This form of love explains V's political gift to Evey: releasing her from a debilitating fear of Norsefire *and* giving her the means to act on her new radicality. In turn, Evey has given V a superb gift as well. As did Valerie's message of love two decades earlier, Evey's coming to care for V, whether romantically or as a friend, has rehumanized V from his monstrosity, bringing him back in from the cold. Their last exchange could signal as much:

> *Evey*: V, I don't want you to die.
> *V*: That's the most beautiful thing you could've given me . . .

After waging 20 years of lonely warfare against Norsefire, V has been rescued, once more, from his blind rage as a monster. He still carries out his vendetta against Sutler, not as an act of hate-driven

and individualistic revenge, but as one of devotion to pluralism and democracy—that is, as a political act that honors the memory of Valerie by giving Evey and all of us the chance at a better day. According to this reading of McTeigue's film, V cries after Evey leaves the Shadow Gallery not over lost love, but out of a realization that Evey is correct in calling him a monster. If his motive is only hate, he's a beast created by a beast—exactly in the way John Connor and the Machines mirror one another. If his motive turns to socialistic love—that is, into giving *Evey* the option to rebel—V becomes a hero as well. These might be the emotions played out just before Evey kisses V. When V says, "You were right about what I am. I've no tree waiting for me. All I want, all I deserve is at the end of that tunnel," he refers to his abject monstrosity. When Evey replies, "That's not true," she asserts her belief that V has not lost his humanity. Her kiss, then, is not passionate, but compassionate. Evey's kiss verifies V's personhood—precisely what Norsefire strived to cancel when imprisoning him as a scapegoat and torturing him into a freak. Evey's great gift to V is *not* hoping to see him a dead monster.

As an overtly and aggressively political film, *V for Vendetta* fittingly ends not with V and Evey sitting as lovebirds up in a tree. Instead, it ends with our seeing Evey bravely putting into action all the political lessons taught to her by V, lessons that originated with Valerie. When Chief Inspector Finch gets the drop on Evey after she's put V's body onto the bomb train, he orders, "Stop! Get your hand off that lever!" Evey turns, calmly stares down the barrel of Finch's pistol, and says firmly to him, "No." Her peculiar nerve disarms Finch.

> *Finch*: Why are you doing this?
> *Evey*: Because he was right.
> *Finch*: About what?
> *Evey*: That this country needs more than a building right now. It needs hope.

Finch's lowering his gun marks his becoming a pupil of Evey's—a reversal of power in the Norsefire scheme of things. This brings us to the final topic in our analysis of McTeigue's movie: rebelling masculinities.

Other Others

Like the Lacanean Real, a monster is that which resists symbolization. As argued in these early chapters, however, the fabrication of

a Symbolic Order entails, frequently if not always, degrees of social violence on a terrible scale. Called into question is who is the greater monster: the excluded outsider or those framing and enforcing what early queer theorist Michael Warner terms "regimes of the normal" (xxvi)? In the Spartans of *300* and Norsefire of *V for Vendetta*, we witness a power elite at work brutally demarcating normal. In *300*, hegemonic masculinity, militaristic zeal, and essentialist insularity are celebrated and glorified; in *V for Vendetta*, those same ideologies are laid bare for our deliberation. With Norsefire, we witness the modern beast of neoliberal hegemony hideously in action and watch V, the ostensible monster, kill it. Imperative to V's success, however, is that he does not remain the loner monster, the horrific one-off threatening the conventional. By the end of the film, V has made himself the new normal as thousands upon thousands of him gather to witness the destruction of Parliament as a symbol of modern oppression. Compare V to King Kong, a monster who, at the end of that film, only falls dead off its symbol of modern oppression, the Empire State Building. What distinguishes V from Kong is that, while both go on a rampage against dominant corporate-militarism, V wins over to his point of view more than a single follower. Evey and Ann (in Peter Jackson's film), of course, are vital allies to these monsters. Other characters, though, representing the wider society, come over to V's otherness in a way that does not happen in *King Kong*. Moreover, one particularly telling feature of the rebellion fomented by V is the recruiting of masculinities other than the patriarchal ideal.

V's identity has been discussed earlier as being queer. Evey's identity is nonnormative as well in that, during the course of the film, she performs multiple genders and subject positions. Evey starts out as conventionally middle-class feminine. She applies make-up and is concerned with her appearance; she is submissive to authority, especially male authority; she is timid personally and disengaged politically. In short, Evey is a female milquetoast. In her attempt to escape from V, she becomes, ironically, even more demeaningly defined by the patriarchy. Garishly made-up and dressed as a baby-doll sex object for the pedophilic lusts of Bishop Lilliman, Evey finds herself further disempowered in the role of an underaged and lower-class prostitute. She counts herself fortunate to find refuge at Gordon Deitrich's house to reassume, for a short while, her conformist identity. Her encounters with V, however, compromise utterly not only personal security but also stable subjectivity for Evey. It's not until after her prison ordeal that Evey gains voice and agency against Norsefire. In the process, though, she's had her head shaved—shedding the traditional

feminine marker of long hair—and behaves in the currently dominant masculine ways of being calculating, autonomous, and emotionally distant. When Evey walks away from the Shadow Gallery, she's dressed in trousers, striding almost cockily down the middle of the street, looking and acting quite masculine. At this point in the movie, Evey is a striking example of Halberstam's contention that masculinity is most legible when performed by female bodies. Evey's queering, however, goes beyond her being, as Keller sees it, "fully masculinized" (84–85). She does not become simply a tough chick. In McTeigue's film, hegemonic masculinity is not asserted as the all-powerful norm or as the all-norming powerful. Instead, Evey mingles traditional feminine and masculine into an improved and, ultimately, society-saving amalgam. We see this most when she returns to the Shadow Gallery and during the climactic scenes in the Underground station. Then, Evey's gender hybridity (and monstrosity) is marked by her masculine shaved head and matter-of-fact demeanor in combination with her feminine attire (a pretty skirt and flats) and nonlethal political action (Parliament is empty when she blows it up). In other words, unlike Sarah Connor and Leonidas's Queen (from *300*), Evey does not adopt the vicious practices of hegemonic masculinity to fight fire with fire, perpetuating destruction. Evey is something else: She adopts the love and pluralism of Valerie to become a kind of socialistic water that blends and cultivates different identities in order, assertively, to expand democracy. Thus, while both Evey and Ann (from Jackson's *King Kong*) are women breaking free of modern patriarchy to redefine themselves as fearless socialists, only Evey's more radical gender bending—and blending—leads to her pulling the lever to bring down capitalistic hegemonic masculinity. Bravely joining her struggle are two non-hegemonic males, Gordon Deitrich (Stephen Frye) and Chief Inspector Finch (Stephen Rea), demonstrating that at the heart of this power trouble is, equally, masculinity trouble.

During V's rogue telecast from Jordan Tower, we see repeatedly three main characters transfixed by V's speech: Evey, Gordon, and Finch. Each takes in V's every word. With Evey, Gordon and Finch turn out to be two others who answer V's call for freedom from oppression. The several identity positions of these two men are interesting to note. Politically, Gordon is a liberal while Finch is a neoconservative, yet both make the transition to socialist and activist. Gordon's changeover is accomplished by his being an artist and a satirist who dares, like V, to separate Norsefire truth from Norsefire power, exposing Sutler for the tyrant he is. Finch's changeover takes longer but is likewise Foucaultian in that, as a detective, Finch dares to dig into the

actual, dark history of Norsefire's rise to power. Foucault proposes that "the most certain of all philosophical problems is the problem of the present time" ("Subject and Power" 134), meaning both what we are and how we got here. Finch's investigation into V's "terrorist" activities leads him precisely into such an investigation, instead, of the Norsefirean here and now.[13] As Finch uncovers the real circumstances behind Larkhill and the St. Mary's virus, the audience shares his alarm and distress—and his political conversion. What is more, with regard to gender, integral to their dissension against Norsefire is that neither Gordon nor Finch performs as a hegemonic male according to Connell's patterns for modern Western masculinity. Instead, at one level, both are complicit males. Like Carl Denham and Jack Driscoll from Jackson's *King Kong*, Gordon and Finch enjoy the patriarchal-neoliberal dividend that comes with being a white man, even though they don't behave in the pompous and belligerent manner of, say, Sutler, Creedy, and Prothero. Finch especially, as a neoconservative and high-ranking Norsefire official, indulges in the obliviousness of male privilege. Unlike Denham and Driscoll, however, Gordon and Finch wake up in time to their complicity. Due to the educational influence of V upon them, their knowledge does not come too late. They come to realize the utter fraud of the Norsefirean hegemony and, then, to take concrete steps to bring it down. Significantly, their conversion to radical and plural democracy hinges on each of them belonging, along with being a complicit male, to an even lower status of masculinity. Gordon is a subordinate male, while Finch is a marginalized male.

A number of critics recognize the importance of Gordon Deitrich as a gay character who parallels in evocative ways the character of V.[14] Crowell in particular points to Gordon as one of the "key alterations made at the character and plot levels" that makes McTeigue's film, in comparison to Moore's graphic novel, "distinctly, instead of vaguely, Wildean" (36–37). In the graphic novel, Gordon is a minor character and briefly Evey's lover before his being killed by criminals. In the film, Gordon is a television celebrity and host of "Deitrich's Half Hour," a comedy program that skates on the edge of official censorship and so serves as an undisruptive and permitted liberal counterpart to Prothero's neoconservative "The Voice of London." In other words, though colorful, Gordon is comfortably part of the Norsefire status quo. When he harbors Evey in his home, however, Gordon reveals to her that he is also a closeted gay man and deeply opposed to Sutler's ideology. Like V, Gordon has a Shadow Gallery of his own filled with banned art, literature, political material, and photographs.

Thus, as he commiserates with Evey, "we're both fugitives in our own way." Forced concealment of his sexuality is exceptionally burdensome to Gordon, but his subordination by hegemonic masculinity imposes on his entire identity and polity. As he explains to Evey: "The truth is, after so many years, you begin to lose more than just your [sexual] appetite. You wear a mask for so long, you forget who you were beneath it." Gordon's oppressed masculinity, then, like Valerie's oppressed lesbianism, is a trigger point in the film not only for gay rights and liberation, but for wider post-Marxist revolt. Winning a flimsy "tolerance" from the dominant culture is not the aim; structural social change is. Like V, Gordon is an aesthete-subversive with an erased personal identity who has been forced by the chauvinism of Norsefire to don a mask. At this point, Gordon's disguise is worn strictly for his own protection. Acting under the influence of V's televised speech, however, Gordon soon will turn his personal, defensive mask into the public and offensive mask of satire, which, like V's Guy Fawkes mask, he deploys as a semiotic weapon against Norsefire.

In a parallel to her experience in V's Shadow Gallery, Evey wakes to find Gordon in the kitchen preparing her an "eggie-in-the-basket" for breakfast. When Evey points out this strange coincidence, Gordon jokes how the obvious explanation is that he is V.

> You're stunned. I know. It's hard to believe, isn't it, that beneath this wrinkled, well-fed exterior there lies a dangerous, killing machine with a fetish for Fawkesian masks. Vive la Révolution!

Nothing in what Gordon says, though, turns out to be a joke or untrue. By the end of the film, Gordon, like everyone else, will, in fact, be V. Gordon's humor here, characteristic of a satirist, is pointed, not random. He draws ironic attention to his comfortable, middle-class collusion with a suppressive regime. As both a complicit male and a bourgeois, Gordon ridicules his own masculine-liberal, patriarchal-economic prerogative. His barbs, as well as his guilt, become apparent when he also says to Evey, in all seriousness, about V: "Of course, he was right, wasn't he? There is something wrong with this country." Obviously, Gordon paid close attention to V's broadcast diatribe against Norsefire. It's noteworthy that Gordon, even before Evey, is the first character in McTeigue's movie to risk direct Norsefirean wrath with his open defiance of Sutler. For all the Benny Hill slapstick of his show, Gordon's non-censor-approved script featuring actors impersonating Chancellor Sutler and V is deft political satire. In many ways, Gordon's show is a comedic mirror of

V's Jordan Tower speech: where V asked his fellow citizens to take a hard look at themselves, Gordon provides them the opportunity to take a critical look at Sutler and Norsefire. Depicted in farcical ways is the brutality of the regime (soldiers pointing guns at the audience to guarantee applause for Sutler), its policy of official lies (Sutler haughtily declaring "The terrorist has been neutralized" when a moment later the cigar planted by V explodes in the Chancellor's face), and, above all else, the idea that the actual terrorist is Sutler himself—not V. The symbolism of Sutler's tearing off V's mask only to discover another Sutler beneath it is an unmistakable satiric revelation and reversal of Norsefirean propaganda. Moreover, the clear political solution proposed by Gordon is the elimination of Sutler and Norsefire. A Keystone Cop insurrection is what is accomplished when each of the two Sutlers orders the soldiers to shoot the other and both Chancellors, to the great delight of the audience, wind up dead. Lest anyone should mistake the satiric message of the show to read it as being that Sutler and V coequally are evil terrorists, Gordon ends the program with a shot of V alive, well, and mischievously in possession of Sutler's purloined cigar. Adroitly turned around, then, is the Norsefirean binary of good Sutler/evil V.[15] Gordon suffers severe consequences for his audacity and wit. As Crowell points out, like Oscar Wilde, Gordon is a gay aesthete-avenger who "uses art to push the limits of social and political critique and miscalculates both the reach of his fame and the reach of the law" (40; see also 38–40). However, despite being executed for this affront to power, Gordon strikes an important blow for fundamental political change with his innovative use of popular media. In that respect, Gordon's satire is not unlike the film *V for Vendetta* itself, and the character of Gordon, perhaps, is something of a stand-in for Lana Wachowski.

Another pupil of V whose rebellion stems from a position of non-hegemonic masculinity is Chief Inspector Finch. Finch is little remarked on by critics, but his character is pivotal to the film in several ways. First, his criminal investigation of V that mutates into a criminal investigation of Norsefire is the primary mover of plot for the film. Second, Finch's gradual discovery of all the nasty secrets of Sutler's rise to power functions simultaneously as the audience's education about the neoliberal hegemony. Finch provides the evidence to support V's political claims. Third, Finch affords viewers with a look into what Michael Kimmel terms Guyland: the twenty-first-century American culture of hegemonic masculinity that operates by means of an egocentric and brutal groupthink. Finch is a long-standing member of the Norsefire Party and among Sutler's inner circle of power.

With Finch, we are in the belly of the beast. From the start, however, we see that Finch is out of step with the Norsefire groupthink. His critical and investigative disposition (at one point he says to his lieutenant, "I'm a cop. I have to know") makes him less fanatical and obsequious than his brethren, and thus more complicitly masculine than hegemonic. Even more noteworthy is Finch's subject position as marginalized due to his Irish heritage. For all his appearance as a full-fledged hegemonic male, Finch also has one foot outside that charmed fraternity. This small removal allows him the parallax view and questioning mind to recognize, eventually, Norsefire for the monster it is.

Anti-Irish racism first occurs in the film, seemingly incidentally, with Prothero, the peacock of Norsefirean hegemony. Upset with a Director of Photography who cannot light him satisfactorily, Prothero barks into the phone, "There will be no negotiation, Roger. When I arrive tomorrow the paddy will be gone!" It's with the investigation of Prothero's murder, as well, that Finch first starts encountering troubling coincidences. He discovers that Prothero was one of the richest men in the country as a major stockholder in Viadoxic Pharmaceutical, the corporation that developed the cure for the St. Mary's virus. Later in the film, Finch learns how the cure was known before the intentional release of the virus by Norsefire, and how, once Sutler was elected, a miracle cure was found by "a pharmaceutical company controlled by certain party members that made them all obscenely rich." Moreover, when Finch finds a link between Prothero and the Larkhill Detention Centre, but official roadblocks hinder his investigation, he knows to follow the money by checking out overlooked financial records relating to that military installation. Finch remarks to his associate: "One thing is true of all governments: the most reliable records are tax records." The maneuver produces information that will expose the full extent of Norsefire's wrongdoing. Thus, understated yet decisively present in *V for Vendetta* is the hegemonic greed and manipulation of the system intrinsic to capitalism.

If Prothero offers us a glimpse into the narcissism and avarice of the current hegemonic masculinity, Creedy, one of the masterminds of Norsefire Guyland, reminds us of its bias and brutality. After the murder of Bishop Lilliman, Creedy intervenes in Finch's investigation. As the head of the secret police, Creedy is not interested in revealing facts but in safeguarding lies, telling Finch that, "The security of information is paramount." What Creedy is concealing, we'll come to understand, is Larkhill as the source of the St. Mary's virus. As a way to stop Finch's inquiries, Creedy threatens the Chief

Inspector with possible charges of treason, insinuating that Finch is in league with V.

> *Finch*: Are you saying I'm under surveillance, Mr. Creedy?
> *Creedy*: At this time it would behoove you to cease any investigation of matters that have long since passed and concentrate on the concerns of our present.
> *Finch*: You mean Larkhill.

Creedy's moves are standard practices of modern state discipline and neoliberal ideology. First, Creedy stipulates acceptable boundaries within which Finch is allowed to act; second, he declares, in effect, the end of history by asserting that there is no need to scrutinize the circumstances of the present. How Norsefire came into being is immaterial because, runs Creedy's dogma, such a corporatist-militarist nation as England under the Sutler regime is the teleological and sociological crown of creation. When Finch challenges these attempts to impose limits on his professional and personal agency, Creedy smugly plays the race card.

> *Creedy*: Your mother was Irish, wasn't she? [long pause] Terrible what St. Mary's did to Ireland, wasn't it?
> *Finch*: I've been a Party member for twenty-seven years.
> *Creedy*: If I were you, Chief Inspector, I'd find the terrorist, and I'd find him soon.

Here Creedy not only bullies but delights in reminding Finch of his marginalized status as a mongrel according to long-standing English prejudice against the Irish as well as Norsefirean standards for racial purity. Chillingly, in this small exchange, we also discover that Norsefire chose to release its deadly virus on Ireland, no doubt as yet one more effort by an English ruling class to pacify that uncooperative island.[16] Creedy's threats and slurs anger and motivate Finch, making him more determined to get to the bottom of things. At this point, it's unclear whether Finch acts out of a need to prove his Party loyalty, is simply doing his job, or is starting to turn away from Norsefire. However, the closer he gets to uncovering Norsefirean truth, the more he is confronted and disgusted by the underhanded tactics of Norsefirean power.

When Finch comes into possession of the Larkhill laboratory journal of Dr. Delia Surridge (Sinead Cusack), he acquires a full account of the medical atrocities committed at that secret facility. V ensured that the journal came into Finch's hands, and, as a result, Finch must

face the full authority of High Chancellor Sutler. The Inspector finds himself alone in the Chancellor's Cabinet Room with the giant face of Sutler looming over him on the large monitor. The Chancellor is adamant that no one else be allowed to see the contents of that journal, claiming them to be "a matter of National Security...as well as a blatant violation of the Articles of Allegiance." As Sutler elaborates on the nature of this interdiction, the camera zooms in closer and closer on his enormous, ordering mouth as it dominates the tiny figure of Finch. It's evident that Sutler spins out lies and cover-ups. As did Creedy, the Chancellor ends with a threat: "any discussion of this document or its contents will be regarded at the very least as an act of sedition if not a willful act of treason. Is that understood, Mister Finch?" Finch is told that he would do well "to put it out of your mind." Ignorance is bliss, of course, is another standard operating procedure of the modern state as well as a bourgeois mantra. Disinterest in knowing about the governmental–corporate skullduggery carried out on "our" behalf is a hallmark of modern citizenship. One of the primary functions of Finch as a character is to demonstrate for audiences the opposite impulse, namely, political inquisitiveness. Defying Sutler and Creedy, the Inspector continues to ask the hard questions and to dig for their answers, no matter how disturbing they might be. The evidence leads him to pose to his lieutenant, Dominic (Rupert Graves), the most disquieting question of all: "if our own government was responsible for the deaths of almost 100,000 people, would you really want to know?" In the era of American Empire, this kind of question and moral dilemma hovers over every US citizen who dares to think about the workings of power.

As with Evey, V orchestrates Finch's civic education. That instruction culminates with V once more using the lie of art as a way to communicate a truth. Similar to Evey's counterfeit prison experience, V stages Finch's encounter with Rookwood. Allegedly a former covert intelligence agent in hiding who can provide hard evidence against Norsefire, Rookwood is, in fact, V in disguise. V has supplied Finch with all the names and dates needed to understand Sutler's crimes. What Finch needs help piecing together is the shocking big picture.

> *V*: What you want, what you really need, is a story.
> *Finch*: A story can be true or false.
> *V*: I leave such judgments to you, Inspector.

V then spells out—for Finch's consideration as opposed to the indoctrination demanded by Sutler and Creedy—Norsefire's aims and

means as a political organization. He minces no words in saying that the goal behind the Larkhill project "is power: complete and total hegemonic domination." The word "hegemonic" is not one Hollywood often tosses around. Along with Sutler's belligerent religiosity, V asserts Creedy is the Machiavellian evil genius behind the scenes.

> He is a man seemingly without a conscience, for whom the ends always justify the means, and it is he who suggests that their target should not be an enemy of the country, but rather the country itself.

The parallel with the political roles of Bush and Cheney is patent here. So is the modus operandi of the Republican NeoCons. Says V: "But the end result, the true genius of the plan was the fear. Fear became the ultimate tool of this government." At this moment, the full monstrosity of Norsefire is revealed. When Finch asks Rookwood why he hasn't come forward with this information sooner, what was he waiting for, V answers: "Well, for you, Inspector. I needed you." In other words, V knows that without the inquiring minds of citizens willing to act on evidence set before them, the brute force and alluring lies of a regime such as Norsefire are nearly impossible to combat. Even when Finch later discovers that it was V playing the role of Rookwood, the facts of V's story hold together for him. Finch is compelled to visit the ruins of Larkhill—"I had to see it"—and when he does, "I suddenly had this feeling, that everything was connected." Under V's tutelage Finch connects all the dots, sees the big picture, and is primed to step out of the fog of hegemonic masculinity. When he confronts Evey in the train car, as she's poised to pull the lever, it is her queer disposition and serene courage that finally, and nearly literally, disarm him. Evey, having now assumed the principal rebel's mantle from V, provides Finch with his final political lesson: that what the country needs right now is hope, not more brutal fear. At that moment, Finch decides to discard his complicit masculinity to emerge fully from the thuggery of the Norsefirean hegemony. A straight white man with a discerning and open mind can be a hero of radical and plural democracy, too. Significantly, the moment Finch lowers his gun in the Underground station, the troops above ground facing the masses of Londoners dressed like V lower their weapons as well. The people, as Evey says "all of us," have begun the process of altering the neoliberal military–corporate complex.

Valerie's love wins over Prothero's hate by the necessary means of V's liberatory violence over Sutler's despotic violence.

Moving On

V for Vendetta is the most overtly political of the monster movies covered in this book. Not only are the nature of government and the rights of citizens openly discussed in the film, but we should not lose sight of the timing of its release. Coming out in 2006 positioned the film and its anti-NeoCon messages to influence the American presidential elections of 2008. Even though Norsefire seems intended as an allegory for the Bush–Cheney administration, the eventual Republican ticket of McCain–Palin fit the bill perfectly as neoconservative replacements for that exiting neoliberal duo. Opposing that ideology on the Democratic ticket emerged the pluralistic coalition of Obama–Biden promulgating Hope—frankly making McTeigue's film appear prophetic. Fueled by the minority and the youth vote, Obama's election was a something of a post-Marxist rebellion in its own, distant way. Liberalism was at least nudged to the left.[17] It's not unreasonable to think that the political conversation initiated by *V for Vendetta* had a hand in shaping voter attitudes. Like Kong leaping into the well-heeled Broadway audience, V leaps off the screen and into the political lives of American moviegoers to upset our complacency toward and complicity with the neoliberal hegemony. The demise of most postmodern monsters, if scrutinized carefully, can make us sad. As in the case of Kong, their battles with modern power, though instructional, often end badly. V, on the other hand, if scrutinized carefully, calls us to action and can serve to embolden our political resolve, especially if we are inclined to communitarian principles.

In the next chapter, we analyze another movie that goads audiences in the direction of an overt and contemporary political response. At first glance, *Tropic Thunder* seems a far cry from any kind of politicality—let alone legitimate consideration as a monster movie. We assert, nonetheless, that monstrosity and masculinity have everything to do with it as a film. Moreover, as a strategy for evoking strong reactions from viewers, *Tropic Thunder* employs the famously monstrous and politicized genre of satire. For centuries, that hybrid and outlaw form has been a means to challenge power and to undermine conventional thinking. In outrageous and confrontational ways, satire seeks to overturn current configurations of normal. At these monstrous aims, *Tropic Thunder* excels.

Going "Full Retard" in *Tropic Thunder*

Weeks before *Tropic Thunder* opened in August 2008, disability advocates on Patricia Bauer's website, *News and Commentary on Disability Issues*, damned the Ben Stiller film for the actor/director's playing "a role that leans heavily on the term 'retard' " (Bauer). Neither Bauer nor the responders to her online posting had seen the film and so could not understand that "leans heavily" was a misstatement. That potential for misunderstanding seems immaterial; even tangential use of the r-word to this group represents an affront. Not having seen the film, though, the posters do not express dismay about any of the following offenses: a white Australian actor in black, African-American face; an overweight, drug-addled comic whose film opus relies on scatological humor; the same-sex sexual desires of a white Irish monk or a black American rap artist; the Shylockian depiction of a Jewish film producer; and the faux physical disability of a veteran fabricating his combat heroics. Nor do they protest against *Tropic Thunder*'s jesting depiction of war at a time of war, heroin production, cruel and inscrutable Asians, and sundry profane machinations of Hollywood. Clearly, the film is brimming with monstrosities. Although critics called attention to some of these elements of the film after its release, no criticism gained more interest than that leveled at a representation of intellectual disability by the pre-release disability advocates. That the disability advocates protested while ignoring the representation of a veteran's physical disability is not contentious or atrocious. Instead, the advocates' desire to condemn the film's use of the r-word heedless of the use's context indicates not only censoriousness but also willful ignorance of and about the film's genre: satire. Whereas *V for Vendetta* skirts the satire that its graphic novel version occasionally attempts, *Tropic Thunder* fully assumes a satiric voice, going riskily, in the parlance of *Tropic Thunder*'s Kirk Lazarus, "full retard." This film's representations of disability demonstrate the deconstructive

abilities of satire as, like a monster, "it threatens to reveal that difference originates in process, rather than in fact" (Cohen 14). In other words, the problem of disability is not so much in its physical or mental embodiment as in the social interpretation of such embodiment; monstrosity is as much in the interpretations provoked by *Tropic Thunder*'s masculinist, satiric form as in its subject matter. Although Stiller's film purportedly is limited to parodying Hollywood's overwrought and opportunistic production of Vietnam War films like the *Rambo* series, *Platoon*, and *Apocalypse Now*, as soon as it invokes disability, particularly in the ignominious Vietnam War's context, it border-crosses from the relative simplicity of parody to the notorious complexity of satire, thereby challenging notions of authenticity in war, period. In this sense, after all, Bauer's disability advocates weren't far off the mark: *Tropic Thunder*'s attack on neoliberal militarism and corporatism does hinge on disability as it turns the audience's stare away from the monstrous freak—those with disabilities—and to the monstrous normative—Hollywood and the production of American militarism.

Tropic Thunder's satire is multi-metafictional, with so many layers of actors playing actors acting out multiple story lines and characters that the acting—all of it—moves from conscious performance to unconscious performative; the "real" becomes indiscernible and authenticity, always unachievable. Even the actors seem uncertain about their current place in the film, mirroring the misorientation of the viewers. Spectators aren't ambushed by such a conundrum, though: The trailers already signal the multi-fictionality of the images.[1] Three movie previews and an advertisement warn viewers that what they are about to see in the film is not just entertainment but a satiric brain twister troubling notions of the real. In the previews, Kirk Lazarus (Robert Downey Jr.) plays a medieval monk who sexually desires another monk (Tobey McGuire); Tugg Speedman (Ben Stiller) plays a hardbody hero in another preposterous action thriller sequel; Jeff Portnoy (Jack Black) predictably enacts a scatologically based comedy; and Alpa Chino (Brandon T. Jackson) peddles "Booty Sweat" and "Bust-A-Nut," his energy drink and bar. The previews parody trailers accompanying Vietnam War movies, but they also spotlight film as a political medium. As Carl Boggs and Tom Pollard point out, because they are central to ideologically preparing a populace for actual war, war films cannot be dismissed as merely entertainment (52). The trailers draw attention to the normalizing power of film as they ridicule it.

Judith Butler's notion of gender performativity pertains here: Gender "is a stylized repetition of acts...which are internally

discontinuous...[so that] the appearance of substance is precisely that, a constructed identity, a performative accomplishment which the mundane social audience, including the actors themselves, come to believe and to perform in the mode of belief" (*Gender Trouble* 179). The many layers of this satire—what Butler might term "drag"— emphasize and thereby subvert the constructedness of each identity position played by each actor. There is no one, true actor nor one, true soldier; all is performative. The film underscores how, regardless of which level of fiction, all of its characters' roles are iterative, and it is only the iteration and reiteration of actions and behaviors that make them seem natural. There is no Platonic heaven where the quintessential "actor" and "soldier" reside. Instead, the film asserts, repeating the acts of an "actor" makes an actor; repeating the acts of a "soldier" makes a soldier.

The gist of *Tropic Thunder* is that it is a film, about making a fictional Vietnam War film, which is based on a (faux) combat veteran's war memoir, with all of the attendant confusions such an endeavor brings. To try disentangling the multiple filmic layers, in this chapter, we refer to: as Stiller Film the movie featuring the actors moviegoers know as Ben Stiller, Robert Downey Jr., Jack Black, Jay Baruchel, and Brandon T. Jackson; as Speedman film the movie featuring Tugg Speedman (as Staff Sergeant Four-Leaf Tayback, the ostensible veteran), Kirk Lazarus (as Sergeant Osiris), Jeff Portnoy (as Fats), Kevin Sandusky (as Brooklyn), and Alpa Chino (as Motown); and as documentary the movie about making the Speedman film. Even more confusing is that the first two of these movies are titled *Tropic Thunder*, as is the Tayback memoir on which the Speedman film is based, and the third movie, the documentary, is titled *Tropic Blunder*, thus challenging spectators to distinguish between the real and unreal already within the realm of the fictional.

The Stiller Film actors (Stiller et al.) perform as actors (Tugg Speedman et al.) whose Speedman film is not going well because they patently are acting as soldiers (Four-Leaf Tayback et al.) when tragic verisimilitude is expected in a Vietnam War movie. Tutored as American audiences are to expect elegiac yet realistic movie depictions of American troops victimized by that war, "tragic Vietnam" is what attracts spectators, wins awards, and thereby produces profits.[2] But it is expensive to fund *Tropic Thunder*'s requisite jungle locations, helicopters, napalm conflagrations, and movie star accommodations, so after the first week of moviemaking the Speedman film is over-budget and behind schedule. To save it and its funding, on the advice of the actual memoir writer (but faux combat veteran) Four-Leaf Tayback

(Nick Nolte) Director Damien Cockburn (Steve Coogan) helicopters his cast to what Tayback calls "the shit," an isolated Vietnamese jungle locale where Cockburn expects from the actors more authentic performances as soldiers in Vietnam. There the actors still have trouble distinguishing between authenticity and inauthenticity, however. When the director is disintegrated by a landmine left over from the actual French war in Vietnam half a century earlier—yet another narrative layer—the leading actors think his disappearance a ruse and continue their actorly performances as soldiers while the actors with lesser roles dutifully, though skeptically, follow along.[3] To all of the actors, moviemaking is as much reality as it is fiction. While the actors continue to enact the script, they are detected by Vietnamese drug producers in the jungle who subsequently take prisoner several of the cast members and crew. This situation precipitates a rescue mission by the remaining cast members, the result of which is an Oscar-winning documentary film, *Tropic Blunder: The True Story Behind the Making of the Most Expensive Fake True War Story Ever.* This is where Ben Stiller's parody might end, with poking fun at a genre, at Vietnam War movies, their making, their opportunism, and the vain obtuseness of their blockbuster film actors. But with the layering of fiction and reality, the Stiller Film satirizes beyond Stiller's parodic intent of skewering Hollywood's production of Vietnam War films, a satirizing grounded in the Film's representations of disability.

Monstrous Satire

Parody is not satire. Parody targets aesthetic conventions, such as filmic and literary forms, in more or less a lighthearted fashion. In contrast, satire targets social conventions, setting out a serious polemic on important current affairs. Although parody may serve as a tool of satire, it is not always so (Jonathan Gray et al. 17). Moreover, American filmgoers' understanding of satire tends to be limited; therefore, it is no wonder that *Tropic Thunder* often is misread as only a light send-up. Closer reading reveals the satiric foundation of the movie and how it exceeds Stiller's stated intentions: "we're making fun of the over-the-top nature of these [Vietnam war] movies, and these guys [actors] taking themselves too seriously" (Curtis 86). As a genre, satire is one of Western culture's oldest literary and artistic forms. It's likely the most difficult to define, as well. In *Anatomy of Satire*, Gilbert Highet describes the classical Roman verse satires of Horace and Juvenal as "jok[ing] about serious things" (233). Leonard Feinberg complains that such a definition is inadequate,

saying content and form are interdependent, and assaultive content demands an assaultive genre, one routinely violating generic boundaries. "Satire is not a pure genre or mode and cannot be forced into any precise category," he explains. "Satire often mixes materials and forms. Its distinguishing characteristics are that it always criticizes, it always distorts, it always entertains" (36). Don L. F. Nilsen reiterates and adds to Feinberg's ideas: satire is grounded in reality but twists that reality as the satirist attacks patterns of conventional social behavior (1–4). In *Theorizing Satire* (1996), Brian Connery and Kirk Combe specify the characteristics of a satirist's attack, saying "The one thing we know about satire is that it promises to tell us what we do not want to know—what we may, in fact, resist knowing." They name its generic volatility "monstrosity" and characterize satire as a "literary Trojan horse" (1–2). Satire tells us in its "radically masculinist" (12) way what we resist knowing: It is historically specific; its purpose is primarily social, not aesthetic; it tends toward irresolution and chaos; it is a shape-shifter as it appropriates and morphs into other, more discernible forms; and it actively refuses the unity and coherence classical theorists like Aristotle exhort of art (4–6). "Satire," Connery and Combe insist, "is culture's way of exposing the violence that civilization conceals" (7).[4]

Most recently, in *Satire TV* (2009) editors Jonathan Gray, Jeffrey P. Jones, and Ethan Thompson paint as a democratizing force the currently most widespread use of satire, satire television. In exposing and criticizing social norms, television satire empowers viewers to "recognize the naked emperor" (16). In this way, satire is an analytical tool that encourages and facilitates active democracy. Moreover, Gray, Jones, and Thompson claim, satire does not always produce laughter nor is it apparently funny, so some of its television audience members, expecting the laugh-out-loud comedy of sitcoms and variety shows, can be alienated (13–14). "Satire can be 'work'," they say, and so it requires of its audience "a heightened state of awareness and mental participation...not to mention knowledge" (15). In sum, then, satire is an "attack by means of a manifest fiction upon discernible historical particulars" (Rosenheim 31). That is, via its invasion of other genres and its manipulated representations of issues and personages, satire mounts a case against dominant orthodoxies of the day.

Satire's generic boundary crossing, hybridity, and historical timeliness recall what Cohen says about monsters: that the monster "signifies something other than itself" (4), that monsters "must be examined within the intricate matrix of relations (social, cultural, and literary-historical) that generate them" (5), challenge boundaries and

notions of the normal (6), and elicit escapist fantasy and sometimes comedy until they threaten boundaries between the real and unreal (17–18). Fundamentally, however, monsters and the monstrous "ask us to reevaluate our cultural assumptions about race, gender, sexuality, our perception of difference, our tolerance toward its expression. They ask us why we have created them" (20). In effect, as satire contests social norms (which include common representations of disabilities) and thereby boundaries, satire is the monster.

What Patricia Bauer's online posters object to most is "Simple Jack," the title character Tugg Speedman plays in a film preceding *Tropic Thunder*. Simple Jack is a role Speedman hoped would win him an Oscar. Assured by his agent that his playing a young man with an intellectual disability would rejuvenate his dwindling career as an action hero, Speedman is disappointed that critics have panned the role and his performance. Viewers of the Stiller Film *Tropic Thunder* have only two limited exposures to *Simple Jack*; the first is when we are shown a clip from the movie during a television critique of the film, a clip demonstrating the preposterous caricature of Speedman's performance as Jack. In the scene he stammers, speaks slowly with a heavy southern drawl, and with an overdrawn naiveté reminiscent of Tom Hanks's portrayal of Forrest Gump. Signifying externally Simple Jack's intellectual disability, his hair is bowl-cut, he is snaggle-toothed, wears denim overalls, and is bare-footed. According to Sharon L. Snyder and David T. Mitchell's analysis of film "body genres" and representations of disability, "disabled bodies are made [in films] to demarcate the culturally policed borders of respectability itself" (187). That is, spectators of *Simple Jack* should regard the titular character as, like a monster, at the limits of social respectability because he is unable to control his body and his mind. Because *Tropic Thunder* satirizes Speedman's performance and his obtuse desire to believe his agent's assurances, rather than this clip evoking the sense of superiority Snyder and Mitchell hypothesize audience members will feel for Simple Jack, they are likely instead to experience disgust with or disdain for Speedman (188). Disdain for the actor and not the character stems not only from Speedman's hyperbolic acting, but also from Speedman's mercenary motive for playing the role. At the core of satire is a passionate argument against something and in favor of something else. A combination of *laus et vituperatio*, praise and blame, animates satiric attack. In this case, blame of Hollywood depictions of disability serves as the gateway issue into a range of social censure offered by the film. Following such blame down the rabbit hole of satire will lead us to many such disruptions of the normal.

For example, Speedman's performance as Jack in what is a satire— the Stiller *Tropic Thunder*—exposes audience expectations for representations of disability. "Film spectators," Snyder and Mitchell contend, "arrive at the screen prepared to glimpse the extraordinary body displayed for moments of uninterrupted visual access—a practice shared by clinical assessment rituals associated with the medical gaze" (181).[5] The "mainstream fiction films" to which Snyder and Mitchell refer— and which Bauer's posters deduce of *Simple Jack*—often do invite such scrutinizing by audience members (180). Like disability theorists who aim to disrupt "debilitating narratives of dysfunction and pathology" (193), *Tropic Thunder* instead turns the scrutiny back onto spectators, demanding that they rethink their responses to any number of actual Oscar-winning films of the last two decades featuring characters with physical, mental, and/or intellectual disabilities: *Rain Man* (Best Picture, 1989), *My Left Foot* (Best Actor, 1990), *Philadelphia* (Best Actor, 1994), *Forrest Gump* (Best Picture and Actor, 1995), *Shine* (Best Actor, 1997), *A Beautiful Mind* (Best Picture, 2002), *Million Dollar Baby* (Best Picture and Actress, 2005), *The Hurt Locker* (Best Picture, 2010), and *The King's Speech* (Best Picture and Actor, 2011). With such a legacy, action star Speedman's hope that *Simple Jack* will earn him at least an Oscar nomination is not unwarranted. But clearly, Speedman and Hollywood are not the only ones to blame here. Audience members play a damning role in this act of simultaneous exclusion and exploitation of disability. As Charles Riley, a critic of disability representations in media, cynically suggests:

> The safest nomination bets for Oscar gold, year after year, are disability flicks... Producers, directors, and writers package disability in such a way as to safely ensure that the audience feels nobly uplifted, even ethically superior, for supporting what is in effect an oversweetened version of life with a disability as concocted by a community that cannot countenance physical imperfection except in certain sanctioned and saccharine forms. (70–71)

More extensive and elucidating is the audience's second exposure to Simple Jack as a medium for satire, when Speedman is taken prisoner by the drug producers. There he is recognized by their child-leader as Simple Jack, the character in the one videotape the camp owns, and is forced to reenact the role for the camp's entertainment. With crude, whiteface make-up, straw for a blond wig, and the ill-fitting dentures of an old man in the camp's audience, Speedman's reenactment in less-than-ideal conditions spotlights what Tobin Siebers calls

"disability drag," which occurs when able-bodied actors play characters with disabilities for able-bodied audiences (114). Such audiences do not typically recognize the parallel between performances of disability and male drag queens performing women, though, the result that the "bombastic performances" of able-bodied actors paradoxically reinscribes, through the "ideology of ability," able-bodiedness as invisibly normal (102). Speedman's performance of Simple Jack for the drug camp's sadistic pleasure, however, blatantly calls attention to his drag performance, thereby making visible the dependence of disability's interpretation on its social environment. That is, Speedman's performance of Simple Jack out of the context of the film, *Simple Jack*, but in the context of the satire, *Tropic Thunder*, indicts the monstrous way in which disability can be used in US-produced fiction films— not only Vietnam War films—to normalize able-bodiedness. Thus, by way of masquerade and distortion, satire shows a dominant group what it doesn't want to understand about itself: that it exists by means of the unfair and violent exclusion of others.

Hollywood's standard use of disability is especially satirized in the Speedman film's scene when Speedman and Lazarus discuss *Simple Jack*. As they walk through the jungle, Speedman expressing his appreciation for what he thinks is the (dead) director's hands-off method of provoking them to great performances, Speedman refers to *Simple Jack*. Encouraged by Lazarus's saying how Speedman had "swung for the fences" with his performance as Jack, Speedman confesses that his deep preparation for the role often made him feel "retarded, like really retarded." After Lazarus—a white Australian actor who is reported to have gone through a medical procedure to color his skin black so he could more authentically play the role of an African-American soldier—recites a catalog of odious words for Jack's character, he commends Speedman, but with a caveat that deflates Speedman's illusion of his performance as high art. "Hats off for going there. Especially knowing how the Academy is about that shit," Lazarus says to a befuddled Speedman. "Everybody knows you never go full retard" in a film, asserts Lazarus, citing as instances of Academy-approved and -awarded performances of intellectual disability Dustin Hoffman in *Rain Man*, Tom Hanks in *Forrest Gump*, and Peter Sellers in *Being There*. However, Lazarus sneers, Sean Penn went "full retard" in *I Am Sam* and he did not win an award.[6] It is no small irony, of course, that it is Lazarus who enlightens Speedman about the state of the film industry, given Lazarus's patent drag performance as an African American and a soldier, and his having won Oscars. But this scene, in combination with the other two featuring

Speedman as Simple Jack, makes highly visible what ordinarily is supposed to remain invisible: that popular film's invitation to scrutinize (disabled) bodies effectively propagates the hegemony of able-bodiedness. The monster that is satire illustrates that representations of disability cannot win; even earnest filmic renditions of disability meant to spotlight the humanity of people with disabilities conclude that able-bodiedness is a fundamental requirement for what is considered human.

Compounding the representations of disability through Simple Jack in Speedman's *Tropic Thunder* is the inclusion of "Four-Leaf Tayback," a supposed Vietnam War combat veteran whose hands seemingly were traumatically amputated and on whose memoir, also called *Tropic Thunder*, the Speedman film is based. Tayback is present on set as an adviser, always appearing in shadow and speaking in oracular language that baffles everyone. Perhaps his mysteriousness is supposed to signify mental disability/PTSD, and any challenge to his meaning-making, others in the Speedman film might think, will initiate the rage and flashbacks they understand is endemic among Vietnam War veterans. In an early-twenty-first-century American "support the troops" atmosphere, Tayback is further shielded from other's interrogations by his physical disability, the alleged mark of heroic behavior in war; a combat veteran, especially one with a war-incurred disability, should be lauded, not challenged.[7] Illustrating a hierarchy among disabilities, Simple Jack's genetically incurred intellectual disability positions him low in the hierarchy and socially vulnerable while Four-Leaf Tayback's physical war-incurred wound positions him high in the hierarchy and socially venerable. However, once the Speedman film cast and crew learn the extent to which Tayback fabricated his story—under his prosthetic hooks are his unwounded hands, he was in the Coast Guard during the War, never left the United States, and wrote *Tropic Thunder* as "a tribute"—our attitudes are likely to change from veneration to outrage at his "stolen valor."[8] Tayback's storytelling is prevarication enough, but he uses his "disability" to ensure that the story will be accepted without question. Valuing the firsthand narrative of war and visual confirmation of such participation, as Americans so often do, stops anyone from challenging Tayback's story of heroism. Moreover, as Riley points out above, able-bodied audience members desire the saccharine version of disability: The virtue of Tayback's alleged disability counterbalances the horror of Simple Jack's. Given how close even a war-incurred physical disability is to the borders of social respectability/monstrosity, and given the prevailing ideology of ability—that able-bodiedness is the

normal and preferable condition—viewers cannot fathom why some-
one would feign such a state. The response audience members might
have to Tayback's prevarication could be less about the fabricated
war story, then, and more about how the story exacted credibility—
through his absent hands. Spectators have been dupes to believe his
story; just as *Simple Jack* demands audience members reconsider their
responses to filmic depictions of disability, Tayback's *Tropic Thunder*
demands that they reconsider their responses to firsthand accounts of
war. Once more, satire has kicked askew spectators' visions of what
they regard as normal.

To an extent, then, Patricia Bauer's online posters are right to iden-
tify disability as central to *Tropic Thunder*. But because they mis-
understand disability as a universal signifier, as an identity whose
meaning transcends context, and not as an identity whose meaning is
constructed within the social and temporal environment in which it is
depicted, they cannot envision *Tropic Thunder*'s use of the r-word as
anything but reprehensible. Given the context of a monstrously mas-
culinist satiric war film, however, disability in *Tropic Thunder* turns
scrutiny away from the freak and toward the normative. The normal
becomes the monster, and that monster is neoliberal militarism.

SATIRIZING WAR

That Stiller elected to parody Vietnam War films and not those of
other wars is significant to the impact of his satiric, monsterizing
project. Each twentieth-century war in which the United States has
engaged has a distinct cultural legacy: World War I signals a tragic
beginning to the modern warfare of chemicals and automation;
World War II evokes the unequivocally good war fought for justice
and freedom against the unmitigated forces of evil; Korea marks such
an inconclusive and shameful ending that American forces still are
occupiers more than half a century later; and Vietnam? Vietnam, says
scholar David Elliott, "is shorthand for failure," imperial overreach,
and mistrust of those in positions of power (19). One now cannot
refer to this war without evoking visions of the solemn black granite
memorial wall in Washington, homeless, drug-addicted and wheel-
chair-bound veterans, antiwar protests, the My Lai massacre, allusions
to PTSD, and the ubiquitous sound of airborne helicopters. Although
George H. W. Bush declared in 1991 at the end of the First Gulf
War that the Vietnam Syndrome—a late-twentieth-century version
of isolationism—had been conquered, the war's residue has been
embedded in American culture. It is ingenuous to think otherwise,

to imagine that Vietnam or any other war film signifies equally in United States national culture or that the lessons of Vietnam do not resonate with the early-twenty-first-century American wars in Iraq and Afghanistan.

Moreover, though all wars signal challenges to gender positioning, Vietnam representations especially signal in the current US ethos the instability of American masculinity. The Vietnam era represents a period of social turmoil in American history, when many of what had been the dominant master narratives were challenged and overturned. Many liberation movements were born in this era: for women, people of color (including African-, Latino-, Asian-, and Native-Americans), people with disabilities, and people who identify as gay or lesbian. As artifacts of the War era's sensibility, Vietnam War narratives always already imply these many challenges to the status quo. Because Vietnam was the last American war to feature almost entirely male homosocial combat groups, its narratives focus attention on the various ways male bodies perform gender—both masculinity and femininity—under the dire conditions that war presents. Vietnam War films like the ones *Tropic Thunder* parodies are rife with such performances, so much so that the elegiac quality of these films could be regarded as grieving the exposure in war of normative (white, male, heterosexual, able-bodied, rational) masculinity's performativity. What Vietnam War narratives frequently reveal is the volatility of gender roles whose viability is premised on their being stable. The presumed monolithic quality of masculinity in war stories is foiled in Vietnam War narratives especially, subsequently undermining notions on which the practice of war relies, like honor, heroism, and courage.[9] The failure to which David Elliott refers earlier is not only about military strategy and national ethos, then, but also about traditional understandings of gender. Consequently, as soon as *Tropic Thunder* narrates Vietnam, it narrates masculinities, and as it parodies these films, it satirizes the masculinities on which the actual US military continues to rely.

R. W. Connell's notion of hierarchical masculine structures is useful here for interpreting *Tropic Thunder*, as Connell's theory elucidates that, rather than there being a single masculinity practiced and valued across histories and cultures, masculinity not only varies by historical and cultural context but there also are varieties of masculinities among males (and females) within those contexts (Connell; Connell and Messerschmidt). In any given context, there is a dominant/hegemonic masculinity whose very dominance confers the power to subordinate and marginalize other forms of masculinities. The hegemonic

form relies for its sustenance, too, on the complicity of people who may not actively participate in the masculine hierarchy but who none-theless benefit from there being a masculine structure. Furthermore, a person's masculine status is not guaranteed across contexts; while one's performance may be considered constitutive of a hegemonic group in one culture, for instance, that same performance may be deemed subordinate in another. Thus, Connell concludes, masculin-ity always is in crisis as its participants constantly vie for dominance and thereby the power to establish categorical boundaries. As satiric components, the multiple layers of the Stiller Film *Tropic Thunder*, like the many layers in Jackson's *King Kong*, call attention to this potential for variation in and competition among people within over-lapping, hierarchical, masculine structures.

Perhaps the most illustrative example of masculinities' dependence on context occurs early in the Speedman film, when the cast and crew in Vietnam have assembled to teleconference with the movie's pro-ducer, Les Grossman (Tom Cruise). Grossman is an irascible, profan-ity-spewing, Diet-Coke-hyped Hollywood mogul who terrorizes all who work for him, and during the conference, he advises the direc-tor to "spank" the petulant actors holding up the Speedman film's making. Four-Leaf Tayback, gruffly speaking from the shadows of the already ill-lit room hosting the cast and crew, cautions that spank-ing is not the answer: The cast will be motivated only by the actual fear generated from living in a remote area without modern nice-ties. Grossman's voice takes on a deferential tone when he learns that Tayback is the writer of the memoir on which the Speedman film is based, Grossman's deference suggesting that Tayback's status as mas-culine American Military Hero is consistent across contexts and stable across time. That is, the masculinity conferred on Tayback because of his heroic performance during a long-ago war is a lifetime award: once earned, always possessed. "Oh," Grossman intones reverentially as he peers into the camera, "you're a great American. This nation owes you a huge debt." Grossman's next line, though—"Now shut the fuck up and let me do my job!"—points to two ways in which masculinity var-ies by context: first, the 2008 film's "support the troops" scriptedness of Grossman's mantra-like deference; and ultimately the primacy of corporatism over militarism in this milieu. Although Tayback's status may be elevated to Hero/hegemonic in the context of the Vietnam War, in the context of making a film about that experience, he is demoted to being a marginalized nosey body who impedes the telling of his story. Performances of military masculinity prevail in a combat context, but in a film context a different masculine hierarchy prevails,

with the brash money person—the producer, Les Grossman—at the top, deciding on the structure of this masculinist pyramid. In this case, and reminiscent of Carl Denham in Jackson's *King Kong*, masculine heroics in a war film (or in war) count only when and to the extent that Hollywood's hegemonic masculine form decides they count.

The discontinuity in masculine status that Tayback experiences in this instance is repeated throughout the Stiller Film and Speedman film. Based as a military institution is on rank a story about the military already imposes a hierarchy, and, as discussed earlier, a story about the American war in Vietnam imposes additional narrative hierarchies. The American film world also is hierarchical, determined largely by awards but especially those from the Academy of Motion Picture Arts and Sciences, the Oscars. Thus, the Speedman film, *Tropic Thunder*, arrives loaded with various intersecting pyramidal structures of which the actors are only vaguely aware. What is patent to them all is the existence of a Hollywood ladder. Kirk Lazarus has won multiple Oscars and so is at the apex of one pyramidal structure. Tugg Speedman's career has been spent in multiple renditions of the same action film, but with *Simple Jack*, he has tried transitioning to the type of film that might be considered Oscar-worthy and thereby moving into the hegemonic spot in another pyramidal structure. Based on the types of films they make, Alpa Chino and Jeff Portnoy both are on the fringes of Academy-respectability, and Kevin Sandusky is not even on the fringe as he plays a "cherry" in the Stiller Film but is also a "cherry" when acting in the Speedman film. An example of the Hollywood and military filmmaking structures overlapping is in the relationship between Lazarus and Speedman. Although as an Oscar winner Lazarus clearly "outranks" Speedman in the world of Academy Award performances, in the *Tropic Thunder* Vietnam War narrative, the Speedman film, Speedman, as Staff Sergeant (E6) Four-Leaf Tayback, outranks Lazarus, as Sergeant (E5) Lincoln Osiris. Status conflicts between these two men first surface in the opening scene of the Stiller Film, when character Tayback (played by Speedman who is played by Stiller) has been wounded and Osiris (played by Lazarus who is played by Downey) comes to rescue him. The scene demands that both characters weep, but while Lazarus can blubber on command, Speedman, derogatorily referred to as "Action Jackson" by Lazarus, cannot produce tears. Speedman is confused by Lazarus's "pulling (actor) rank" when it is Speedman playing the focal character of the film that outranks Lazarus's character. With the boundaries of masculine contexts intersecting, Speedman is flummoxed as his masculine status fluctuates.

A second instance of masculine discontinuity occurs when the Speedman film's cast is walking through the jungle but disagrees on which direction to take and on what they should be doing. Even though the group members are uncertain of when they are acting and when they are not, when they are being filmed and when they are not, Speedman steadily assumes that his dominant rank in the combat film script confers dominant rank on him when they are a cast. Earlier, for instance, when the director's head is blown off, Speedman alleges that unlike the others, as a star of action films, he recognizes the special effects fakery being perpetrated on the group. At this earliest point in their jungle venture, as the boundary between their military and actorly selves is being established, Lazarus defers to Speedman's judgment. Later, however, in this second instance, Lazarus's disrespect for Speedman becomes apparent as, despite his lower military rank as Sgt. Osiris, Lazarus plans to foil Speedman's desire to continue walking through the jungle. Unlike Speedman, Lazarus understands that the movie's Director was killed by a landmine and so is eager to return to the safety of the drop zone where the cast can be airlifted out of the jungle. Thus, first Lazarus and then Speedman conspiratorially approach Sandusky to ask his help in furthering each of their plans, Lazarus to navigate the cast back to the drop zone because Sandusky can read a map and Speedman to help keep the movie on task while, he thinks, Lazarus tries to "torpedo" it. This conflict between the two vying for dominance within the group reaches a turning point when, led by Speedman, they arrive at a river and Lazarus insists that they are lost. To appropriate from Speedman the group's only map, Lazarus—always in character as Sgt. Osiris though not abiding by the military ranking hierarchy—distracts vain Speedman with flattery, disarming Speedman so that Lazarus can seize the map. Speedman invokes military language when he protests that "we're supposed to be a unit," but the cast splits into two: Speedman heading off on his own to continue performing Staff Sergeant Tayback while the others aim in the opposite direction for the pick-up point. Over his shoulder, Lazarus exhorts Speedman with a now laughably obsolete Army marketing slogan: "You go be all you can be." Both actors are perplexed by the demands of the overlapping hierarchies of the military and of Hollywood, neither able to sustain a hegemonic position across these intersections. While Lazarus maintains his African American character but not his character's rank, Speedman has trouble maintaining a consistent character or rank.

The documentary, *Tropic Blunder*, is another venue for masculine discontinuity. But as a standard "band of brothers" narrative, where

the men initially compete to assume the dominant position and find through the trials of war and collective action that they would sacrifice anything for one another, the documentary resolves this internal conflict. The band of brothers narrative is typical of World War II combat films, whether they were made during, immediately after, or decades following the conclusion of the War. Because their aim is to emphasize the collective action of Americans who, despite their individual differences, ally against forces of evil, the band of brothers World War II films typically insist that all versions of masculinity are fundamentally the same and of equal value (Basinger). As discussed earlier, the story of *Tropic Blunder* is that vying for masculine dominance as they perform the Speedman *Tropic Thunder* divides the men, sending Tugg Speedman off on his own venture. Inept at surviving in the jungle but performing what he imagines those skills to be, Speedman subsequently is captured and imprisoned by the drug producers. Cody (Danny McBride), the crew member responsible for pyrotechnics and operating the helicopter, and Four-Leaf Tayback, the memoir writer, also have been captured by the drug producers. *Tropic Blunder* narrates how the remaining cast members—Kirk Lazarus (still in character as Sgt. Osiris), Kevin Sandusky, Alpa Chino, and Jeff Portnoy—comically plot to rescue Speedman. The documentary's resolution of the individual group members' competition for masculine dominance mandates that all of the participants in the rescue mission are forgiven their previous sins against collective welfare, thereby conferring on them this band of brothers masculinity. During the climactic rescue mission, the central actors acknowledge their personal fakeries and commit to the survival of the (all-masculine) group. Tugg Speedman emerges from his narcissistic fog (à la Marlon Brando in *Apocalypse Now*) to help all of the men escape from the drug camp; rejecting the Vietnamese child he fantasized parenting and not flinching at the destruction of the Tivo he'd earlier thought essential illustrate Speedman's emergence from egocentricity and into brotherhood. Kirk Lazarus peels off what turns out to be his blackface mask, revealing his dependency on artifice and the support of other actors; Jeff Portnoy denies himself the heroin he craves and instead selflessly uses the powder as a weapon against the drug producers; Alpa Chino daringly initiates the rescue despite his earlier confession of being gay; and Four-Leaf Tayback, revealed as a fake, uses his hands to detonate the bridge that stops the drug producers' pursuit. Paradoxically, *Tropic Blunder* (satirically) suggests, only when males surrender the impetus to perform individual, often conflicting military masculinities will they discover the liberations

of collective action. This, of course, is the logic of actual American military units that rely on the interchangeability of human cogs in the military machine. The band of brothers happy ending is evident at the Academy Awards where all of the brothers' wishes come true: Tugg Speedman wins his Oscar, Kirk Lazarus humbly confers the award on Speedman, Sandusky has a date with gorgeous actress Jennifer Love Hewitt, Alpa Chino has a date with gorgeous singer Lance Bass, and Jeff Portnoy looks healthy, as though he's kicked his drug habit. Ironically, the men's admission of not embodying military masculinity is required to earn it, World War II style. This happy ending is satirized as preposterous, however, and the actors' complicity in maintaining the Hollywood hierarchy is revealed as the final image of the Stiller Film—Les Grossman/Tom Cruise dancing lewdly by himself—reminds the audience of who is the ultimate winner of this film's Academy Award success: the monster behind-the-scenes, the Hollywood War Machine.[10]

What might be said about filmic satire is that it is grounded less in the historical era represented than in the historical era *in which it is produced* by calling attention to and thereby attacking contemporary political and social follies, attacks that usually discomfort its viewers. Sometimes viewers laugh at that discomfort, and sometimes they do not. Most responders to Patricia Bauer's website do not laugh; one even writes, "We are not ready to laugh yet." Presumably, those who did laugh at Simple Jack and others of the *Tropic Thunder*'s barbs are repeating the same refrain heard in response to *300*: Get over it! It's only entertainment! Reviewers of *Tropic Thunder* are as divided about the Stiller Film as those taking offense and those laughing. Citing it as lampoon, parody, spoof, send-up, comedy, and farce, critics from mainstream hard-copy sources as well as those strictly online are at odds. Those pleased with Stiller's Film appreciate its chaotic satirical elements. David Ansen of *Newsweek* calls it "the most giddily entertaining, wickedly smart and cinematically satisfying comedy in a season overloaded with yuk-'em-ups"; Stephanie Zacharek of Salon.com says "comedy needs the right to be offensive" and "*Tropic Thunder* is an imperfect work of genius, a satire of Hollywood excess and vanity that dares to tread territory laden with minefields." Richard Knight of *Knight at the Movies* lauds the Film's representations of gay sexuality, noting appreciatively that the laughs coming from "apparently straight dudes" in the audience when he saw the movie were not derisive. Moreover, he calls *Tropic Thunder* a "large scaled comedy that doesn't resort to the smarmy adolescence of the Judd Apatow movies for its laughs and is easily just as entertaining if not more so."

A few reviewers are less sure about the Stiller Film. Armond White is fastidious about detaching it from "modern warfare," suggesting that parodying Vietnam War films demonstrates how "Hollywood is so far past post-war guilt and anxiety that the sanctimony of films like *The Deer Hunter, Apocalypse Now*, and *Platoon* are ripe for parody." Manohla Dargis of *The New York Times* cites "the [full] retard scene" of Speedman and Lazarus as perhaps the best in the Film but sniffs that *Tropic Thunder* is made by the "professional offender" Ben Stiller. Other reviewers unequivocally object to the movie, objections based largely on its not being accurately satirical. "Satire can be more than saying something sillier and louder than the original," scolds Justin Stewart of *StopSmilingOnline*. Speaking to satire's reliance on historical immediacy for its impact, Hunter Stephenson of *Slashfilm* disparages not the Film's politically incorrect jokes aimed at racial and sexuality differences so much as their tardiness: "[I]t's too damn late for 'un-PC' white/black jokes" and jokes aimed at gays and rap musicians. Similarly, the *VillageVoice.com*'s Robert Wilonsky notes the movie's using Hollywood's convention of ridiculing itself. *Tropic Thunder*, he laments, is "just another action movie pretending it's not just another action movie...And that's the thing about satire: It doesn't play past its expiration date." Conversely, while Stewart, Stephenson, and Wilonsky think the Stiller Film as a satire does not target closely enough contemporary social conventions, Peter Rainer of *The Christian Science Monitor* objects to the Film's being *too* proximate to contemporary events, saying that the movie "comes dangerously close to making fun of actual soldiers." Rainer grumbles, "the laughter catches in our throat," when a more skilled director would have allowed audience members "to supply our own derision." *Variety* critic Todd McCarthy complains about the Stiller Film's "lack of grounding" and "small details that don't feel right," while Dave Itzkoff of *The New York Times* derides *Tropic Thunder* as yet another raunchy, adolescent-boy-titillating movie.

These negative reviews indicate the minefield that is satire. On the one hand, it must address and attack social and political conventions of a particular historical period (i.e., Stewart; Stephenson; Wilonsky). On the other hand, satire's aggressive attack creates discomfort as nothing is sacrosanct and everything is targetable, even supposedly protected groups like actual soldiers and people with intellectual disabilities (i.e., Rainer; Bauer; White). In his discussion of *WALL-E* and *Tropic Thunder*, Bernard Beck writes that the tenor of joking at any given time is an accurate measure of social transformation, and that "[t]he dominant narrative of creativity and progress in any

cultural field now emphasizes the resistance of comfortable, respectable opinion to new, unexpected, shocking, and correspondingly improved ideas." Humorists aim to disrupt, so audience displeasure and unease serve as "confirmation, not contraindications, for comic invention" (91). Consequently, says Beck, what is considered funny is less predictable, especially because people who in the past have been the object of jokes—people with intellectual disabilities, for instance—often refuse that objectification now. What is monstrous about *Tropic Thunder* is its two-pronged assault: It parodies Vietnam War films as a Hollywood genre, but it also satirically attacks war as it currently is being practiced (or, perhaps, generally). We agree with Peter Rainer of *The Christian Science Monitor* when he notices *Tropic Thunder*'s proximity to soldiers at war now, though we think the film is attacking less individual soldiers than the social rhetorics—which include blockbuster films—taking them to war.

MANNING UP IN THEATERS OF WAR

A central element of these go-to-war rhetorics is an appeal to realism. American war movies typically are gauged by the authenticity of their representations and by the extent of the writer/director/cinematographer/actor's experience with war. From the shooting locations to the military equipment and uniforms used to the patois of the "soldiers," war films are perhaps subject to more scrutiny of their verisimilitude than any other genre. Ben Stiller says that he wanted to make a film like *Tropic Thunder* since the late 1980s and worked on the script (with Etan Cohen and Justin Theroux) for a decade before the film's release in 2008 (Curtis 79). Although this decade coincided with the initiation and continuation of American wars in Afghanistan (2001) and Iraq (2003), Stiller contends in interviews that the movie is aimed at the narcissism of actors in Vietnam War movies specifically:

> So there was just a time when everybody was doing these war movies and talking about the best [military preparation, i.e. boot] camps...which just seemed sort of funny to me, that they were talking about these experiences like they were real-life experiences...But it wasn't the real thing. (Qtd. in Greene, "Back to the World" 26)

Oddly, though Stiller discriminates here between "real" and "not real" experiences, he and his interviewers continue to invoke "real" and "realism" for *Tropic Thunder*. He is cited as striving for "a specific

tone that fell somewhere between outlandish comedy and realistic parody" (Curtis 80–81). Stiller sought a "natural" look to the film in hiring John Toll as cinematographer, who insisted on using live explosives and reel film.[11] The latter, Toll explains, provides authenticity, realness; digital filmmaking can only "embellish" on the original, which to Toll can be captured on celluloid (Fisher 45–51). Stiller seems to be of two minds about this objective of reality, though. In "Back to the World," he simultaneously complains that "the reality of filmmaking is pretty ridiculous" but also extols the realness of *Apocalypse Now*'s pre-CGI sequencing. Furthermore, he notes how through improvisation much of *Tropic Thunder* departs from the script and "became its own thing," as though the filmmakers and actors left behind one (constructed) reality in favor of making up another as they went along (26–28).

The "real" is elusive and not always desirable, though. For instance, in an interview about *Tropic Thunder*, a *Rolling Stone* interviewer asks Robert Downey Jr. about the time he spent in prison, and when Downey answers "Let's not bring him [prison-Downey] into this," the interviewer interprets Downey's response to be differentiating between "real" and "true." " 'Let's not bring the *real* me into this . . . Let's not even begin to suggest that it [Downey's prison stay] has anything to do with my *true* identity' " the interviewer imagines Downey rationalizing (Hedegaard 9). While Vietnam War fiction author Tim O'Brien heralds "story-truth" over "happening-truth," or altering the "reality" of the Vietnam War to induce the proper emotional response in the reader,[12] in *Tropic Thunder* there seems to be limits on what realities may be represented. While *Tropic Thunder*'s including profanity accords with most Vietnam War representations (and earned the film an R rating), and Stiller elected to include the objectionable "retard," which is historically accurate, he opted to exclude "nigger," which is also historically accurate ("Retard").[13] Given the imbrication of what spectators may think of as fact and of fiction in the Stiller Film, Stiller is equally confused by the reality of his being both an actor in the Stiller Film and the Speedman film but also the Stiller Film's director. For instance, when he was the director of the Film simultaneous to acting in the film as an actor calling "cut," "It was a very confusing time because nobody knew if it [Stiller's directing or acting] was for real or not" (Greene 28). It is especially ironic that Stiller attempts to approximate "reality" in *Tropic Thunder*; as Stephanie Zacharek points out, the objective of the film is to satirize the "movie realism [that] may be dramatically effective but . . . isn't in itself heroic." Stiller's aims, however, reflect the ethos of Vietnam War representations, both

those made well after the war as well as those contemporaneous to it. As Michael Anderegg claims in *Inventing Vietnam*, the characteristic representational mode of Vietnam is realism:

> The footage from Vietnam, whether on film or videotape, was produced by a generation of filmmakers imbued with the style and technique of cinema verité and direct cinema. One-day delay of film and other forms of rapid dissemination gave much of what Americans watched on the evening news an immediacy and intensity that was new and that forever shaped America's experience of warfare. (2)

Thus, the aim for realism in war narratives is a legacy of the Vietnam War, a product of then, but the aim conflicts with the desire to satirize Vietnam War films, products of now. Any use of Vietnam in films now is as much about now as then.

Stiller's invocation of the "real" is noteworthy, as though realness is an essential, stable entity that preexists its narrative and predictably can be called upon. That is, given his stated motivation for making *Tropic Thunder*, he assumes that engaging in combat during war is less performative—less about the anticipation and naturalization of behavior that comes through reiteration—than is performing engaging in combat during films. His concern for the "real" in this Film, and the unpredictable monstrosity of satire, however, exposes the equivalence of the two positions: just as the actors in the Stiller Film cannot distinguish between authentic and inauthentic venues of war and strive to understand the elusive "real," Ben Stiller the writer and director perversely strives for realism in the film whose satiric objective is to trouble that distinction. In effect, spectators of *Tropic Thunder* are positioned as the Speedman film's actors: befuddled by what they think they are seeing. Jan Mieszkowski's claim about war's being "a signifying performance," that seeing and participating in war is not synonymous with understanding it, can clarify Stiller's predicament.

> To attend the theater of war may be to engage as much *with what one should see or should have seen* as with what one does see. In this way, watching a war and imagining what it must be like to do so prove to be inextricably interconnected activities. The story of a combatant or bystander witnessing a battle unfold live thus becomes a testimony to the mediated quality of an event that ostensibly gains its significance from the immediacy of its physical horrors...[A]ny war is permanently under suspicion of being a phony war, in that it emerges as a political program on the basis of a sustained distinction between an act and the plan to act. (1649; emphasis added)

Thus, Stiller's aim to make his representation of war "realistic" is a futile one, as what viewers understand of war always already is mediated by what they expect war to be, even when they are combatants (or when they are trying to laugh at war's representations). This expectedness is especially the case with the highly mediated understanding of Vietnam that Americans have. As Mieszkowski explains further, "the story about *what and how one should see* when witnessing a military venture will be just as important as what one does see" (1653; emphasis added). Mary Louise Pratt adds to the idea of war's already mediated meaning as she argues against claims that the horrors of war supplant language: "where there is violence, language is nearly always present, supplying meanings and alibis and inflecting injuries of its own" (1516). Linguistic meaning-making is integral to warring, Pratt avers, especially in transmitting appeals to "transcendent object[s]" like honor and heroism that sustain the willingness of a populace to continue its warfare (1520). Suggesting that war is an alibi for the "blood sacrifice" of citizens needed to provide group coherence and solidarity,[14] reminiscent of how Connery and Combe characterize satire as unmasking civilization's inherent violence, Pratt says "meaning making works to conceal that which cannot be sustained if it is recognized" (1521). If we know that fundamentally national coherence relies on "blood sacrifice"—the regular sacrifice of certain of its citizens—and war is the medium for such sacrifice, we will be less or unwilling to condone war. Thus, appeals made to concepts like "honor," "duty," and "freedom" are linguistic alibis to conceal the ultimate objective of war: to sacrifice our own, not kill the others.

As a satire/monster, *Tropic Thunder* unveils this kind of meaning-making especially because it concerns itself with Vietnam War films made before September 11, 2001, and not those made after that date or about World War II or Korea. In *Inventing Vietnam*, Michael Anderegg suggests that these pre-9/11 Vietnam War films were made sufficiently long after the end of the war that they serve as "meditations on and explications of America's military and political involvement in Indochina" (3). But they are not only retrospectives on the Vietnam War. As Anderegg points out, "they became and continue to be barometers of current attitudes. In the Vietnam cinema, the war is not presented so much in the realm of history or memory as it is projected beyond history and memory into the present. The Vietnam War, one feels, never really ends" (4). That the films say as much about the time in which they are released as about the war era itself is evident in war films produced since 9/11. For instance, in his

2002 discussion of *Black Hawk Down* (released in January 2002) and *We Were Soldiers* (released in March 2002), Tom Doherty points out how both films—the first about the 1993 American military disaster in Somalia and the second about the 1965 American military disaster in Vietnam—paint a portrait of warfare long ago influenced by September 11, 2001. If *Black Hawk Down* and *We Were Soldiers* are indicators, "A moral clarity heretofore the exclusive province of World War II," Doherty says, "will likely guide the sensibility of the cycle of the future." Moreover, films that deal directly with 9/11 "will be one step removed, wrapped in disguise, erased from the skyline, revealing themselves as 'about' 9/11 only decades later" (221). Thus, our war narratives, filmic and otherwise, are shaped and conditioned as much or perhaps more so by our current sensibilities as by those contemporaneous to the events depicted.

In ways similar to *King Kong*'s speaking to present-day issues of race and class, *300* speaking to modern-day American militarism, and *V for Vendetta* speaking to contemporary neoconservative politics, *Tropic Thunder* speaks to actual war (Figure 4.1). War films inherently are political mythmakers, even when they avoid overt mentions of Politics and History and narrate repercussions for the individual, not geopolitics. As Andrew Bacevich declares in *Washington Rules*, "Myth making in relation to war is never innocent" (205). *300* obscures the historical Spartan and his echo in today's world using blue-screen technology, stylized imagery that replicates the look of Frank Miller's graphic novel, and the facelessness of Xerxes's shock troops, the

Figure 4.1 Aiming at Hollywood, hitting the Pentagon.

Immortals. It is challenging, then, to see beyond this monstrous feint to *300*'s saturation in modern-day American militarism. Apropos of a Vietnam War film, however, realistic *Tropic Thunder* appears as though it conceals nothing, as though it naturally is outside of political and historical realms.[15] As a parody, it thumbs its nose at the genre of Vietnam War films specifically. As a satire the film expands its target, aiming to make everything painfully visible and thereby foolish or knavish: not only vain and obtuse actors, but also racial difference, sexuality, masculinity, hard bodies, soft bodies, intellectual and physical disabilities, and the hubris and toadying exemplified by corporate Hollywood. Because all of these identity positions and behaviors are connected to at least one focal character in the Speedman film, almost all of whom are played by actors with deep and long-standing connections to Hollywood, it appears that Hollywood antics alone are being satirized. As Cohen observes, however, "The co-optation of the monster into a symbol of the desirable is often accomplished through the neutralization of potentially threatening aspects with a liberal dose of comedy: the thundering giant becomes the bumbling giant" (18). In this case, the murderous intents of heavily armed and potent actual soldiers become the naive efforts at rescue of actors with figurative and literal blanks in their weapons.

One character in the Stiller Film is exempt from this broad attack on "Hollywood," his exemption exposing the film's satirizing of actual war: the earnest and unjaded new actor, Kevin Sandusky (Jay Baruchel). Because he is the only one to have attended boot camp and consequently he is the only one with the map-reading skills to get them out of the jungle, Sandusky is the closest among the actors to being an actual soldier. After all, when combatants first enter war, they, too, have been trained but not extensively in live fire.[16] Furthermore, the actor's name, Sandusky (AKA "Brooklyn" in the Vietnam War Speedman film), tips off the audience to his American Everyman status, as names and nicknames are significant in war films.[17] While he resists the absurd military masculinities consciously performed by the other actors, Sandusky does not reject traditional military masculinity altogether; as a result of its being reiterated in his military training, military masculinity has been naturalized.[18] For instance, as Sandusky, Lazarus, Alpa Chino, and Portnoy deliberate on how they will rescue Speedman from the heroin producers, it is Sandusky who reminds them that they have a ready-made plan—the "Wet Offensive"—in the memoir on which the film is based and in the film's script.[19] Alpa Chino objects to their actualizing that plan when they have neither functional weapons nor military training;

Lazarus counters that their acting skills are comparable to military training, skills that will see them through this challenge. "Time to man up," Lazarus exhorts the others. Having read the memoir and the script and having gone to basic training, Sandusky alone has studied and practiced the scripts of how to perform military masculinity but the others—Lazarus, Portnoy, and Alpa Chino—think they have only their acting skills to perform what they imagine is military masculinity, to "man up."[20]

What it means to "man up" might be the central issue of *Tropic Thunder*, given the various layers of fictionality and masculine hierarchies in the movie and especially given the men's reliance on their performative skills to rescue Tugg Speedman. Their manning up is referential: based on an expectation of what war should be (Mieszkowski, earlier), developed through an American filmic legacy of masculine signifiers in combat, and enacted in films like *300* and Vietnam War films like the *Rambo* series as "hypermasculinity." Citing the 1970s' origination of this term in criminology and its 1980s' expansion to the fields of sociology and psychology, Kirby Shroeder defines "hypermasculinity" in this way: "Hypermasculinity refers to sets of behaviors and beliefs characterized by unusually highly developed masculine forms as defined by existing cultural values" (Kimmel and Aronson 417). Like R. W. Connell's outline of masculinities in *Masculinities*, Shroeder's definition is relational and so is applicable across cultures and histories; forms of hypermasculinity are not limited to American wars or to the twentieth and twenty-first centuries. It is effectively a version of the hegemonic masculinity at any given time in any given place. In "Hypermasculine Warfare: From 9/11 to the War on Iraq," Francis Shor specifies what are these "highly developed masculine forms" in relation to the "cultural values" of the United States for the last decade. "Hypermasculinity," he claims, has been "deeply embedded in the military intervention and war-making encouraged by US imperial policies, especially since the Cold War."

> Fearing vulnerability and eschewing empathy and compassion, hypermasculinity projects a punitive posture and a dismissive attitude towards any supposed feminine attributes. Embracing characteristics of the bully, hypermasculinity attempts to browbeat and punish those who threaten the pseudo-sense of invulnerability fostered by an aggressive masculinity. Hypermasculinity is not an eternal nor essential feature of manhood; rather, constructions of hypermasculinity are nourished by historical conditioning and socio-cultural practices and complicated by class, race, and sexual orientation. (Para 1)

That these actors have to refer to film scripts for their understand-
ing of what it means to "man up" does not differ from how gender
is learned and practiced generally. Heterosexual male masculinities,
which include military hypermasculinities, are developed through
repetition and the "scripts" provided in everyday life. These cultural
scripts are pervasive, from catalog photos to war films to digital gam-
ing. As the hegemonic forms of masculinity exert their normalizing
pressures, Americans are tutored to internalize certain forms of gen-
dered behavior as normal and others as deviations from that norm.
Judith Butler's notion of gender performativity in the context of
"compulsory heterosexuality" is useful here in elucidating the ongo-
ingness of this script:

> [H]eterosexuality is always in the process of imitating and approximat-
> ing its own phantasmatic idealization of itself—*and failing*. Precisely
> because it is bound to fail, and yet endeavors to succeed, the project
> of heterosexual identity is propelled into an endless repetition of itself.
> Indeed, in its efforts to naturalize itself as the original [sexuality],
> heterosexuality must be understood as a compulsive and compulsory
> repetition that can only produce the *effect* of its own originality; in
> other words, compulsory heterosexual identities, those ontologically
> consolidated phantasms of "man" and "woman," are theatrically pro-
> duced effects that posture as grounds, origins, the normative measure
> of the real. ("Imitation" 313)

In this case, there is no original, true form of heterosexual being;
heterosexuality is an act, a performance, not a condition or state. It is
only in repetition of the effects of heterosexuality that heterosexual
gender norms are constituted. Butler concludes "the parodic or imi-
tative effect of gay identities works neither to copy nor to emulate
heterosexuality, but rather, to expose heterosexuality as an incessant
and *panicked* imitation of its own naturalized idealization" (314). As a
satire, *Tropic Thunder* manifests and calls attention to this repetition-
producing panic, not only in terms of male masculinity as constructed
in Vietnam War films but also of war generally.

Tropic Thunder's alignment of the Vietnam War with movies is
not limited to this film, moreover. Not only is it likely that most
Americans have learned what they know about the American war
in Vietnam from the kinds of movies *Tropic Thunder* parodies, but
fiction and nonfiction narratives also use the trope of film to char-
acterize the Vietnam War and subsequent wars. Michael Anderegg
confirms this in the opening sentences of *Inventing Vietnam*:

The essays here collected testify to the unique relationship between the U.S.-Vietnam War and the images and sounds—on celluloid and videotape—that have been employed to represent it. Whereas World War II, despite all the cinematic treatments it inspired, found its most characteristic depictions in historical writings, memoirs, and novels, the Vietnam War, though it has produced a number of brilliant novels and nonfictional prose accounts, has thus far been given its imaginative life primarily through film. (1)

Similarly, Albert Auster and Leonard Quart begin their book, *How the War was Remembered* with a discussion of war films' influence on conceptions of American manliness, quoting from Tim O'Brien's 1978 magical realism novel about the war, *Going After Cacciato*: "Honest, it was such a swell war they should make a movie" (1). In Michael Herr's 1977 *Dispatches*, at the same time that he names this book his movie (188), he indicts war movies for influencing "grunts" as they perform what they have been trained to think is military masculinity:

> I keep thinking about all the kids who got wiped out by seventeen years of [WWII] war movies before coming to Vietnam to be wiped out for good. You don't know what a media freak is until you've seen the way a few of those grunts would run around during a fight when they knew there was a television crew nearby. (209)

Famously, Anthony Swofford recounts in *Jarhead*, his memoir about being a Marine during the first Gulf War, that Vietnam War films in particular—*Apocalypse Now, Platoon, Full Metal Jacket*—are what his unit uses to prepare themselves for the coming battle. Despite the antiwar reputations of these films, Swofford and his mates see them as decidedly prowar. The films' images laud the murderous abilities of the American infantrymen and excite Swofford's marines about the coming battle. "[T]he magic brutality of the films celebrates the terrible and despicable beauty of their fighting skills. Fight, rape, war, pillage, burn. Filmic images of death and carnage are pornography for the military man" (5–7). Most recently, Karl Marlantes, author of the acclaimed Vietnam War novel, *Matterhorn* (2010), in *What It Is Like To Go To War* (2011) reflects 40-some years later on his medal-garnering episode while in Vietnam War combat:

> That day on the assault I felt like someone in a movie. I remember thinking, "This is like a movie. I'm the hero, and the dumb kid has just gotten in trouble with the enemy machine gun, and now the hero

will go rescue him." The movies are America's mythological matrix. I also remember thinking, "This is your chance. You throw this one away and you'll never get your medal." (165)

The repetition of this trope implies not only that the Vietnam War was *like* a movie but that it *was* a movie. War and film are equated, both performative. Repeat their acts often enough and they start to seem "true."

Practicing War

At the conclusion of *Tropic Thunder*, overweight, balding, bling-wearing, and hirsute Les Grossman, played by Tom Cruise, celebrates *Tropic Blunder*'s winning an Oscar. Alone in his ready room, Grossman jubilantly dances under a convenient spotlight as the credits roll. The movie's viewers might conclude that this scene is the apt culmination of a film parodying the confections of Hollywood alone. Here, viewers might think, is Power Exposed: the real Dance of Power and Grossman, the real puppeteer. However, as monstrous satire *Tropic Thunder* exposes "the violence that civilization conceals" (Connery and Combe 7); in this case, the enduring and painfully close relationship between war and film is exposed. The Introduction to Guy Westwell's "Short Cuts" guide, *War Cinema: Hollywood on the Front Line*, begins succinctly:

> The war movie is as old as the cinema itself, and from early experiments through to today's high-concept blockbusters, war has been a staple Hollywood product. War movies lend shape and structure to war, identifying enemies, establishing objectives and allowing audiences to vicariously experience the danger and excitement of the front line. (1)

This correspondence between American visual media and the behavior expected of American military people at war is not accidental or serendipitous. Instead, as evidenced by our discussion of video games in chapter 2, it is the result of a calculated collaboration between American military and entertainment forces, the result being that it is nearly impossible to distinguish between the two. What the long-standing relationship between war practice and filmmaking suggests, however, is that when a war film is released, there is likely another ready room full of uniformed officers doing a similar dance of celebration as one more war film tutors Americans—especially males—in going to war. Ostensibly fictional representations of military people

in action are designed to be indistinguishable from actual practices of war.

The reverse happens as well: Practices of war are designed to look like fiction. Witness briefly two 2012 cultural productions attesting to this hybrid interchangeability of representations of war. The first is the film *Act of Valor* (2012), previously mentioned in this book's introduction. In its representation of Navy SEALs, *Act of Valor* panders to the mania for all things SEAL following SEAL Team 6's covert capture and killing of Osama bin Laden in May 2011. While the film features elements of reality filmmaking—shaky, shoulder-held camera work, grainy film, dim lighting, and actual Navy SEALs on what seem to be action-packed, dangerous, and actual missions—what is even more indicative of the desire to integrate the actual and the fictional is that the same person who wrote the script for *Act of Valor*, Kurt Johnstad, also wrote the script for *300* ("Kurt Johnstad"; Longwell). Both films do what it takes to normalize war-making.

An even closer equivalency is drawn between actual war-practice and its fictional representations in the second cultural production, a new television show, "Stars Earn Stripes." Premiering on NBC in August, 2012, and following directly on the heels of NBC's nationalistic presentation of the 2012 Olympics, this television feature is described on its website as an "action-packed competition show that pays homage to the men and women who serve in the U.S. Armed Forces and our first-responder services." Celebrities—the "stars"—undertake the "real danger" of "real American heroes" to demonstrate "just how incredible these heroes' missions really are." Each celebrity is "paired with a special operative from a military branch or one of our first-responder forces, including former U.S. Army Delta Force and Green Berets, U.S. Navy SEALS, U.S. Marines and police officers," and the pairs engage in challenges mirroring "real military exercises." This blending of supposed actual "operatives" and supposed representational actors is hybrid enough. What makes the show especially ironic as a model of hybridity is its use of the esteemed General (Ret.) Wesley Clark as a "host" who "put[s] the missions in perspective" ("Stars Earn Stripes"). The celebrities and heroes do not trade places; they blend their roles so that celebrities become "heroes" while "heroes" become celebrities, all with the objective of normalizing warfare as the venue for heroic acts. "This," exclaims the show's advertisement run during the Olympics, "is where it gets real."

Tropic Thunder as a satire calls attention to such equivalencies as it monstrously discloses the proximity and the thin boundary between films of war and practices of war: a parody of war films is a satire of

war-making. War movies provide to young men especially their scripts for performative American military masculinity. Parodying the filmic genre—regardless of the war film's era—satirizes the enactments of war generally. In *Tropic Thunder*'s authenticity-challenging context, to "go full retard" means to ridicule and thereby reveal the under-pinnings of war generally, to call attention to the emperor with no clothes (be it Les Grossman or Wesley Clark), to resist the rhetorical appeals to "duty," "honor," "freedom," and manhood that take us to war. Most importantly, "full retard" brilliantly asks all viewers to consider the roles they play in going to war.

CHAPTER 5

The New Millennium Manliness

Hegemonic masculinity is the gender performance that, at any given time, becomes "culturally exalted" over alternative masculine behaviors (Connell, "Social Organization" 38). Exemplars of modern hegemonic masculinity frequently are film actors, sports heroes, or even fantasy characters, ideals difficult or impossible to achieve. The actual practitioners of hegemonic masculinity, however, are people possessing institutional position or considerable wealth. Explains Connell of those exercising its power:

> Hegemony is likely to be established only if there is some correspondence between cultural ideal and institutional power, collective if not individual. So the top levels of business, the military and government provide a fairly convincing *corporate* display of masculinity, still very little shaken by feminist women or dissenting men. (39)

Tycoons, generals, and politicians being able to *imagine* themselves as John Wayne because of cultural endorsement might be a useful way to think about aspects of American domestic and foreign policy since World War II. Connell stresses as well that hegemonic masculinity is always only a currently accepted strategy:

> When conditions for the defence of patriarchy change, the bases for the dominance of a particular masculinity are eroded. New groups may challenge old solutions and construct a new hegemony. (39)

Hegemony is "a historically mobile relation," and Connell theorizes its mutability as "a key element of the picture of masculinity" (39). Both hegemonic discourse and hegemonic masculinity are cultural constructions perpetually under negotiation, making crisis inherent to these formations.

In the movies we've analyzed thus far, multiple masculinities have been on display, often in conflict with one another. Two kinds of masculine performances stand out more than enough, however, for us to theorize that, at the start of the twenty-first century, the hegemonic struggle taking place in Western and American masculinity is chiefly between two irreconcilable modes of manly behavior. At a simple level, this antagonistic divide is visible in the wrangling of red-state Republicans versus blue-state Democrats in the United States. The opposing masculinities we suggest, however, bear a cultural significance beyond the limited scope of conservative versus liberal politics. As a way to conceptualize this bifurcation in new millennium manliness, think of Leonidas versus V. Similar to the monstrosity smackdown of Alien versus Predator, these two characters illustrate nicely the competing forms of masculinity evident in turn-of-the-century America especially. As argued in chapter 2, Leonidas is the incarnation of neoconservative cultural and sexual politics. He's the right-wing man's man: steely eyed, flat-bellied, an unwavering proponent of the Spartan–American Way. His epic standoff against the Persians fictively signifies neoconservative American jingoism, plutocracy, and patriarchy. To use Connell's phrase, Leonidas can be seen as the cultural ideal inspiring much of the current US "*corporate* display of masculinity." He's the John Wayne of the New American Century; his brand of masculinity exudes the hyper-acquisitive xenophobic militarism distinguishing today's right-wing ideology. Accordingly, we'll call one extreme of masculine behavior presently in contention for cultural exaltation "NeoCon masculinity." As argued in chapter 3, *V for Vendetta* pillories American neoconservatives in its depictions of Sutler, Creedy, and Prothero. Their Norsefire party epitomizes the ultra-chauvinistic and avaricious neoconservative mindset; their state regime is a modern business, military, and government manifestation of Leonidas's belligerent "reason." Combating Norsefire is the extraordinary V. Not only does he crusade against NeoCon tyranny, V also blends, blurs, and problematizes virtually all established identity positions. His is the simultaneous disruption of neoliberal authority and NeoCon masculinity. V's performance is so radical and pluralistic that describing it as "masculine" would be to misrepresent its significance. V severs the false bond between supremacy and conventional Western manliness. V erodes the bases for the dominance of a particular masculinity so thoroughly that patriarchy itself collapses. Accordingly, we'll call the other extreme of behavior presently in contention for cultural exaltation not "masculinity" at all but "post-Marxist agency."

We theorize this stark divide in current hegemonic performance because our investigation of monstrosity has led to it. The masculine normal that Leonidas so easily seems in *300* readily warps, under scrutiny, into a disturbing monstrosity. The reverse holds as well. The monstrous abnormal that V ostensibly embodies normalizes, by the end of that film, into an admirable political worldview. It strikes us that nowadays the hegemonic "normal" teeters between these two perspectives. Much American political debate splits along this neo-conservative versus communalist divide. To be clear, we don't propose the NeoCon masculinity of Leonidas versus the post-Marxist agency of V as an either/or binary. These are not the only choices available for hegemonic behavior. Instead, we see these two postures marking the extremes of hegemonic conduct as that power position is being nego-tiated currently in Western society. That is, NeoCon masculinity and post-Marxist agency vie as poles on a sliding scale of power behaviors. As part of the subject formation of modern discipline, they establish a set of actions upon other possible actions; they designate the con-straints within which hegemonic masculinity-agency can improvise. No one necessarily needs to be all-Leonidas or all-V.[1] If we regard monsters as cultural portents and warnings, though, at present, many of our monsters tell us that we stand at a fork in the road. We can maintain the neoliberal and patriarchal status quo that likely leads to grim global outcomes, or we can alter our track toward collectiv-ist and inclusivist practices that could lead to global sustainability. *V for Vendetta* and Jackson's *King Kong* have shown us this appalling dynamic in action. Two more recent blockbuster films, *District 9* and *Avatar*, press our urgent choice by foregrounding the negotiation of new millennium manliness. That is, central to these monster movies is the clash of NeoCon masculinity versus post-Marxist agency.

HE-MEN, HOI POLLOI, AND MILQUETOASTS

Neill Blomkamp's debut film, *District 9* (2009), enjoyed a hefty pro-duction budget, estimated at US$30 million (*IMDB*) thanks to the backing of Peter Jackson, as well as considerable financial success, bringing in a worldwide gross of over US$210 million (*Box Office Mojo*). Blomkamp's film also received general critical praise and was nominated for four Oscars, to include Best Picture. No doubt this monster story made a sizable cultural splash around the world. Intriguingly in this sci-fi movie, the operational metaphor for the encounter of humans with space aliens is the controversial one of apartheid. Without explanation, a gigantic spaceship has parked over

Johannesburg for the past 20 years, and its million or so oddly behaving extraterrestrials (basically, seven-foot-tall insects) have been shuttled to ground and ghettoized in a shanty town called District 9. This arrangement has become intolerable for the humans, however, so the plan now is to move the aliens out of District 9 and resettle them in a far-distant District 10.[2] Thus, at the heart of Blomkamp's film are issues of racism and segregation. While the aliens are constructed to seem unearthly and from beyond human cultural experience, it's quickly apparent that these monsters in fact originate from *within* modern society as representatives of those excluded, dominated, and marginalized by power. Moreover, while the alterity these extraterrestrials signify most is the racial Other, and specifically the black African suffering under apartheid, equally prominent in the movie is neoliberal hegemony and its primary enforcer, NeoCon masculinity, as the source of oppression not only racial but economic. Tracking the crisis of hegemonic masculinity in *District 9*, then, reveals best its postmodern monstrosity at work.

Corporatism in *District 9* is exemplified by MNU, Multi-National United, which is a conglomeration of the world's biggest companies. MNU has won the rights to and patents on any innovations and products it may be able to glean from the alien technology. In exchange for this exclusive access, MNU has agreed with the stipulations of an UN-like world organization, in the film identified only by the acronym UIO, to look after the aliens. Hence the heavy-handed presence of private military contractors, private police, and private zoning regulations such as the bogus eviction notices (Form I-27) MNU forces the aliens to "sign." The fate of the aliens has been put into the hands of, as Blomkamp describes it, an "ethic-less and moral-less huge conglomerate" ("Conception and Design"). Obviously, MNU's sole interest in this deal is profit, not caring for the aliens in any meaningful way. In fact, the aliens, derogatorily called Prawns for their physical appearance, are treated as chattel. Not only will MNU brutally relocate them; it secretly dissects aliens and uses them as specimens for experimentation as well. What MNU wants most is to gain access to the alien weaponry, which is more advanced than that of humans but also biologically specific, meaning that these weapons only work when handled by the aliens. It would seem that, at its core, MNU is a weapons dealer. That both the South African government and the UIO, due to insufficient funding, are unable to cope with the social problems sparked by the presence of the aliens is concerning enough. That these civic institutions have abdicated responsibility altogether and turned operations over to MNU, a ruthless megacorporation

with bottomless pockets, figures the disturbing final triumph of neo-liberal hegemony, namely, the corporatization of the state itself. In the only slightly altered present day of *District 9*, the elected democracies of individual nation states are more or less irrelevant. In effect, the world is privatized, that is, managed by multinational corporations in single-minded pursuit of the bottom line.

In many respects, MNU is the apotheosis of Frank Miller's Spartan ideals as they find expression in *300*. So-called reason is combined with abject brutality in the pretense of freedom. Like the cult of Leonidas, MNU is both a coldly calculating and testosterone-laden organization. NeoCon masculinity abounds at this corporate HQ, with two characters in Blomkamp's film particularly he-manning it up. One is Piet Smit (Louis Minnaar), Managing Director of MNU South Africa and reluctant father-in-law of protagonist Wikus Van De Merwe (Sharlto Copley). Smit epitomizes magnate masculinity, basically, soft businessmen sipping scotch while envisioning themselves as economic cowboys riding the financial range. Smit's conniving after profit knows no shame. He lies to his daughter about Wikus's condition as easily as he lies to the public about the extraordinary situation of his son-in-law metamorphosing into an alien. Smit also uses his daughter's love for Wikus against the couple, tracing her emotional phone call to her husband as a way to locate the fugitive. There's little other way to describe Smit than as an incarnation of pure corporate greed. He's exploitative, sexist, racist, classist—barely recognizable as human in his appetite for capital. The other apotheosis of NeoCon masculinity is Koobus Venter (David James), an actual John Wayne type. Koobus heads MNU's "first reaction battalion," a mercenary force modeled on a South African military unit that was notoriously active in Africa during the 1990s ("Conception and Design"). They're a heavily armed and trigger-happy bunch, with Koobus a psychopath given license to run amok ("Innovation"). While pistol-whipping an alien, Koobus laughs, "I can't believe I get paid to do this. I love watching Prawns die." When preparing to execute the transforming Wikus, Koobus sneers, "You half-breed piece of shit!" Like his boss, Koobus is a supremacist of many kinds. In sum, Smit is the corporate hyper-acquisitivist while Koobus is the militarist xenophobe. Together, they choreograph MNU's clandestine dirty-ops with impunity.

The most gruesome scenes in *District 9* occur inside MNU-Headquarters and leave no doubt that the real monster in this film is globalized corporate capitalism. Moviegoers witness a chamber of rational–brutal horrors as MNU scientists go to any length to turn Wikus's accidental transformation into a payday. Within the long,

white corridors and sterilized operating rooms, all guarded by armed men, Wikus is poked and prodded mercilessly while ignored personally. No one answers his many questions. No one seems to be listening to him at all. He's already become, in MNU eyes, a piece of potentially profitable meat. MNU is excited that Wikus's left hand has mutated into an alien appendage capable of pulling the trigger on all manner of alien weapons. We watch footage of the weapons testing on the underground firing range where Wikus is forced to fire weapon after weapon, obliterating pig carcasses and, in a grand finale, a live alien hostage. We also watch MNU executives watching the testing. Smit gives the initial okay for tests to be run on Wikus, but the results are so impressive that a higher-up needs to be called in. This unnamed MNU Executive (Anthony Fridjhon) laughs gleefully over the successful tests, slapping Smit on the back and spouting things like, "That's amazing!" What really captures his attention, though, is that, for the final firing, the scientists force Wikus to use his right hand, that is, his still human hand to fire the weapon. And it works. The Executive's jaw drops and he gasps in disbelief, "Shit." MNU has won the corporate lottery; it now has an opportunity to market alien technology as human technology. The most chilling moment in *District 9* follows. Standing over Wikus strapped to a gurney, Smit and the Executive listen to the findings of the MNU Lead Medical Technician (Norman Anstey). He reports that Wikus's "DNA is in perfect balance between alien and human." If the metamorphosis progresses much further, they won't be able to discover how to replicate this balance and make accessible these marvelous armaments. Of Wikus, the scientist concludes:

> What happens to him isn't important. What's important is that we harvest from him what we can right now. This body represents hundreds of millions, maybe billions of dollars worth of biotechnology. There are people out there—governments, corporations—who'd kill for this chance.

Like ghouls, the three then contemplate indifferently how the procedure is going to "basically strip him down to nothing." When the Executive, holding a handkerchief to his nose against the unpleasant smells of the laboratory, worries about the potential legal issue of next of kin, Smit, ignoring Wikus's entreaties for help, says stonily, "I'll handle that." As though deciding what to order for lunch, the Executive then nods and says, "Okay. I say let's go." The scientist is elated. How peculiar that the only intellectual curiosity displayed by

these men toward the astounding event of Wikus's transformation is discovering a way to militarize it for earnings.

While the Norsefire regime in *V for Vendetta* obscures its corporate greed with evangelical fervor, MNU is straight-up, stone-cold neoliberal supremacy. Like Les Grossman in *Tropic Thunder*, nothing can stand in its way; anything and anyone can be converted into commodity. So thoroughly naturalized is this cutthroat behavior that even those subjugated by it implement its outlook. We see evidence of internalizing the oppressor in the interviews with underclass black South Africans who, ironically, want to see the aliens evicted from their slums. An even more powerful example of this sociological phenomenon is the Nigerian gang that also profits from the presence of the aliens. Although Jason Polley's reading of the Nigerians as "avant-garde urban freedom fighters defend[ing] their slum sector" is compelling, a better way of regarding their inclusion in the film is as a sardonic mirroring of MNU. There's little difference in the criminal aims and methods of the two groups. The Nigerian warlord, Obesandjo (Eugene Khumbanyiwa), is more or less the same person as the MNU CEO, Dirk Michaels (William Allen Young). Both orchestrate from behind the scenes their unsavory commercial empires; both are obsessed with profit over any manner of social justice or human dignity; both are driven to acquire the alien weaponry at any cost. Perhaps Obesandjo's pursuit of this last goal using some kind of weird juju—he intends to cut off and eat Wikus's mutated arm in hopes of absorbing the deviltry to fire the weapons—is a mordant comment on Michaels's use of bastardized science to do the same. The only real distinction between the two organizations is that MNU is better funded, meaning it can buy legitimacy where the Nigerians cannot. Admittedly, Blomkamp's depiction of the gang is uncomfortably over-the-top. Its members come across as grinning, psychopathic delinquents who are, at best, national caricatures (so that *District 9* was banned in Nigeria) and, at worst, racial stereotypes. Interesting to note, though, is that Blomkamp portrays the Afrikaner mercenaries in a similarly hyperbolic fashion. They are, to a man, cardboard cutouts of paramilitary thugs every bit the sociopaths as their Nigerian counterparts. Watching their gun battle near the end of the film is an exercise in wanting both sides to lose.

An unmistakable feature in the world of *District 9*, then, is that the ideology and the modus operandi of neoliberal hegemony and NeoCon masculinity predominate. Pushing back are two sources of post-Marxist agency in the film. One, distinctly on the fringe, is protesters and some UIO workers concerned over "alien rights." We catch glimpses of their demonstrations against MNU policy in the opening

newsreel montage of the film. Evidently, not all humans partake of the corporatist mindset, but they certainly lack the clout to have an impact. The other source of collectivist behavior in Blomkamp's movie is the aliens themselves. Although under tremendous stress from their ghettoized conditions, these extraterrestrials live as a cooperative. As the pre-metamorphosis Wikus explains during the eviction process: "The Prawn doesn't really understand the concept of ownership or property. So we have to come there and say, this is our land. Please, will you go." Blomkamp is stingy about revealing solid information about these beings. We have no idea where they're from, why they're on earth, what's wrong with their ship, why they behave the way they do, or what their intentions might be toward humans. Unlike the invaders of *Battle Los Angeles* (2011), a virtual remake of *Independence Day* (1996) in its glorification of American militarism, Blomkamp's aliens are completely enigmatic. Moreover, to have technologically advanced aliens come to earth only to wind up as disempowered "bottom feeders" marks a radical departure from usual sci-fi storylines, and one that makes complex use of monsters as cultural symbols.[3] Along with offering commentary on race relations in South Africa and perhaps worldwide, the plight of the Prawns represents more than simply racial apartheid; what we're being shown is class apartheid as well. Polley analyzes *District 9* through the "intersecting lenses of urban studies and biopolitics." He finds that:

> Blomkamp's illegal aliens...translate into more than just the Calibans of apartheid Africa...[Their] differentiation has spread globally— and often beyond race. The clash of classes, the rich stealing from the poor, the poor feeding off the remnants of the rich's excess, is materialized physically in the slum and polito-culturally in the fear of contamination.

These extraterrestrials, described early in the film as malnourished, unhealthy, and aimless, symbolize the world's mushrooming population of urban slum dweller, dehumanized outright as giant cockroaches. Subjected to and controlled by a forced itinerancy, the urban poor have multiplied at the hands of global capitalism to number currently over a billion people—one-sixth of the world's population with that fraction poised to double by 2030.[4] Blomkamp shows us the aliens engaged in stereotypical indigent behavior: dumpster-diving, public urination, brawling, gambling, rioting, drunkenness, even prostitution (though asexual beings). What these extraterrestrial welfare bums also signify is the potential danger this swelling multitude of the dispossessed poses

to the neoliberal hegemony. If these masses ever were to organize, class warfare would no longer be the one-sided swindle of plutocracy that it is now. Poor people could be marshaled into a formidable force. As in *V for Vendetta*, then, the real threat of Blomkamp's monster is post-Marxist rebellion. Enter the hero of *District 9*, the savior of the Prawn hoi polloi: Christopher Johnson (Jason Cope).

Evocative of transatlantic African slaves, these aliens have been branded with an MNU logo stenciled onto their heads, as though property, and labeled with European names. This act of appropriation brings with it all manner of social assumptions, relationships, and associations. For example, it seems that MNU has gendered these aliens masculine, assigning them men's names and referring to individual aliens as "he." These aliens reproduce asexually, however, via eggs ("Conception and Design"). Ascribing masculine gender and male sex to the aliens can be seen as a blasé act of patriarchy, and one that places them in Connell's hierarchy as marginalized male ("Social Organization" 41–42). Similar to Kong and the crew of the *Venture* in Jackson's *King Kong*, these aliens are racial and class inferiors who exist to be exploited by hegemonic masculinity. Their resistance to MNU power, then, brings with it issues of race, class, *and* gender—the monster trifecta. Moreover, their leader is the antithesis of NeoCon masculinity. Unlike his companions, Christopher Johnson is not aimless, slow of mind, or driven by inexplicable appetites. We discover that for the past 20 years, "he" has been painstakingly gathering and distilling what's referred to as "the fluid," a thick black liquid that powers the alien technology, in a plan to restart the alien spaceship and return the extraterrestrials to their home planet. His leadership role, both actual (instigating a slave revolt and escape) and symbolic (organizing underclass unrest and unity), is replete with post-Marxist agency. Unquestionably, "Christopher Johnson" is a "man" of the "people." Ironically, his imposed name also signals this altruistic behavior. The name Christopher is from the Greek "christos" (the anointed one, Christ) and "phero" (I carry). According to legend, Christopher carried the young Jesus across a river and, as a result, became the patron saint of travelers. The name Johnson is, of course, patronymic, but the name "John" derives from the Latin "Johannes," which is derived from the Hebrew "Yohanan" meaning "Jehovah has favored." In combination, these two popular Christian names carry associations of selflessness, care for others, and divine approval. The alien Christopher Johnson lives up to these qualities. He looks after the welfare of these space travelers. In his relationship with his small and precocious "son," he seems to be protecting the next hope or savior of his kind.

Movie viewers can only speculate if Christopher Johnson and his son are technocrats or leader caste for their society. If so, they go about their duties in a fundamentally different way than the executive class of neoliberal hegemony. The only humane conduct we witness in *District 9* comes from Christopher Johnson. After seeing the horrors taking place in the MNU labs, he makes his priority collective escape, not immediately reversing Wikus's transformation, explaining to the human, "first I must save my people." Corporate well-being, not corporate profit, motivates this enslaved alien. To Wikus's angry protests Christopher Johnson declares: "I will not let my people be medical experiments!" In contrast, the audience already has seen how the rich and respected Piet Smit is perfectly willing, if not eager, to let his own son-in-law be a medical experiment. Even more admirable is Christopher Johnson's camaraderie extending to Wikus, his oppressor. Up until the very end of the movie, Wikus treats Christopher Johnson appallingly, as one might expect a master to abuse a slave. Wikus tries illegally to evict the alien, threatens to take away his child, attempts to steal his spaceship, and abandons him to sure death at the hands of Koobus's mercenaries. In spite of this treatment, Christopher Johnson enters into an alliance with Wikus. They work together to retrieve the black fluid from MNU Headquarters. Despite the setback of some of the fuel being lost and the alien needing "all the fluid to travel quickly" so that he can "go home and get help," Christopher Johnson promises to return in three years to fix Wikus. All indications are that this alien monster is honorable and sincere (Figure 5.1). During the climactic battle against Koobus,

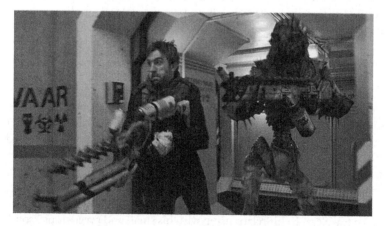

Figure 5.1 Monsters fight The Man!

even when Christopher Johnson has an opportunity to escape, he will not abandon the wounded Wikus, saying, "No, we stick together. I'm not leaving you here." Were the situation reversed, it's doubtful that Wikus would return the favor. In short, these aliens take care of their own—even when a hybrid human. After Wikus has shielded Christopher Johnson-and-son's escape, his showdown with Koobus ends not with him heroically vanquishing his burly and deranged antagonist, but with Wikus being saved by, now, his fellow Prawns. Alarmingly, aliens swarm, decapitate, and devour Koobus as Wikus looks on. Like it or not, he's joined the collective. What is more, this communal Other appears to be on the verge of striking back in a V-like uprising against its neoliberal, Leonidas-esque oppressors. Three years—meaning the release of *District 10*—will tell.

Wikus Van De Merwe, however, is no hero of this uprising in the making. Unlike Ann from Jackson's *King Kong* or Evey from *V for Vendetta*, Wikus never commits to post-Marxist agency regardless of the incredible events he undergoes. His is not a stirring tale of birth of a populist champion, à la Tom Joad. Instead, the story of Wikus is the extraordinary yet petty one of a bourgeois dispossessed, à la Victor Frankenstein. Like Victor, Wikus is a victim of the monster he created, if not in the laboratory then via the modern discipline he helps impose on the aliens. Wikus is the blithe agent of the MNU panopticon configured to segregate and commodify the aliens. His character, in fact, is quite similar to that of Michael Scott from the American television show *The Office*. Both are bumbling, endearing, good-natured bureaucrats who, at the same time, are maddeningly blind and obedient to the corporate enormities going on around them. While their dim-wittedness and even their mild competencies make for amusing viewing, at core we're watching portraits of deeply indoctrinated middle-class ignorance. When Wikus tosses tins of cat food rather than canisters of teargas at the aliens to quell a potential riot, we laugh. Yet, when it comes down to bald-faced crowd control, what's the real difference between Wikus's actions and Koobus's shooting Prawns from a helicopter? Piet Smit does not put Wikus in charge of the alien eviction out of nepotism. Obviously, Smit has no regard whatever for his son-in-law. Instead, the Managing Director wants a tractable fool running this public relations whitewash, and Wikus, with his eager smile and nebbish sweater vest, is the ideal booby. Even his mother (Marian Hooman) tells the camera, "Everybody always say that Wikus was not a very smart boy, but he was a wonderful son." Corporatism demands legions of such mid-level, credulous drones to keep its oppressive machinery working. Evey is locked into this same

situation working for BTN until the monster, V, pulls her out of her middle-class comfort/ignorance zone. Christopher Johnson does not have the same thoroughly educative effect on Wikus. Where Evey initially resists V's point of view but then overcomes her fear to take up rebellion against neoliberal hegemony, Wikus never takes that crucial crossover step. His struggle is to remain middle class, even to fight his way back into that state of complacency. Polley identifies this keynote social issue of *District 9* exactly:

> Though prima facie a sci-fi thriller pitting the human against the alien, at the heart of the possible-world that Blomkamp cinematizes is an all-too-modern, all-too-human war: the one between the vanishing urban middle-classes and the explosion of urban poor.

Wikus is a pathetic portrait of *how* deeply ingrained neoliberal ideology is in the middle class, of *how* desperately the marginally well off want to disregard the brutalization of the vast underclass socially beneath them—*even while the middleclass is slowly transforming into that underclass*. Wikus's metamorphosis into a Prawn is a socioeconomic objective correlative for a purblind middle-class being divested of wealth and disenfranchised of political say—that is, gradually being abjectified into slum dwellers—by the corporate superrich. Even though Wikus will man-up to a degree to fight back against MNU, his conviction is never to liberate the enslaved, but to return to the normalcy of his nice house and mousy wife in the suburbs.

Wikus's inadequate post-Marxist agency is on display everywhere in *District 9*, but particularly when he commandeers the alien shuttle to attempt ascending to the mothership. As Wikus blunders at the controls, Christopher Johnson's son climbs onto his shoulder to bite him, trying to stop the skyjacking. Symbolically, Wikus is no Christopher, no bearer-of-Christ, no patron saint of (space) travelers. His is a reckless effort not to abet the aliens, but selfishly to prevent himself from becoming one of them. Compare that image to when Christopher Johnson at last rises to the mothership. We see him at those same controls with his son happily, almost beatifically, sitting on his lap, eagerly asking, "We go home now?" Christopher Johnson works for the benefit of all, Wikus included, as a marginalized "man" defying NeoCon masculinity. Wikus, however, in the conflict of modern masculinities, remains snared, preposterously, in his complicity with patriarchy. Wikus experiences firsthand what it's like to be on the wrong side of power. Because in the course of his oppressive duties he's sprayed with the alien fluid, initiating his strange transformation,

Wikus discovers what it's like to be a biological commodity. He's ripped from his wife, Tania (Vanessa Haywood), and their safe, white, suburban life. After he escapes the corporate laboratory, he's hunted by MNU as "the most valuable business artifact on earth" due to his genetic splicing with the aliens. He's forced to hide in the slums of District 9, tasting that wretched lifestyle for the first time. Wikus is even denigrated as a sexual deviant, therefore becoming something of a subordinated male in Connell's scheme ("Social Organization" 39–40). MNU issues the official lie that Wikus is dangerously contaminated due to his having had "prolonged sexual activity" with aliens. A large part of middle-class fear of the poor is the perceived threat of disease, in particular AIDS. Wikus is betrayed and ghettoized, then, in every possible way by neoliberal hegemony. Even so, he has a difficult time casting off his petty bureaucratic habits. When he discovers Christopher Johnson's shuttle hidden underneath the shack, Wikus rants: "For twenty years you've had this fucking thing hidden down here! This is…this is very illegal. This is…this is…a find, you know…if they catch you with this." Notwithstanding that MNU has just had him strapped to an operating table preparing to vivisect him for parts, Wikus is conflicted in his loyalties. He seems deeply to regret not being able to report this amazing find himself, thereby earning the brownnoser points coveted by middle management.

At the crux of Blomkamp's monster movie, then, is the conflict between Koobus as the hegemonic male and Wikus as the complicit male. These two square off early in the film, as soon as Wikus is put in charge of the eviction project. In an organizational meeting, Wikus announces to his MNU coworkers: "I think it's a great thing to see that it's not the military guys in charge this time." However, he immediately gestures to the back of the room, where Koobus stands looking on disdainfully, to joke nervously about how, of course, "the cowboys…are always wanted." In the very next cut, Wikus complains to the documentary camera that, "the cowboys, they shoot first and then they answer the questions, you know." But when he tries to exercise his new authority over the cowboy mercenaries, limiting the amount of ammunition they can take into District 9, Koobus countermands Wikus's order, feinting and barking at him, "Listen to me, you fuck!" then violently shoving the camera away. Clearly, the military guys still are in charge, and Wikus is a laughingstock with his egregious lack of the right kind of manliness. He's a pencil-pushing, married-to-the-boss'-daughter nincompoop who likes to fashion silly craft projects as love-tokens for his timorous wife. As Smit comments

when lying to his daughter about Wikus's terminal medical condition: "You know Wikus. He never was very strong." The stage is set perfectly, then, for a familiar Hollywood rise-of-the-milquetoast plot. And, indeed, Wikus cowboys-up to a considerable degree as the movie goes on—albeit always reluctantly and, maybe, as a result of his splicing with the alien DNA. He starts telling hegemonic men, from MNU doctors to Nigerian gangsters, to "fuck off." He breaks out of MNU Headquarters only to shoot his way back in, with Christopher Johnson, to recover the black fluid. He does the right thing by telling Christopher Johnson and his son that, in truth, they won't be better off going to District 10, which is "actually more like a concentration camp." For Wikus, hitherto an adherent of MNU's modern discipline, to admit such a thing is no insignificant act of mettle, and the scene plays that way more than Wikus's displaying solidarity with the aliens. In the end, Wikus even takes on Koobus man-to-man—or, more accurately, man-to-man/alien hybrid in an armored combat suit. Appropriately, the climax of Blomkamp's film is High Noon on the dusty streets of District 9.

Wikus's final bit of pluck occurs after he abandons Christopher Johnson to MNU, screaming at Koobus, "You can have the Prawn! Okay! Just let me fucking go!" As Wikus flees inside the combat suit, Koobus taunts him: "Run! And keep on running, you fucking coward!" Realizing he has nowhere to escape, Wikus returns to rescue Christopher Johnson and, in a battle with Koobus and his men, escort the alien successfully to his shuttle. During the combat, Wikus splatters gratifyingly many of these thick-necked MNU henchmen. Wikus's heroism is not quite textbook, however. As noted earlier, Wikus is not the one to take out Koobus; fellow aliens pounce to accomplish that job. Nor is Wikus's self-sacrifice pure. Knowing his combat suit is breaking down, Wikus tells Christopher Johnson to go on without him: "You go ahead. You can make it. I'm gonna just...hold them off here...Take your boy, and go home." However, unlike V or Evey or Ann, Wikus is not willing to die for the liberty of all; instead, he's fighting for his eventual return to the suburbs: "You have to make it—don't make me go through all of this and not make it. You understand?" Without a doubt, Wikus performs admirably in donning the mantle/combat suit of hegemonic masculinity to rescue the oppressed alien father and son. Nonetheless, it's equally certain that Wikus never embraces genuine insurgent principles. His only motivation for resisting MNU has been to reunite with Tania. His frantic cell-phone conversations with her indicate that purpose. Whether he's emphatically telling his wife "I would

never have any kind of pornographic activity with a fucking crea-
ture!" or reassuring her "I know how to fix myself and it will be
me and we'll be back together," Wikus draws his resolution from
Tania's not abandoning him. He urges her, "Don't give up on me,
okay, because I haven't given up on you." Strangely, then, Wikus is
a complicit male who performs, perforce, hegemonic masculinity for
a time in order to win back his status as a complicit male—that is,
to return to his middle-class, whitebread, gullible existence under
neoliberal hegemony.

It's touching how Wikus, as a fully formed alien at the close of
District 9, makes and delivers little metallic flowers to Tania in the
suburbs. It's also contemptible and alarming. Knowing what he
knows about MNU, Wikus should be organizing the aliens into a
rebellion, not waiting for Christopher Johnson's promised return
to transform him back into a milquetoast. Wikus's close encounter
with postmodern monstrosity makes no impression whatever—not
even the knowledge-too-late experienced by Jackson's Carl Denham.
Wikus can be read, then, as heralding the outright closing of the mid-
dle-class mind. Even when turned into a slum dweller, this lemming
is slow to perceive, loath to admit, and incapable of taking action
against the political and economic tyranny at work in front of his
eyes. Thus, an ominous reading of *District 9* is that the underclass
can't count on their middle-class betters for help in redistributing
wealth or equalizing opportunity. That is, only the oppressed can
free themselves. Class warfare, then, is the threat on the horizon in
Blomkamp's movie. When interviewee and journalist Grey Bradnam
(Jason Cope) wonders, at the close of the film, whether Christopher
Johnson "will effect a rescue plan" or "come back and declare war on
us," such a distinction is invalid. To do the first, the alien must do the
second; to intend the second means carrying out the first. In other
words, extricating his kind from biological commodification necessi-
tates Christopher Johnson, like V, meeting exploitative violence with
restorative violence. The dispossessed of our planet—that multitude
swelling in number every day who are sadly and aptly represented
by the Prawn hoi polloi of *District 9*—are in the same boat. If, like
Wikus, the middle class of the world stand by navel-gazing, never
forming solidarity with the poor, never understanding that they, too,
are exploited by the 1 percent, then only escalating turmoil is in our
future.[5] High Noon on the global horizon is the showdown between
MNU machismo and Prawn blowback. Unlike in the movies, this
real-world hegemonic confrontation is unlikely to be heroic or to have
a happy ending.

PAPA DRAGONS AND BLUE MONKEY MAMAS

James Cameron's 2009 mega-blockbuster *Avatar*, to date the highest-grossing movie in history, delivers a monster story from the middle of the twenty-second century. At that point, the socioeconomic confrontation predicted by *District 9* has occurred—and didn't go well. In the future imagined by Cameron, by the year 2154, the corporatism and militarism of neoliberal hegemony has turned the earth, in the words of hybrid border-crosser Jake Sully (Sam Worthington), into a "dying world." The capitalist scramble is now on to exploit the resources of outer space. Humans have become the invading aliens. In the clash of cultures depicted in the film, the easy reading is that of colonizer (European) and colonized (Native American). Cameron's screenplay encourages this interpretation. Earthlings encountering Na'vi feels like a sci-fi *Dances with Wolves* (1990) or *Pocahontas* (1995). In its environmental messages, *Avatar* also resembles *FernGully: The Last Rainforest* (1992).[6] However, a more sophisticated reading of this first encounter is available in Cameron's movie. As in *District 9*, NeoCon masculinity is pitted against post-Marxist agency, and once again the crisis of hegemonic masculinity is on display. *Avatar* goes beyond issues of masculinity, though, to stage arguably the mother of all gender confrontations: the collision between Earth-Goddess Matriarchy and Sky-God Patriarchy. Moreover, a better reading of Cameron's tale reverses the simpler postcolonial interpretation, flipping the binary of civilized/savage. The Na'vi are the more technologically advanced and culturally mature society, while earthlings play the role of benighted primitives.

The first step to appreciating an inverted reading of *Avatar* is to note the mirroring between the Sky People (humans) and the Omaticaya (Na'vi). Parker Selfridge (Giovanni Ribisi) as the boss of the mining project is mirrored by Eytukan (Wes Studi) as the tribal chief. Colonel Quaritch (Stephen Lang) as the security officer is mirrored by Tsu'tey (Laz Alonso) as the leader of the war party. While these males are in important leadership positions, Selfridge and Quaritch, among the Sky People, are unmatched in their patriarchal power and authority. Eytukan and Tsu'tey, on the other hand, share high status with Omaticaya females. In fact, as essentially the brawn of the Na'vi, these two male leaders defer to the brain of the society's female leaders. To return to the mirroring, Dr. Grace Augustine (Sigourney Weaver) as the scientist is echoed by Mo'at (CCH Pounder) as the shaman. Trudy Chacon (Michelle Rodriguez) as the martial tomboy is reflected by Neytiri (Zoë Saldana) as the adept hunter and warrior.

The difference here is that where Grace and Trudy must bend gender roles to challenge the patriarchy, suffering branding as anomalies, Mo'at and Neytiri act as mainstream Na'vi females. If Omaticaya culture includes distinct behavioral expectations for females and males, those expectations *don't* involve females being weak of mind and body. Eytukan and Tsu'tey never seem threatened by the strong females around them. In contrast, Selfridge and Quaritch spend most of their time, and have their hands full, suppressing Grace and Trudy—to the point of Quaritch murdering both females. In sum, Sky People society is a hierarchical pyramid with avaricious and violent males at its summit. Omaticaya society is an egalitarian circle (symbolized several times in the film during their ceremonial gatherings) with a shared leadership at its center. Which social order is the more raw? Which the more monstrous?

More unexpected, this Na'vi cultural superiority is founded on their technological superiority over the Sky People. Such a statement of course sounds absurd. In the movie, humans have all the cool gadgets. Noting again the mirroring at work, however, reveals that the Na'vi possess even cooler gadgets—theirs being biological, not mechanical. Trudy whooshes about in her Scorpion assault ship; Neytiri dives and banks riding her declan, a flying creature resembling a dragon. Grace sticks a probe into a root to measure the electrochemical activity of the trees on Pandora; Mo'at sticks a stiletto tip into Jake's avatar body to gauge his role among the Omaticaya. Quaritch glides through the skies in his massive airship christened *Papa Dragon*; Jake takes down Papa Dragon riding his gigantic flying toruk. Selfridge oversees mining operations inside his vast command center at Hell's Gate; Eytukan presides over Hometree and Mo'at over the Tree of Souls. Quaritch makes his last stand in an Amplified Mobility Platform (AMP) suit; Neytiri and Jake fight him together each wearing her or his own version of a physically enhancing tool: Neytiri bonded with a thanator (a huge, aggressive panther-like creature) and Jake inhabiting his avatar. Where everything is synthetic and mechanistic for the humans, for the Na'vi everything is organic and biotic. This crucial distinction extends even to their computer systems. The Sky People depend on electronic data processors. The Na'vi enjoy the greater connectivity of Eywa. Early in the film, Jake characterizes anything having to do with Eywa as "tree-hugger crap." Environmentalism, however, turns out to be the basis for Na'vi advanced civilization. The Na'vi access Eywa via the neural interface at the ends of their long ponytails, making *shahaylu*, the bond, with the natural world in order, not to dominate it, but to act in conjunction with it. Thus,

the Na'vi manipulate the world of Pandora not by destructive altera-
tion but by respectful interaction. Theirs is a planet-centric, "god-
dess" society committed to sustainability. Compare this relationship
with the ecosystem to that of the Sky People. The crude humans in
Avatar constitute a Sky God cult adhering to the directive in Genesis
1:26–28, stating that the earth and everything in it was given by
God to man (sexism intended) to rule over and subdue.[7] As noted
earlier, in Cameron's twenty-second century, near ecological collapse
has stricken the earth, and humans have extended their gluttony for
natural resources to outer space. As Jake explains to Eywa, the Sky
People "killed their mother," and they will do the same to Pandora
"unless we stop them." Jake's warning to Eywa is Cameron's primary
message to movie audiences: indiscriminate free-market capitalistic
expansion will bring about certain environmental disaster. What is
more primitive than arrogant self-destruction?

The second step to reversing the civilized human/savage Na'vi
binary ostensibly at work in *Avatar* is to reexamine its plot *with* the
crucial bit of information in mind that we come to know only by
film's end: that Eywa is not a fairy story but in fact a sentient and
active being. As Grace explains the situation to the Selfridge: "I'm
not talking about some kind of pagan voodoo here. I'm talking
about something real, something measurable in the biology of the
forest…The wealth of this world isn't in the ground. It's all around
us. The Na'vi know that, and they are fighting to defend it." Eywa as
real negates a pre-reading of the Na'vi as the victims of colonization
and, thus, merely as imaginative stand-ins for Native Americans. The
clash of cultures occurring in Cameron's film, while raising postcolo-
nial issues, is not about the one-sided aggression of a technologically
superior society subduing a weaker one; instead, the film depicts two
competing *configurations* of society—one capitalistic and one social-
istic—with socialism proving, in the end, to be the more capable,
rational, and appealing formation. The animating socialistic force is
Eywa, with Jake as her chosen champion. Just as Quaritch exploits
Jake's weird hybridity to infiltrate and reconnoiter Na'vi society, Eywa
returns the favor in order to penetrate and disrupt the Sky People
operations on Pandora. Eywa can be understood, then, as a monster
found. From a human point of view, she is a Pandoran abomination
that outwits and overmasters them. Eywa's hand in this stratagem is
observable throughout the film in the actions of the Great Mother's
matriarchal chain of command among the Omaticaya: Mo'at and
Neytiri. They are Blue Monkey Mamas, so to speak, doing battle
with the Papa Dragons of Selfridge and Quaritch. The confrontation

between these two pairs of power players represents the most important instance of mirroring in the film, that of collectivistic matriarchy and post-Marxist agency in opposition to exploitative patriarchy and NeoCon masculinity.

Eywa begins her scheme by signaling to Neytiri, first, not to kill Jake with her bow and arrow and, second, to take this unusual creature back to Hometree. In doing so, Neytiri countermands the standing order of Eytukan, enforced by Tsu'tey, that all dreamwalkers are to be shot on sight. At Hometree, it is Mo'at, expressly described by Neytiri as "the one who interprets the will of Eywa," who inspects Jake. When she tastes this avatar's blood, we see by the expression on her face that Mo'at receives some unusual and important information from Eywa. Although it is Eytukan who decrees that, as "the first warrior dreamwalker we have seen," Jake must be studied by the Omaticaya, Eytukan acts on Mo'at's assessment of the situation. Moreover, it is Mo'at who makes the determination to teach Jake the ways of the People and who appoints Neytiri to be his instructor. As Mo'at's daughter, Neytiri is next in line to be the clan's *Tsahik*, their link to Eywa. Obviously, Eywa entrusts Project Jake Sully only to female hands. When Mo'at warns, "Learn well, Jake Sully. Then we will see if your insanity can be cured," the insanity to which she refers is the neoliberal and patriarchal ideology of the Sky People. Attempting to turn Jake away from his human social disciplining is a gambit by Eywa, but the early parts of the film hint repeatedly at Jake's potential receptiveness to a new cultural template. As Neytiri sums up Jake: "You have a strong heart. No fear. But stupid!" These are unsurprising traits for an ex-Marine, and by stupid, what is referenced is not Jake's basic unintelligence (after all, we're told he has "a gorgeous brain, nice activity") but his self-professed empty-headedness. Unlike his twin brother, Jake is no scientist; he assures Mo'at that his head is an empty cup ready to be filled. Jake is also profoundly dissatisfied with his current status as a human being. He evidently believed in his Marine Corps mission back on earth, but no longer. Recent events have turned him cynical. Worse is his confinement to a wheelchair and inability to afford the medical care available that could restore his able body. From the start, the film emphasizes Jake's delight whenever his consciousness occupies the strong and agile avatar body. Jake is the ideal instrument of Eywa because NeoCon masculinity and neoliberal hegemony have used him and then failed him miserably.

With Jake, Eywa recruits Grace into this matriarchal power play. Before Jake's arrival on Pandora, Grace lived among the Na'vi, learning their language and culture as well as teaching them hers.

Grace devised the Avatar Program to promote harmony between the Omaticaya and the Sky People. Ideologically, Grace and Eywa are on the same page; as an avatar driver, Grace is something of a Blue Monkey Mama herself. However, Grace labors under a violent and ignorant patriarchy that tolerates her only as an expedient toward its money-oriented goals. When Grace steps too far out of line, Quaritch shoots and kills her. As a film, *Avatar* turns on this crisis moment and, more particularly, on Eywa's scheme—as enacted by the three principal female characters—coming to fruition around this turning point. First is Neytiri. She's been in charge of bringing Jake fully into the circle of the People. Her decisive move in that task is mating with the synthetic-Na'vi, informing him afterward, "I'm with you now, Jake. We are mated for life." If the human Jake wakes to wonder what the hell he's doing, an answer might be: you're being pulled into Eywa's master plan, you Jarhead. As with V and Evey down in The Shadow Gallery, viewers certainly want to believe that True Love fills the poisonous air of Pandora. At some level, though, one must wonder if Neytiri really is so naive to mate with a bio-machine. Second is Mo'at. She plays her cards at a critical moment, too. While Quaritch and his air cavalry blast Hometree, Mo'at approaches the bound Jake with a drawn knife, as though intending to kill him as a traitor. Instead of slitting his throat, she pointedly cuts him free and pleads, "If you are one of us, help us!" Obediently, Jake springs into action, his Sky People insanity cured. Third is Grace. She is likely the lynchpin of Eywa's strategy, not in the sense that Eywa arranges her death, but that by assimilating Grace into her database, Eywa obtains the information necessary finally to fathom the Sky People. That is, the humans are in fact insane, they have indeed killed their Mother Earth, and Eywa, to prevent Pandora from succumbing to the same end, needs to commit the entirety of her planetary defenses to defeating these barbaric invaders. Jake brings Grace to Eywa hoping to heal her gunshot wounds. Grace delivers the most important lines of the movie when, instead of being mended, she passes into Eywa, saying: "I'm with Her, Jake. She's real." With this confirmation of Grace's scientific hypothesis about the remarkable electrochemical networking taking place on Pandora, audiences realize there's been a formidable behind-the-scenes presence at work throughout the film. A reassessment of the plotline—and of our estimation of the Na'vi—is in order. They are the advanced matriarchy. We are the patriarchal mouth-breathers.

Finally, using narrative framing, Cameron draws our attention to this victory of matriarchal planning by having Neytiri kill Papa

Dragon himself. Just as Eywa stayed Neytiri's hand from shooting Jake at the outset of the stratagem, at its climax, Eywa puts Neytiri in the position to shoot two arrows deep into Quaritch's chest. Without Jake's Eywa-engineered rebellion, Neytiri likely never would have gotten such a clear and definitive shot at knocking out the alien patriarchy. Nor should the ironic symbolism of the phallic and penetrative arrows be lost on us: a dick is killed with a dick launched by a tough chick.

Shifting focus to the masculine behaviors visible in *Avatar*, they are multiple, not performed only by human male bodies, and engaged in the violent renegotiation of hegemony. Jake, Selfridge, and Quaritch exhibit best, however, the sliding scale between post-Marxist agency and NeoCon masculinity. During the film, Jake travels from pole to pole of the new millennium manliness—from company muscle to tree-hugging revolutionary. He's an invader–savior on Pandora, a hybrid and unhomely monstrosity shuttling across the borders separating human from Na'vi society. To the Na'vi, Jake initially is a monster found, dropping from the sky with the rest of the insane aliens who had come to dispossess them of their land. To the humans, Jake becomes a monster made, yet another science experiment gone wrong to turn on its maker. For audiences, Jake figures the monster-cum-hero who, like V, battles even more monstrous forces to bring about a brighter day. As a tool of the Eywa matriarchy, Jake fits the role of post-Marxist liberator, a legitimate, probably foremost, reading of his character. Masculinity, though, can be troublingly illegible. An additional way to regard Jake is as a freakish version of the Euro-white man who "goes native." This rescue-and-liberate narrative is a well-worn tale colonizing societies enjoy telling, combining as it does salve with justification for the colonial act. Put in a charitable light, the invader–savior is equal parts benevolent and more capable. His story always revolves around coming to possess a "dark" indigenous woman as well. Jake displays such cultural superiority first by winning Neytiri away from her intended mate, Tsu'tey, and then by being better suited to lead the Na'vi in their fight against the Sky People. But do we have a happy ending at the close of the movie when Jake pops open his yellow avatar eyes? He's a mix of human and Na'vi DNA—with five fingers instead of the Na'vi four—and this weird strain is about to be introduced into the Omaticaya bloodline. Is everybody all right with this technological, genealogical, and genetic rape? Along with underdog hero, then, Jake equally can be seen as a strange, colonizing entity worming its way into virgin Na'vi territory. Instead of *toppling* the militarist-masculinist human culture, Jake's uprising can be read

as part of the ferocious renegotiation of hegemonic masculinity and thereby a *continuation* of patriarchy. One wonders if Jake is entering the circle of Na'vi society or if the Na'vi are entering the pyramid of Jake society. Although mitigated, patriarchal performativity might be inevitably what Jake brings to Pandora. Or maybe Eywa's matriarchy will prevail. Or maybe all borders have been scrambled as a result of this monstrous swirl of cultural intermingling. Whatever the case, Jake improvises within the constraints of new millennial masculinity where few are all-Leonidas or all-V. Within that span, he tracks decidedly toward the position of post-Marxist agency. Inclining opposite to him, toward NeoCon masculinity, are Selfridge and Quaritch.

As a corporate manager for Resources Development Administration (RDA), Selfridge is on Pandora to pave paradise and put up a parking lot. As an RDA security chief, Quaritch orchestrates the militaristic mandance to make that happen. Together, these men expand the neoliberal and patriarchal status quo. More than working for the company, though, the company works them. In *Avatar*, the monster is not Eywa, the Na'vi, hybrid Jake, or even the duo of thickheaded Selfridge and mad-dog Quaritch. The real Beast in Cameron's movie is the Corporation, not as a vague bad thing but as a technology run amok. Similar to the Machines of the *Terminator* films, the Corporation is depicted in *Avatar* as a form of *cultural* Artificial Intelligence—that is, as an organizational and ideological ersatz entity that has got out of control, that is a monster made, and that now threatens to destroy its maker. Like Norsefire in *V for Vendetta* or MNU in *District 9*, RDA is an instrumental mode of modern power, designed by some for the government of many, which has come to dictate individual agency by dominating the society as "normal." In Foucault's terms, the Corporation is a discipline that combines goals, forms of communication, and particular power relations toward a social end.[8] In the clash of cultures and genders depicted in *Avatar*, RDA is the Sky-God Patriarchy invading Pandora. Cameron's portrayal of neoliberal synthetic being is divided in two, between the characters of Selfridge and Quaritch. Selfridge represents the corporate nabob. Quaritch represents the corporate psychopath. Both types are integral to the discipline of Corporation.

Selfridge is not necessarily a bad guy. He's just bought into an evil system. Capitalism demands cheap materials in combination with cheap labor in order to turn profit. Many a boss dances on the edge of unaware nebbish and brutal enforcer when it comes to this modern formula for the means of production. We see this oblivious quality in Selfridge when he explains to Jake, in man-to-man intonations,

what he considers to be the last word with regard to relocating the Omaticaya away from Hometree:

> Look, killing the indigenous looks bad. But there's one thing that shareholders hate more than bad press, and that's a bad quarterly statement. I didn't make up the rule. So just find me a carrot that'll get them to move. Otherwise, it's gonna have to be all stick. Okay?

Selfridge sees as innate and sacrosanct RDA's need and right to harvest "unobtanium" from under the feet of the Na'vi in order to deliver revenue to investors. To a believing capitalist, this arrangement of a limited liability corporation is not an economic device; it's reality itself, the way of the world that is also the way of the galaxy as the Corporation expands its domain into outer space. As a film, *Avatar* works to denaturalize this neoliberal hegemonic discourse and structure, exposing corporatism for its duplicity and imperialism.[9] Just prior to the destruction of Hometree, Jake sums up this counter-knowledge aptly when he exclaims: "This is how it's done! When people are sittin' on shit that you want, you make them your enemy! Then you're justified in taking it." The Corporation is a modern monster opposed by the numerous postmodern monsters in the movie, similar to V's taking on Chancellor Sutler.

Selfridge is by no means unaware that RDA is perpetrating raw expansionism on Pandora. At some level, he knows Jake is right. As the capitalistic professional manager, though, his job is to maintain a kind of corporate double consciousness. Selfridge is able to suppress ideas and evidence that run contrary to objectives of the Corporation. This purposive naiveté is among the most grisly qualities of imperialist ideology: as a monster, neoliberal hegemony is adroit at making monsters of Others. Frequently during the film, Selfridge mouths trite and contrived pretexts for RDA's expropriation of the Na'vi. Sometimes he claims that RDA, benevolently, is offering these primitives a chance at a better life. At other times, he considers these "blue monkeys," as he marks them, so uncultured that RDA's actions couldn't possibly disrupt their crude existence. Selfridge shouts: "They're fly-bitten savages that live in a tree!" How ironic and chilling that a nonbeing, the Corporation, possesses the power to deny actual beings, in this case the Na'vi, their authentic status *as* beings. Yet such is a fundamental cultural method of empire. Significantly, Selfridge lets himself be talked into allowing Grace and Jake, in their avatar bodies, a last desperate chance to convince the Omaticaya to abandon Hometree. He seems particularly swayed by Jake's candid

confession to him: "You don't want that kind of blood on your hands. Believe me."[10] As a spineless corporatist drone, Selfridge would really rather not get his hands dirty. In this regard, his character is similar to that of Wikus from *District 9* or, better, Carl Denham from Jackson's *King Kong*. All three are complicit males who prefer to stay blind to the privilege they enjoy and the oppression they help to inflict. In fact, the overall contemplation of colonialism in *Avatar* is quite similar to that in Jackson's movie. Just as Ann allies with a giant and symbolic victim of colonization-cum-embodiment of nature in Kong, Jake allies with the same combination of symbol in Eywa. Just as Denham, another not-bad guy, experiences knowledge too late with regard to the slaughter of Kong, Selfridge experiences knowledge just in the nick of time when he finds himself defeated by Eywa and, shamefacedly, sent packing back to Earth by Jake. Selfridge's failure on Pandora, however, should not be taken to mean that he's seen the error of his neoliberal ways or that he's now a genuinely good guy. When push comes to shove, it's likely that Selfridge always will adhere to the pitiless hunt after corporate profit. His nice guy-ness ends where the RDA bottom line begins. What's most important to note about him, then, is his ability, like Carl Denham, to fool himself. In his own way, Selfridge is likewise remarkable for "his unfailing ability to destroy the things he loves." That contradiction is at the heart of his Sky People insanity. As a bourgeoisie, as a complicit male, as a performer of corporate hegemonic masculinity, Selfridge is scary dumb: He induces his downfall by pursuing his advancement. Such is the power of the Corporation, as a cultural A. I., to cloud human beliefs and to manipulate human actions.

Working in conjunction with Selfridge as the corporate toady is Quaritch as the corporate maniac. These two types function in tandem, one with eyes fixed on the profit margin and the other providing the muscle to ensure profit happens. Theirs is the marriage of corporatism with militarism, a belligerent partnership highlighted early in Cameron's film. When arriving at Hell's Gate, Jake muses in voiceover about its well-armed personnel: "Back on Earth, these guys were army dogs. Marines. Fightin' for freedom. But out here they're just hired guns. Takin' the money. Workin' for the Company." Jake's status also is mercenary—and based on his economic desperation. He informs us: "They can fix a spinal, if you got the money. But not on vet benefits, not in this economy." A century and a half from now, envisions Cameron, we're still in the unjust place we are today as a society: "supporting" the troops when it comes to sending them off to resource wars, but not when its time to bring them back home

to adequate medical care and a living wage. The militarization of trickle-down economics is embodied in *Avatar* by these privatized corporate troops. They serve under the guidance of no democratically elected government officials, but at the pleasure of an upper management whose pay package depends on maximizing profits for shareholders. The apotheosis of this melding of business praxes with martial clout is Colonel Quaritch. Just another day at the office for him is standing in the cockpit of his massive airship, *Papa Dragon*, casually sipping from a mug of coffee while burning out the homes of native populations—or, as he puts it, "And that's how you scatter the roaches!" Quaritch is that hard-nosed, grizzled veteran—a stock character in most war movies—whose job it is to enforce uncritically the neoliberal hegemony and to oversee emphatically the patriarchal transformation of feminine boys into masculine men. As we've seen in previous chapters, Four-Leaf Tayback in *Tropic Thunder* satirizes this character type, and Leonidas from *300* in many ways attempts to be this character's archetype. Quaritch's particular manifestation of this role in Cameron's film is as unadulterated NeoCon masculinity fused with certifiable psychopathy.

Colonel Quaritch could not be more stereotypically a military macho man. To him, Grace's Avatar Program is just a "buncha limp-dick science majors." Along with his anti-intellectualism, he sees everything in terms of us-versus-them aggression and habitually expresses his viewpoints in sexist and scatological terms. When it's clear that Jake has allied himself with the Omaticaya and, more particularly, with Neytiri, Quaritch says to him in nasty tones: "You let me down, son. So what, you...you find yourself some local tail and you just completely forget what team you're playing for?" The Colonel supplies the xenophobic militarism to partner with Selfridge's hyper-acquisitiveness, thereby completing the dominant ideology of capitalistic and racist patriarchy. Quaritch and Jake's association begins as one of familiarity and mutual respect. When Quaritch recruits Jake to be his eyes and ears against the Na'vi, their conversation is more than businesslike. There's an intimacy about it suggestive of that between father and son. As Marines, both men were in "First Recon," evidently an elite advance-group that infiltrates enemy territory. Quaritch reveals that, in his younger days, he did "three tours of Nigeria." Jake recently has survived a tour of Venezuela, which Quaritch acknowledges as being "some mean bush." Glancing down at Jake's wheelchair, Quaritch remarks with even more approval in his voice, "You got some heart, kid, showin' up in this neighborhood." Jake replies confidently, "Figured it's just another hell-hole."

The older and the younger men share the bond of combat experience. Both have been frequent border-crossers into what the US military calls Indian Country: any hostile territory controlled by opposing forces. Pandora is the quintessence of Indian Country for this pair of manly, military men. Quaritch presumes to retain Jake's services within the discipline of Corporation by getting him back into the saddle of hegemonic masculinity. While climbing into his AMP suit, Quaritch makes his pitch to Jake: collect good, actionable information, and the payoff will be a restoration of his able-bodiedness.

> *Quaritch*: Son, I take care of my own. You get me what I need, I'll see to it you get your legs back when you rotate home. [Points to Jake's shriveled legs.] Your *real* legs.
> *Jake*: That sounds real good, sir.

The Colonel strikes a virile, hands-on-hips pose, mimicked by the massive AMP suit he wears, while Jake sits helplessly dwarfed in his wheelchair. What Quaritch offers Jake is the chance to escape his plight as a disabled, marginalized man and to put back on the suit of NeoCon masculinity. Ultimately, Jake finds another suit to don in the form of Na'vi physique and culture—and post-Marxist agency—breaking free of the bleak neoliberal alternatives of serving either as industrial drudge or as military fodder. When legs are used as capital, as bargaining chips, it's time to seek out a different socioeconomic paradigm, one that does not commodify people.

Finally, if Selfridge is scary ignorant as a devotee of Corporation, Quaritch is just plain scary. He's not a nincompoop heedlessly obeying an evil system; he's a criminal taking full advantage of an evil system as a way to engage in malevolence. The theory of Corporate Psychopaths is relevant when examining Quaritch's behavior. Since the 1990s, and especially leading up to and in the aftermath of the Global Financial Crisis of 2008, psychologists have studied the phenomenon of psychopathic persons rising to prominence in corporations and, in particular, financial corporations. Psychopaths are the 1 percent of people who "lack a conscience, have few emotions and display an inability to have any feelings, sympathy or empathy for other people" (Boddy 256). Due to abnormal brain connectivity and chemistry, such people do not care for anyone other than themselves; as a result, they show a coldly calculating and ruthless attitude toward others. The theory of Corporate Psychopaths proposes that in the deregulated, hostile takeover, job-hopping corporate world of the past three decades, such personalities have thrived.[11] Quaritch plays

well as a neoliberal fiend. He's cold-blooded toward fellow human and Na'vi alike in his single-minded imposition of the RDA agenda on Pandora. When the crisis arises, the Colonel assumes command, gunning down Grace and devising, as one of the scientists characterizes it, "some kind of Shock-and-Awe campaign" against the Na'vi. Cameron's reference to Bush's war in Iraq, as well as to the neoconservative doctrine of preemptive warfare, is blunt. To a roomful of grimly nodding corporate soldiers, Quaritch barks out: "Our only security lies in pre-emptive attack. We will fight terror with terror." Given that RDA has imported the terror in the first place, such policy is palpable nonsense and imperialist doublespeak. RDA is there to plunder natural resources, resources that—whether unobtanium or oil—will not, in the end, satisfy the insanity of perpetual neoliberal expansionism. Thus, more than Quaritch's being a psychopath, the Artificial Intelligence of the Corporation itself is psychopathic in temperament and outlook. Like the Machines of the *Terminator* films, the Corporation schemes only for its own self-preservation and gain. To achieve those ends, the Corporation willingly kills those who invented it, ironically, in their own image.

When Quaritch and Jake square off in a knife fight at the finale of *Avatar*, they don't battle as hero against villain. Instead, both perform in suits of distinct masculinity and monstrosity. In his hulking AMP suit, Quaritch functions very much like a Terminator. He's a projection of the military–corporate complex animated by NeoCon masculinity; he's the modern Corporation looking to retain its dominance.

Figure 5.2 Monster, skewered.

In contrast, Jake is supple in his biotech bodysuit. He represents collectivism and environmentalism animated by post-Marxist agency; he's postmodern socialism looking to ascend to dominance. Neither is "natural" or "normal." As signifiers, both are options for cultural exaltation as the new millennium manliness; each polity is monstrous to the other. In their showdown, hegemonic discourse is inevitably and violently modified. When Neytiri steps in to slay the Papa Dragon of Corporation, she performs as a complex signifier as well. Quaritch and Leonidas are the self-same character: the personification of modern neoliberal hegemony. Neytiri, then, is analogous to the Persian hordes: an exotic challenger to Western "reason" and "good." How different the flight of arrows, however, at the end of *300* compared to the end of *Avatar*. Leonidas dies martyred, a Caravaggio-like Christ figure, at the hands of fanatical cowards, and the audience is meant to grieve. Quaritch dies a Beast, finally put down, by a principled and statuesque matriarch, and the audience is meant to cheer (Figure 5.2). That the same situation renders opposite responses illustrates the difference between modern and postmodern monsters. The Persians are meant to induce fear and abhorrence of all things Middle Eastern and Islamic. The Na'vi are meant to rouse critical examination of corporate folly and brutality. Good Us fabricating Bad Them insures the concomitant Good Them fabricating Bad Us. Contrariwise, the creation of postmodern monsters—Neytiri, Christopher Johnson, V, Kong—challenges and, potentially, erases distinctions motivated by ignorance, fear, hatred, bigotry, and, maybe most of all, greed.

Coda: The Monster's Suit

This book investigates how contemporary filmic depictions of masculinity and monstrosity can be indicators of our cultural moment. As we've demonstrated in the preceding chapters, when dealing with movie monstrosity, a host of issues interact: gender, socioeconomics, warfare, sexuality, able-bodiedness, race. Some films reify the human/monster binary to endorse a social "normal." Some films blur that boundary, thereby distressing the very concept of "normal." Our aim has been not to assert that our readings of these monster movies are the only ones available; rather, we hope to show that deep interpretation is possible, useful, and necessary. Culture may seem a fixed circumstance at any particular time, but history and geography prove culture to be incessantly variable—and a moving target. Although the delineation of monstrosity and masculinity might seem straightforward, upon inspection, each concept in itself becomes multidimensional if not puzzling. Pair the two descriptions, as we've done in this study, and whole social systems begin to crumble. To conclude this book, instead of summarizing our many points, we'll end with an exercise in puzzling multidimensionality by taking the monstrous/masculine pulse of the 2010 Oscar winner for Best Picture, *The Hurt Locker*. This finale is not intended to render a thoroughgoing reading of director Kathryn Bigelow's movie. Rather, we stir up trouble.

DONNING THE BOMB SUIT

The Hurt Locker is set in a region of the world where, because national and cultural boundaries are under contention, monstrosity's potential is patent. These boundaries are evident in the futuristic, fantastical, or satirical films we've discussed in previous chapters. Where there is conflict over the contours of normalcy, the monster abides, "interdicting through its grotesque body some behaviors and actions, envaluing others" (Cohen 13). Unlike these other films, Bigelow's depicts an actual situation in naturalistic detail, the earlier part of the American occupation of Iraq.[1] The tale revolves around a three-person

Explosive Ordnance Disposal (EOD) team with a focus on the team's new leader, SFC Will James (Jeremy Renner). Although the film's opening clarifies that EOD standard procedure requires using robots to disarm bombs while involving more than one teammate, James always opts to disarm the bombs alone, in the suit.[2] Prompted by the Chris Hedges quote prefacing the film—"The rush of battle is often a potent and lethal addiction, for war is a drug"—typical interpretations of this character render him a rogue soldier horrifyingly victimized by his addiction to meaningless war. We think this reading is partial. We read James instead as the ideal maverick within the current version of hegemonic masculinity—which makes him monstrous. Emblematized by his choosing to wear "the suit" as a first and not last resort, James loves war, disarming bombs, being deployed, and has no problem distinguishing between enemy and friend. But when James is not in his suit or when in it only partially, he is less certain, revealing his position as the monster who is both inside and outside, who reveals and warns (Cohen 4). If our book's other films require of spectators allegorical mind-bending to apprehend the films' relationship to the world currently, *The Hurt Locker* elucidates the applicability of masculinity and monster theories to this, the American "real" world of the last decade.[3]

The Hurt Locker is a lower-budget (US$15 million) film that did not perform well at the box office (US$49 million worldwide) (*Box Office Mojo*). It was a critical hit, however, garnering national and international awards and winning six 2010 Academy awards, including Oscars for Best Picture and Best Director ("Awards"). The film's wins are noteworthy not only because Bigelow was the first woman to win Best Director but also because *The Hurt Locker* was in closest Oscar competition with two box-office hits, films we discussed in the previous chapter: *District 9*, with a budget of US$30 million and box office grosses of nearly US$211 million worldwide; and *Avatar*, with an estimated production budget of US$500 million and a worldwide gross of just under US$3 billion (*Box Office Mojo*; Cieply).

Striking about all three films is that their (male) protagonists experience a transformation—sometimes attitudinal, sometimes physical, and sometimes both. In the course of both *Avatar* and *District 9*, the protagonist is transformed into a subordinate position: *Avatar*'s Jake converts from complying with to opposing the patriarchal neoliberal hegemony and *District 9*'s Wikus unwillingly becomes both human and alien. By each film's conclusion, neither character seems likely to revert to his previous condition. *The Hurt Locker*'s Sergeant First Class Will James, however, is not transformed whatsoever. Instead,

his story concerns the ongoing mutability of his monstrous character: He is both Ranger and bomb disposal expert, suited and unsuited, married and not-married, father and not-father. As Cohen comments, "The monster is the abjected fragment that enables the formation of all kinds of identities...as such it reveals their partiality, their contiguity" (19). Monsters are designed by the culture's members to embody the cultural fears and anxieties of the period in which the monsters are created. For this coda, then, we explore how, for the past decade, James is the monster Americans have needed—indeed, one Americans have *made*. James's monstrosity is that he is neither neoliberally hegemonic nor a post-Marxist agent—he is in the liminal space between, monstrously improvising between these polar constraints.

A major lament about the voluntariness of the early-twenty-first-century US military is that too few people volunteer to serve, so that those few volunteers feel intensely the repercussions of constant war. Not only do military members deploy to war now frequently, but they subsequently experience high rates of divorce, suicide, and mental illness caused by post-traumatic stress disorder, traumatic brain injury, and moral injury ("Army Health"). Notwithstanding the nationalistic fervor following September 11, 2001, it is also likely that the ailing American economy in the millenium's first dozen years has driven a significant proportion of the US military members to enlist. They may be as motivated to have guaranteed employment, shelter, food, and health care as they are to engage in combat or defend the homeland. Despite these conditions, a volunteer military necessitates a rhetoric that its members have opted to engage in patriotic service to the country, a rhetoric patent in recruiting slogans.[4] Since 9/11/2001, the American military has deemphasized the individualistic, post-Vietnam "Be All You Can Be" era and marketed itself as a humanitarian force in the world, as a charitable collective.[5]

The humanitarian ethos of these recruiting tactics resonates in *The Hurt Locker*. Awarding Best Picture to the depiction of a bomb technician is not happenstance. Who is represented and in which wars is neither random nor arbitrary. Some wars, Bernard Beck points out, are ones Americans try to forget, and because the political justifications for most wars are too sensitive to be explored in war films, the apolitical, individual soldier is the central focus (214). Citizens sending soldiers to war regard themselves as nobly supporting the troops when they view filmic images of soldierly nobility, says Beck. Certainly a focus on the individual is the case in *The Hurt Locker*. Furthermore, James's casting as a bomb technician and not the Ranger he was beforehand has the effect of making him harmless,

benign.[6] As a Ranger, he would aggressively and secretly be pursuing "bad guys."[7] As someone whose combat activity is defensive, who protects innocents as he disarms bombs laid by people whose intent is to hurt others, James unambiguously is one of the good guys. According to the tenets of American humanitarianism, American military members must appear as "reluctant killers" (Harpham 200). Thus, the benignity of James's position as a bomb technician parallels the American military appeals to humanitarianism and the advantages of collectivism.

This parallel and the apparent American desire to divide the world into good guys and bad ones is compounded by the film's epigraphic quote from Chris Hedges's book, *War Is a Force That Gives Us Meaning*. Prefaced as the film is by the "war is a drug" quote, bomb disarmer James seems victimized by war; war becomes an ineluctable component of human nature, something humans are unable to resist. The quote provides an inescapable logic: (1) War's primary objective is to lure men[8] to it; (2) once they are there, the drug of war makes them desire it; (3) because it is addictive, war always has been and always will be; (4) all observers of war can do is pity the addicted victims of inexorable war. According to this logic, SSG Thompson (James's predecessor) and James's teammates Sanborn and Eldridge cannot resist the allure, either. This, the film's use of the quote avers, is the soldier's condition.

War's inevitability is not Hedges's argument, however. Instead, he rues that modern war is the outcome of modern life's meaninglessness. War is neither fundamental nor inevitable. We moderns go to war, often over silly disagreements, because we cannot find better ways to fulfill our lives. Speaking as a war correspondent of some 25 years, Hedges grieves:

> The enduring attraction of war is this: Even with its destruction and carnage it can give us what we long for in life...purpose, meaning, a reason for living...And war is an enticing elixir [to the "vapidness" of modern life]. It gives us resolve, a cause. It allows us to be noble. (3)

While war is characteristic of the human condition, our human weakness takes us to war, not our human nature, says Hedges. Claiming that war is human nature and therefore inexorable absolves citizens of responsibility for sending fellow citizens to war. Although James himself cannot identify his monstrosity—he asks Sanborn to explain why James "is the way [he] is"—the "man in the bomb suit" asks the movie's viewers to consider not only why James has gone to war but also why and by

whom he has been sent. That James goes willingly to war as a defensive savior salves American viewers' consciences; that he cannot articulate why he does what he does should give American viewers pause.

BLOOD SACRIFICE AND MONSTROSITY

Carolyn Marvin and David Ingle might explain that pause as fear of complicity in "blood sacrifice," a central element of totemism. Originally conceived by Emile Durkheim in the nineteenth century, the totemic system is a series of emblems, fetishes, and rituals that signify and solidify the agreement humans have made to form a society. Although totemism typically has been understood by scholars to characterize traditional societies, Marvin and Ingle insist not only that "totem dynamics [are] vigorously at work in the contemporary United States," but also that their centrality to our political culture goes "unacknowledged," unrecognized, and "vigorously denied" (1–2). Every nation, they argue, regardless of its developmental stage, engages in a totem system reliant on regular human sacrifice to ensure the nation's endurance: "blood sacrifice." To mitigate disintegrative violence within the totemic/national group, a (blood) sacrificial class is designated "to absorb the anger group members feel toward one another" (72). Only the male leaders of the totem system, the fathers, may authorize the blood sacrifice that demarcates the nation's boundaries; females, the mothers, are prohibited killing power as they define the nation's regenerative center (115–116). War is the most convenient vehicle for totem sacrifice, as the enemy conducts the killing that coheres the nation (12). Although they go as "reluctant killers," members of the sacrificial class willingly offer their lives for the nation, as their patriotism gives meaning to war's violence (8). Going to war requires crossing a border and becoming an outsider, however, so that "every insider," as Marvin and Ingle put it, "is a sacrificial outsider in the making" (69). Maintaining the totemic system necessitates blood sacrifice but also keeping secret the nation's reliance on sacrifice (21); maintenance also mandates citizens' frequent rededication to the nation by fetishizing national flags (as the totem emblem), reciting pledges, and singing anthems (38). Members of the sacrificial class—the military—who survive war participate in guarding the secret sacrifice; they can be reincorporated into the nation only if they "cast off the knowledge of who sent them to die. They foreswear revenge and refuse to tell what they know" (73). The unity of the nation relies on such quietude. Chris Hedges acknowledges this coupling of sacrifice and silencing.

But war is a god...and its worship demands human sacrifice. We urge young men to war, making the slaughter they are asked to carry out a rite of passage...That the myths [to legitimize war-making] are lies...is carefully hidden from public view. The tension between those who know combat, and thus know the public lie, and those who propagate the myth, usually ends with the mythmakers working to silence the witnesses of war. (11)

Marvin and Ingle's theory of blood sacrifice suggests, then, that as the designated protectors and thereby boundary-crossers, male soldiers are de facto monsters made, fabricated by the culture internally to face those made externally (5). James signals this liminal position as he moves in and out of his bomb suit. In line with the traditional characterization of American military heroes, some viewers may imagine that James's rejection of technology by removing the bomb suit ensures his achievement of masculinity. We think instead that both attires—in and out of the suit—are problematized by gender expectations; it is often James's pursuit of masculinity that produces his monstrosity. The suit also denotes the tension between the American veneration of individualism (gendered as masculine) and its emphasis on collective action (gendered as feminine). The certainty James demonstrates when inside the suit suggests neoliberal hegemony/individualism except that he cannot perform masculinity. Instead, he can only enact traditional femininity: defensive, not offensive, reactive, not proactive, and subject to penetration, not penetrative. When James is not in the suit and attempts performing the masculinity inhibited by it, he is confounded by collectivism's demand: human interaction. As a monstrously amorphous, illegibly gendered being, his inability to explain why he does what he does as a bomb technician calls attention to the unutterable: American dread of ambiguous gender, the impossibility of achieving masculinity, and the contradiction inherent in the American ethos that includes simultaneously individualism and a people united. Although James cannot articulate the blood sacrifice he is expected to offer and the related in-between state he inhabits, he is uncomfortably conscious that that is where he resides.

One may choose to wear the suit but cannot assume it alone; wearing the armored suit requires being put inside it and being protected once inside.[9] Sanborn and Eldridge together clothe James once he becomes the team leader, and they follow a ritual they seem to have done numerous times before.[10] While James's superior rank determines he inhabit the bomb suit, he cannot achieve this on his own, nor can he defend himself once in the suit. Thus, whether by remotely

operated robot or single person in a bomb suit, defusing a bomb is a group effort. In the team's initial mission, James's individualist actions indicate his awareness of the collectivist activity, of procedure, and his defiance of them. First, though Sanborn and Eldridge have prepared the robot to investigate the improvised explosive device (IED), James insists on using the suit. Second, once James starts down the street, he stops communicating with Sanborn and throws a smoke grenade to obscure the line of sight Sanborn and Eldridge need to protect James. Third, when an Iraqi taxi emerges onto the street and stops directly in front of James, he takes matters into his own hands. James fires his pistol at the ground, then at the windshield, and finally points the weapon against the taxi driver's head. But James knowingly evaluates his offensive, individualistic behavior when he says to himself after the taxi driver is seized by other American troops: "Well, if he wasn't an insurgent he sure as hell is now." Because these actions occur before James locates and disarms the "daisy chain" IED, the film implies that such success relies on a maverick's procedural violations. It is the suit that James wants to believe enables these activities and is the suit to which James will return—as the consistently illegible monster—at the conclusion of the film.

James senses that there are limits to the suit's charm, though. When he is charged with disabling a car bomb at the UN headquarters and discovers the task's enormity, he removes the inhibiting suit. "There's enough bang in there to send us all to Jesus. If I'm going to die, I want to die comfortable," James remarks. Although Sanborn wants to leave the disabling to engineers, James's desire to complete this job himself forces Sanborn and Eldridge to guard the increasingly threatening perimeter. In removing the suit and refusing communication with Sanborn, James forces his agenda on his team members: to enact individualism and to understand the person who rigged the bomb.[11] Even Colonel Reed (David Morse), a career Army officer and thereby most invested in procedure, uniformity, and collective action, is susceptible to the lure of heroics (by definition individual). Not only does Reed illegally order his men to kill the captured sniper responsible for the car bomb, but also after James disarms the bomb Reed glorifies James's "hot shit," admiringly calling James "a wild man." James appears unconcerned about the colonel's appraisal—he is more interested in deciphering the anonymous constructer of the bomb—and later comments about the circuit he saved from it: "Dead man switch—boom! This guy was good. I like him."

James is reminded of the suit's limits when he must disarm the bomb vest of a suicide bomber who has changed his mind. Although

disarming inanimate IEDs and car bombs while in or accompanied by the bomb suit can support the illusion of maverick masculine activity, this episode illustrates how a live person's being the bomb foils James's imagination. SSG Thompson was killed by a remotely detonated IED, and the film intimates that both James's daisy chain IED and UN car bomb will be remotely detonated. Sinister-looking Iraqi men with electronic devices lurk everywhere and it is James's challenge to outwit them in what are struggles over dominant masculinity. In the suicide-bomber episode, however, time—fixed, unrelenting, neutral—becomes James's competitor. The bomb's clock denies James time to disarm it, and the padlocks on the iron vest prevent James's removing it. James is rattled in this scene; his efforts are futile yet he persists in trying to free the man, assuring Sanborn that the bomb suit offers him protection. As time expires, James runs from the vested man, turning at the last moment to observe the explosion. Although the suit might save James, it could not enable his rescuing the suicide bomber from his fate with time. The scene's emphasis on time amplifies the number of days left in the unit's tour. Sanborn alludes to the American soldier's difficult relationship with time when he laments not having anyone to care should he die:

> *Sanborn*: I'm not ready to die, James.
> *James*: Well, you're not going to die here, bro.
> *Sanborn*: Another two inches. Shrapnel zings by—slices my throat. I bleed out like a pig in the sand. Nobody will give a shit. I mean my parents, they care, but they don't count, man. Who else? I don't even have a son.
> *James*: Well, you're going to have plenty of time for that, amigo.
> *Sanborn*: No, man. I'm done. I want a son. I want a little boy, Will.

Sanborn's concern for passing time references the status of all soldiers under the dictates of blood sacrifice: It is only a matter of time before each is expected to give his life. Thus, to make meaning of one's life—as Sanborn intimates, "I don't even have a son"—one participates in the "totem lineage" by reproducing a son, who also will be persuaded that having a son makes life meaningful through blood sacrifice (Marvin and Ingle 211).

Reiterating Masculinity, Being Monstrous

If wearing the bomb suit cannot guarantee James's performance as a masculine, individualistic bomb technician, neither does his being out

of the suit ensure his permanent acquisition of masculinity. Because masculinity is an iterative process and not a state, James must repeat the acts, hoping to achieve the state and stymied that he cannot.[12] This reiteration of military masculinity is evident in the long episode of the EOD team in the desert, first as they detonate bombs, then with the mercenaries, and finally as they defend themselves against Iraqi snipers. In the detonating scene, Sanborn and Eldridge contemplate exercising their masculine agency by "accidentally" killing James. They opt not to kill him, a decision affirmed later when James helps them perform masculinities. He enables Sanborn's penetrative efforts by sighting-in the Iraqi snipers and by hydrating the keen-eyed marksman, he helps Eldridge prepare the projectiles that Sanborn will fire, and he emboldens Eldridge to kill an Iraqi who emerges from behind them. These are hegemonic masculine performances SSG Thompson could not encourage.[13]

Although James's status in the team is rectified by these desert activities, they do not guarantee a masculine condition for any of the men. Back on post and in James's quarters, military masculinity must be practiced repeatedly, as the team drinks alcohol, as they wrestle and punch one another, as they discuss women and babies. Although James senses otherwise, Eldridge and Sanborn think that wearing the suit emblematizes achieved masculinity so that Sanborn asks whether James thinks "I got what it takes to put on the suit." James reveals in his response—"Hell no. Night, boy"—and his earlier naming Sanborn "bitch" when James "rides" Sanborn—his uncertainty about Sanborn's masculine status. That Sanborn grants James the authority to decide on his worthiness deems James an expert on masculinity as a father figure. James reveals uncertainty about his own masculine status, however, when in the most chilling scene of the film, he sits on his cot and puts on the bomb suit helmet but not the rest of the suit. He understands he is in-between: nothing, neither the bomb suit nor the fatigues of the US military, can ensure the permanence or legibility of his masculine enactments.

Undefeated, James continues to repeat and thereby try to normalize his masculine acts, especially in what he imagines to be a fatherly way. Three episodes that refract the desert episodes and revolve around the Iraqi boy, Beckham, dramatize this repetition best: disarming the body bomb James thinks is Beckham; searching for Beckham's killer; and the foray from the oil-tanker site into Baghdad alleyways. First, rather than blowing up the body bomb, James extracts the bomb with his hand and in a gentle, paternal way, carries the body to Iraqis waiting outside the building. He is ambivalent about his

actual parental role, though, demonstrated by his phoning home after the bomb extraction but not speaking to his ex-wife on the other end who holds their baby son. Second, suspecting Beckham's Iraqi employer of responsibility for the boy's horrific death and seeking Ranger-inspired retribution, James leaves the boundaries of American occupation and forces the employer to drive him to Beckham's home. Like his wearing the bomb suit helmet alone, James is clothed in a hybrid outfit of fatigue pants and dark hoodie, an outfit facilitating his boundary-crossing into Beckham's purported home. Instead of finding a terrorist cell, James encounters the pleasant domestic space of a kindly, multilingual professor who welcomes James as an agent of the Central Intelligence Agency—as though that sort of invasion had been normalized for the professor—and an irate woman who ejects James from the house. Despite his running through chaotic down-town Baghdad, James's recrossing the boundary into quiet American territory is most threatening to him, when guards at the border cannot read his hybridity and threaten to shoot him. Whatever Ranger-inspired masculine vengeance James is trying to wreak in tracking down Beckham's killer, it does not work as James anticipated.

Still, James persists. The third and final scene of James trying to enact and secure his masculinity through a penetrative act is when the EOD team is summoned to do the "post-blast assessment" of an oil-tanker explosion. Frustrated by his failure to track down Beckham's killers and with the reactive mode of this mission, James insists that the team pursue the Iraqi insurgents he imagines "are laughing at *this*," meaning American impotence in the face of such destruction.[14] Sanborn argues that there are "three infantry platoons here whose job it is to go haji hunting," but Eldridge agrees with James to "get in a little trouble." Eldridge might not have so glibly agreed had he anticipated the trouble would be his: abducted by Iraqis and then shot by James as he and Sanborn rescue Eldridge. So, while the team does penetrate into the alleyways of Baghdad, all they accomplish—all James accomplishes—is penetrating one of their own.

Although the desert scene has positive implications for the team and their desires to confirm their individual masculinities, its conclusion—James alone on his cot with the bomb suit helmet perched on his head—is unsettling. The conclusion to the Beckham scenes is less enigmatic, elucidating not only James's failure to secure a masculine state but also the hazards of trying to achieve it. First, after shooting Eldridge, James realizes that he has masculinely penetrated a person he had tried to "father" and falls weeping and fully clothed into the shower. Second, as James goes to see Eldridge

medevac'ed, he and Beckham spot one another but James ignores the boy. Beckham's being alive spotlights James's inadequate and foolish "parenting": He had taken too many risks on what he had assumed was Beckham's behalf. Third, as James and Sanborn see Eldridge off, Eldridge damns James's recklessness:

> *Eldridge*: You see that! [Gestures toward his leg.] Fuckin' see that? That's what happens when you fuckin' shoot someone, you motherfucker.
>
> *James*: I'm sorry. Sorry, Owen.
>
> *Eldridge*: Fuck you, Will. Really, fuck you. Thanks for saving my life but we didn't have to go out looking for trouble so you could get your adrenaline fix, you fuck.[15]

The real conclusion to the Beckham scenes, then, is what follows Eldridge's departure: the man-in-the-bomb-vest scene discussed earlier where, as penance for his misguided efforts to assert his penetrative powers in the Baghdad alleyways, James unsuccessfully tries to prohibit the penetration of the reluctant suicide bomber. James sees the futility of his efforts, but in his quest to secure a masculine, in-control state, he persists.

Over the course of his 38-day stint with the Sanborn and Eldridge EOD team, the film depicts James's problematic relationship with masculinity and the bomb suit. But when James rotates home—without the bomb suit—his monstrosity becomes evident. Another trio of situations occur to drive James back to the suit, to what he is encouraged to think is the locale of fixed masculinity. The first situation is his family that is not-family. He explains to Sanborn and Eldridge that he and his (always unnamed) girlfriend married when she became pregnant but that they divorced. Because she still lives in their house with their son and says she and James are still together, James can't find the words to categorize their ambiguous relationship, saying "She's just loyal." The second situation, James's cleaning the house's leaf-filled gutters, demonstrates that though their relationship is ambiguous, in the domestic sphere, James performs a traditionally masculine role. He does not look happy or satisfied protecting from the elements the people he allegedly loves, but he dutifully completes the suburban chore.

In the third event, James and his not-family are at the grocery store. James seems baffled by this "cathedral to consumerism" with a Muzak soundtrack, especially in the cereal aisle (Boal, *The Hurt Locker* 111). For a man who decides who lives and who dies, faced

with a multitude of alimentary choices, James has been read as endearingly flummoxed.[16] But we think that this is James's most monstrous moment as he reveals the film's horrific boundary between "tyranny" and "freedom." There is Iraq, where tyranny means merciless sun and dusty streets full of sinister men, burqa'ed women, and boys turned into bombs; here is the United States, where freedom means benevolent rain and leaf-filled gutters, cereal choices, and a baby boy whose greatest delight is a jack-in-the-box. While James plays with his baby, he explains adulthood as a dwindling of delights. "The older you get," says James, "the fewer things you really love. And by the time you get to be my age, maybe it's only one or two things. With me, I think it's one." The desert scene series' conclusion is James sitting on his cot in the bomb suit helmet, enacting his liminal condition. The Beckham-related scene series' conclusion is James recognizing the limits of the bomb suit to sustain bodily integrity. Despite James's awareness evidenced in these two endings, the conclusion to the stateside scene series is James's return to Iraq: combat boots leaving a military transport plane morph into the boots of an assured-looking James in a bomb suit, walking down another Iraqi street with another 365 days to go. Viewers might logically conclude that it is the feminine domesticity of American culture depicted in the film that drives James back to his addictive, masculine sanctuary of war. But viewers have witnessed the film also alleging that war is not the masculine sanctuary it is purported to be. What might explain James's return?

Addressing that question requires circling back to the dictates of "blood sacrifice" and to *300*, a film that ultimately concerns itself with the totem lineage a father or paternal figure requires of his literal or figurative son(s) (Figure C.1). Rather than the trope of brotherhood often used in modern American war narratives and satirized in *Tropic Thunder*, in *The Hurt Locker*'s trio of scene series, viewers can see on close inspection a meditation on fathers and sons.[17] In the desert series, it is reflected in James's fathering the two men in his team and Sanborn's conflicted emotions about becoming a literal father himself; the Beckham series asks what is a father's responsibility for the bodily integrity of his "son" and Sanborn's tearful conclusion that he needs neither parents nor lover but male progeny to memorialize his life; and the stateside series ends with James's leaving his biological son and returning to Iraq because *that* is what he loves. That both *300* and *The Hurt Locker* dwell on this issue of men choosing war suggests that it is domesticity driving both protagonists to their maverickness, not war's allure. That is, were it not for the domestic cultures of Sparta and Knoxville, Tennessee, this logic

Figure C.1 The sacrificial mandate.

would argue, neither man would be impelled to the masculinity to which he aspires. Leonidas's domestic foes are those impeding his unilateral decisiveness; James's are the chores of modern domestic life at which he is oddly incompetent. Chris Hedges's argument is that our modern lives are so empty of meaning and purpose that war fills that void, offering what seems the best option for nobility and happiness. James's lust for the bomb suit and the masculinity it seductively promises reveals how he is pushed to war not only by the disappointment of modern domesticity but also, and perhaps initially, by the mandate of the blood sacrifice.

Belief in the inevitability of war and totem lineage is patent in the two male soldiers' relationships with their biological sons. Both Leonidas and James teach their sons—those in modern American society responsible legally via Selective Service for continuing their fathers' sacrificial legacies—that one only can accept war, that such acceptance is the male condition in a totem system. "Fathers do not so much tame violence in boys," claim Marvin and Ingle, "as elicit it for the sake of channeling it. Boys are transformed into men by fathers who push them to the borders," thereby ensuring not only the boy's boundary-lurking monstrosity but also the meaning of a father's life (212). The fathers camouflage their obligation to sacrifice their sons to war in the totem lineage with words like "duty," "freedom," "honor," even "love," and the promise of manhood (80). But those disguises negate neither the sacrificial mandate nor the father's obligation to keep the mandate secret.[18] In *300*, fathers teach their sons

how to war. Leonidas's father taught him, and he teaches his son.[19] Mothers stand by, watching the fathers and sons interact in this way, accepting and supporting the preparation for blood sacrifice and its inherent monstrosity. That the arrival of the Persian messengers interrupts Leonidas's work with his son emphasizes the necessity for such readiness: males are instructed that they always must be prepared for threats to the nation's boundaries and for the call to disperse, monstrously, to those borders. Leonidas says to his son, "Fear is always constant, but accepting it makes you stronger."

The home scene series in *The Hurt Locker* echoes this insistence that males always must be prepared for the nationally mandated blood sacrifice. Juxtaposed against James's failure to defuse the suicide bomb vest and his subsequent conversation with Sanborn about Sanborn's wanting male progeny, James's interaction with his baby son demonstrates the price of such preparation. Contrary to Sanborn's belief, having a son does not validate one's life but in the totem context does ensure the perpetuation of war. James's son is not old enough to understand that James loves war—but James violates the secret of the blood sacrifice when he utters those words and viewers witness the utterance. Film spectators know that soldier James is a monster as he crosses boundaries. But to send soldiers to war, citizens persuade themselves that the boundary-crossing nobly is for the benefit of the collective and that individual males will benefit from war's power to transform feminine boys to masculine men. In Iraq, however, James demonstrates the war's failure to ensure the acquisition of masculinity. By confessing to his son his personal desire for war, James violates a taboo on which blood sacrifice and monstrosity rest: silence. Just as fathers threaten the coherence of the nation if they reveal the blood sacrifice and so are obliged to secrecy, the monster threatens culture if he exceeds his bounds: "Escapist delight gives way to horror only when the monster threatens to overstep these boundaries, to destroy or deconstruct the thin walls of category and culture" (Cohen 17).

For both films, the message audience members are left with is that, unless they are willing to accept abject decadence and tyranny, or its flip side, the tedium of modern life, war is inevitable. It becomes the moderate option between two extremes. Combat's inevitability is produced by the quietism integral to blood sacrifice that turns males into monsters, and is ritualized in American culture as what we call the Support the Troops Syndrome. This syndrome responds to the mythically bad treatment of Vietnam War veterans and is symbolized by a yellow ribbon. Americans have long used the ribbon as a talisman, from the early Puritans, through both World Wars, into the

Vietnam War era. Their use in the last decade is as magnets shaped as yellow ribbons adhering to car bumpers.[20]

Currently, yellow ribbons signal the Support the Troops Syndrome as they call for positioning military members iconically, a position exempt from criticism and analysis, almost holy. Allegedly, supporting the troops means Americans can distinguish clearly between (bad) politicized government that self-interestedly makes decisions about whether to go to war and (good) apolitical troops who only are victimized by those decisions. While support of soldiers, marines, and airpersons fighting American wars might be genuinely desirable, it serves less as support for troops and more as salve for the guilt of having so few citizens carry the weight of American wars. After all, in American representative democracy citizens are both: the government that declares war and the troops who engage in combat. As a function of blood sacrifice, the Syndrome is an insistent mantra, a position that all patriots *must* take. One *either* supports the troops—and the war by which they are victimized—or one *does not* support the war and thereby the troops. To encourage the voluntariness of the blood sacrifice class, of the internally made monsters we need to face the made monsters at the border, there can be no in-between. One may not both disagree with the war but support the troops; patriots who desire the coherence of the nation and thus the blood sacrifice may not assert, "I don't support the troops." The end effect of the Support the Troops Syndrome is confusion about what is political and what is not, and quietism about war generally. If Americans view their military personnel as victimized by war and by the government bigwigs making the decisions, then citizens mustn't beat up the troops when they are down. We mustn't criticize them, even when they do things we abhor, because they facilitate warring—and thereby national coherence. Consequently, the Support the Troops Syndrome demands an emotional, not a rational, response, and in these two films especially audience members only may pity or appreciate the troop. *Feel* the troop's anguish, the films command. And who can argue with pathos? Who can say that one's emotional response to a film is inaccurate, or the wrong response to have?

Within the logic of the Syndrome, geopolitics are games of wily politicians, and objections to war are regarded as, at least, loony, and at most, traitorous. So Americans remain quiet but assured they are doing all they can to participate in our wars by raising flags, mounting yellow ribbon magnets on car bumpers—and maybe even granting a Best Picture Oscar to such pathos-driven renditions as *The Hurt Locker*. Citizens assure themselves that they are not responsible for

sending American males to the boundaries of monsterhood. The Syndrome's quietism might seem benign; it might even seem like peace. We think, however, that it can lead to the new American militarism Andrew Bacevich outlines in his 2005 book, *The New American Militarism: How Americans are Seduced by War.* "Americans," he says, "in our own time have fallen prey to militarism, manifesting itself as a romanticized view of soldiers, a tendency to see military power as the truest measure of national greatness, and outsized expectations regarding the efficacy of force" (2). Bacevich refers not only to obvious manifestations of militarism. He also indicts Hollywood for seducing film viewers with romanticized images of masculine warriors. Because the heroes of *300* and *The Hurt Locker* are so iconic—Leonidas recalls a Caravaggio-esque Christ as he lays dying on the battlefield, and be-suited James is the embodiment of technology's promise to ease war's strains—and the wars so inevitable that viewers cannot and must not respond to them in any way but emotionally.

SFC James of *The Hurt Locker* isn't the same kind of unmitigated monster that Leonidas of the cartoonish *300* is, but the character takes on the qualities of monstrosity even in a film aiming at verisimilitude. Critics and viewers, especially veterans, dispute the film's accurate portrayal of the war in Iraq and of the US military, and many question the film's politics. Few of even the most critical argue with the representation or implications of a soldier addicted to war, however. This absence of critique suggests that James represents to American audiences the psychologically complicated modern-day soldier/monster. He relishes situations the ordinary person probably would avoid, and he endangers the two men of his unit in indulging his pleasures. But James is not so unlike Leonidas after all: skilled, focused, intent, a man of action especially characterized by his willingness to defy protocol and even knowingly risk his own life—and others'—to accomplish necessary tasks. Although unlike Leonidas, James's motivations are depicted as patently self-centered, like Leonidas, he doesn't gain personally from his warring. Both knowingly are engaged in suicidal acts, and Americans love them for that. We love their commitment, their unambiguous acceptance of their role as masculine Protectors of Boundaries, and we love that they don't ask anything more of us than that we unquestioningly accept—and thereby support—what they are doing. They are the monsters we need.

NOTES

INTRODUCTION: OF MASCULINE, MONSTROUS, AND ME

1. See Smiley and West; see also Chang.
2. See *Undoing Gender* (2004) for more about gender performativity.
3. See Butler, *Undoing Gender* (3).
4. Among film critics and commentators, the T-X also has picked up the unsettling sexualizing nickname of the "Terminatrix."
5. See Gilmore's Chapter 10.
6. See Graham's Chapters 1 and 2.
7. The enormously popular *Mass Effect 1–3* (BioWare 2007–2012) and *Halo 1–4* (Bungie 2001–2012) are sci-fi action videogames currently moving the genre of first-person shooter into the filmic realm of role-playing and player-created storyline. The theatrical trailer "Creating Halo 4" (July 2012) promises gamers: "You're the director. You are the star. We'll give you the tools to blaze a new trail and allow you to experience and inhabit worlds of heroes in a way a movie never can. It's your journey. You control your own destiny. And there's no magic quite like it."

1 TOSSING BLONDES IN PETER JACKSON'S *KING KONG*

1. Jackson's remake is a financially successful one, too. The film grossed over US$550 million and then set sales records for Universal Pictures DVD releases; see *Box Office Mojo*.
2. For readings of Cooper's film relating to class, see Torry; Carroll; Schleier; and Hanley. For readings related to race, see Snead; Bellin 21–47; Hellenbrand; and Rice 188–200.
3. Such hard times were familiar to movie audiences of 2005, but these conditions reverberate more painfully now in the wake of the Great Recession of 2008.
4. See Montag.
5. See Cashill 39; David Griffin 18.
6. See Bellin 24–35; Hellenbrand; and Guerrero 41–68.
7. See Cooper's *King Kong*, disc two, "The Mystery of the Lost Spider Pit Sequence"; see also Morton 63–64.

8. See also Schleier.
9. While David Griffin thinks Naomi Watts is lovely in the role of Darrow, he also complains that Watts "doesn't have Wray's luminous expression of terror" (19).
10. See Morton, Chapter 5.
11. See in particular hooks's Chapters 3 and 4.
12. See in particular Snead 36–40; Rice 189–191.
13. See Torry 72–74.
14. For a concise description of these four masculinities, see Connell, "Social Organization," 38–42. In an extensive reevaluation of this influential concept of "hegemonic masculinity," Connell and Messerschmidt reassert the core features of the original theory. Where they alter and expand the idea of hegemonic masculinity is in the complexity of possible gender hierarchies that can be formed (847–853).
15. See Peary.
16. See Haraway 26–58.
17. See Erb 103–119.
18. Connell and Messerschmidt discuss the possibility of reconceptualizing marginalized masculinity as "protest masculinity," which they define as: "a pattern of masculinity constructed in local working-class settings, sometimes among ethnically marginalized men, which embodies the claim to power typical of regional hegemonic masculinities in Western countries, but which lacks the economic resources and institutional authority that underpins the regional and global patterns" (847–848). Such a description suits the crew of the *Venture*.
19. See, for example, Said 207–208; see also McLeod 39–50.
20. In this regard, Kong and Mr. Hayes are quite similar. Both are marginalized by race and by class, yet both embody a more admirable form of protest masculinity, one that features, in place of self-interest and greed, altruism and solidarity—traits of socialism that capitalist patriarchy is eager to stigmatize as "weak" and "feminine." For this reason, the moment when Kong snatches up Mr. Hayes and then kills him is disorienting and shocking. It's as though Denham, as the hegemonic male, has managed to pit fellow marginalized males against one another. Similar to how the trenches of modern war are filled on either side by working-class men, Denham's business enterprise takes advantage of marginalized males both working for him and opposing him.
21. For this litany of power moves, see Johnson 115–129.

2 HOOAH! WE . . . ARE . . . SPARTA!

1. See Michael Kimmel's *Guyland* for more on this demographic group (145).

2. In interviews Miller cites two different ages for having first seen *The 300 Spartans* (Brayshaw 65; Mendelsohn 38).
3. See Interviews Three and Five of the *Comics Journal Library* volume on Frank Miller (Milo) for discussions of Miller's battle against censorship.
4. Noted expert on ancient Spartan culture and A. G. Leventis Professor of Greek Culture at Cambridge University Paul Cartledge comments that he, too, was consulted about the film but his advice "was not heeded" ("Forever Young" n. 26, 23).
5. Ernle Bradford agrees with Cartledge's suspicions that Leonidas was involved in Cleomenes's death (85).
6. The novel makes Leonidas about 50 years old at Thermopylae (11); the film makes Leonidas 40 years old. Cartledge estimates Leonidas was born around 540 BCE (*The Spartans* 257), putting him closer to 60 during the events depicted.
7. In *Spartan Women*, Sarah Pomeroy says that such an endogamous practice was not unusual in ancient Spartan society (73).
8. Ten years before Thermopylae, due to religious duties, the Spartans notoriously arrived at Marathon after the battle was completed. See Matthews and Cartledge (*Spartans*) for discussion of this episode.
9. It is debatable whether the Helots were slaves in the way Americans understand slavery. See Bradford (59) and Pomeroy (100).
10. It was Sparta's King Agesilaus, not Leonidas, who is recorded by Plutarch as having boasted this, 36 years after Leonidas's death (Bradford 66).
11. Simonides's epitaph is translated dramatically differently, either as pathetically resigned (Bradford 147) or bitterly resentful (de Selincourt 7.228).
12. For discussion of the Spartan Helot system, see Luraghi and Alcock; Hunt.
13. Cartledge claims that the Ephors annually declared war on the Helots, legitimizing the Krypteia hunt (*Thermopylae* 69).
14. Cartledge notes that the Spartans notoriously were corruptible and willing to take bribes (*Spartans* 123).
15. Both Cartledge (*The Spartans* 128) and Bradford assert that Ephialtes was unjustly treated (117).
16. The number of Greeks in this holding force could be doubled to 6,000 or 7,000 (Cartledge, "Forever Young" 13; Bradford 105).
17. According to Herodotus, there were two other indications of the Greek defeat at Thermopylae: the Delphic oracle's portent that the Spartans must "sacrifice the life of a king, or the Persians would destroy them and occupy their land" (Cartledge, *Thermopylae* 127) and from the seer accompanying the Greeks, Megistaus, who at dawn on the final day of battle, "read their doom in the victims of sacrifice" (Herodotus 7.219).
18. Scholars are not unanimous about sexual relationships among Spartan men and boys. See Bradford 64.

19. Wives of Spartan kings played no more elevated role in Spartan society than wives of other Spartiates. See Pomeroy 75, 92.

20. See Millender; Powell.

21. It was likely that Spartan warrior bodies would be buried at the battlefield, including Spartan kings. Leonidas's remains were buried at Thermopylae and recovered 40 years later (Cartledge, *Thermopylae* 160).

22. See Cartledge, *Spartans* 123–127, for more about Gorgo as a remarkable woman.

23. Herodotus says no emissaries were sent to Athens and Sparta before Xerxes's invasion: "To Athens and Sparta Xerxes sent no demand for submission because of what happened to the messengers whom Darius had sent on a previous occasion: at Athens they were thrown into the pit like criminals, at Sparta, they were pushed into a well— and told that if they wanted earth and water for the king, to get them from there" (7.133). Gorgo is reported by Plutarch as making this claim to an Athenian woman, an audience and context that changes the claim's meaning. "On being quizzed by an Athenian woman, 'Why is it that you Spartan women are the only ones who rule your men?' she [Gorgo] replied, 'because we are the only women who give birth to (real) men' " (Cartledge, *Spartans* 125).

24. Lycurgus reportedly prescribed red cloaks because it would be the color least likely to be worn by women (Bradford 104).

25. See Van Nortwick for more on how threatening were women with power independent of men in ancient Greece (155).

26. In "Xerxes Goes to Hollywood," D. S. Levene says about the accents used in *The 300 Spartans*, the film inspiring Frank Miller to write *300*, that American accents were used to distinguish the earnest, principled, plain-speaking Spartans from the British accents of the dandyish, educated, politicians of Athens (389–394).

27. Here is how the "hero kills" are described in *300: The Art of the Film*: Spartans killed by Persians "required a slightly different approach in terms of focus and details. To address this, the visual effects team came up with the following approach: 'There's going to be numerous situations when comping in a bit of dodgy squib footage just won't cut it. Our blood [i.e. the production team possibly identifies with the Spartans] has to be a lot better than that. Hero Kills are where the main focus of the shot is the act of violence, be it a spear, a sword strike, or a punch. These are the shots where we also linger on the aftermath of the act, rather than the simple moment of impact. Often some sort of time effect is applied to these shots as well, e.g. ramping into slo-mo. In these situations there needs to be thought and design put into the depiction of the blood' " (78).

28. In an interview including Frank Miller, Zack Snyder, Victor Davis Hanson, and Bettany Hughes, Hanson and Hughes agree that hoplites typically did not act individually. Hughes comments: "What

was really important to them [the Spartan hoplites] was to defend the man on their left with this shield, so they would move together in mass. It was described by contemporary others, like [a] hideous monster that moved as one." She continues: "It is a very effective way to fight as it [the phalanx] is very difficult to penetrate. So even though there is a tiny number of Spartans, they were able to stick together and fight as a unit, by using this balance. They fought as one, rather than individuals." Hanson adds: "On historical vase paintings they show warriors individually stabbing and slicing, even though we know that didn't take place as much as mass pushing and stabbing" (Seller 20).

29. Cartledge explains what Ollier means by "le mirage spartiate": "the series of more or less distorted, more or less invented images whereby Sparta has been reflected and refracted in the extant literature by non-Spartans, beginning in the late fifth century with Kritias of Athens, pupil of Socrates, relative of Plato, and leading light (or Prince of Darkness) of the 30 Tyrants" ("The Socratics' Sparta and Rouseau's").

30. See Cartledge, *Thermopylae*, pages 154–194, for a discussion of the forging of the "Thermopylae Legend."

31. A Vietnam War film thematically connected to Thermopylae is *Go Tell the Spartans* (1978), based on Daniel Ford's 1967 novel, *Incident at Muc Wa*, but scholars rarely comment on the film or this connection.

32. Levene quotes the consultant, Roger Beck: "There exists a popular belief in our society that Sparta was the home of many virtues. I believe it would be profitable for the purpose of your picture to uphold this belief. It cannot be upheld by honestly and accurately portraying the conditions existing there at the time of your story—many facts would shock the modern audiences. I suggest, therefore, that in portraying Spartan life, great care should be taken to omit certain facets of that life which would almost certainly invite unfortunate comparisons with the recent attempts to introduce regimented society into the world [i.e. Korea, Cuba, the Soviet bloc]. I think you should strive to avoid this" (386).

33. See Dabashi.

34. Boggs and Pollard elaborate on the pervasiveness of the warrior ethos in videogames (229).

35. This term was coined and theorized by political scientist Samuel P. Huntington in 1993 and is detailed in his 1996 book, *The Clash of Civilizations and the Remaking of World Order.*

36. Bacevich discusses the Iraq Liberation Act as an example of how neoconservative ideas had been normalized well before the 2001 attack on the World Trade Center (90).

37. Of the 24 signatories to the "Statement," 7 were part of or connected to the George W. Bush administration that began in 2001.

3 LOVE AND VIOLENCE IN *V FOR VENDETTA*

1. England's Reform Act of 1832 largely accomplished that feat, while on the continent the middle class squelched the Revolutions of 1848.
2. See T. Williams 17–20; Ott 39–40; Davidson 158–159; Porton 53–54; Smith.
3. See also Zizek, *Parallax* 301; John Gray 29.
4. See also Hardt and Negri, Part 4.
5. See Call; Maggie Gray; Reynolds; Keller 21–24; Porton 53.
6. See also Paik 163–165.
7. See Paik 169–173, 178–179.
8. See Keller 103–104.
9. See Combe's analysis of Spielberg's *War of the Worlds* (2005) as an anti-Bush allegory.
10. See Collier 32–33, 160–164; Laclau, "Identity and Hegemony" 45–53.
11. Butler discusses how subordinate subject identities are either falsely named within a society or never brought into the realm of the nameable, thus being not subjects but "abjects"; see "Imitation" 311–312.
12. See Keller 66; Ott 46–47.
13. Unlike what happens in *300*, where audiences are discouraged from interrogating "Spartan."
14. See T. Williams 21; Call 168–169.
15. McTeigue accomplishes the same distinction between V and Sutler when V pulls off the Chancellor's mask in the Underground station before killing him. Like Gordon's vaudevillian V, McTeigue's monstrous V does not mimic Sutler's tyranny; he puts a stop to it.
16. While modern American audiences might not be attuned to Anglo-Irish enmity, certainly Americans have numerous examples of race-based prejudice and hatred in our own national experience to draw on to relate to this unfair treatment of Finch. For centuries, the Irish were relegated to being a separate "race" by the English, and, in America, Irish immigrants were not considered "white" until early in the twentieth century. See Ignatiev.
17. During the 2012 presidential race, the same opposing visions for America were on offer again.

4 GOING "FULL RETARD" IN *TROPIC THUNDER*

1. The multi-fictionality is compounded by a network of online texts including a mockumentary, Twitter accounts, and websites for the film's fictions. See Nastovici.
2. Veneration of realism in combat films is echoed in the dedication of *Combat Films: American Realism, 1945–2012*: "To the men and women of our armed forces, who jeopardize their lives every day to keep us safe in our beds. And to the filmmakers who go the extra mile to immortalize some of those stories with a sense of realism and respect" (Rubin v).

3. Making the mine detritus from the French Indochina War of the 1940s and 1950s is a change from the Cohen, Stiller, and Theroux "Tropic Thunder Script" of 2006, where they specify the mine is an American claymore (42). Clearly, it would be hazardous to implicate Americans in killing their own when *Tropic Thunder* was produced, during the American wars in Iraq and Afghanistan; the French, perceived as duplicitous, are a more acceptable target to American audiences.

4. For histories of satire, see Connery and Combe, and Dustin Griffin.

5. Rosemarie Garland Thomson redefines this gazing as "the stare." "If the male gaze makes the normative female a sexual spectacle, then the stare sculpts the disabled subject into a grotesque spectacle. The stare is the gaze intensified, framing her body as an icon of deviance... [T]he stare is the gesture that creates disability as an oppressive social relationship. And as every person with a visible disability knows intimately, managing, deflecting, resisting, or renouncing that stare is part of the daily business of life" (26).

6. Sean Penn was nominated but did not win an Oscar for Best Actor for his performance in *I Am Sam* (2001).

7. *Tropic Thunder* reveals a twenty-first-century attitude about physical disability rather than one from the Vietnam era. In the Vietnam era, war-incurred disabilities signified ambivalently; the war was regarded as ignominious and so were its disabilities. When *Tropic Thunder* was produced in the era of the Iraq and Afghanistan wars and a "support the troops" chorus, physical disabilities, especially "traumatic amputations" and subsequent prostheses, sometimes are regarded as "badges of honor." For the signification of Vietnam War disability, see Boyle, *Masculinity*, Chapter 3: "Men Out of Mind: Disabilities in Vietnam War Stories." For the "badge of honor" signification of Iraq and Afghanistan disability, see Wolff. For the less heroic signification of Iraq and Afghanistan disabilities, see Glantz.

8. See Burkett and Whitley.

9. See Boyle, *Masculinity in Vietnam War Narratives* and "Rescuing Masculinity." See also Jeffords.

10. See Boggs and Pollard.

11. Toll was the cinematographer for Terrence Malick's 1998 *The Thin Red Line*.

12. See *The Things They Carried, Going After Cacciato* and *In the Lake of the Woods*.

13. According to the *Oxford English Dictionary*, the first recorded use of the following definition of "retard" was in 1968: "A person (or occasionally thing) regarded as being mentally or physically deficient, stupid, or incompetent." The original script had Sgt. Osiris, the Irishman-playing-an-African-American character (ultimately played by Downey as Australian), using "nigger," but Brandon T. Jackson objected to that use and so it was omitted (Rottenberg and Chessum 5).

14. "Blood sacrifice" is the term used by Carolyn Marvin and David W. Ingle in *Blood Sacrifice and the Nation: Totem Rituals and the American Flag*. Marvin and Ingle argue that totem sacrifice and ritual are not limited to primitive tribes, but that all enduring social groups rely on violence to outline and secure their boundaries. The blood shed by this group's citizens is what sustains the group. Rather than the society executing these members, societies send these members to their deaths through war. Thus, war is an alibi for the deathly mandate. See this book's Coda.

15. Auster and Quart say Vietnam War films are apolitical (xiv).

16. See *TRADOC*.

17. The names of other characters in the Stiller Film and Speedman film are equally significant, with Kirk Lazarus's perhaps having the most extended meaning. For instance, Lazarus (Robert Downey Jr.) plays Sgt. Osiris: Jesus is said to have raised Lazarus from the dead; Osiris was the Egyptian god of rebirth. Together, they indicate not only Lazarus's revival as a black-skinned actor, but they also intimate the resurgent career of Robert Downey Jr.

18. See Buchbinder to understand Sandusky as inadequately or incompetently masculine. See Halberstam (*The Queer Art*) to understand Sandusky as the "millennial dimbo" (57).

19. The preposterousness of the plan is indicated by its name, the Wet Offensive, a satiric take on the well-known Tet Offensive, the South Vietnam-wide attack by the National Liberation Front beginning in January 1968.

20. In the 2006 script, it is Sandusky who appeals to the others' humanity and masculinity. Sandusky is less assertive in the film version, that role being assigned instead to Lazarus.

5 THE NEW MILLENNIUM MANLINESS

1. For example, when President Obama announces his support of gay marriage or comprehensive immigration reform, he could be seen as behaving in a V-like, post-Marxist manner. On the other hand, when President Obama announces that SEAL Team 6 has killed Osama Bin Laden or does not adequately regulate the financial industry, he could be seen as behaving in a Leonidas-like, NeoCon manner. Political or identity positions are rarely clear-cut.

2. The name District 9 and the situation depicted in Blomkamp's movie are obvious references to the infamous Sixth Municipal District of Cape Town, where from 1968 to 1982 more than 60,000 people were forcibly evicted and relocated, their homes bulldozed, under the racist law of the South African state.

3. Remarks Blomkamp on his odd use of this familiar genre: "all I'm trying to do is make a film that has all the sci-fi elements that I really

like, injected into a slightly twisted version of how we normally see it" ("Conception and Design").

4. See Polley; Davis. To dispel the Western myth that Africa is destined for underdevelopment, see Chang, Chapters 11, 15.

5. Even after the Great Recession of 2008, brought about by decades of Reaganomics, many US voters continue to support "trickle-down" economic theories that patently don't work; see Chang, Chapters 13, 14, 16, 20, 21.

6. Cameron first wrote his screenplay in the 1990s, when these plotlines were fresh. Film technology didn't catch up with Cameron's vision until after the turn of the century.

7. Although the doctrine of Christian stewardship seemingly calls our caretaking role toward the environment, equally clear in Christian dogma is the earth having a shelf life. Doomsday is inevitable (e.g., 2 Peter 3:10–13); therefore, indefinite sustainability of the planet is never the goal. Subjugation of the world for human advantage is.

8. See "Subject and Power" 136–37, 140–41. For an account of the history and rise to prominence of the modern corporation, see Bakan. With the 2010 *Citizens United* decision by the US Supreme Court, granting significantly enhanced "personhood" legal status to corporations, the first steps have been taken in creating this strange manifestation of monstrous A.I.

9. Likely that's why Cameron so heavy-handedly names RDA's prize on Pandora: what free-market capitalism requires and seeks—unlimited markets and unlimited resources for unlimited consumption—is, in the end, unobtainable.

10. Evidently, during his time back on Earth as an able-bodied Marine, Jake was involved in similar questionable neoliberal operations.

11. Comments Boddy on this post-Reagan neoliberal corporate setting: "the whole corporate and employment environment changed from one that would hold the Corporate Psychopath in check to one where they could flourish and advance relatively unopposed…Corporate Psychopaths are ideally situated to prey on such an environment and corporate fraud, financial misrepresentation, greed and misbehaviour went through the roof, bringing down huge companies and culminating in the Global Financial Crisis that we are now in" (258).

CODA: THE MONSTER'S SUIT

1. Mark Boal's screenplay was inspired by his 2004 experience as an embedded journalist in Iraq (*The Hurt Locker Shooting Script* vii–viii). Three articles chronicle his experiences in Iraq: "Death and Dishonor"; "The Man in the Bomb Suit"; and "The Real Cost of War."

2. In *The Long Walk: A Story of War and the Life That Follows*, former bomb technician Brian Castner stipulates: "No one takes the Long

Walk [in the suit to disarm a bomb] lightly. Only after every other option is extinguished. Only after robots fail and recourses dwindle. The last choice. Always" (170–171).

3. Bigelow and Boal's most recent film, *Zero Dark Thirty* (2012), features a similarly monstrously masculine character, CIA agent Maya.
4. See Bailey.
5. See Ewing, "New Army Recruiting Slogan"; Fontaine.
6. See Zizek, "Soft Focus."
7. From the US Army Ranger website: "Today's Ranger Regiment is the Army's premier direct-action raid force...Their capabilities include...capturing or killing enemies of the nation" ("U.S. Army").
8. We use the male gender nomenclature deliberately; there are no female soldiers depicted in the film.
9. Castner remarks: "No one can put on the bomb suit alone; your brother has to dress you, overalls pulled up, massive jacket tucked, earnest in his careful thoroughness" (170).
10. The *Shooting Script* describes Sanborn's clothing Thompson as "like a squire working on a knight" (Boal, *The Hurt Locker* 7).
11. Unlike the film, Castner distinguishes between EOD's job and the security detail's traveling with them. "The trust was sacred between security and EOD team: outside the wire, they protected us from gunfire and grenades and kept us from getting lost; we protected them from IEDs and hidden danger and kept them from getting blown up" (107).
12. See Boyle, "Rescuing Masculinity."
13. Before he is killed Thompson nudges Sanborn away from the robot controls when Sanborn cannot "push it [the robot's camera] in," likening the camera to a "dick," and Eldridge under Thompson's command is so hesitant to fire his (masculine) weapon at the bomb detonator that Thompson is killed.
14. Castner describes frustration with his EOD unit's passive stance: "For once, we wanted to surprise a known IED construction cell, actually catch someone before we bled...For a week I had begged them to do this. I was sick of defense. Let's go on offense" (130).
15. The *Shooting Script* has Eldridge finish his last line not with "you fuck" but with "you fucking war mongerer" (Boal, *The Hurt Locker* 100). Eldridge's line in the film makes James more the norm than the exception.
16. See Halberstam for discussion of white male stupidity as the new macho (*Queer Art* 53–86).
17. Castner emphasizes the trope of brotherhood among bomb technicians: "You take the Long Walk for your brother's wife, your brother's children, and their children, and the line unborn. No greater love does one brother have for another than to take the Long Walk" (171).

18. Marvin and Ingle indicate that the greatest taboo of blood sacrifice is for fathers to reveal it to their sons, as the revelation would implicate fathers (74).

19. In *300*, save for the Captain's son, Leonidas took with him to Thermopylae only men who had sons, thereby ensuring the totem lineage.

20. See Marvin and Ingle for history of the yellow ribbon's use as an American talisman (237–242); Dutton 120–121; United States Bureau of Veteran Affairs.

WORKS CITED

300: The Art of the Film. Text by Tara Dilullo. Foreword by Dr. Victor Davis Hanson. Milwaukee, OR: Dark Horse, 2007. Print.

300. Dir. Zack Snyder. Perf. Gerard Butler, Lena Headey, David Wenham, Dominic West. Special Edition DVD. Warner Brothers, 2007. Film.

The 300 Spartans. Dir. Rudolph Maté. Perf. Richard Egan, Ralph Richardson. Twentieth Century Fox, 1962. Film.

Aandahl, Vance. "King Kong." *Jeremy Silmann,* 17 Jan. 2006. Web. 22 May 2012.

Act of Valor. Dir. Mike McCoy and Scott Waugh. Perf. Alex Veadov, Roselyn Sanchez, Nestor Serrano. Relativity Media, 2012. Film.

"America's Army," n.d. Web. 22 Oct. 2010.

Anderegg, Michael, ed. *Inventing Vietnam: The War in Film and Television.* Philadelphia, PA: Temple UP, 1991. Print.

Ansen, David. *Newsweek,* 11 Aug. 2008. Web. 9 Feb. 2011.

Apocalypse Now. Dir. Francis Ford Coppola. Perf. Marlon Brando, Martin Sheen, Robert Duvall. United Artists, 1979. Film.

Arendt, Paul. *BBC Movie Reviews,* 19 Mar. 2007. Web. 18 May 2010.

"Army Health Promotion, Risk Reduction, Suicide Prevention Report 2010." 2010. Web. 25 Aug. 2012.

Associated Press. " '300' Males Easy Conquest of Box Office." 11 Mar. 2007. Web. 24 Mar. 2010.

Atkinson, Mitchell. "Zack Snyder's Film *300*: Gerrard Butler and a Greek Xerxes and Leonidas Battle for Boxoffice." 7 Apr. 2007. Web. 11 Feb. 2010.

Auster, Albert and Leonard Quart. *How the War was Remembered: Hollywood & Vietnam.* New York: Praeger, 1988. Print.

Avatar. Dir. James Cameron. Perf. Sam Worthington, Zoe Saldana, Sigourney Weaver. Twentieth Century Fox, 2009. Film.

"Awards for *The Hurt Locker.*" *IMDB,* n.d. Web. 22 July 2012.

Bacevich, Andrew J. *The New American Militarism: How Americans are Seduced by War.* New York: Oxford UP, 2005. Print.

———. *Washington Rules: America's Path to Permanent War.* The American Empire Project. New York: Henry Holt, 2010. Print.

Bailey, Beth. "The Army in the Marketplace: Recruiting an All-Volunteer Force." *Journal of American History* 94.1 (2007): 47–74. Print.

Bakan, Joel. *The Corporation: The Pathological Pursuit of Profit and Power.* New York: Simon & Schuster, 2004. Print.

Basinger, Jeanine. *The World War II Combat Film: Analysis of a Genre.* Middletown, CT: Wesleyan UP, 2003. Print.

Battle Los Angeles. Dir. Jonathan Liebesman. Perf. Aaron Eckhart, Michelle Rodriguez, Bridget Moynahan. Columbia Pictures, 2011. Film.

Bauer, Patricia E. "Tropic Thunder: 'Once upon a time...There was a retard.'" *PatriciaEBauer: News & Commentary on Disability Issues,* 1 Aug. 2008. Web. 28 May 2010.

Beautiful Mind, A. Dir. Ron Howard. Perf. Russell Crowe, Jennifer Connelly. DreamWorks, 2001. Film.

Beck, Bernard. "Don't Make Me Laugh: People are Funny in *WALL-E* and *Tropic Thunder." Multicultural Perspectives* 11.2 (2009): 90–93. Print.

———. "Hail the Conquering Hero: Remembering the Troops in *The Hurt Locker, Inglorious Basterds,* and *Avatar." Multicultural Perspectives* 12.4 (2010): 213–216. Print.

Bellin, Joshua David. *Framing Monsters: Fantasy Film and Social Alienation.* Carbondale, IL: Southern Illinois UP, 2005. Print.

Bhabha, Homi. *The Location of Culture.* New York: Routledge, 1994. Print.

Blundell, Sue. *Women in Ancient Greece.* Cambridge, MA: Harvard UP, 1995. Print.

Boal, Mark. "Death and Dishonor." *Playboy* (May 2004): 108–112, 134–141. Print.

———. *The Hurt Locker: The Shooting Script.* Newmarket Shooting Scripts Series. New York: Newmarket, 2009. Print.

———. "Man in the Bomb Suit." *Playboy* (Sept. 2005): 68–74, 148–154. Print.

———. "The Real Cost of War." *Playboy* (Mar. 2007): 53–54, 62, 128–134. Print.

Boddy, Clive R. "The Corporate Psychopaths Theory of the Global Financial Crisis." *Journal of Business Ethics* 102 (2011): 255–259. Print.

Boggs, Carl, ed. *Masters of War: Militarism and Blowback in the Era of American Empire.* New York: Routledge, 2003. Print.

Boggs, Carl and Tom Pollard. *The Hollywood War Machine: U.S. Militarism and Popular Culture.* Boulder, CO: Paradigm, 2007. Print.

Bowden, Hugh. "Hoplites and Homer: Warfare, Hero Cult, and the Ideology of the Polis." Rich and Shipley 45–63.

Boyle, Brenda M. *Masculinity in Vietnam War Narratives: A Critical Study of Fiction, Films and Nonfiction Writings.* Jefferson, NC: McFarland, 2009. Print.

———. "Rescuing Masculinity: Captivity, Rescue and Gender in American War Narratives." *The Journal of American Culture* 34.2 (June 2011): 149–160. Print.

Box Office Mojo. 300, n.d. Web. 29 Mar. 2010.

———. *Avatar,* n.d. Web. 29 Mar. 2010.

———. *District 9,* n.d. Web. 29 Mar. 2010.

———. *The Hurt Locker,* n.d. Web. 29 Mar. 2010.

———. *King Kong,* n.d. Web. 29 Mar. 2010.

———. *Tropic Thunder,* n.d. Web. 29 Mar. 2010.

———. *V for Vendetta*, n.d. Web. 29 Mar. 2010.

Bradford, Ernle. *Thermopylae: The Battle for the West*. New York: McGraw Hill, 1980. Print.

Brayshaw, Christopher. "Interview Four: 'To me now, it would be strange to write and draw a comic book that took it for granted that somebody could fly.'" Milo 65–87.

Bresnan, Conor. "Around the World Roundup: '300' Conquers More Countries." *Box Office Mojo*, 26 Mar. 2007. Web. 29 Mar. 2010.

Brewer, Susan A. *Why America Fights: Patriotism and War Propaganda from the Philippines to Iraq*. New York: Oxford UP, 2009. Print.

Bridges, Emma. "The Guts and the Glory: Pressfield's Spartans at the *Gates of Fire*." Bridges, Hall, and Rhodes 405–421.

Bridges, Emma, Edith Hall, and P. J. Rhodes, eds. *Cultural Responses to the Persian Wars: Antiquity to the Third Millenium*. New York: Oxford UP, 2007. Print.

Buchbinder, David. "Enter the Schlemiel: The Emergence of Inadequate or Incompetent Masculinities in Recent Film and Television." *Canadian Review of American Studies* 38.2 (2008): 227–245. Print.

Burkett, B. G., and Glenna Whitley. *Stolen Valor: How the Vietnam Generation Was Robbed of its Heroes and its History*. Dallas, TX: Verity Press, 1998. Print.

Butler, Judith, Ernesto Laclau, and Slavoj Zizek, eds. *Contingency, Hegemony, Universality: Contemporary Dialogues on the Left*. London: Verso, 2000. Print.

Butler, Judith. *Gender Trouble: Feminism and the Subversion of Identity*. 2nd ed. New York: Routledge, 1999. Print.

———. "Imitation and Gender Insubordination." *The Lesbian and Gay Studies Reader*. Ed. H. Abelove, M. A. Barale, and D. M. Halperin. New York: Routledge, 1993. 307–320. Print.

———. *Undoing Gender*. New York: Routledge, 2004. Print.

Burr, Ty. "Bombs Trump Big Ideas in Potent 'Vendetta.'" *The Boston Globe*, 16 Mar. 2006. Web. 22 May 2012.

Call, Lewis. "A is for Anarchy, V is for Vendetta: Images of Guy Fawkes and the Creation of Postmodern Anarchism." *Anarchist Studies* 16.2 (2008): 154–172. Print.

Carroll, Noël. "*King Kong*: Ape and Essence." *Planks of Reason: Essays on the Horror Film*. Ed. B. K. Grant and C. Sharrett. Lanham, MD: Scarecrow, 2004. 212–239. Print.

Cartledge, Paul. "Forever Young: Why Cambridge Has a Professor of Greek Culture." A. G. Leventis Inaugural Lecture Given in the University of Cambridge, 16 February 2009. New York: Cambridge UP, 2009. Print.

———. "The Socratics' Sparta and Rousseau's." *Institute of Historical Research*, n.d. Web. 16 Apr. 2010.

———. *The Spartans: The World of the Warrior-Heroes of Ancient Greece*. New York: Vintage, 2004. Print.

———. *Thermopylae: The Battle That Changed the World*. New York: Vintage, 2007. Print.

Cartledge, Paul. "What Have The Spartans Done For Us?: Sparta's Contribution to Western Civilization." *Greece & Rome* 51.2 (2004): 164–179. Print.

Cashill, Robert. "All Things Kong-Sidered." *Cineaste* (Spring 2006): 39–43. Print.

Castner, Brian. *The Long Walk: A Story of War and the Life That Follows.* New York: Doubleday, 2012. Print.

Cawson, Frank. *The Monsters in the Mind: The Face of Evil in Myth, Literature and Contemporary Life.* Sussex: Book Guild, 1995. Print.

Chamber, Samuel A. and Terrell Carver. *Judith Butler and Political Theory: Troubling Politics.* New York: Routledge, 2008. Print.

Chang, Ha-Joon. *23 Things They Don't Tell You about Capitalism.* London: Penguin, 2011. Print.

Chivers, Sally and Nicole Markotic, eds. *The Problem Body: Projecting Disability on Film.* Columbus, OH: The Ohio State UP, 2010. Print.

Cieply, Michael. "A Movie's Production Budget Pops from the Screen." *The New York Times,* 8 Nov. 2009. Web. 22 July 2012.

Clough, Emma. "Loyalty and Liberty: Thermopylae in the Western Imagination." Figueira 363–384.

Clover, Carol. "Her Body, Himself: Gender in the Slasher Film." Grant 66–113.

Cohen, Jeffrey Jerome. "Monster Culture (Seven Theses)." *Monster Theory: Reading Culture.* Ed. J. J. Cohen. Minneapolis: U of Minnesota P, 1996. 3–25. Print.

Collier, Andrew. *Marx: A Beginner's Guide.* Oxford: One World, 2004. Print.

Combe, Kirk. "Spielberg's Tale of Two Americas: Postmodern Monsters in *War of the Worlds.*" *The Journal of Popular Culture* 44.5 (October 2011): 934–953. Print.

"Conception and Design: Creating the World of *District 9.*" *District 9.* Dir. Neill Blomkamp. Tri Star, 2009. DVD. Disc 2.

Connell, R. W. *Gender.* Malden, MA: Blackwell, 2002. Print.

———. *Masculinities.* 2nd ed. Berkeley: U of California P, 2005. Print.

———. *The Men and the Boys.* Berkeley: U of California P, 2000. Print.

———. "The Social Organization of Masculinity." *The Masculinities Reader.* Ed. S. Whitehead and F. Barrett. Cambridge: Polity, 2001. 30–50. Print.

Connell, R. W. and James W. Messerschmidt. "Hegemonic Masculinity: Rethinking the Concept." *Gender & Society* 19.6 (December 2005): 829–859. Print.

Connery, Brian A. and Kirk Combe. "Theorizing Satire: A Retrospective and Introduction." *Theorizing Satire: Essays in Literary Criticism.* Ed. B. Connery and K. Combe. New York: St. Martin's, 1995. 1–14. Print.

Corliss, Richard. "Can a Popcorn Movie Also Be Political? This One Can." *Time,* 5 Mar. 2006. Web. 30 June 2012.

Count of Monte Cristo, The. Dir. Rowland V. Lee. Perf. Robert Donat, Elissa Landi. RKO-Pathé Studios, 1934. Film.

Creed, Barbara. *The Monstrous-Feminine: Film, Feminism, Psychoanalysis.* New York: Routledge, 1993. Print.

Crowell, Ellen. "Scarlet Carsons, Men in Masks: The Wildean Contexts of *V for Vendetta*." *Neo-Victorian Studies* 2:1 (Winter 2008/2009): 17–45. Print.

Curtis, Adrienne. "There's a Rumble in the Jungle." *Film Review* 700 (September 2008): 78–94. Print.

Dabashi, Hamid. "The '300' Strokes." *Al-Ahram Weekly* 856 (2–8 Aug. 2007). Web. 15 May 2010.

Dances with Wolves. Dir. Kevin Costner. Perf. Kevin Costner, Mary McDonnell. Orion, 1990. Film.

Dargis, Manohla. "War May Be Hell, But Hollywood Is Even Worse." *The New York Times* E:1 (13 Aug. 2008). Print.

Davidson, Rjurik. "Vararies & Violence in *V for Vendetta*." *Screen Education* 46 (2007): 157–162. Print.

Davis, Mike. *Planet of Slums*. New York: Verso, 2006. Print.

Denby, David. "Blowup." *The New Yorker*, 20 Mar. 2006. Web. 16 June 2012.

———. "Men Gone Wild: *Shooter* and *300*." *The New Yorker*, 2 Apr. 2007. Web. 17 Mar. 2011.

Derrida, Jacques. "Structure, Sign, and Play in the Discourse of the Human Sciences." *Criticism: Major Statements*. Ed. C. Kaplan and W. D. Anderson. New York: Bedford/St. Martin's, 2000. 493–510. Print.

District 9. Dir. Neill Blomkamp. Perf. Sharlto Copley, Jason Cope, David James. Tri Star, 2009. Film.

Doherty, Tom. "The New War Movies as Moral Rearmament: *Black Hawk Down* and *We Were Soldiers*." *The War Film*. Ed. Robert Eberwein. New Brunswick: Rutgers UP, 2005. 214–221. Print.

Dutton, George. "Reflections on Two American Wars." *Amerasia Journal* 31.2 (2005): 116–121. Print.

Eagleton, Terry. *Marxism and Literary Criticism*. Berkeley, CA: U of California P, 1976. Print.

Edelstein, David. "Gorilla My Dreams: Peter Jackson's *King Kong* Celebrates Interspecies Love." *Slate*, 12 December 2005. Print.

Elliott, David. "Parallel Wars? Can Lessons of Vietnam be Applied to Iraq?" *Iraq and the Lessons of Vietnam: Or How Not to Learn from the Past*. Ed. L. Gardner and M. Young. New York: New Press, 2007. 17–33. Print.

Erb, Cynthia. *Tracking King Kong: A Hollywood Icon in World Culture*. Detroit, MI: Wayne State UP, 1998. Print.

Ewing, Philip. "New Navy Slogan Aims at Sense of Service." *Navy Times*, 30 Sept. 2009. Web. 23 July 2012.

Faludi, Susan. *The Terror Dream: Fear and Fantasy in Post-9/11 America*. New York: Henry Holt, 2007. Print.

Feinberg, Leonard. "Satire: The Inadequacy of Recent Definitions." *Genre* 1 (1968): 31–37. Print.

FernGully: The Last Rainforest. Dir. Bill Kroyer. Perf. Tim Curry, Samantha Mathis, Christian Slater. Twentieth Century Fox, 1992. Film.

Fight Club. Dir. David Fincher. Perf. Edward Norton, Brad Pitt, Helena Bonham Carter. Twentieth Century Fox, 1999. Film.

Figueira, Thomas J., ed. *Spartan Society.* Swansea, Wales: Classical Press of Wales, 2004. Print.

Fish, Stanley. *Surprised by Sin: The Reader in* Paradise Lost. 2nd ed. Boston: Harvard UP, 1998. Print.

Fisher, Bob. "Wartime Lies." *ICG Magazine,* (1 Aug. 2008): 45–51. Print.

Fontaine, Scott. "Air Force Adopts New Motto." *Air Force Times,* 7 Oct. 2010. Web. 23 July 2012.

Ford, Daniel. *The Incident at Muc Wa.* Garden City, NY: Doubleday, 1967. Print.

Forrest Gump. Dir. Robert Zemeckis. Perf. Tom Hanks, Sally Field, Robin Wright. Paramount, 1994. Film.

Foucault, Michel. "The Subject and Power." Rabinow and Rose 126–144.

———. "Truth and Power." Rabinow and Rose 300–318.

———. "Questions of Method." Rabinow and Rose 247–258.

Friedman, John. *The Monstrous Races in Medieval Art and Thought.* Cambridge, MA: Harvard UP, 1981. Print.

Garland Thompson, Rosemarie. *Extraordinary Bodies: Figuring Physical Disability in American Culture and Literature.* New York: Columbia UP, 1997. Print.

Giles, Jeff. "Anarchy in the U.K." *Newsweek* 147:12 (20 March 2006): 69. Print.

Gilmore, David. *Monsters: Evil Beings, Mythical Beasts, and All Manner of Imaginary Terrors.* Philadelphia, PA: U of Pennsylvania P, 2003. Print.

Girard, René. *The Scapegoat.* Trans. Y. Freccero. Baltimore, MD: Johns Hopkins UP, 1986. Print.

Gladiator. Dir. Ridley Scott. Perf. Russell Crowe, Joaquin Phoenix. DreamWorks, 2000. Film.

Glantz, Aaron. *The War Comes Home: Washington's Battle against America's Veterans.* Berkeley, CA: U of California P, 2009. Print.

Golding, William. "The Hot Gates." *The Hot Gates, and Other Occasional Pieces.* New York: Harcourt, 1966. 13–20. Print.

Go Tell the Spartans. Dir. Ted Post. Perf. Burt Lancaster, Craig Wasson, Jonathan Goldsmith. Mar Vista Productions, 1978. Film.

Graham, Elaine. *Representations of the Post/Human: Monsters, Aliens and Others in Popular Culture.* New Brunswick: Rutgers UP, 2002. Print.

Grant, Barry Keith, ed. *The Dread of Difference: Gender and the Horror Film.* Austin, TX: U of Texas P, 1996. Print.

Gray, Brandon. "Hordes Drive '300' to Record." *Box Office Mojo,* 12 Mar. 2007. Web. 12 Mar. 2010.

Gray, John. *Black Mass: Apocalyptic Religion and the Death of Utopia.* New York: Farrar, Straus and Giroux, 2007. Print.

Gray, Jonathan, Jeffrey Jones, and Ethan Thompson, eds. *Satire TV: Politics and Comedy in the Post-Network Era.* New York: New York UP, 2009. Print.

Gray, Maggie. " 'A fistful of dead roses …'. Comics as Cultural Resistance: Alan Moore and David Lloyd's *V for Vendetta.*" *Journal of Graphic Novels & Comics* 1:1 (June 2010): 31–49. Print.

Greene, Chad. "Back to the World." *BoxOffice* 144.8 (August 2008): 24–28. Print.

Griffin, David. "The Once and Future Kong." *The New York Review of Science Fiction* (March 2006): 18–19. Print.

Griffin, Dustin. *Satire: A Critical Reintroduction*. Lexington, KY: UP Kentucky, 1994. Print.

Guerrero, Ed. *Framing Blackness: The African American Image in Film*. Philadelphia, PA: Temple UP, 1993. Print.

Halberstam, Judith. *Female Masculinity*. Durham: Duke UP, 1998. Print.

———. *The Queer Art of Failure*. Durham: Duke UP, 2011. Print.

Hall, Donald. *Queer Theories*. New York: Palgrave, 2003. Print.

Hall, Edith. "Asia Unmanned: Images of Victory in Classical Athens." Rich and Shipley 108–133.

Halter, Ed, ed. *From Sun Tzu to Xbox: War and Video Games*. New York: Thunder's Mouth, 2006. Print.

Hanley, Lawrence. "Popular Culture and Crisis: King Kong Meets Edmund Wilson." *Radical Revisions: Rereading 1930s Culture*. Ed. B. Mullen and S. L. Linkon. Urbana, IL: U of Illinois P, 1996. 242–263. Print.

Hanson, Victor Davis. "History and the Movie '300'." *Private Papers*, 11 Oct. 2006. Web. 25 Mar. 2010.

———. *The Western Way of War: Infantry Battle in Classical Greece*. New York: Knopf, 1989. Print.

Haraway, Donna. *Primate Visions: Gender, Race, and Nature in the World of Modern Science*. New York: Routledge, 1989. Print.

Hardt, Michael and Antonio Negri. *Empire*. Cambridge, MA: Harvard UP, 2000. Print.

Harpham, Geoffrey Galt. "The Depth of the Heights: Reading Conrad with America's Military." *The Humanities and the Dream of America*. Chicago, IL: U of Chicago P, 2011. 191–203. Print.

Hedegaard, Erik. "The Man Who Wasn't There." *Rolling Stone*, 21 Aug. 2008. Wed. 9 Feb. 2011.

Hedges, Chris. *War is a Force That Gives Us Meaning*. New York: Anchor, 2003. Print.

Hellenbrand, Harold. "Bigger Thomas Reconsidered: 'Native Son,' Film and 'King Kong.'" *Journal of American Culture* 6:1 (Spring 1983): 84–95. Print.

Herodotus. *The Histories*. Trans. Aubrey de Selincourt. Revised with Introduction and notes by John Marincola. New York: Penguin, 2003. Print.

Herr, Michael. *Dispatches*. New York: Vintage, 1991. Print.

Highet, Gilbert. *The Anatomy of Satire*. Princeton, NJ: Princeton UP, 1962. Print.

Holleran, Scott. "History Hijacked by Horror." *Box Office Mojo*, n.d. Web. 29 Mar. 2010.

hooks, bell. *Ain't I a Woman? Black Women and Feminism*. Boston, MA: South End, 1981. Print.

Hopkinson, Stephen and Anton Powell, eds. *Sparta: New Perspectives.* Swansea, Wales: Classical Press of Wales, 1999. Print.

Hopton, John. "The State and Military Masculinity." *Military Masculinities: Identity and the State.* Ed. Paul R. Higate. Westport, CT: Praeger, 2003. 111–123. Print.

Horn, John. "King Kong." *Los Angeles Times,* 16 January 2005. 1–5. Print.

Hunchback of Notre Dame, The. Dir. William Dieterle. Perf. Charles Laughton, Maureen O'Hara. RKO Radio Pictures, 1939. Film.

Hunt, Peter. *Slaves, Warfare, and Ideology in the Greek Historians.* New York: Cambridge UP, 1998. Print.

Hunter, Stephen. " 'King Kong': A Beauty of a Beast." *The Washington Post,* 14 Dec. 2005. Print.

———. " 'V': D for Disappointing." *The Washington Post,* 17 Mar. 2006. Web. 12 June 2012.

Huntington, Samuel P. "The Clash of Civilizations?" *Foreign Affairs* 72.3 (Summer 1993): 22–49. Print.

———. *The Clash of Civilizations and Remaking of the World Order.* New York: Simon and Schuster, 1996. Print.

Hurt Locker, The. Dir. Kathryn Bigelow. Perf. Guy Pearce, Jeremy Renner, Anthony Mackie, Ralph Fiennes. Summit, 2009. Film.

I Am Sam. Dir. Jessie Nelson. Perf. Sean Penn, Michelle Pfeiffer. New Line, 2001. Film.

Ignatiev, Noel. *How the Irish Became White.* New York: Routledge, 1995. Print.

Independence Day. Dir. Roland Emmerich. Perf. Will Smith, Bill Pullman, Jeff Goldblum. Twentieth Century Fox, 1996. Film.

"Innovation: The Acting and Improvisation of *District 9.*" *District 9.* Dir. Neill Blomkamp. Tri Star, 2009. DVD. Disc 2.

Itzkoff, Dave. "The Refined Art of Tastelessness." *The New York Times,* 17 Aug. 2008. Web. 5 July 2011.

Jeffords, Susan. *The Remasculinization of America: Gender and the Vietnam War.* Bloomington, IN: Indiana UP, 1989. Print.

Jhally, Sut. "Advertising at the Edge of the Apocalypse." *Critical Studies in Media Commercialism.* Ed. R. Andersen and L. Strate. Oxford: Oxford UP, 2000. 27–39. Print.

Johnson, Chalmers. "American Militarism and Blowback." Boggs 111–129.

Kahane, David. "300 Shocker: Hollywood Takes a Detour to Reality." *National Review Online,* 12 Mar. 2007. Web. 14 Apr. 2010.

Keller, James. *V for Vendetta as Cultural Pastiche: A Critical Study of the Graphic Novel and Film.* Jefferson, NC: McFarland, 2008. Print.

Kennell, Nigel M. *Spartans: A New History.* Malden, MA: Wiley-Blackwell, 2010. Print.

Kenny, Glenn. "*V for Vendetta.*" *Premiere,* 17 Mar. 2006. Web. 12 July 2012.

Kimmel, Michael S. *The Gendered Society.* 2nd ed. New York: Oxford UP, 2004. Print.

———. *Guyland: The Perilous World Where Boys Become Men.* New York: Harper, 2008. Print.

————. *Manhood in America: A Cultural History.* 2nd ed. New York: Oxford UP, 2006. Print.

Kimmel, Michael S. and Amy Aronson, eds. *Men and Masculinities: A Social, Cultural and Historical Encylopedia.* Santa Barbara, CA: ABC-CLIO, 2004. Print.

King Kong. Dirs. Merian C. Cooper and Ernest B. Schoedsack. RKO Radio Pictures, 1933. Two-Disc Special Edition DVD. Turner Entertainment Co., 2005. Film.

King Kong. Dir. Peter Jackson. Perf. Naomi Watts, Jack Black, Adrien Brody, Andy Serkis. Deluxe Extended Edition. Universal Pictures, 2006. Film.

King's Speech, The. Dir. Tom Hooper. Perf. Colin Firth, Helena Bonham Carter. Weinstein, 2010. Film.

Knight, Richard. "Guy Stuff: *Tropic Thunder—What We Do Is Secret.*" *Knight at the Movies: Film from a Queer Perspective* (Archives), n.d. Web. 28 May 2010.

"Kurt Johnstad." *IMDB,* n.d. Web. 12 Aug. 2012.

Laclau, Ernesto. "Identity and Hegemony: The Role of Universality in the Constitution of Political Logics." Butler, Laclau, and Zizek 44–89.

Laclau, Ernesto, and Chantal Mouffe. *Hegemony and Socialist Strategy: Towards a Radical Democratic Politics.* 2nd ed. London: Verso, 2001. Print.

Levene, D. S. "Xerxes Goes to Hollywood." Bridges, Hall, and Rhodes 383–403.

Lianeri, Alexandra. "The Persian Wars as the 'Origin' of Historiography: Ancient and Modern Orientalism in George Grote's *History of Greece.*" Bridges, Hall, and Rhodes 331–353.

Loewen, James W. *Lies My Teacher Told Me: Everything Your American History Textbook Got Wrong.* New York: Simon & Schuster, 2007. Print.

London, Jack. "How I Became a Socialist." *The Portable Jack London.* Ed. E. Labor. New York: Penguin, 1994. 458–461. Print.

Longwell, Todd. "Johnstad: Epic Heroes Make Big Impact on the Page." *Variety,* 12 Dec. 2011. Web. 28 July 2012.

Luraghi, Nino and Susan E. Alcock, eds. *Helots and Their Masters in Laconia and Messenia: Histories, Ideologies, Structures.* Cambridge, MA: Harvard UP, 2003. Print.

Lyall, Sarah. "From the Wachowski Brothers, an Ingénue Who Blows Up Parliament." *The New York Times,* 19 June 2005. Web. 11 June 2012.

Marincola, John. "The Persian Wars in Fourth-Century Oratory and Historiography." Bridges, Hall, and Rhodes 105–125.

Marlantes, Karl. *Matterhorn.* New York: Atlantic Monthly P, 2010. Print.

————. *What It Is Like To Go To War.* New York: Atlantic Monthly P, 2011. Print.

Marvin, Carolyn and David Ingle. *Blood Sacrifice and the Nation: Totem Rituals and the American Flag.* New York: Cambridge UP, 1999. Print.

Marx, Karl. *Capital (Das Kapital)*. Ed. D. McLellan. Oxford: Oxford UP, 2008. Print.

———. *The Communist Manifesto*. Ed. F. Bender. New York: Norton, 1988. Print.

———. *Early Writings*. Trans. R. Livingstone and G. Benton. Harmondsworth: Penguin, 1975. Print.

Matrix Reloaded, The. Dir. Andy Wachowski, Lana Wachowski. Perf. Laurence Fishburne, Carrie-Anne Moss, Keanu Reeves. Warner Bros., 2003. Film.

Matthews, Rupert. *The Battle of Thermopylae: A Campaign in Context*. Stroud, UK: Spellmount, 2006. Print.

McCarthy, Todd. "*Tropic Thunder*." *Variety*, 25 July 2008. Web. 28 May 2010.

McLeod, John. *Beginning Postcolonialism*. Manchester: Manchester UP, 2000. Print.

McKenzie, Kwame. "Big Black and Bad Stereotyping." *TimesOnline*, 13 Dec. 2005. Web. 25 June 2012.

Mendelsohn, Daniel. "Duty." *The New York Review of Books*, May 31, 2007. 37–39. Print.

Mieszkowski, Jan. "Watching War." *PMLA* 124.5 (October 2009): 1648–1661. Print.

Millender, Ellen. "Athenian Ideology and the Empowered Spartan Woman." Hopkinson and Powell 355–391.

Miller, Frank and Lynn Varley. *300*. 1998. Milwaukee, OR: Dark Horse, 2006. Print.

Million Dollar Baby. Dir. Clint Eastwood. Perf. Clint Eastwood, Hilary Swank. Warner Bros., 2004. Film.

Milo, George, ed. *The Comics Journal Library, Volume Two: Frank Miller*. Seattle, WA: Fantagraphics, 2003. Print.

Montag, Warren. " 'The Workshop of Filthy Creation': A Marxist Reading of *Frankenstein*." *Frankenstein*. Ed. R. C. Murfin and J. M. Smith. 2nd ed. New York: St. Martin's P, 2000. 384–395. Print.

Moore, Alan and David Lloyd. *V for Vendetta*. New York: Vertigo, 1990. Print.

Morris, Ian MacGregor. "The Paradigm of Democracy: Sparta in Enlightenment Thought." Figueira 339–362.

———. "'To Make a New Thermopylae': Hellenism, Greek Liberation, and the Battle of Thermopylae." *Greece & Rome* Second Series 47.2 (Oct 2000): 211–230. Print.

Morton, Ray. *King Kong: The History of a Movie Icon from Fay Wray to Peter Jackson*. New York: Applause, 2005. Print.

Murray, G. N. "Zack Snyder, Frank Miller and Herodotus: Three Takes on the 300 Spartans." *Akroterion* 52 (2007): 11–35. Print.

My Left Foot. Dir. Jim Sheridan. Perf. Daniel Day-Lewis, Brenda Fricker. Miramax, 1989. Film.

Nastovici, Catie. "Three *Tropic Thunder* websites may prove what we already know—Ben Stiller is smart at playing dumb." *Ioncinema.com*, 16 July 2008. Web. 28 July 2011.

"New Army Recruiting Slogan." *Military.com*, 9 Oct. 2009. Web. 23 July 2012.

Nietzsche, Friedrich. "On Truth and Lies in a Nonmoral Sense." *Philosophy and Truth: Selections from Nietzsche's Notebooks of the early 1870's*. Trans. and Ed. D. Breazeale. Atlantic Highlands, NJ: Humanities, 1979. 79–97. Print.

Nilsen, Don. "Satire—The Necessary and Sufficient Conditions—Some Preliminary Observations." *Studies in Contemporary Satire* 15 (1988): 1–10. Print.

Nisbet, Gideon. *Ancient Greece in Film and Popular Culture*. 2nd ed. Bristol, UK: Exeter, 2008. Print.

O'Brien, Tim. *Going After Cacciato*. New York: Delacorte, 1978. Print.

———. *In the Lake of the Woods*. Boston, MA: Houghton Mifflin, 1994. Print.

———. *The Things They Carried*. New York: Broadway, 1998. Print.

O'Rourke, Meghan. "Kong in Love: The Sexual Politics of Peter Jackson's King Kong." *Slate*, 14 December 2005. Print.

Ott, Brian. "The Visceral Politics of *V for Vendetta*: On Political Affect in Cinema." *Critical Studies in Media Communication* 27:1 (March 2010): 39–54. Print.

Otto, Jeff. "*V for Vendetta*." *IGN Movies*, 16 Mar. 2006. Web. 11 June 2012.

Paik, Peter. *From Utopia to Apocalypse: Science Fiction and the Politics of Catastrophe*. Minneapolis, MN: U of Minnesota P, 2010. Print.

Passion of the Christ, The. Dir. Mel Gibson. Perf. Jim Caviezel, Maia Morgenstern. Icon, 2004. Film.

Peary, Gerald. "Missing Links: The Jungle Origins of *King Kong*." *The Girl in the Hairy Paw*. Ed. R. Gottesman and H. Geduld. New York: Avon, 1976. 37–42. Print.

Philadelphia. Dir. Jonathan Demme. Perf. Tom Hanks, Denzel Washington. TriStar, 1993. Film.

Platoon. Dir. Oliver Stone. Perf. Charlie Sheen, Tom Berenger, Willem Dafoe. Orion, 1986. Film.

Pocahontas. Dir. Mike Gabriel, Eric Goldberg. Perf. Irene Bedard, Mel Gibson, Christian Bale. Walt Disney Pictures, 1995. Film.

Podhoretz, John. " 'A' for Absurd." *The Weekly Standard* 11:25, 20 Mar. 2006. Web. 20 June 2012.

Polley, Jason. " 'Ceaseless Social War': *District 9*." *JGCinema.com*, n.d. Web. 17 Oct. 2011.

Pomeroy, Sarah B. *Spartan Women*. New York: Oxford UP, 2002. Print.

Porton, Richard. "*V for Vendetta*." *Cineaste* (Summer 2006): 52–54. Print.

Powell, Anton. "Spartan Women Assertive in Politics? Plutarch's Lives of Agis and Kleomenes." Hopkinson and Powell 393–419.

Pratt, Mary Louise. "Harm's Way: Language and the Contemporary Arts of War." *PMLA* 124.5 (Oct. 2009): 1515–1531. Print.

Pressfield, Steven. *Gates of Fire*. New York: Bantam, 1998. Print.

Price, Stuart. "Displacing the Gods? Agency and Power in Adaptations of Ancient History and Myth." *Journal of Adaptation in Film and Performance* 1:2 (2008): 117–132. Print.

Puig, Claudia. "Vengeance is Theirs in Sharp 'Vendetta.' " *USA Today*, 15 Mar. 2006. Web. 3 May 2012.

Rabinow, Paul and Nikolas Rose, eds. *The Essential Foucault: Selections from the Essential Works of Foucault 1954–1984.* New York: New Press, 2003. Print.

Rain Man. Dir. Barry Levinson. Perf. Dustin Hoffman, Tom Cruise. United Artists, 1988. Film.

Rainer, Peter. "Review: *Tropic Thunder.*" *The Christian Science Monitor,* 16 Aug. 2008. Web. 28 May 2010.

"Retard." *Oxford English Dictionary,* n.d. Web. 20 July 2011.

Reuters. " '300' Racks Up Record Body Count at Box Office." *Reuters,* 11 Mar. 2007. Web. 29 Mar. 2010.

Reynolds, James. " 'Kill Me Sentiment': *V for Vendetta* and Comic-to-Film Adaptation." *Journal of Adaptation in Film & Performance* 2:2 (2009): 121–136. Print.

Rich, John and Graham Shipley, eds. *War and Society in the Greek World.* New York: Routledge, 1995. Print.

Rice, Alan. *Radical Narratives of the Black Atlantic.* New York: Continuum, 2003. Print.

Riley, Charles A. II. *Disability and the Media: Prescriptions for Change.* Hanover: UP of New England, 2005. Print.

Rose, Peter W. "Teaching Classical Myth and Confronting Contemporary Myths." *Classical Myth and Culture in the Cinema.* Ed. M. M. Winkler. New York: Oxford UP, 2001. 291–318. Print.

Rosenheim, Edward. *Jonathan Swift and the Satirist's Art.* Chicago, IL: U of Chicago P, 1963. Print.

Rottenberg, Joseph and Jake Chessum. "The Thunder Cats!" *Entertainment Weekly* 1006 (August 15, 2008): 22–28. Print.

Rubin, Steven Jay. *Combat Films: American Realism, 1945–2010.* 2nd ed. Jefferson, NC: McFarland, 2011. Print.

Ryan, David C. "*300* Lies? Give Poetics a Chance." *Bright Lights Film Journal* 57 (Aug. 2007). Web. 9 Oct. 2009.

Ryan, Maureen. *The Other Side of Grief: The Home Front and the Aftermath Narratives of the Vietnam War.* Amherst, MA: U of Massachusetts P, 2008. Print.

Said, Edward W. *Orientalism.* New York: Random House, 1978. Print.

Schleier, Merrill. "The Empire State Building, Working-Class Masculinity, and *King Kong.*" *Mosaic* 41:2 (June 2008): 29–54. Print.

Scott, A. O. "Battle of the Manly Men: Blood Bath With a Message." *The New York Times Online,* 9 Mar. 2007. Web. 29 Mar. 2010.

Seller, Jay, ed. "Literature to Film Lecture on the Movie *300,* 2007." *Teachfilmstudy.com,* n.d. Web. 16 Dec. 2009.

Shelley, Mary. *Frankenstein.* Ed. J. M. Smith. 2nd ed. New York: Bedford, 2000. Print.

Shepard, Lucius. "Say You Want a Revolution?" *Fantasy & Science Fiction,* Aug. 2006. Web. 7 May 2012.

Shine. Dir. Scott Hicks. Perf. Geoffrey Rush, Justin Braine. Fine Line, 1996. Film.

Shor, Francis. "Hypermasculine Warfare: From 9/11 to the War on Iraq." *Bad Subjects*, 2005. Web. 24 June 2011.

Siebers, Tobin. *Disability Theory*. Ann Arbor, MI: U of Michigan P, 2008. Print.

Smiley, Tavis, and Cornel West. *The Rich and the Rest of Us: A Poverty Manifesto*. New York: SmileyBooks, 2012. Print.

Smith, Andrew. "Politics behind 'V for Vendetta.' " *The Pendulum Online*, 2006. Web. 17 June 2012.

Snead, James A. "Spectatorship and Capture in *King Kong*: The Guilty Look." *Representing Blackness: Issues in Film and Video*. Ed. V. Smith. New Brunswick: Rutgers UP, 1997. 25–45. Print.

Snyder, Sharon L., and David T. Mitchell. "Body Genres: An Anatomy of Disability in Film." Chivers and Markotic 179–204.

Sobchack, Vivian. "Introduction: History Happens." *The Persistence of History: Cinema, Television, and the Modern Event*. Ed. V. Sobchack. New York: Routledge, 1996. Print.

Solomon, Jon. *The Ancient World in the Cinema*. 2nd ed. New Haven, CT: Yale UP, 2001. Print.

Solomon, Norman. "Mass Media: Aiding and Abetting Militarism." Boggs 245–260.

"Stars Earn Stripes." *NBC*, n.d. Web. 10 Aug. 2012.

"Statement of Principles." *Project for the New American Century*, 3 June 1997. Web. 19 Sept. 2011.

Stephenson, Hunter. "Movie Review: *Tropic Thunder*." *Slashfilm.com*, 19 Aug. 2008. Web. 5 July 2011.

Stevens, Dana. "A Movie Only a Spartan Could Love." *Slate*, 8 Mar. 2007. Web. 14 Apr. 2010.

Stewart, Justin. "Shooting War: Ben Stiller's *Tropic Thunder*." *Stopsmilingonline.com*, 15 Aug. 2008. Web. 28 May 2010.

Stoker, Bram. *Dracula*. Ed. M. Ellmann. New York: Oxford UP, 1996. Print.

Streufert, Paul D. "Visualizing the Classics: Frank Miller's *300* in a World Literature Class." *Teaching the Graphic Novel*. Ed. S. Tabachnick. New York: MLA, 2009. 208–214. Print.

Swofford, Anthony. *Jarhead: A Marine's Chronicle of the Gulf War and Other Battles*. New York: Scribner, 2003. Print.

Terminator, The. Dir. James Cameron. Perf. Arnold Schwarzenegger, Linda Hamilton. Orion, 1984. Film.

Terminator II: Judgment Day. Dir. James Cameron. Perf. Arnold Schwarzenegger, Linda Hamilton. TriStar, 1991. Film.

Terminator III: Rise of the Machines. Dir. Jonathan Mostow. Perf. Arnold Schwarzenegger, Claire Danes. Warner Brothers, 2003. Film.

Terminator Salvation. Dir. McG. Perf. Christian Bale, Sam Worthington. Warner Brothers, 2009. Film.

Thin Red Line, The. Dir. Terrence Malick. Perf. Nick Nolte, Jim Caviezel. Twentieth Century Fox, 1998. Film.

Torry, Robert. " 'You Can't Look Away': Spectacle and Transgression in *King Kong*." *Arizona Quarterly* 49:4 (Winter 1993): 61–77. Print.

TRADOC Regulation 350–6. U.S. Department of the Army, May 2007. Web. 3 Nov. 2011.

Travers, Peter. "*300.*" *Rolling Stone*, 7 Mar. 2007. Web. 29 Mar. 2010.

Tropic Thunder. Dir. Ben Stiller. Perf. Ben Stiller, Robert Downey Jr. Dreamworks, 2008. Film.

"Tropic Thunder Script." Etan Cohen, Ben Stiller, Justin Theroux, 5 Sept. 2006. Web. 4 June 2011.

Troy. Dir. Wolfgang Petersen. Perf. Brad Pitt, Eric Bana. Warner Bros., 2004. Film.

United States Bureau of Veterans Affairs. "Yellow Ribbon Program." n.d. Web. October 23, 2012.

"U.S. Army Rangers," n.d. Web. 24 July 2012.

V for Vendetta. Dir. James McTeigue. Perf. Hugo Weaving, Natalie Portman. Warner Brothers, 2006. Film.

Van Nortwick, Thomas. *Imagining Men: Ideals of Masculinity in Ancient Greek Culture.* Westport, CT: Praeger, 2008. Print.

Wallensten, Jenny. "300 Six Packs: Pop Culture Takes on Thermopylae." *European Journal of Archaeology* 10:1 (April 2007): 79–81. Print.

Warner, Michael, ed. *Fear of a Queer Planet: Queer Politics and Social Theory.* Minneapolis, MN: U of Minnesota P, 1993. Print.

Westwell, Guy. *War Cinema: Hollywood on the Front Line.* New York: Wallflower, 2006. Print.

Wetta, Frank J. "Film Review." *The Journal of Military History* 72.2 (April 2008): 631–632. Print.

White, Armond. "Reel War is Hell." *New York Press*, 20 Aug. 2008. Web. 5 July 2011.

Williams, Linda. "When the Woman Looks." Grant 15–34.

Williams, Tony. "Assessing *V for Vendetta.*" *CineAction* 70 (November 2006): 16–23. Print.

Wilonsky, Robert. "*Tropic Thunder*: A Consummate Movie-Biz Parody." *VillageVoice.com*, 12 Aug. 2008. Web. 28 May 2010.

Wolff, Alexander. "Prosthetics: Between Man and Machine." *Sports Illustrated*, August 8, 2011. 50–53. Print.

Xenakis, Nicholas. "T for Terrorist." *The National Interest* (Summer 2006): 135. Print.

Zacharek, Stephanie. "*Tropic Thunder.*" *Salon.com*, 13 Aug. 2008. Web. 28 May 2010.

Zero Dark Thirty. Dir. Kathryn Bigelow. Perf. Jessica Chastain, Mark Strong. Columbia, 2012. Film.

Zizek, Slavoj. "Class Struggle or Postmodernism? Yes, Please!" Butler, Laclau, and Zizek 90–135.

———. *In Defense of Lost Causes.* London: Verso, 2008. Print.

———. *The Parallax View.* Cambridge, MA: MIT, 2006. Print.

———. "A Soft Focus on War: How Hollywood Hides the Horror of War." *In These Times*, 21 Apr. 2010. Web. 16 Feb. 2012.

INDEX

Note: Locators followed by 'n' refer to notes.

.

Made in the USA
Monee, IL
18 July 2020